Art in the Asia-Pacific

As social, locative, and mobile media render the intimate public and the public intimate, this volume interrogates how this phenomenon impacts art practice and politics. Contributors bring together the worlds of art and media culture to rethink their intersections in light of participatory social media. By focusing upon the Asia-Pacific region, they seek to examine how regionalism and locality affect global circuits of culture. The book also offers a set of theoretical frameworks and methodological paradigms for thinking about contemporary art practice more generally.

Larissa Hjorth is Professor in the Games Programs, School of Media & Communication, RMIT University, Australia.

Natalie King is Director of Utopia at Asialink, The University of Melbourne, Australia.

Mami Kataoka is Chief Curator at the Mori Art Museum in Tokyo, Japan.

Routledge Advances in Art and Visual Studies

Art in the Asia-Pacific
Intimate Publics

**Edited by Larissa Hjorth,
Natalie King, and Mami Kataoka**

Routledge
Taylor & Francis Group

LONDON AND NEW YORK

First published 2014
by Routledge

Published 2014 by Routledge
711 Third Avenue, New York, NY 10017

and by Routledge
2 Park Square, Milton Park, Abingdon, Oxfordshire OX14 4RN

*Routledge is an imprint of the Taylor and Francis Group,
an informa business*

First issued in paperback 2015

Library of Congress Cataloging-in-Publication Data

 Art in the Asia-Pacific : intimate publics / edited by Larissa Hjorth, Natalie
King, Mami Kataoka.
 pages cm. — (Routledge advances in art and visual studies ; 8)
 Includes bibliographical references and index.
 1. Art and society—Pacific Area—History—21st century.
2. Technology—Social aspects—Pacific Area—History—21st
century. 3. Place (Philosophy) I. Hjorth, Larissa, editor of
compilation. II. King, Natalie, editor of compilation. III. Kataoka, Mami,
editor of compilation.
N72.S6A7515 2014
709.182'3—dc23
2013039562

ISBN 978-0-415-72274-2 (hbk)
ISBN 978-1-138-96116-6 (pbk)
ISBN 978-1-315-85810-4 (ebk)

Typeset in Sabon
by Apex CoVantage, LLC

Contents

PART II
When Art and New Media Collide

PART III
Vernacular, Media Practice, and Social Politics

Figures

Acknowledgments

The editors would like to thank both the writers and the artists for their contributions.

Larissa Hjorth would like to acknowledge the Digital Ethnography Research Centre at RMIT University, Melbourne, and the Australian Research Council Discovery *Online@AsiaPacific* (DP0986998). Natalie King would like to acknowledge Asialink, University of Melbourne, especially her colleagues in the Asialink Arts team. She also thanks her family, David, Lilly, Coco, and Woody Weissman, for their unwavering support.

This collection was developed through a special issue of *Broadsheet* (Volume 40, No. 4, December 2011). Thanks to *Broadsheet*'s editor Alan Cruickshank. Utopia@Asialink is supported by Arts Victoria.

1 Intimate Publics

The Place of Art and Media Cultures in the Asia-Pacific Region

*Larissa Hjorth, Natalie King,
and Mami Kataoka*

INTIMATE ENTANGLEMENTS

In India, one can find the third biggest usage of Facebook with more than 57 million users. In Indonesia, there are nearly 43 million Facebook users in a nation that has been dubbed "Twitter Nation". In China, where Facebook is banned, a healthy diet of QQ, Weibo, WeChat, and Jiepang dominate, highlighting the significance of media-rich mobile media. For many of the older Chinese users, the mobile phone has been their only portal for the online, especially through QQ, which for many is synonymous with the not just social media but also with the Internet. With a strong *shanzhai* (copy) phone culture that keeps the smartphone prices down, we see more than 420 million of China's total 564 million online users doing so from the mobile.

The Asia-Pacific is home to much of the world's production of online and mobile technologies as witnessed in the exposé of Foxconn's inhumane working conditions producing the world's Apple products. It is also home to the world's first example of mainstream mobile Internet in Japan more than fifteen years ago. With strong production and consumption patterns the region's various and contesting social and mobile media cultures play a pivotal role in everyday life. Yet, discussions about the role of these media cultures and their relationship to art practice have remained relatively cursory. This is partly to do with the discomfort between art and new media practice which was reenacted by Claire Bishop in her recent discussion of the two fields.[1] What becomes apparent is that the distance between the two fields is no longer tenable in practice, and thus, we need more complex conceptualizations about art's role in contemporary online and mobile media.

This opening vignette seeks to sketch some of the complex and diverse ways online media in the region is playing out. It is *personal* as it is *political*. It is *intimate* as it is *public*. It is about providing new ways of traversing the social with the geographic, the political with the personal. With social and mobile media so prevalent, it requires us to revisit some of this century's recent phenomenal shifts and turns—mobility, affective, and intimate—that have marked the social, cultural, and political fabric for this century. For some this saw the interior becoming the new exterior;[2] for others it marked

new types of migration (some chosen, some enforced). With the uneven rise of smartphones and social media globally, we see the growing significance of local and vernacular within media and art practices. As social, locative, and mobile media render the intimate *public* and the public *intimate*, how is this shaping, and being shaped by, the role of place, art practice, and politics? How are these new models for engagement, distribution, and participation—promised by online media—changing the way art is practiced and how audiences participate?

The all-pervasive role of social media within contemporary everyday life has created new challenges for traditional art and new media divides.[3] In this mediascape, what becomes apparent is the unavoidable role of media, and its focus on intimacy, as an integral part of the contemporary condition. Given that the "intimate" turn predates social media, turning to some of the initial debates by the likes of Lauren Berlant and Michael Warner can give us much insight into the politics of intimacy today. Writing before the onset of social media, Berlant observed that intimacy has taken on new geographies and forms of mobility, most notably as a kind of "publicness".[4] As intimacy is negotiated within networked social media, the publicness—along with the continuous, full-time multitasking—of intimacy becomes increasingly tangible. They are now *intimate publics*. This shift undoubtedly transforms how we think about the politics of the personal. The impact on art, political or not, is unquestionable.

Taking intimate publics as the departure point, this collection of essays from key scholars, researchers, and curators in the region seeks to expand on the way in which place, screen media, and art are both practiced and reconceptualized in a period marked by increasingly mobile media cultures. Through the notion of *intimate publics*—as a rubric for new types of art engagement, literacy, and politics—the various essays reflect upon practices and challenges for the region. Drawing from a variety of case studies including the new regional initiative, *Utopia,* this publication tackles contemporary paradigms for art, politics and participation in the region.

In *Intimate Publics*, we bring together the worlds of art and media culture to rethink their intersections in light of participatory social media. Moreover, we consider the impact of social media and how it is shaping, and being shaped by, shifting public and private spaces. By focusing on the Asia-Pacific region, we also seek to examine how regionalism and locality are affecting global circuits of culture. In short, *Intimate Publics* endeavors to reveal new insights for conceptualizing the complicated entanglement of art and digital culture, and offers a set of theoretical frameworks and methodological paradigms for thinking about contemporary practice more generally. The contributions from a diversity of art and digital culture experts from within and outside the region aim to contextualize, explore, and interrogate some of the key issues facing art and digital culture today.

In this introductory chapter, we outline some of the key theoretical notions informing this section, namely, *mobile intimacy* and *intimate (social)*

publics. This section stems from a three-year Australian Research Council Discovery study on online media and intimacy in the region conducted by Hjorth and Michael Arnold.[5] Rather than defining the relationships through networks,[6] we draw from Sheller and Galloway who prefer "publics" to discuss the various overlays between media, culture, and politics. As we suggest in the conclusion of this chapter, "mobile publics" affords more possibilities for engaging with the complex encounters between media, art, and the environment today.

From the outset, we have noted that our approach to technology draws from science and technology studies (STS) traditions in which we see media as shaping, and being shaped by, culture. Just as social media has been deployed for banal activities that simplify definitions of the social, so too has it been viewed as a tool for political activism. Here it is important not to grant social media with the agency of making these politics happen but rather providing particular nodes of entanglement across temporal and spatial divides that have afforded new types of political affects. The paradoxical dynamic around the role of new media, between control and freedom,[7] and emerging forms of politics is most evident in the "ambivalent" and yet "situated" context of the Asia-Pacific region.[8] From demonstrations against nuclear power in locations such as Japan (post 3/11) to the political deployment of Facebook in Singapore for governmental elections, to the use of locative media for corporate surveillance in South Korea,[9] we are seeing social and mobile media being utilized to both reinforce older forms of politics while also creating more intimate and micro politics.

In particular, we differentiate "intimate publics", that are tightly bound and share common emotional ground, "social publics" that also share emotional affinities, but are broader and less tightly bound by those affinities, and "social networks", which are not constituted in common affect, but are instrumentally related in interconnected and ramified ego-based formations.[10] By deploying the notion of intimate publics and social publics as distinct from social networks, we argue that performances of affective interpersonal intimacy reflect an emerging approach to identity and collectivity and to the management of the social labor required to engage with others in this new public sphere.

Within art, the Asia-Pacific region is a leader in the take-up of social media to facilitate local and global connections and engagements between artists, publics, and institutions. There is a significant difference in how these media forms are being used in an explicitly political manner, which challenges the non-politicized discourses of participatory and collaborative practice that tend to dominate Eurocentric approaches. It was not by accident that one of the leaders in locative art, Rafael Lozano Hemmer, has conducted seminal works in the region. In particular, *Relational Architecture 1*, featured at the opening of the YCAM (Yamaguchi Center for Arts and Media) in Japan (2003), required that participants' phone have cutting-edge locative media capacities. Only in Japan, with its innovative mobile media, could such an event have taken place.

With a few exceptional examples, however, art has been slow to adopt such technologies innovatively and continues to employ online media as a method to facilitate the production and distribution of information, rather than encouraging innovative user participation.

Japanese new media groups such as Candy Factory or Korean/American collaborative team Young-Hae Chang Heavy Industries has been seen as indicative of the first generation of internet artists.[11] But when one probes their motivations and ideologies, we see that the place of the online and mobile runs as an alternative to the preferred offline space. The aesthetics of both groups epitomizes the flash style of Web 1.0, yet in interview with the Candy Factory, the site of the online is a default space that runs parallel to the offline events. In sum, they are using the online as a site for dissemination rather than as part of the conceptual package.[12] Yet regional precursors such as Japan's Dumb Type and Korea's Paik Nam June were quick to embrace the popular technologies of the moment as a commentary of broader sociopolitical trends.

Web 2.0 generation artists particularly China's Cao Fei have been quick to incorporate online spaces such as Second Life as a parallel gallery and performative place. China's most famous and political artist, Ai Weiwei, has eagerly incorporated new media tools especially Twitter to engage with Western audiences about Occidental views of China (given that Twitter is banned in China his engagement is clearly aimed at non-Chinese). So too, did the Korean collaborative group, INP, begin with Blast Theory–type performances (using mobile technologies to explore hybrid realities) and then quickly moved to software and hardware mobile-hacking workshops to unpack the political dimensions of media practice. INP saw mobile technologies as symbolic of South Korean politics and media ecology; thus, by deconstructing these symbols INP provided a space in which participants could question and challenge hegemonic technonationalism.[13]

As one of the key regions for producing mobile technologies for global consumption, the politics of media practice—in its both software and hardware dimensions—can provide much fuel for conceptual and aesthetic exploration. As projects like Command N's *Akihabara TV Project* (2000, 2001) demonstrated by placing video works on public and private screens in Tokyo's Akihabara (Electric City), mobile media are transforming screen cultures and their role in place-making practices. As McQuire and Papastergiadis have explored in their *Large Screens and the Transnational Public Sphere* project, mobile technologies reflect the growing blur between public and private, work and leisure spaces as they discuss in their chapter in this collection. In *The Media City,* McQuire has eloquently explored these shifts in the urban fabric, a move away that could be characterized by the change from *flâneurian* to phoneurian depictions.[14] Rather than the nineteenth-century wanderer, *flâneur*, strolling through the streets representing a new form of leisure and encapsulating the urban experience,[15] the twenty-first-century urban stroller is more akin to the parkour or phoneur with mobile

phone (and mini-world) in hand. The phoneur, as Robert Luke notes, is a node in the informational circuits of the city.[16] For Katina Michael and Roger Clarke, locative media's threat to privacy is most ominous in its covert forms. This "überveillance" "has to do with the ability to obtain identification, near real-time locative tracking and condition monitoring of the subject".[17] As Alison Gazzard notes, second-generation locative media such as Foursquare promote the user to become the stalker,[18] whereas Ingrid Richardson argues that, locative media, with its ontology in mobile gaming, has adapted our experience of "being online" by dismantling actual/virtual dichotomies, which, in turn, provide complex and dynamic range of modalities of presence.[19]

With locative media, we see the arrival of increased accessibility to augmented reality. Instead of replacing the analogue with the digital, the physical with the virtual, they open up hybrid realities that need new conceptual tools and located frameworks to unravel the dynamics. For de Souza e Silva, this creates what she calls "hybrid" spaces—that is, social situations in which borders between remote and contiguous contexts can no longer be clearly defined.[20] In other words, locative media disrupt binary modes of co-presence such as virtual versus actual as well as highlighting the growing importance of localized notions of place. We are no longer looking at just the technology-mediated hypervisual digitality but also exploring what these location-based services (LBS) augment and simulate in everyday practices. In this shift from first- to second-generation LBS—from subcultural to mainstream practice—there is a need to reframe locative media not as part of a new media "revolution" but instead as part of a mobile media evolution.

If we are indeed in the age of the phoneur in which the city is an overlay of informational and corporate cartographies, then this has an impact on art and new media practice—especially apparent in times of ecological disaster in which city textures are informed by affective layers of shock and displacement. An example would be the earthquake, tsunami, and nuclear disaster in Tokyo called 3/11. As the horrific events unfolded, mobile devices were crucial in material and immaterial ways. In an ethnographic study conducted by Hjorth and Kim in which they interviewed people post 3/11 about the role media played in crisis management, many spoke about the ways how when the technology failed functionally, it grew in its symbolic importance.[21] One respondent spoke about cradling her *keitai* as she went home as if it contained all her friends and family. For others, when the technology did work, it made them feel bombarded and overwhelmed as they attempted to grasp the reality while in the fog of shock and frozen by grief.

Increasingly the use of social media in political activity is anything but prosaic.[22] The recent 3/11 protests in Japan relied significantly on social media in order to publicize and represent the issues involved: the reliance on nuclear power in Japan. Mainstream press reports minimized the reporting of the event, although it is arguably one of the more significant forms of

public protest in Japan since the 1970 AMPO (Treaty of Mutual Coopera-
tion and Security between the US and Japan)[23]. Social media was also a key
factor in distributing public information in the days following the 3/11 earth-
quake, tsunami, and Fukushima disaster. Local government launched pub-
lic appeals for aid through YouTube, and individuals used blogs and other
means to disseminate alternative information regarding radiation levels in
urban areas.[24] What is significant is the way that these uses combined with
traditional media forms and outlets to share sources and materials.

Just as social media are used by individuals, groups, and movements to
mobilize, coordinate, motivate, and inform people, they are effective because
they were personal, prosaic, intersubjective, and everyday (see Figure 1.1).
They were effective—that is, efficient, fast, cheap, and easily configured
and reconfigured for various purposes, but they were also *affective*—that
is, their functionality was structured on what we call social and intimate
publics, and had the credibility derived from the social capital accumulated
by those publics. In order to understand the complex, political, social, cul-
tural, technical, and, above all, dynamic nature of mobile social media, art,
and eco-media in the Asia-Pacific, we suggest three key concepts: mobile
intimacy, intimate, and social publics. In this discussion we draw on the idea
of art as social platform to flesh out some of these rubrics.

Figure 1.1 Larissa Hjorth, *Three Forms of Mobile Novels* (2004). Lightbox photo-
graph, 45 × 60.

Source: Courtesy of the artist.

MOBILE INTIMACY

One way to understand the tensions around salient and transitory modes of intimacy is in terms of "mobile intimacy". By "mobile", we are not only referring to technologies that move with us and enable us to move, but also the various ways in which non-geographic mobilities play out through mobile media practices. In considering the forms mobility takes beyond geographic space, we might first do well to remember that as a notion, mobility qua "being moved" has long been attached not only to emotion,[25] particularly labile or volatile emotion, but also to its more sanguine forms. Second, mobility is also closely connected to the properties of fluidity, and we argue that fluidity (and its close cousin, instability) is important in understanding the structural conditions of mobile intimacy. Fluids have moving surfaces (inner and outer), moving boundaries (private and public), often caused by moving currents (flows of communication). In addition to these two spatial referents of the trope, mobility may also be put in a temporal context, in which case it refers to transience, to time shifting, to speed, and to moving in time. We argue that all these forms of mobility bear upon our experience of intimacy and our understanding of intimacy in conditions of mobile intimacy that can help to understand contemporary entanglements between art, media practice, and place.

In regard to the various forms of large-scale global mobility that characterize our era—mobile people, mobile ideas, mobile resources, mobile markets, mobile labor, and mobile capital—the computer and the Internet are clearly implicated.[26] Regarding various forms of smaller-scale mobility—the daily mobility of family members, the mobility of a given work force, the mobility of our personal arrangements in time and place, the mobile phone, the smartphone, and their various social applications are also implicated. As technologies of propinquity (temporal and spatial proximity), they are both instrumental in, and symbolic of, new erosions of the boundary between family and profession, public and private, and work and leisure.[27] Although the movement of intimacy toward the public was happening long before social and mobile media, the ways of mapping social, mobile, and locative media require explanation.

The widespread appropriation of locative media as part of the everyday mobile media experience has shifted the manner in which we imagine and navigate the online in conjunction with physical spaces. One way of conceptualizing this straddling between co-present worlds is identifying the localized and vernacular versions of intimate publics in an age of mobile intimacy, that is, the ways in which *intimacy* and our various forms of *mobility* (across technological, geographic, psychological, physical and temporal differences) infuse public and private spaces through mobile media's simultaneous mediation of both intimacy and space.[28] Personal mobile media present us with boundaries between online and offline worlds, public and private spaces, and an inner life and a social performance and at the same time enable us to skip back and forth across those boundaries at will. This socio-technical

configuration has constructed a hybrid in which our geographic position and our location in place are overlaid with an electronic position. This technology can both draw attention to position and place (e.g., through locative media) and can elide position and place (through communications at a distance). At the same time relational presence is achieved, which is emotional and social. This overlaying of the material-geographic and electronic-social sets the conditions for what we call *mobile intimacy.*

Not that this phenomenon is entirely new. A case could be made to use the historical continuity and discontinuity of mobile intimacy as a rubric for understanding and marking particular epochs as the overlay between mobility and intimacy changes forms, contexts, platforms, and affects. As Timo Kopomaa observes, today's personalized mobile media can be seen as an extension of nineteenth- and twentieth-century mobile media such as the pocket watch and the wristwatch, which both personalized and mobilized time telling.[29] Similarly, technologies such as mobile media reconstruct earlier co-present practices and interstitials of intimacy; for example, the metaphor of "posting" SMS (Short Message Service) both reflects and subverts earlier epistolary traditions such as nineteenth-century letter writing.[30] Here we must understand intimacy as something that is always mediated: by language, gestures, and memories.

Many scholars of co-presence including Christian Licoppe have argued that new forms of co-presence like e-mail are linked into earlier practices of intimacy through the absent presence of media such as visiting cards. Intimacy thus needs to be understood within broader lineages of technologies of propinquity and mediation. However, there are some striking differences too. Mobile media can been considered as part of shifts in conceptualizing and practicing intimacy as no longer a "private" activity but a central component of public sphere performativity. Intimacy has taken on new geoimaginaries, most notably as a kind of "publicness" that is epitomized by the mobile phone.[31]

The Asia-Pacific region has been pivotal in the production, shaping, and consumption of personal new media technologies,[32] and through social and mobile media, we can see emerging certain types of personal politics that are inflected by the local. Place is inflected by a sense of locality such as that offered by a community. It is both intimate and public as it can be social and mobile. In the cartographies of media in the region, there is a need to investigate the politics of the platform. As noted by the Ai Weiwei example in which he uses Twitter to speak to his global audience about the politics of China, the very nature of platforms and its various dimensions—political, technological, ecological, cultural, and social—come into play.[33]

Platform as metaphor has played a key role in exploring the social and cultural dimensions of art practice. It is fitting to mention the series of annual exhibition organized by Sunjung Kim called *Platform* (see Kim's chapter in this collection) in which she explored alternative paths for exhibition contexts and audiences including one site, an old military base in the

center of Seoul, South Korea. In this 2009 event, the ghost of the political haunted every element of the artworks by the likes of Lee Bul and Paik Nam June. In Chapter 16 we look at *Utopia*, a roving series of exhibitions and alternative forums, established by Asialink also attempted to create new platforms of audience engagement. *Utopia* was conceived through a series of cross-cultural collaborative discussions among Asialink, Tokyo Wonder Site, and Singapore Art Museum as well as extensive regional research and consultation. These discussions followed on from forums in Sydney and Tokyo in 2006 and 2008 during which *Utopia* was put forward as a key regional priority.

Utopia evolved in response to the growing "biennale" phenomenon in the region, as an attempt to recast the focus onto more collaborative, transnational synergies. The inaugural *Utopia* exhibition and forum, titled *Intimate Publics*, held in 2011, sought to bring together the various team members through a video screening, a forum, and a special issue of *Broadsheet* art magazine.[34] For director Natalie King, *Intimate Publics* operated as a vehicle for the following broad themes: cross-cultural collaboration, the impact of social mobile and screen culture on art practice, reconceptualizing the Asia-Pacific, new dynamics/models for engagement, and creativity, politics and emergent curatorial frameworks. So how might we begin to reconceptualize a notion of public that is both intimate and social and, as Warner notes, involves the counter as not just tacit?

INTIMATE AND SOCIAL PUBLICS

Intimacy is not a fixed state but is both fluid and contingent on circumstances—personal, historic, cultural, and socio-technical.[35] We argue that among these circumstances are recent socio-technical changes associated with the rise of social media and "affective" technologies such as mobile phones, providing yet another of the many contingencies that shape the conception and performance of intimacy. The hangover of Nicolas Bourriaud's relational aesthetics clearly demonstrates the important role of intimacy and social publics in contemporary art practice.

The relationship between changing notions of the public and private through the lens of intimacy was made apparent by the work of Berlant and Warner. As discussed in the Introduction, writing before the onset of social media, Berlant observed that intimacy has taken on new geographies and forms of mobility, most notably as a kind of "publicness", and social media constitute a new sociotechnical instantiation of public intimacy.[36] Intimate relations are not simply performed both in pairs and in the self-defined and bounded groups we call "intimate publics", they are also performed in geographic public but electronic privacy and in electronic public but geographic private. The moves across the boundaries of the interpersonal group, geographic public–private, and electronic public–private are

quick and frequent. The very existence of a boundary to move across is also compromised, as within the same social performance we attend to, as we traverse the interpersonal and the group, the geographic public and our private interlocutor (who might be here, or at a distance), and/or our electronic public and private interlocutor (who also might be here, or at a distance).

Intimate publics and their deployment of media that are at once *personal*, *mobile*, and *social* are thus situating intimacy in a fluid interpersonal and conceptual space in which binaries and boundaries are problematic. As social, locative, and mobile media become more pervasive, different modes of using these media mean that increasingly publics are defined by *intimate*, rather than networked, relationships. Just as intimacy can no longer rely on pure binaries to underpin it, so too the notion of the "public"—and its foundational binaries—become subject to the same fluidity, the same hybridity. As referenced in the previous discussion of intimacy, the notion of mutually exclusive private spaces and public spaces is problematized by socio-technologies that enable public interaction from a position of privacy and a switching between the two. As Sheller puts it, "there are new modes of public-in-private and private-in-public that disrupt commonly held spatial models of these as two separate 'spheres' ".[37]

Social media also offer affordances that facilitate the construction of multiple publics, and multiple modes of addressing those publics and their members, either as a group sharing personal intimacies or as interpersonal dyads. This, too, is a phenomenon that predates mobile social media,[38] but is materialized in different ways as it is mediated electronically. Through social media, multiple publics are formed around multiple personas, sometimes constructed by the same person, and the membership of these publics shifts and overlaps. These challenges to clear binaries between the definitions of private and public are reinforced through new understandings of "public" or "community" as multifarious. A public's boundary is in this way similar to a horizon, what Jeff Malpas calls "the marker of an internal unity that is also outwardly integrated"[39].

Important too is that a public lacks institutional being;[40] that is, like a community, it is not an arm of the state but stands between individuals and the state. Warner's work is particularly important in redefining notions of the public as dialectical to counter-publics.[41] Here we start to see a more liquid notion of public as something imagined and experienced, intimate and yet shared, mobile and immobile. Galloway's use of "mobile publics", as discussed later, provides a more productive way to think about the public as an assemblage of intimate and political gestures.[42] Mobile publics, like intimate publics, afford a space for political play. This notion of political play is often characterized by the intimate, fleeting, and micro gestures within social and mobile media.

We recognize, however, that not all publics that gel around an emotional affinity via social media can be described as intimate. The coming together

of loosely defined friends and acquaintances forms a public that shares collective ground, is self-forming, shares a horizon and is not institutionalized. It does this through a shared social affect, but the nature of this affect is not strong enough or tightly bound enough to warrant the term *intimate*. They are, after all, just friends. It is, however, a "social public" insomuch as the common ground, the motivating dynamic for a coming together, is a collective emotional or affective horizon, albeit more loosely defined and more fluid than is the case with an intimate public.

These characteristics are, we think, significantly different to the characteristics of a "network", a model which privileges ramified dyadic relationships, and fails to signify collectivity, emotional affect, and a shared horizon. By emphasizing hybrids of sociality, intimacy, mobility and publics rather than focusing on networks, we are trying to bring back a more nuanced relationship between sociality, politics, multiple publics, and media practice. As probes, social publics, mobile publics, and intimate publics allow us to move into more culturally nuanced understandings of what it means to be online in the Asia-Pacific. Although the deployment of social mobile media expands earlier modes of civic engagement and media, as evidenced by the role of SMS in the "people power" revolution in the Philippines,[43] Korea at the turn of the century,[44] and subsequently in the 2011–2012 Arab Spring,[45] social media in the context of intimate publics also departs from previous media by providing various modes of visual and aural communication with greater *affective* personalization. Within the highly connected and personalized worlds of social and mobile media, the capacity for political engagement and its relationship to the personal takes on new forms. Social mobile media also provide new spaces for networked, *effective* civic responses and connected, *affective* interpersonal responses.

Although the notion of socially networked political action existed prior to media such as mobile phones and social media, these conduits allow for a new sense of collective affective power that makes us *feel* more "connected". In this space, collective affective power is necessarily politicized as a mode of critique. It is at this affective, interpersonal level that we would like to consider the role of mobile intimacy and intimate publics in connecting a *political vernacular* that reflects the personal, the public, and a situated sense of place. Although we acknowledge that there are limitations in this model, the growing significance of the person, intimate and affective, on one hand, provides new forms of political agency and, on the other hand, echoes earlier counter-public models such as the feminist mantra, the personal as political.

Although much work has been conducted into the role of social and mobile media in socializing, relationship management, and identity construction,[46] or, more overtly, political examples of civic engagement,[47] there have been few investigations of the affective interpersonal sociality and intimacy that is part and parcel of political and civic participation in this new public sphere and how these relate to art practice. This is another aim of

this book—to explore the intersections between art and media in the region along contemporary lines whereby social and mobile media are an embedded part of everyday life and popular culture.

In the next section we outline the architecture of the book and how each chapter formulates a position on the entanglement between art and screen media in the region. We have chosen chapters that not only represent the diversity of the region's contested localities but also provide different disciplinary approaches and frameworks.

STRUCTURE OF THE BOOK: RUBRICS AND CHAPTERS

The book is structured by three rubrics that take the form of sections. Although these sections overlap, in this book we have created divisions in order to understand some of the various ways art and digital media are shaping, and being shaped by, the multiple and contested localities under the geo-imaginary of "Asia-Pacific". Through the various chapters and sections, we hope to provide different ways to imagine the region and its changing modes of creativity and politics in the face of uneven media engagement and resistance. In this introduction, we outline some of the key themes for this book, namely, art, new media, and social media in the Asia-Pacific at crossroads. Although each of these areas has gained attention, their convergence has been overlooked. This convergence represents new types of politics and engagement that cannot be ignored.

In this chapter, we have outlined three ways for thinking through these intimate and yet public, mobile and yet immobile practices in the region. The three modes take the form of the book's three parts: Reconceptualizing the Region, When Art and New Media Collide, and Vernacular, Media Practice, and Social Politics. Part I consists of chapters exploring some key factors such as journal and biennale cultures informing the region. Part II compromises case studies of the various contesting media cultures whereby art and new media collide in different ways. Part III investigates more closely the notion of "intimate publics" as a rubric for understanding the dynamics between the vernacular (local), media practice, and social politics. We will discuss some of the specific chapters and link them to the overarching themes.

In Part I we explore the different ways to map the region from triennales such as the APT and the changing nature of biennales in the region to the role of art journals and mobile apps in reshaping the various contested boundaries, public, intimacies, and practices. In this overview, we discuss the art of mapping and how we can redefine the region through art and media dynamics. We begin with Anthony Gardner and Charles Green's "Mega-Exhibitions, New Publics and Asian Art Biennials", which considers the role of the specific biennials in the Asia-Pacific region—particularly the Asia Pacific Triennial (or APT) in Brisbane, Australia, and the Fukuoka

Art Triennial, in Fukuoka, Japan—to show four narratives in contemporary art. Historicizing the phenomenon from the biennial culture of the early 1990s, they trace the practice back to the experimental art of the 1960s and 1970s and the changing role of curatorial practice in an age of globalization. As they note, the expansion of a complex, internally differentiated public for contemporary art and shared, highly social experiences of experimental art provide new contexts for intimate encounters with art.

This is followed by a case study of the Asia Pacific Triennial of Contemporary Art by senior curator Russell Storer. Rather than trying to summarize the twenty years of the triennial, Storer focuses in on three initiatives that have spanned across the time of the triennial to discuss changing relationships to audiences and publics that are social, cultural, and intimate in flavor. In Chapter 3, writer and editor of the highly influential *Art Asia Pacific* magazine Elaine W. Ng reflects on "Beyond Institutional Thinking" in the region through the rise of online media. Ng provides us with a few key initiatives that have utilized the online to help document and shape the region's art practices in order to engage audiences in new ways through devices such as mobile apps.

In Gridthiya Gaweewong's "Art and Digital Culture in the Asia-Pacific Region", she discusses the often-overlooked role of Southeast Asian practices in the Asia-Pacific rubric. Reflecting on the important role of the oral in much of Southeast Asia, Gaweewong considers the challenges, opportunities, and possibilities the online poses for artists over the past decade. This chapter is followed by Sunjung Kim's "Models beyond the Biennale", in which she draws from her own curatorial practice to challenge the dominant models for art consumption. Expanding on the provocations initiated with Gardner and Green's chapter, this chapter reflects on whether we can think about art engagement beyond the biennale and how this plays into broader sociocultural, economic, and political factors from the 1990s.

In Part II, When Art and New Media Collide, we discuss the changing dynamics of media spaces and capital in the region and how this is shaping, and being shaped by art practices and modes of audience engagement. We begin with Vietnam's San Art director Zoe Butt, who challenges the regulatory role of the state in surveillance via the online. As Butt notes in Vietnam, access to information is a strictly controlled environment. All public cultural activities, from visual art to performance to literature to film are subject to the antiquated opinions and surveillance of the Vietnamese Cultural Ministry and Cultural Police. Although the regulation of online media in places such as China has captured the world in debates around democracy vis-à-vis freedom of speech, locations such as Vietnam have been relatively overlooked. Drawing upon a variety of projects undertaken by San Art—Vietnam's most active independent, nonprofit contemporary art space and reading room—Butt examines the predicament of language and context in the usage of the online as promotional and pedagogical tool.

From surveillance to ecology, the next chapter considers the relationship between the environment, screen media and public art. In "Screen Ecologies", Larissa Hjorth, Kristen Sharp, and Linda Williams reflect on how effectively art and screen media will adapt as agents of social change in the context of rapidly escalating environmental deterioration. Providing an overview of this nexus, they consider some of its limitations and the social impediments to environmental resilience.

The next chapter, by Mami Kataoka, explores the idea of "Intimacy and Distance with the Public" through the practices of Ai Weiwei, Lee Ming-wei, and Allan Kaprow to consider the post-3/11 Japanese condition in art and the public. This is followed Sean Cubitt's "Regional Standardization", in which he takes us through the technical, environmental, and political implications of the struggles between open-source and proprietary models, as part of a boarder struggle for control over the meaning and destiny of network communications in general. As Cubitt argues, these material and immaterial technologies are having an impact on how not only intimacy and ideas of the public are understood but also how they are categorized. Part II concludes with Weng Choy Lee and Hjorth's "PlayStations: On Being Curated and other Geo-Ethnographies", in which they reject Claire Bishop's controversial article on the majority of visual artists ignoring the digital, instead focusing on how media spaces are creating renewed cartographies and ways to imagine place that are, in turn, having an impact on how art is curated and contextualized. In particular, they focus on the new types of maps, play, and reflexive practices that have shaped collaborations both inside and outside the artworld.

In Part III, Vernacular, Media Practice, and Social Politics, the various chapters discuss the notion of intimate publics as a productive way for understanding the dynamics between art and new media in the region. This begins with Nikos Paspastergiadis, Scott McQuire, Amelia Barikin, and Audrey Yue's "Public Screens and Participatory Public Space" in which they identify the increasingly importance public screens play in contemporary urbanity and thus the need to reexamine our understanding of the dynamics of public space. Drawing on a range of contemporary projects, this chapter examines how the linking of public screens between Melbourne and Seoul can be utilized to facilitate a transnational participatory public space. They argue that these media dense environments challenge the fundamental categories for representing city life.

Next is Chapter 13 by Edwin Jurriens, which is titled "Mediating the Metropolis: New Media Art and Urban Ecology in Bandung, Indonesia". As Jurriens notes, since the late 1990s, Indonesia has witnessed a remarkable growth in independent art spaces and communities, often with a specific focus on new media art. This has been partly the result of the increased freedom of speech in the country since the fall of the totalitarian New Order regime in 1998. Moreover, the art scene has been influenced by the wider availability and accessibility of electronic and digital consumer media, and some of the dominant trends in global information and communication society,

particularly the cultures of networking, interactivity, and do-it-yourself (DIY). This chapter focuses on the Bandung-based independent new media art community Common Room and how new media art and other forms of art and information and communication technology (ICT) is used to rethink and raise awareness about the urban development of Bandung and other cities in Indonesia.

In "The Virtual Extimacies of Cao Fei", Justin Clemens provides a detailed and philosophical study of Cao Fei. As an artist who is well-known for her use of Second Life and avatars, her "work goes straight to the complexities and consequences for intimate behaviors online". As Clemens notes, "part of Cao Fei's genius in this regard hinges on her ability to explore issues of intimacy in the virtual world, which she does with an as-yet unparalleled fusion of emotional sensitivity, conceptual inventiveness, and technical facility". So much so that Cao Fei's work epitomizes "new practices and paradoxes of intimacy in virtual environments". Clemens's chapter is followed by Darren Tofts's "The conjugations of remix" in which he explores the work of Australian remix collective Soda_Jerk (Dan and Dom Angeloro). According to Tofts, Soda_Jerk has elevated the DIY aesthetic of repurposing found footage into a compelling contemporary art practice. Their collaboration speaks more broadly to the "audio-visual remix" which, as Tofts observes, has emerged as "the signature aesthetic paradigm in the age of the social network and the ecology of participatory media".

Figure 1.2 Nikhil Chopra, *Yog Raj Chitrakar Visits Lal Chowk* (2007) (still). Digital video, 12:50 minutes.

Source: Costume Design: Tabasheer Zutshi. Photograph: Sujan Chitrakar. Courtesy of the artist.

In "Towards Utopia: A Pan-Asian Incubator", director Natalie King takes us through an exploration of the processes and dynamics informing her collective, Utopia, and the way this porous and agile platform intersects with new media practices and curatorial modalities (see Figure 1.2). In the concluding chapter "Beyond the Intimate? The Place of the Public in the Region", we reflect upon the rubric of intimate publics and how the region is being reimagined through the convergence between art, new media, and social media. Bringing together the four sections through a summary of the different arguments, we then propose some questions for future research.

CONCLUSION: MOBILE PUBLICS

In this chapter, we have discussed the ways in which the social and the intimate, the public, and the political have, and continue to be, entangled. Through the rubrics of mobile intimacy and intimate/social publics, we have sought to revise how we might interpret contemporary intersections between art, media, and the environment in the region. Given the impact social and mobile media has had in political activism, as well as debates about the dumbing down of the social into a prefix for social media and its attendant banalities, we have reflected on how these shifts in the role of media, and its mediation of intimacy, politics, and notions of the public, are reshaping art and its place in the environment.

In this concluding section, we would like to reflect on one last concept to illuminate intersections between art and screen media—that is, mobile publics. Galloway's reworking of mobile publics as a preferred motif to network in helping to understand contemporary art and politics in an age of social and mobile media. As one of the first theorists working on locative media, Galloway's expertise can provide much insight into the dynamics and entanglements of media and art today. With nearly a decade since Mimi Sheller's important notion of the "mobile public",[48] mobility and publics have taken on even more complexity. As Galloway notes,

> Given the imperatives to locate and connect that are embedded in oth-
> erwise diverse technologies, it should come as no surprise that today's
> wireless and wearable devices and applications offer unique glimpses
> into crucial sets of values and expectations surrounding "the fate of the
> public".[49]

If we understand a "public" as a situated but heterogeneous assemblage of people, and as (public) places, (public) objects, and (public) discourse, then mobile affordances for imaging, mapping, locating, blogging, recording, tweeting, media sharing, and the like are all affordances that mediate the mobilization of a public. The near-ubiquitous deployment of mobile media and the affordances provided for the assembly of a public draws new

attention to the old question of how a public that is so assembled might be understood and represented. As we have seen, the most common answer to the question is that mobile media assembles a network, not a public. However, as long as mobile publics are defined in terms of networked publics, "we risk oversimplifying complex relations in ways that may actually prevent certain kinds of political action".[50] Reflecting on public and counter-public debates in relation to case studies of locative media art projects, Galloway considers how emergent and contingent forms of public are being formed, and informed, by mobile media. As Galloway suggests, these "messy" and "fluid" assemblages of mobile publics are more than just networked. As a politically powerful rubric, Galloway argues that more research needs to be conducted into localized forms of mobile publics.

Publics, rather than networks, provide a useful rubric for us to understand the converging and localized forms of social, locative and mobile media practices with art, politics and the environment in the Asia-Pacific region. In keeping with Galloway's call for more work into sociocultural and political uses of mobile media in constructing publics beyond the "private life/public space" trope, our various case studies illustrate the performance of social and intimate publics in the region. In this chapter, through the concept of mobile intimacy and intimate publics we have elaborated on some of the tacit features involved in entanglements between art, media, and place today. Now, take a journey through the various ways intimate publics are framing, and are being framed by, art and screen media in the region.

NOTES

1. Claire Bishop, "Digital Divide: Contemporary Art and New Media", *Artform* September 2012, accessed June 5, 2013. http://artforum.com/talkback/id=70724.
2. Sukhder Sandhi (2005). Cited in Maria Margaroni and Effie Yiannopoulou, "Intimate Transfers: Introduction", *European Journal of English Studies* 9, no. 5 (2005): 221–228.
3. As Claire Bishop notes, digital technology—whether through embrace or denial—is central in contemporary debates. For Bishop, new media seems to use digital media as a technique rather than a subject for critique. See Bishop, "Digital Divide."
4. Lauren Berlant, "Intimacy: A Special Issue", *Critical Inquiry* 24, no. 2 (Winter 1998): 281–88.
5. Larissa Hjorth and Michael Arnold, *Online@AsiaPacific* (New York: Routledge, 2013).
6. Manuel Castells, *The Rise of the Networked Society* (New York: John Wiley & Sons, 1996); and Barry Wellman and Barry Leighton, "Networks, Neighborhoods, and Communities: Approaches to the Study of the Community Question", *Urban Affairs Quarterly* 14, no. 3 (1979): 363–90, accessed June 20, 2012, http://courseweb.lis.illinois.edu/~katewill/fall2009-lis590col/wellman%20leighton%201979%20networks%20neighborhoods.pdf.
7. Wendy Chun, *Control and Freedom* (Cambridge, MA: MIT Press, 2006).

8. Rob Wilson and Arif Dirlik, eds., *Asia/Pacific as Space of Cultural Production* (Durham, NC: Duke University Press, 1995); and Rob Wilson, "Imagining 'Asia-Pacific': Forgetting Politics and Colonialism in the Magical Waters of the Pacific. An Americanist Critique", *Cultural Studies* 14 no. 3/4 (2000): 562–92.

9. Kwang-Suk Lee, "Interrogating 'Digital Korea': Mobile Phone Tracking and the Spatial Expansion of Labour Control", *Media International Australia* 141 (2011): 107–17.

10. Hjorth and Arnold, *Online@AsiaPacific*.

11. Rachel Greene, *Internet Art* (London: Thames & Hudson, 2004).

12. Larissa Hjorth, 'Frames of Discontent: Social Media, Mobile Intimacy and the Boundaries of Media Practice', in *New Visualities, New Technologies: The New Ecstasy of Communication*, ed. Hila Koskela and Greg J. Macgregor Wise (New York: Ashgate, 2013), 99–118.

13. Larissa Hjorth, "The Game of Being Mobile: One Media History of Gaming and Mobile Technologies in Asia-Pacific", *Convergence: The International Journal of Research into New Media Technologies* 13, no. 4 (2008): 369–81; and Larissa Hjorth, "The Politics of Being Mobile: A Case Study of a Different Model for Conceptualizing Mobility, Gaming and Play", in *Digital Cityscapes*, ed. Adriana de Souza e Silva and Daniel Sutko (New York: Peter Lang Group, 2010), 83–99.

14. Scott McQuire, *The Media City: Media, Architecture and Urban Space* (London: Sage, 2008).

15. This notion is depicted by Walter Benjamin in *The Arcades Project*, ed. Rolf Tiedemann and trans. Howard Eiland (Cambridge, MA: Harvard University Press, 2002).

16. Robert Luke, "The Phoneur: Mobile Commerce and the Digital Pedagogies of the Wireless Web", in *Communities of Difference: Culture, Language, Technology*, ed. Peter Trifonas (London: Palgrave, 2006), 185–204.

17. Mark Michael and Katina Michael, "Towards a State of Überveillence", *IEEE Technology and Society Magazine* 29, no. 2 (2010): 9–16.

18. Alison Gazzard, "Location, Location, Location: Collecting Space and Place in Mobile Media", *Convergence: The International Journal of Research into New Media Technologies* 17, no. 4 (2011): 405–17.

19. Ingrid Richardson, "The Hybrid Ontology of Mobile Gaming", *Convergence: The International Journal of Research into New Media Technologies* 17, no. 4 (2011): 419–30.

20. Cited in Eric Gordon and Adriana de Souza e Silva, *Net Locality* (West Sussex, UK: John Wiley & Sons Ltd, 2010), 86.

21. Larissa Hjorth and Yonnie Kim, "The Mourning After: A Case Study of Social Media in the 3.11 Earthquake Disaster in Japan", *Television & New Media* 12, no. 6 (2011): 552–59.

22. Larry Diamond and Marc Plattner, eds., *Liberation Technology: Social Media and the Struggle for Democracy* (Baltimore: John Hopkins University, 2012); and Christian Christensen, "Twitter Revolutions? Addressing Social Media and Dissent", *The Communication Review* 14, no. 3 (2011): 155–57.

23. David H. Slater, Nishimura Keiko, and Love Kindstrand, "Social Media, Information and Political Activism in Japan's 3/11 Crisis", *Japan Focus*, (2012), accessed June 12, 2012, http://japanfocus.org/-Nishimura-Keiko/3762.

24. Ibid.

25. Amparo Lasén, "Affective Technologies—Emotions and Mobile Phones", *Receiver*, 11 (2004), accessed July 11, 2012, www.receiver.vodafone.com.

26. Castells, *The Rise of the Networked Society*.

27. Judy Wajcman, Michael Bittman, and Jude Brown, "Intimate Connections: The Impact of the Mobile phone on Work Life Boundaries", in *Mobile technologies*, ed. Gerard Goggin and Larissa Hjorth (London/New York: Routledge, 2009), 9–22.

28. Larissa Hjorth and Sun Sun Lim, "Mobile Intimacy in an Age of Affective Mobile Media", *Feminist Media Studies* (December 2012): 1–8.

29. Timo Kopomaa, *The City in Your Pocket: Birth of the Mobile Information Society* (Helsinki: Gaudemus, 2000).

30. Larissa Hjorth, "Locating Mobility: Practices of Co-Presence and the Persistence of the Postal Metaphor in SMS/MMS Mobile Phone Customization in Melbourne", *Fibreculture Journal* 6 (2005), accessed December 10, 2012, http://journal.fibreculture.org/issue6/issue6_hjorth.html.

31. Leopoldina Fortunati, "Italy: Stereotypes, True and False", in *Perpetual Contact: Mobile Communications, Private Talk, Public Performance*, ed. James E. Katz and Mark Aakhus (Cambridge: Cambridge University Press, 2002), 42–62 (48).

32. Larissa Hjorth, *Mobile Media in the Asia-Pacific: Gender and the Art of Being Mobile* (London and New York: Routledge, 2009); and International Labour Office, "Global Employment Trends For Women", 2008, accessed March 2, 2010, www.ilo.org/public/english/employment/strat/global.htm.

33. Tarleton L. Gillespie, "The Politics of 'Platforms' ", *New Media & Society* 12, no. 3 (2010): 347–64.

34. *Intimate Publics* forum, chaired by Larissa Hjorth (RMIT University) and Daniel Palmer (Monash University), presented by Utopia@Asialink (University of Melbourne) in association with Melbourne Festival and RMIT University, October 18, 2011. *Intimate Publics* exhibition was curated by Utopia@Asialink. Curatorium: Yusaku Imamura, Sunjung Kim, Natalie King, Deeksha Nath and Tan Boon Hui. Artists: Nikhil Chopra (India), Daniel Crooks (Australia), Larissa Hjorth (Australia), Masaru Iwai (Japan), Amar Kanwar (India), Takashi Kuribayashi (Japan), Charles Lim (Singapore), Minouk Lim (Korea), Tran Luong (Vietnam), and Jewyo Rhii (Korea), Fehily Contemporary, Melbourne, October 13–November 5, 2011.

35. Lyn Jamieson, *Intimacy: Personal Relationships in Modern Societies* (Cambridge, UK: Polity Press, 1998); and Richard E. Sexton and Virginia Staudt Sexton, "Intimacy: A Historical Perspective", in *Intimacy*, ed. Martin Fisher and George Stricker (New York: Plenum Press, 1982), 1–20.

36. Berlant, "Intimacy: A Special Issue," 281.

37. Mimi Sheller, "Mobile Publics: Beyond the Networked Perspective", *Environment and Planning D: Society and Space* 22 (2004): 39–52 (39).

38. See Goffman on everyday performativity. Erving Goffman, *The Presentation of Self in Everyday Life* (Harnmondsworth: Penguin Books, 1969).

39. Jeff Malpas, "The Place of Mobility: Technology, Connectivity, and Individualization", in *Mobile Technology and Place*, ed. Rowan Wilken and Gerard Goggin (New York: Routledge, 2012), 26–38 (33).

40. Michael Warner, "Publics and Counterpublics", *Public Culture* 14, no. 1 (2002): 49–90 (61).

41. Ibid.

42. Anne Galloway, "Mobile Publics and Issues-Based Art and Design", in *The Wireless Spectrum*, ed. Barbara Crow, Michael Longford and Kim Sawchuk (Toronto: University of Toronto Press, 2010), 63–76 (69).

43. Vincent Rafael, "The Cell Phone and the Crowd: Messianic Politics in the Contemporary Philippines", *Popular Culture* 15, no. 3 (2003): 399–425.

44. Howard Rheingold, *Smart Mobs: The Next Social Revolution* (Cambridge, MA: Perseus Books, 2002).

45. Christensen, "Twitter Revolutions?"; and W. Lance Bennett and Alexandra Segerberg, "Social Media and the Organization of Collective Action: Using Twitter to Explore the Ecologies of Two Climate Change Protests", *The Communication Review* 14, no. 3 (2011): 197–215.

46. danah boyd, "Why Youth (Heart) Social Networked Sites: The Role of Networked Publics in Teenage Social Life", in *MacArthur Foundation Series on Digital Learning—Youth, Identity, and Digital Media Volume*, ed. David Buckingham (Cambridge, MA: MIT Press, 2007), 119–142; and Mizuko Ito, danah boyd, and Heather Horst, *Digital Youth Research, online publication* (2008), accessed August 14, 2012, http://digitalyouth.ischool.berkeley.edu/.

47. W. Lance Bennett, "Changing Citizenship in the Digital Age", in *Civic Life Online: Learning How Digital Media Can Engage Youth*, ed. W. Lance Bennett (Cambridge, MA: MIT Press, 2008), 1–24; W. Lance Bennett, Chris Wells, and Allison Rank, "Young Citizens and Civic Learning: Two Paradigms of Citizenship in the Digital Age", *Citizenship Studies*, 13, no. 2 (2009): 105–20; and Howard Rheingold, "Using Participatory Media and Public Voice to Encourage Civic Engagement", in *Civic Life Online*, 97–118.

48. Sheller, "Mobile Publics", 39.

49. Galloway, "Mobile Publics and Issues-Based Art and Design", 69.

50. Galloway, "Mobile Publics and Issues-Based Art and Design".

Part I

Reconceptualizing the Region

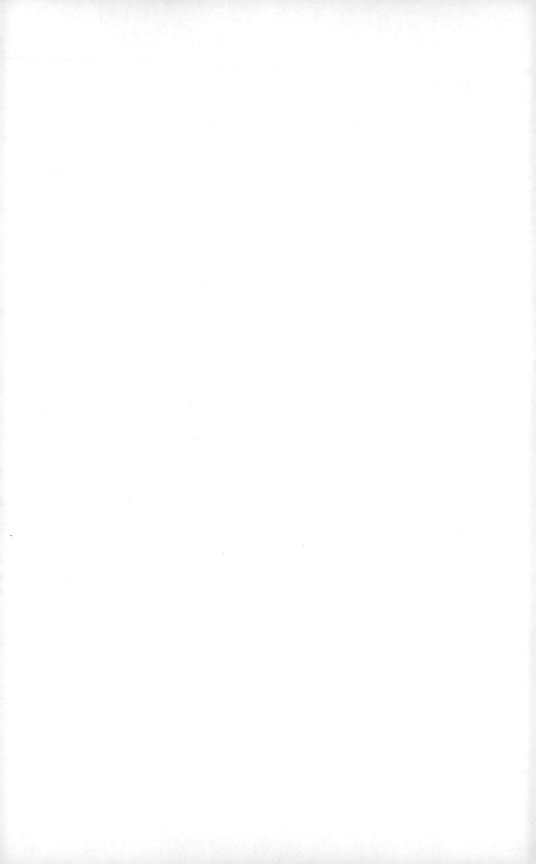

2 Mega-Exhibitions, New Publics, and Asian Art Biennials

Anthony Gardner and Charles Green

INTRODUCTION

The recent apotheosis of the large scale, perennial, international exhibition of contemporary art—better known as the biennial—has brought with it significant institutional and theoretical consequences. Exhibition and curatorial studies, and particularly studies of the rise of the biennial (sometimes called "biennialization", sometimes called "biennialogy", but always given a grotesque neologism), have begun to take root in art school and art history departments around the world. From Central St Martins in London, to Bard College in New York, and more recently still at Monash University in Melbourne, the rise of exhibition studies, and their blurring of practice and discourse, has displaced the traditional (and, by now, decidedly démodé) disciplinary divide between art practice and art history and theory. This shift has gone hand in hand with the phenomenal rise of publications and books dedicated solely to exhibition studies, even to biennials alone, and their significant transformation of contemporary art.[1] What is most often encountered in these readings, it seems, is the charge that biennials—with their yearnings for international attention, bloated artist lists, equally bloated budgets, and necessarily loose themes—are little more than hand-maidens to neoliberal globalization.

Biennials may have opened the contemporary art world out to new artists, new curators and new parts of the world—albeit "new" solely for art world aficionados whose parochialism prevented them straying far from trips across the Atlantic Ocean—but that "newness" has been easily transmogrified into new markets for global capital to continue its same old business. In this sense, biennials are like the growing number of A++ global cities, with Tokyo, Hong Kong and Mumbai joining New York, Paris, and London as "global centers" (although when have these metropolises never been global?), not to change how we perceive "the global" but only to expand even farther the outreach of neoliberal capital. The rise of biennials worldwide since the early 1990s, it is often claimed, is thus but another symptom of global power stretching out from colonial-era centers, with the Venice Biennale and the colonial World Fairs being the New York and London of the art world.[2]

Figure 2.1 Paramodel, *Paramodel Joint Factory* (2012). Toy train track components, carpet, styrofoam.

Source: Commissioned by Kids' APT with support from the Tim Fairfax Family Foundation. Installation view, APT7, Gallery of Modern Art. Photograph: Mark Sherwood. Image courtesy: Queensland Art Gallery | Gallery of Modern Art. Courtesy of the artists and MORI YU GALLERY © the artists.

The reality is much less simple, of course. Asia is often touted as exemplifying this neoliberalization of international art. The call seems to be along the lines of "look at how many biennials, triennials and art fairs there are in China alone these days, all apparently cannibalizing the western biennial model!"[3] But the use of biennials as a means of generating and presenting international cultural exchange is hardly a post-1989 phenomenon. The Triennale of World Art began in New Delhi in 1968, the Arab Art Biennial in 1974, Fukuoka's Asian Art Show in 1979, and the Asian Art Biennale in Dhaka in 1981. The Biennale of Sydney was already promoting itself as a meeting point between artists, curators and writers from along the Pacific Rim in its second edition in 1976.[4] The relationship between nascent understandings of "globality" and biennials in Asia-Pacific requires more precision than that offered by the usual broad brushstroke approach if we want to do justice to the complex histories of inter-cultural connection across the region. We thus need to shift from the general to emphasise the particular—to focus on specific biennials, even specific editions of specific biennials—in order to understand how the biennial is functioning in this part of the world.[5]

As a consequence, this essay considers specific biennials in the Asia-Pacific region—particularly the Asia Pacific Triennial (or APT) in Brisbane, Australia, and the Fukuoka Art Triennial, in Fukuoka, Japan—to show the entwined nature of four narratives in contemporary art (see Figure 2.1). First, we note the ascending, and then descending, arc of biennial culture from the early 1990s to the present. Second, we point to a parallel arc in so-called new media that evolved out of (and which substantially replaced) the experimental art of the 1960s and 1970s. Third, we consider the replacement of a curatorial concentration on tradition with a focus on the transformation of tradition by globalization. Fourth, we see the development and vast expansion of a complex, internally differentiated public for contemporary art flocking to biennials—in search of (and also finding) shared, highly social experiences of experimental art that are, at the same time, also remarkably intimate.

EXPERIMENTAL AND TRADITIONAL ART

First, however, we must consider one of the core markers of contemporary art, of art that embodies the condition of contemporaneity: its stress on the experimental, at both the point(s) of its production and the point(s) of its reception. Indeed, the division between production and reception (like that between theory and practice, or between colonialism and globalism) is now so blurred as to be virtually nonexistent—this is precisely what marks contemporary art's clear distinction from the self-consciously experimental arts of the 1960s and 1970s.[6] This is also quite different from the start of the period under discussion, the early 1990s, when it was still possible for biennial curators in Asia and other so-called peripheral regions to argue

that tradition had become contemporary, given that traditional art had to demonstrate an adaptation to the conditions of contemporaneity if it was to be selected for the emerging biennials. These adaptations had often resulted in profound tension. Witness, for instance, the remarkable lack of interest or understanding (at least by many critics and historians from around the North Atlantic) of the third Havana Biennial in Cuba, with its focus on "Tradition and Contemporaneity", until roughly twenty years after its staging in 1989.[7] Hence, as well the telling title with which one of the most acute and sensitive curators of contemporary Asian art, Apinan Poshyananda gave his landmark Asia Society exhibition in New York in 1996, *Traditions/ Tensions*. (This is telling because he was also a member of the second APT's curatorial collective that year; the tension between the traditional and the triennial was seemingly all too apparent).[8]

But a restrictive definition of experimental art, in which it is more or less identical with the use of technology or with new media art, is neither useful nor particularly convincing. Similarly, a soft and all-inclusive definition of experimental art, in which art is experimental if the artist says it is, is as meaningless as saying that art is contemporary if it is made in the present. Such an open, all-inclusive definition of the contemporary would have meant that Asian art biennials (including the APT) would have included locally celebrated exponents of heritage arts and crafts. The APT's curators were often urged to select these, for instance, the senior Yogyakarta batik artists who fully expected to be considered for APT1. But the Brisbane curators were far from eager to include heritage art in the triennial. They were reluctant because heritage cultures were often associated with conservative state bureaucracies or cliques, or with highly regulated guilds and associations, as opposed to the universities and art schools across Asia, whose professors, students and curricula were not at all dissimilar to their North Atlantic peers. It was these university-based and freelance professional intellectuals—including Jim Supangkat in Jakarta, Geeta Kapur in New Delhi, Kanaga Sabapathy in Singapore and Somporn Rodboon in Bangkok, with their international and emerging regional networks and their knowledge of the cosmopolitan local artists whose works would be most "legible" to roving global curators—who were most often consulted by those international curators hunting for contemporary art.

A more adequate definition of the experimental in contemporary art hinges instead on work that is shaped by the double tropes of collaboration and the delegation of fabrication, opening out to the transdisciplinary as much as the transnational. This definition of the experimental does not see the productivist, new-media-based identification as the only pivot for contemporary art's development. Rather, it recognizes that the experimental was as influenced by new spaces of art's display as it was by new technologies—or to put it in a manner that recalls the conditions of the contemporary, by the dual reformulation of art's modes of reception (into enormous gallery spaces, whether white cubes or postindustrial warehouses, as well as cultural contexts beyond the North Atlantic) and its modes of (technological) production.

This can be seen in various ways. First, spectacular, often expensive new art such as high-definition video installation or hybrid-space interactive game works have required venues able to provide the resources, scale, and public prominence required by these works. This leads to a second consideration, for it was often only large biennials—sprawling through large museums, repurposed buildings, or across entire cities and often with strong private and city backing to help them do so—that could meet these resource demands. Hence, biennials offered contemporary experimental artists an adequate stage on which to participate in the global art scene while enabling a dramatically expanded audience, far beyond the dreams of the older, utopian enclaves of new media art, the chance to see experimental art. Indeed, such was the case that by the second decade of the twenty-first century, experimental art, no matter what its genealogy and regardless of the often-resentful opinion of its technophile pioneers, had seemingly become the preserve of biennials.

This phenomenon was something that net activist and theorist Geert Lovink presciently described in his 2007 book *Zero Comments: Blogging and Critical Internet Culture.*[9] The old spaces and practices of new media art had become obsolete; practitioners either had beached in new media departments scattered atomistically around the world or (as was the case with Raqs Media Collective) had shifted, for tactical and financial reasons, to using the biennial as their platform to present their joint artistic and curatorial practices.[10] For the vast audiences and extraordinary numbers of

Figure 2.2 Ho Tzu Nyen, *Zarathustra: A Film for Everyone and No One* (2009). High-definition digital video, single channel, colour, sound, 24:30 minutes, ed. of 3 Commissioned for APT6.

Source: Supported by Osage Gallery, The Puttnam School of Film and the Institute of Contemporary Arts Singapore, LASALLE College of the Arts. An initiative of the National Arts Council's Arts Creation Fund. Photograph: Olivia Kwok. Image courtesy: The artist and Tzulogical Films.

artists around the world participating in contemporary art, then, it was the sprawling yet exclusive worlds of big-budget biennials and not the fleeting carnivals of the weekend art fair, or the relatively low budgets and conservative programs of the private gallery, showcasing the current state of artistic experimentation (see Figure 2.2). The frequent claims made about the democratization of contemporary art—whether due to the global spread of biennials and their audiences, the use of new technologies, or the demand for audience participation and access to biennials and new technologies—were thus severely put into question.[11]

THE EMERGENCE OF ASIAN BIENNIALS

This brings us to the emerging networks of globalized Asian biennials. If the development of biennials in parts of Asia from the 1960s to the 1980s signals a first wave of the region's mega-exhibitions, then a second wave began in earnest in 1993 with the first APT in the Queensland Art Gallery (or QAG) in Brisbane. This was followed in quick succession by new biennials in the South Korean city Gwangju (1995), in Shanghai (1996), in Taipei (1998), and then in numerous other cities after that. But it is the Fukuoka Art Museum, 1,100 kilometers west of Tokyo, that must be credited as one of the greatest influences on the region's biennials and their dedication to contemporary Asian art. In 1979, the museum staged the first Asian Art Show, showcasing Chinese, Indian, and Japanese contemporary artists. It initially appeared every five years (the same interval as Kassel's documenta), before being rebadged by the new Fukuoka Asian Art Museum in 1999, with a new name and now designed to take place every three years as the Fukuoka Asian Art Triennale. QAG's director, Doug Hall, was well aware of the Fukuoka Triennale's history. One of his first overseas trips after his appointment to QAG's Directorship in 1987 was to Fukuoka; he had thus seen firsthand the museum's policy of acquiring works from its mega-exhibitions so as to generate an important collection of contemporary Asian art, a policy that he used (and which continues today) with great success in Brisbane.

The motivations behind the creation of Asia's new biennials varied, however. Fukuoka's mega-exhibitions were comparable to the APT, in that both became important marketing tools for their midsized host cities, bringing regular cultural attention to industrial ports that were otherwise slightly off the beaten tourist trails. Other East Asian mega-exhibitions relied on different exhibition models. For its first two instalments, the Shanghai Biennial restricted itself to traditional Chinese art and craft, rebranding in 2000 with a heavy injection of state funding and an equally heavy influx of big-name international artists making enormous installations and video work. (This was the year that Ai Weiwei curated his infamous counter-exhibition called *Fuck Off*, making absolutely clear that Ai could protest against a new cultural behemoth while in his quasi-parasitic relation to that behemoth, gaining significant windfall from it.)

The Gwangju Biennale began in 1995 in a spirit of regional boosterism, but also historical commemoration, honoring the May 1980 massacre of pro-democracy protestors in the streets of Gwangju, an event that had been instrumental in helping to bring down South Korea's authoritarian state.[12] The use of the biennial as a memoriam for the protestors and a map for the future was clear from the outset; as the first Gwangju Biennale director, Lee Yongwoo, wrote in 1995, "The objective of the Kwangju International Biennale is to encourage independent cultural behaviour".[13] But the Gwangju Biennale was distinct in other ways too. It insisted on dividing artists according to the continents of their births (a seldom-used division in large-scale exhibitions of any kind). Subsequent iterations continued to experiment with very unusual and often highly idiosyncratic curatorial methods in ways that—due to the extraordinarily large funding, among the largest in the world per edition, given to the biennial by the Gwangju Biennale Foundation—were quite unlike most other biennials, concentrating on curatorial process and innovation rather than seeing the biennial as a resource for creating a permanent collection. Okwui Enwezor and his curatorial team transformed the 2008 biennial by restaging other curators' exhibitions held in different parts of the world during the previous twelve months; the 2012 biennial, *Roundtable*, brought six relatively young curators together from different parts of Asia to work with each other for the first time in realizing a large, sprawling, and, unsurprisingly, highly conflicted exhibition.

Whereas Gwangju strategically sought strong international audiences— often (although, as 2012 suggests, not always) by hiring globally renowned curators based around the North Atlantic, such as Okwui Enwezor, Charles Esche, Massimiliano Gioni, Hou Hanru, and Harald Szeemann—the APT was conceived to bring Australia's predominantly Western cultural context back into the fold of Asia-Pacific regionalism. Nor, when compared with Gwangju, was the APT lavishly funded by either the Queensland or Australian governments, despite the latter's particularly strong promotion of Asia-Australia relations at the time under former prime minister Paul Keating. It was instead conceived in 1990 through the desire of a small "curatorium", led by Doug Hall and QAG senior curator Caroline Turner, to permanently transform the small provincial state gallery into a major regional institution. Part of its method was to discard divisions between artists' nationalities, a staple of many other biennials reliant on the model of the Venice Biennale, which, since its founding in 1895, has persistently used national pavilions as the hubs through which to present art from around the world.

The APT's decision to do away with national barriers—at least through the analogue of the gallery space—instead amplified the diversity, correlations and tensions between art practices across Asia and the Pacific. As such, Turner wrote for the catalogue to the second APT in 1996, the exhibition's immanent diversity could show that "the term 'Asia-Pacific' [was] a construct . . . not implying historical or cultural sameness".[14] Whereas globalization was, already by the early 1990s, implying cultural homogenization or "Coca-colonization", the regionalism of the APT hinged on difference,

cultural specificity but also, crucially, dialogue between artists and cultures rather than their incommensurability.

Nonetheless, the practicalities of international curating put these regionalist ideals under great pressure, for it was difficult not to retreat into expedient nation-state divisions in order to tap local informants' advice about the art practices there. This had been one of the many problems facing Jean-Hubert Martin, André Magnin, and their co-curators for the 1989 exhibition *Magiciens de la terre*. Their lack of knowledge about different countries' art worlds, especially those far away from the curators' Paris base, meant they too had to rely on local informants to generate their artist lists. But those informants also had their limitations, especially when their knowledge was contained to cultural, language, and kinship borders or because each had a protégé or two to promote.[15] There were, however, a couple of upsides to such "outsourcing". By insisting on commissioning local cultural figures to help resource the exhibition, the APT curators (much like Martin and his colleagues in the late 1980s) were conscientiously trying to avoid the fly-in/fly-out methodology developed from European auteur-curator Harald Szeemann, which tended to treat unfamiliar localities as transit zones into which the curator would parachute, and artists as little more than symptomatic of the curators' mythologies about what that cultural context was like.

By contrast, the APT—and here they were once more influenced by the methods of the Fukuoka Asian Art Show—deliberately sought to engage with the complexities and diversities of local cultural contexts. Guided by their informants, the APT sought regional definitions of the contemporary that emerged from the modernizing of cultural traditions (Chinese artist Shi Hui's sculptures woven from bamboo strips and rice paper) or else from the aftermath of highly developed multiple modernisms across the region, from Bangkok and Chiang Mai (Araya Rasdjarmreansook's monumental, dark paintings and installations) to Tokyo (and Shigeo Toya's chainsaw-hewn wood sculptures). In this way, contemporaneity could be understood as developing from, and not necessarily in opposition to, local traditions, whereas the carefully curated contiguity of artworks became the very marker of how globality could be presented from the viewpoints of Asia-Pacific regionalism. That nuanced understanding of contemporaneity was clear in Turner's introductory essay for the first Asia Pacific Triennial catalogue, when she wrote,

> We . . . approach[ed] this exhibition through national contexts, which itself raises significant questions . . . What is apparent is that the artists within this region are confident in their local and regional specificity as well as in incorporating ideas which cross national boundaries—an art which engages with international art practice but is not dependent on international ideas imposed from a "centre".[16]

The downside, however, was that the types of art shown at the first two APTs in particular did not fit the narrative arc of "the experimental" as it informed

comparable North Atlantic exhibitions of contemporary art, such as documenta. The APT—again like its regional counterparts, such as the Fukuoka Triennale or the early editions of the Shanghai and Gwangju biennials—remained far beyond even the peripheral vision of North Atlantic curators who mistook their own parochialism for internationalism. The APT's capacity to bring its aesthetics of regionalism (we might even say its counter-globality) to attention outside Asia-Pacific was thus very far from fulfilled.

THE GLOBALIZATION OF ASIAN BIENNIALS

What happened to the APT, its artists and sister biennials in the Asia-Pacific that led to them later attracting that contemporary, global attention? The shift is perhaps emblematized best not by the APT but instead by the Shanghai Biennial and the Raqs Media Collective. Both Raqs and the Shanghai Biennial quickly took on board the rise and fallout of contemporary art's dependence on new media, especially as new media art and theory, and their reified concepts of interactivity and participation, were becoming first doctrinaire and then anachronistic by the early 2000s. The Shanghai Biennial's move in 2000 away from "traditional" Chinese arts and crafts, and toward large-scale spectacular installations and moving image projections, recognized that these media had now become the dominant modes of "biennial art". They were sites for casual socialization and play as much as they were artworks to be contemplated, and could (although at some cost) be perpetually reexhibited elsewhere around the world, thus dispensing with the constraints attached to site specificity. Geography, culture, injustice, globalization—all these forces had by the 2000s thoroughly periodized and thus (however ironically) rendered *traditional* the kinds of new media practiced by artist-experts in favor of more discursive, skeptical, less phenomenological, and more instrumental hybrid-space practices.

Raqs Media Collective was fully aware of this. As the number of invitations from biennials worldwide started to grow, Raqs started imagining itself as "using" art exhibitions as global platforms for their locally driven activism and aesthetics. This was perhaps nowhere more apparent that at documenta 11 in 2002. Their installation *28f28" N / 77f15" E :: 2001/02* (2002) juxtaposed video and still images, sound, software, and performance documentation on urban dispossession and displacement in India, bringing into an installation format the kinds of activist work the collective had developed through Sarai, the center for publishing and information exchange that they founded in collaboration with a much older research center, the Centre for the Study of Developing Societies (CSDS), in New Delhi. Through this dual yet interconnected method, Raqs could actively moderate (rather than be moderated by) the networks and knowledge circuits of intercultural informants, delegation, and platforms that the "global" art world relied on. Raqs's rapid global renown and consequent global mobility showed once and for all the errors in new media pioneer Roy Ascott's claims (made in his

influential essay, "Art and Education in the Post-Biological Era") that networks tend to erase hierarchy.[17] Networks consolidate hierarchies; however, this is now based more on frequent-flyer miles and word of mouth than on living in London or Manhattan.

But frequent-flyer miles, like new technologies and readily available postindustrial spaces in which to socialize, cost vast amounts of money, a situation that sits uneasily with the view that mega-exhibitions, along with contemporary art installations or projections, are open to all. This proved particularly problematic given the dependence of the twenty-first century editions of many exhibitions, including Asian biennials such as the *Busan Biennale 2012: Garden of Learning*, on defining themselves as sites where democracy would intersect with technologically empowered networks and the experience (although not necessarily in person, in real time) of conversational conviviality and community collaboration. The background to this was the "behavioural economy" engineered by relational aesthetics, as French curator Nicolas Bourriaud argued in 1998, and the safe-house experimentations in Hans Ulrich Obrist and Barbara Vanderlinden's co-curated exhibition in Antwerp, called *Laboratorium* (1999).[18] These curatorial discourses and practices had reinforced the idea of a relationship between large-scale exhibitions and emergent curators' appraisals of experimentation as self-consciously developed through relationships with broad audiences (and decidedly not through experimental new media artists' notions of virtual reality and interactive technologies popular in the earlier 1990s).[19]

The repeated and unmistakeably sincere invocation by biennial curators of relational aesthetics, the laboratory, utopias, and the like was a strong influence on this presumed relationship between biennials and experimentation. But so too was the belief that, if hosting a biennial could boost a city's tourist profile, then the exhibition itself could also concentrate on socialized play and self-display—either as its main thematic concern or as something audiences could enact while holidaying at the biennial. The experimental had thus shifted from media expertise to play time, just as relational aesthetics had shifted, as Hal Foster wittily noted, "from the part à la Lenin to a party à la Lennon".[20] The two arcs were inseparable. Moreover, as biennials increasingly took on the mantle of social and urban laboratories, they revealed that the curatorial performance of democracy was decidedly not activist or even particularly sincere (and this despite Gwangju taking South Korea's democratization as its initial point of reference). The "democracy" of biennials was instead driven by the popular and the populist and was inclined toward a younger visitor demographic.[21]

The strongest evidence of this shift has emerged at the APT, and particularly the exhibition's celebrated education program for young visitors, called "Kids Asia Pacific Triennial". The Kids APT was the unruly, extraordinarily successful offspring of experimental art's absorption and transformation by biennials. At the sixth APT in 2009–10, children were able to experiment with model world-building, while young adults were sufficiently socially

empowered by the image and experience of experimental play to mob the museum in order to hang out and flirt. At the seventh APT in 2012–13, participants could make their own artworks to mimic another artist's work in the galleries above, or be photographed in front of Kazakh tourist attractions projected behind them. The promotional blurb for the *Paramodel Joint Factory* (2012; see Figure 2.1) even read like Bourriaud for babies: "In this spectacular installation, the walls, floor and ceiling are covered with toy rail networks. Children could try their hand at creating patterns and shapes to add to the installation".[22] The resultant images of adults and children of all ages and races revelling in the special Kids APT section of the gallery has, as one might expect, proved an advertising bonanza of smiling faces and manipulable art.

The mode of spectatorship now offered at APT is far from that required by a feature film in a cinema or a modernist painting and, more likely, somewhere along a spectrum between a children's playground and an Occupy site. It was perhaps no accident at all that the anarchistic Occupy movement was quickly transformed into a curatorial methodology and a visual style. It fit with the transformation of experimental art into technologized playthings and democracy into populism outlined earlier, and which a number of artists and critics, from Hito Steyerl to David Joselit, have identified as the direction contemporary art is taking in the 2010s.[23] But the image offered by this new spectatorship is also not far off the impression of diversity and mild-mannered chaos that the APT insisted was what Asia-Pacific regionalism looked like back in the first editions of the Triennial in the mid-1990s—a self-aware but satisfying "construct . . . not implying historical or cultural sameness", as Caroline Turner argued.[24]

That is to say that, despite the various arcs at play in contemporary art and foregrounded at biennials in Asia and the Pacific, there remains a strong and surprising consistency to what a program like the APT has tried to do in its twenty-plus-year history. This is the presentation and production of publics that are able to bring together the very local (through hands-on experiences of new technologies), the regional (the Asia-Pacific), and the global (renowned artists, city boosterism, globally networked technologies) in ways that aspire to be neither homogenizing nor didactic nor foreclosed. As the Kids APT has become the new, somewhat simplified progeny of the experimental and the relational, it has also become the perfect embodiment of the eponymous "intimate publics" of this book—albeit within the vastness of the mega-exhibition.

Rather, precisely because of the vastness of the mega-exhibition. Behind the scenes, a "world art" that we will instead call contemporary art— inclusive of art and experimental practices from around the world, but structured by a new and idealistic curatorial class of mega-exhibition curators—was beginning to replace the North Atlantic canon that still dominated art-historical discourse in Australia and beyond. New media art had appeared within the horizon of this discourse, as earlier had alternative film, as modernism's liminal other. Within this context, and for the various

reasons outlined here, it was biennials that were offering clear, provocative insights into the form, structure and changes underlying the development of experimental art, even as biennial art was inextricably imbricated with contemporary geopolitics and the politics of populist display. The shift toward programs such as Kids APT thus stands as the *contemporary's* liminal other, haunting and yet revelling in the insistence that contemporary art be cosmopolitan, experimental, networked, and memorable all at the same time.

CONCLUSION

We have been obliquely addressing three overlapping questions. First, how had experimental art cultures and biennial cultures functioned within the overarching idea of contemporaneity, and how had art's histories been changed by the conditions of "peripheralism"? On the evidence, the emerging history was one that appropriated a quasi-collective, team-based model of experimentation, matching this to a conventionalized idea of originary artistic experimentation. But second, how had biennials potentially *exceeded* our usual understandings of the experimental, to generate new modes and genealogies of the experimental through the exhibition as a *medium* and as a *context for intimate dialogue*? What gave experimental, contemporary art this intimacy?

The answer, clearly, was located in the social (and in constructed conviviality) rather than in the aesthetic or the technological domains per se, though both were inflected with the desire to map a sense of regional connectedness. Ultimately it is exhibition programs rather than individual artworks that successfully changed the (contemporary) art world as well as changed the way we think about cultural experience. A scattered, restless, globalizing art world internalized the conditions of the experimental as an alternative to both the traditional and the perpetually avant-gardist, having identified these conditions as contemporary. It then sublimated both provocation and intervention so that they now resided within the signifiers of a constructed and childlike intimacy. This was an ingenuous intimacy that idealistically substituted symbolic power for social affect.

NOTES

1. The term *biennialogy* was coined by Elena Filipovic, Marieke van Hal and Solveig Øvstebø in the introduction to their edited volume *The Biennial Reader* (Bergen: Bergen Kunsthall and Ostfildern: Hatje Cantz, 2010), 12–27. Other texts in this emergent discourse include Agnaldo Farias, ed., *Bienal de São Paulo, 50 anos: 1951–2001: homenagem a Francisco Matarazzo Sobrinho*, Fundaçao (São Paulo: Bienal de São Paulo, 2001); Rachel Weiss, Charles Esche, and Gerardo Mosquera, *Making Art Global (Part 1): The Third Havana Biennial 1989* (London: Afterall Books, 2011); and the journals *The Exhibitionist* and *Journal of Cultural Studies*.
2. The most vehement example of this remains George Baker's essay "The Globalization of the False", *Documents*, no. 23 (Spring 2004): 20–25.

3. See, for instance, the many such claims in Robert Storr, ed., *Where Art Worlds Meet: Multiple Modernities and the Global Salon* (Venice: Marsilo, 2005); to an extent, see also Zheng Yan, "Biennials in Asia", *Yishu: Journal of Contemporary Chinese Art* no. 56 (2013): 52–53.

4. We explore these "second-wave" biennials in further detail in Anthony Gardner and Charles Green, "Biennials of the South on the Edges of the Global", *Third Text* 27, no. 4 (2013): 442–55; and Anthony Gardner and Charles Green, "Cultural Translation or Cultural Exclusion? The Biennale of Sydney and Contemporary Art in the South", in *Regionality / Mondiality: Perspectives on Art, Aesthetics and Globalization*, ed. C. Bydler and C. Sjøholm (Stockholm: Södertörn University Press, 2014), forthcoming.

5. For the record, a couple of art historians, principally John Clark, have long been identifying multiple Asian modernities across the Asian region. Our work has benefitted greatly from Clark, and not just from his published writing—although on this count, see John Clark, *Modern Asian Art* (Sydney: Craftsman House/G+B Arts International, 1998)—but also from the generous access he has offered us to his extensive archives of primary sources.

6. For an exhaustive and influential set of definitions of what defines contemporary art, see Terry Smith, *What is Contemporary Art?* (Chicago: University of Chicago Press, 2009), 241–71.

7. Smith was again prescient in this regard, dedicating a chapter of *What is Contemporary Art?* to the third Havana Biennial; see Smith, *What Is Contemporary Art?*, pp. 152–66.

8. See Apinan Poshyananda (curator and ed.), *Contemporary Art in Asia: Traditions/Tensions*, exhibition catalog (New York: Asia Society, 1996).

9. Geert Lovink, *Zero Comments: Blogging and Critical Internet Culture* (London: Routledge, 2007).

10. Alongside their organization of the Sarai media network (cofounded in New Delhi in 2001) and exhibition of artworks in the Venice and Liverpool biennials, documenta in Kassel and the Guangzhou Triennial, Raqs Media Collective was the co-curator of Manifesta 7, the 2007 European Biennial of Art, in the Tyrol region of Italy.

11. See, for instance, Okwui Enwezor, "Mega-Exhibitions and the Antinomies of a Transnational Global Form", *Documents*, no. 23 (Spring 2004): 2–19; Chantal Mouffe, "Democratic Politics in the Age of Post-Fordism", in *Open 16: The Art Biennial as a Global Phenomenon: Strategies in Neo-Political Times*, ed. Pascal Gielen (Amsterdam: NAi and SKOR, 2009), 32–40; and, to an extent, Nikos Papastergiadis and Meredith Martin, "Art Biennales and Cities as Platforms for Global Dialogue", in *Festivals and the Cultural Public Sphere*, ed. Gerard Delanty, Liana Giorgi, Monica Sassatelli. (Routledge, Oxford and London, 2011), 45–62.

12. The best writing in English on Gwangju's biennial as a commemorative marker includes Martin Jay's essay "Kwangju: From Massacre to Biennale" in *Refractions of Violence* (London: Routledge, 2003), 77–85; and Okwui Enwezor, "The Politics of Spectacle: The Gwangju Biennale and the Asian Century." *Invisible Culture*, no. 15 (Fall 2010), 12–39.

13. Lee Yongwoo, "Remapping the Borders", in *The First Kwangju International Biennale. Volume 1. International Exhibition of Contemporary Art: Beyond the Borders* (Seoul: Life & Dream Publishing, 1995), 17.

14. Caroline Turner was QAG's project director for the first three Asia Pacific Triennials. Her critical evaluation of the notion of "Asia-Pacific" continued: "[S]ome would include the United States and the Americas: others would confine the region to Asia and islands in the Pacific". The region's borders may have been porous, but they were also decidedly political. See Caroline Turner, "Introduction", *The Second Asia Pacific Triennial*, exhibition catalogue (Brisbane: Queensland Art Gallery, 2006), 22.

15. This predicament is discussed at length in Colleen Ovenden, "Magiciens de la terre: The Roaring Success of a Failure" (paper presented at the 2004 College Art Association Annual Conference, Seattle, Washington, February 19, 2004). See also Lucy Steeds, Pablo Lafuente, Jean-Marc Poinsot, Rasheed Araeen, Jean Fisher, Thomas McEvilley, Jean-Hubert Martin, Gayatri Chakravorty Spivak, Frédéric Bruly Bouabré, and Barbara Kruger, *Making Art Global (Part 2): "Magiciens de la terre" 1989* (London: Afterall, 2013).
16. Caroline Turner, "From Extraregionalism to Intraregionalism?", *The First Asia Pacific Triennial*, exhibition catalogue (Brisbane: Queensland Art Gallery, 2003), 8–9 (8).
17. Roy Ascott, "The Planetary Collegium: Electronic Art and Education in the Post-Biological Era" (1996), *ISEA Web Archive*, accessed August 16, 2013, www.isea-webarchive.org/content.jsp?id=6284.
18. Nicolas Bourriaud, *Esthétique relationnelle* (Dijon: Les presses du réel, 1998); translated as *Relational Aesthetics*, trans. Simon Pleasance and Fronza Woods (Dijon: Les presses du réel, 2002), quotation at pp. 102 and 104 of the English translation; Hans Ulrich Obrist and Barbara Vanderlinden, eds., *Laboratorium*, exhibition catalogue (Antwerp: Roomade, 1999).
19. Most notably in the work of Howard Rheingold and Jaron Lanier; see, for example, Howard Rheingold, *Virtual Reality* (London: Sacker & Warburg, 1991).
20. Hal Foster, "Arty Party", *London Review of Books* 25, no. 23 (December 4, 2003): 21–22.
21. Further critique of contemporary art's claims to democracy, and its transformation of politics into more problematic neoliberal fantasies, can be found in Anthony Gardner, *Politically Unbecoming: Postsocialist Art against Democracy* (Cambridge, MA: MIT Press, 2014).
22. See the listing for *Paramodel Joint Factory* at the Kids APT website, accessed August 20, 2013, www.qagoma.qld.gov.au/kids/exhibitions/exhibition_archive/kids_apt7.
23. See Hito Steyerl, "Art as Occupation: Claims for an Autonomy of Life," *e-flux journal*, no. 30 (December 2011), accessed January 7, 2013, www.e-flux.com/journal/art-as-occupation-claims-for-an-autonomy-of-life-12/; see also David Joselit and Carrie Lambert-Beatty, "Introduction", in *Occupy Wall Street* issue, *October*, no. 142 (Fall 2012): 3–25; and, in the same issue, the discussions of Occupy as style in the "Occupy Responses" by Rosalyn Deutsche, 42–43; Yates McKee, 51–53; and Martha Rosler, 59–61.
24. Turner, "Introduction", 22.

3 Dots in the Domain
The Asia Pacific Triennial of Contemporary Art

Russell Storer

On New Year's Day 2012, the American art and design site *Colossal* posted an entry on the interactive installation *The Obliteration Room* (2002–present; Figure 3.1), then on display in Yayoi Kusama's solo exhibition in Brisbane.[1] The response was immediate and intense, making it the site's most visited, retweeted, and shared post of the year. It was featured on numerous blogs and online journals such as the *Huffington Post*, *Creative Review*, *Boing Boing*, and *Wired*; broadcast on BBC *One Breakfast* and on *Good Morning America*; and published in the London *Daily Mail*, *Grazia Moda*, and *Time*. The work was picked up for inclusion in Kusama's retrospective at Tate Modern, London, and was subsequently included in touring exhibitions of her work throughout Asia and South America.

The Obliteration Room was originally developed by Yayoi Kusama and the Queensland Art Gallery (QAG) as a children's project for the fourth Asia Pacific Triennial of Contemporary Art (APT4) in 2002. It is a consummate participatory work: Simple yet compelling, it invites gallery visitors to add colored dot stickers to a white room stocked with white furniture. Over time, the room becomes completely covered in brightly hued spots, mapping the presence of its thousands of visitors in a psychedelic accumulation evocative of Kusama's "mirror rooms" and immersive environments, themselves informed by the artist's lifelong condition of visual and auditory hallucinations. The work has been staged at QAGOMA[2] three times in all, but it was only the most recent installment that went viral, due to a unique combination of chance and recent changes in technology, media, and popular culture. The world, it seems, had caught up with Kusama. As the curator of the exhibition, Reuben Keehan, wrote,

> Kusama positions viewers at the centre of the work—not just in The obliteration room, but in her sculptures, installations, videos and larger paintings as well . . . We're beginning to see this approach more and more in museums everywhere. But it's also perfectly in keeping with new media technologies and their impact on the way we experience, discuss and produce culture, life and love. Spectatorship has itself become a form of cultural production and participation, to a point where blogging and tweeting about a work of art can be seen as extensions of picking up a dot and pasting it to a wall, television or piano.[3]

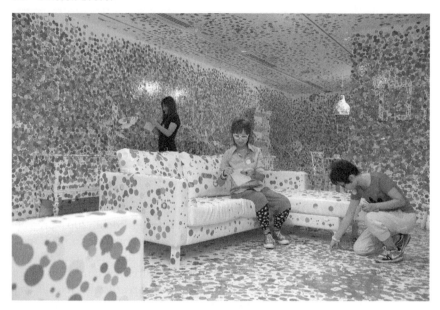

Figure 3.1 Yayoi Kusama's *The Obliteration Room* (2012). Furniture, white paint, dot stickers, dimensions variable.

Source: Collaboration between Yayoi Kusama and Queensland Art Gallery. Commissioned by Queensland Art Gallery, Australia. Installation view, The 7th Asia Pacific Triennial of Contemporary Art, Gallery of Modern Art, 2012. Photograph: Mark Sherwood.

The global reach of Kusama's work from Brisbane demonstrates the operations of image circulation and popular participation via current technology. It propelled the physical experience of the installation, which invites audiences to take part through pressing a dot to the wall, out into cyberspace through the click of a mouse. In this instance, the actual physical site of the work largely ceased to matter; its brilliantly concise concept and its stunning imagery were the hook. This situation aligns perfectly with what theorist David Joselit recently described as the "neoliberal" approach to the circulation of art, in which images are dislocated from their original site and enter "networks where they are characterized by motion, either potential or actual, and are capable of changing format—of experiencing cascading chains of relocation and remediation".[4] Unlike what he defines as a "fundamentalist" position of basing art in a particular place for it to gain its value, this "neoliberal" status allows for complete mobility, with value accumulating through mass circulation—rather than being depleted through the loss of its Benjaminian aura. Joselit describes the contemporary global artwork as a kind of "emissary", "whose power arises out of cultural translation rather than avant-garde innovation, a form of international currency that can cross borders effortlessly".[5]

In part, it is this ability to seamlessly cross borders that makes Kusama such an exemplary contemporary artist, and has contributed to her growing

international attention and acclaim in recent years. Kusama's works are deeply personal, wildly diverse, and visually embracing; they have the capacity, as curator Mami Kataoka has written, to transcend "time, generation, gender, region and culture, as well as the various vocabularies of contemporary art".[6] As Joselit observed, the international language of contemporary art, particularly as it circulates through the channels of museums, biennials and art fairs, is one that continually performs acts of translation, with artists taking on the role of what theorist Nikos Papastergiadis has named "aesthetic cosmopolitans", drawing on "a productive tension between a globally oriented approach and locally grounded practices".[7]

Contemporary art around the world has become deeply enmeshed in these ongoing processes of cultural exchange, knowledge formation, and network building. A crucial aspect of this tendency is the increasing engagement of audiences; Papastergiadis writes, "As the viewer adopts an active role in shaping the whole environment, their subjectivity is in turn shaped by the experience of giving in to it".[8] In other words, we undertake our own process of cultural translation through co-production. One way of observing the development of this tendency is through the lens of the Asia Pacific Triennial of Contemporary Art (APT), established by the Queensland Art Gallery (QAG) in 1993. This exhibition project is characterized by its geographical focus on the contemporary art of Asia and the Pacific, including Australia, presenting primarily new and recent works and commissions, many of which are acquired for the gallery's permanent collection. Accompanying publications, conferences and public programs, as well as a substantial archive, have contributed significantly to research and discourse in the field.

Along the way, the APT has adapted in response to the shifting terrain of Asian and Pacific contemporary art. This includes not only changes in the art being made but also changes in infrastructure, expertise, information flow, communications technology, and funding support, both in Australia and throughout the region. Its shifts in approach also reflect substantial developments in the role of the museum; unlike many biennials, the APT has always been a museum-based exhibition, catering to a broad audience, as befits the QAG's position as a publicly funded state institution. The size and diversity of this audience has substantially grown since 1993 to make it now one of Australia's most visited exhibitions.[9] It has also been one of the most hotly debated, attracting a wide range of critical responses from the outset, tapping as it does into questions of postcoloniality, identity, and representation, as well as how the contemporary museum constructs art-historical narratives and engages its publics.

This chapter traces the way the APT has conveyed the contested cartographies and dynamic ecologies of Asian and Pacific contemporary art to its audiences through the examples of key works and initiatives that have marked moments of change. Seen together, they represent a process that informs subsequent Triennials, culminating in the staging and reception of Kusama's *The Obliteration Room* in 2012, in terms of how the artist, the artwork, and the audience are located and how the relationships between them may be configured within a contemporary art museum.

MAKING MAPS

In the late 1980s, when the APT began to take shape as an idea, Asian and Pacific art was largely understood in Australia in terms of the classical culture and traditions of the region, and its presence in museum collections was composed almost exclusively of historical objects. These were beautiful yet static—"timeless"—and the artists were generally unknown and/or deceased. The first APT was intended to introduce local audiences to the burgeoning contemporary art movements in the immediate region and to involve Australia in the debates that surrounded them. At stake was the writing of alternative modern histories, the impact of colonialism and independence movements, the role of indigenous art and the continuing presence of tradition, and the definitions of "the contemporary", "Asia", and the "Asia-Pacific". Australia's investment in the region was also questioned, particularly in Asia, as a largely European country with a seemingly new curiosity.[10] Although this suspicion was understandable, however, a number of artists, curators and organizations in Australia had been in dialogue with peers in Asia and the Pacific over many years, a number of whom provided the bedrock for the subsequent initiatives. A crucial intellectual framework for these initiatives was the conversation throughout the 1980s and 1990s over the positioning of Aboriginal art as contemporary art. This forced a major reorientation in the conception of Australian art and its relationship to Euro-US art history, and in the constitution of the contemporary.[11]

This period had also seen the Australian government take a major turn toward Asian engagement, including the establishment of multilateral diplomatic and trade institutions such as Asia-Pacific Economic Cooperation (APEC) and cultural institutions such as Asialink. Although the QAG's stated focus on the Asia Pacific certainly aligned with this agenda, it arose from a more complex constellation of factors, from the constitution of the gallery's collections and its desire to distinguish itself from other state institutions to the history and location of Brisbane in relation to its neighbors.[12]

Cofounder Caroline Turner described the early APT exhibitions as a "journey without maps", although cartography was crucial: In APT1, artists' works were organised nationally, and the catalogue opened on a map of East and Southeast Asia and the western Pacific, with further maps and country information leading the national sections under which texts on individual artists were featured. As Turner wrote in the introduction,

> We did approach this exhibition through national contexts, which itself raises significant questions. It is our hope that further countries will be included in the next Triennial. In the future the art may also be selected other than nationally . . . What is apparent is that the artists within this region are confident in their local and regional specificity as well as in incorporating ideas which cross national boundaries—an art which engages with international art practice but is not dependent on international ideas imposed from a "centre".[13]

A primary objective of the early APT exhibitions was to break down assumptions that Asia was homogeneous. Locality, cultural identity and specific histories were key focuses. The theme of the first APT was "Tradition and Change", which was also the title of an accompanying scholarly publication discussing the art histories of different countries in chapters by regional art historians and curators.[14] It had the objective of challenging traditional stereotypes, of "bringing the past into the present",[15] and of directing audiences away from a linear, Euro-American trajectory of artistic development and toward the polycentric, syncretic global art history that we understand today. Artists drawing on surrealism, expressionism, and minimal art demonstrated the legacy of Asian modernisms, which at the time had barely been recognized outside of their own contexts.[16]

The framework of APT2 in 1996 was "Present Encounters", placing an emphasis on the cultural contexts in which contemporary artists were working. Although the national framework was discontinued in the exhibition, it continued in the catalogue, as did the curatorial structure of advisors and co-curators from different countries working with QAG curators. These advisors provided crucial local knowledge and perspectives at a time when there was limited, if any, Internet access and usage and little published on contemporary Asian and Pacific art, particularly in English.

In the early triennials, the more complex realities of cross-cultural and transnational flows were largely played out in the associated conferences, artist talks, and performances. The physical presence of Asian and Pacific artists, curators, and writers provided arguably the most radical break from what had been seen in Australia before, and had perhaps the most lasting impact. In the performances and artist talks, gallery visitors came into close contact with the artists themselves, their bodies asserting their place in the world. They addressed concerns including political violence, gender and sexuality, religion and ritual, environmental degradation, and globalization, critiquing and challenging not only their own social and political situations but also local understandings of contemporary life across the region.[17]

Similarly, the conferences offered intimate and sometimes combative platforms where people were brought together in the same space, often for the first time, to thrash out ideas and build connections. Although they uncovered numerous anxieties and tensions—Singaporean art historian TK Sabapathy observed "a wariness toward accepting or succumbing to orthodoxies emerging, imposed or acquired, from the West, and then adopted, employed, retooled unthinkingly when looking at and writing about art in these regions"[18]—they also contributed substantially to a regional art discourse and identity that reached beyond national borders. Many relationships forged in these gatherings have lasted, generating new dialogues and projects elsewhere and feeding into other growing networks. This also importantly includes the informal meetings and social get-togethers that took place outside the official events, where conversations and friendships were struck, allowing for further cross-pollination of ideas.

The development of contemporary Asian art into its own transnational category has been assisted by the growth throughout the 1990s and 2000s of such networks. The emergence of numerous biennials, art museums, auctions, and art fairs, particularly in East and South East Asia, has been supported by rapid increases in wealth, mobility, and access to communication technologies. Although what has become known as "contemporary Asian art" is enormously diverse and ambiguously defined, it has been neatly described by curator Melissa Chiu and critic Ben Genocchio as a "discursive framework within which experimental art connected to the region can be understood".[19] They go on to note that "such an interpretive framework would seem to have greater currency and use outside of Asia than within it", a perspective echoed in curator and art historian Chaitanya Sambrani's wry observation: "There is no contemporary Asian art in Asia. There is contemporary Thai art in Thailand, and there is contemporary Chinese art in China. But contemporary Asian art is a creature born on the banks of the Brisbane River".[20]

REMAPPING

The APT, then, has taken an active role in the construction of this framework, arguably aided by its position of being closely linked to, but also somewhat outside of, Asia. Amid the region's dense landscape of organizations, exhibitions, and events, its geographical focus on Asia, the Pacific and Australia remains unique. Over time, although the remit remains the same, its framing and extent has shifted, expanding from its close focus on artists from East and Southeast Asia, Australia, New Zealand, and Papua New Guinea in APT1 to take in artists from South, West, and Central Asia and from Pacific islands as far-flung as Hawaii and Tahiti. Gallery presentations are generally framed by artist and artwork rather than by country and are linked by thematics; regionally-based projects such as "The Pacific Textiles Project" (APT5, 2006), "The Mekong" (APT6, 2009), and "0–Now: Traversing West Asia" (APT7, 2012) have emphasized connections beyond national identities, using respectively the mediums of woven mats and textiles, the motif of the Mekong River, and the subject of landscape to explore the movements of and interactions between people, and long histories of change.

These themes connect with the growing appreciation of, and research into, the histories that predate colonial and postcolonial constructions of national identity, which have strengthened intraregional links and formed the basis for new forms of relation, in what curator and critic Nancy Adajania has referred to as "continents of affinity". This term describes a sense of commonality gained not through the "exhausted, even specious cartographies premised on the paradigm of the "West against the Rest", but through "alternative and anterior histories of globalism in order to disclose the hidden sources and strains of cultural selfhood".[21]

The APT's approach to geography and identity took a turn in 1999 in "Crossing Borders", a dedicated section of APT3 that foregrounded artists living in the diaspora and/or engaged in cross-cultural collaboration and interdisciplinary practices. These were artists "who could not be circumscribed within narrow geographical, media or other definitions", and their inclusion aimed to "address ideas related to the changing dynamics of art practice in the contemporary world".[22] It featured works by artists living outside of their birthplace, such as Vong Phaophanit, Chen Zhen, and Simryn Gill; artists with interdisciplinary practices and working in collaboration, such as Michel Tuffery and Heri Dono; and artists who work in traditional or community contexts, such as Sonabai and John Frank Sabado.

Although the limitations of singular identities and national definitions had been acknowledged in previous editions, this was the first explicit attempt to address the issue, pointing to the actualities of a world in which people are increasingly mobile, interconnected, and living between multiple locations and cultures. Many works were temporal or installation based, offering immersive and participatory experiences for audiences that transmitted recent developments in relational art, such as Cai Guo-Qiang's bamboo *Bridge Crossing* (1999) across the QAG Water Mall; Lee Mingwei's *Writing the Unspoken* (1999), which invited visitors to write letters to loved ones that were then posted by QAG staff; and Surasi Kusolwong's *Ruen pae* (*During the Moments of the Day*; 1999–2000), an installation devised as a space for contemplation and conversation, inspired by the floating wooden houses of Ayutthaya.

Many of these artists had become widely known during the 1990s, taking part in numerous biennials and site-specific projects around the world, and working regularly with influential and itinerant curators. Projects such as Hou Hanru and Hans Ulrich Obrist's *Cities on the Move* at the Vienna Secession in 1997 had introduced many Asian artists to Europe for the first time, while the 1999 Venice Biennale featured nineteen artists from China, including Chen Zhen and Cai Guo-Qiang. The nature of these large-scale temporary exhibitions highlighted site-specific, ephemeral works such as installation and performative environments, and Asian artists such as Kusolwong, Rirkrit Tiravanija, and Navin Rawanchaikul (who had participated in APT2) became associated with broader tendencies of relational aesthetics and participatory art. This greater circulation meant a more rapid distribution and wider reception of art works, as well as more frequent interactions between artists from different locations, a development that by the late 1990s had become impossible to ignore.

Subsequent APTs have extended the approach of "Crossing Borders" beyond a dedicated section to in effect encompass the entire exhibition, broadly exploring ideas of cultural exchange and flow, and transregional themes such as urban transformation, ephemeral architecture, collaboration, and collective activity. Collaborative practice emerged as a key theme through the 2000s, for example, with the participation of numerous artist duos and groups, from the Beijing-based *Long March* Project in APT5 to

the Indonesian collective ruangrupa in APT7. Each group is formulated differently, but all demonstrate the growing level of artistic agency and self-organization throughout the region. Some reflect traditional collective formations for the creation of cultural projects, such as the Kwoma Arts group from the East Sepik province of Papua New Guinea, that worked together to create an installation for APT7 based on a men's spirit house. Some came out of artist-run organizations that had established infrastructures for critical discourse and the making and exhibiting of art, often in the absence of institutional infrastructure and funding, such as ruangrupa and Raqs Media Collective, which presented materials from the associated Sarai archive, New Delhi, in APT7. Others such as the Indian duo Thukral & Tagra, who participated in APT6 (2009), and the Osaka-based Para-model, who participated in APT7, have created "brands" in which their collaborative work echoes a form of corporate production, transposing visual elements of local identity onto a wide range of designs, objects, and artworks.

The emphasis in recent art on provisionality, narrative, and self-reflexivity finds expression in an increasing presence in the APT of screen-based art: large-scale video installations, immersive environments, and cinema. As digital production technology became more sophisticated and accessible through the 1990s, it was rapidly adopted by artists for its immediacy and ability to draw audiences into embodied engagements with landscape, history and personal experience. These works are able to re-create familiar modes of spectatorship drawn from cinema and television, providing a context for often highly specific references to undergo a process of cultural translation. The first video installation to be featured in an APT was Zhang Peili's *Endless Dancing* (1999) in APT3, and each edition since has featured major works in this medium, including Dinh Q Lê's three-channel video projection *The Farmers and the Helicopters* (2006), which taps into the legacy and representation of the Vietnam War; Daniel Boyd's four-channel video and sound installation *A Darker Shade of Dark 1–4* (2012), which links space exploration and the theory of "dark matter" to the gaps in understanding of Aboriginal cosmologies; and Tadasu Takamine's multimedia installation *Fukushima Esperanto* (2012), which meshed Eisenhower's triumphant speech on the benefits of nuclear power with an Esperanto lullaby amid a landscape of debris, in reference to the 2011 Fukushima disaster in Japan.

In 1999, APT3 deliberately addressed this developing potential, bringing together several platforms devoted to digital and screen-based culture for the first time, reflecting recent developments in communication and production technologies. The "Virtual Triennial" included video and new media installations and a selection of online projects (APT3 was also the first edition to have its own website). The rapid expansion of digital platforms in the 1990s meant it took some time for major arts institutions to catch up, and grassroots organizations such as Multimedia Art Asia Pacific (MAAP)

in Brisbane and the Faculty of Applied and Creative Arts, Universiti Malaysia Sarawak, led by Niranjan Rajah, were important conduits for access and information. "Screen Culture" was a curated program of film, video, and animation, presented in collaboration with MAAP and bringing together artist films and video works for screenings in the gallery's lecture theater and off-site at a city cinema. It was presented as an event rather than being integrated through the exhibition itself, due in part to the limited facilities available, but the significance of film in understanding broader histories and expressions of visual culture paved the way for the gallery's development of the Australian Cinémathèque, which opened in 2006 with the launch of the Gallery of Modern Art (GOMA), enabling cinema programs and filmmakers to be featured as part of each subsequent APT. On introducing the first APT cinema program, curator Kathryn Weir wrote,

> Filmmakers like Kumar Shahani, Jean Renoir and Viet Linh are representative of a visual production which creates from and for the local, while also taking part in international conversations through distribution and exhibition . . . Viewers are challenged to be ever more receptive as cultural and aesthetic translators to the traditions-in-use distilled through contemporary art and film.[23]

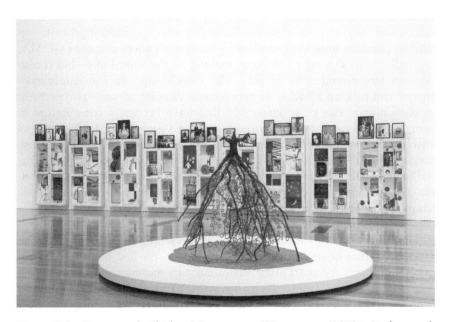

Figure 3.2 Foreground: Shirley Macnamara, *Wingreeguu* (2012). Background: Atul Dodiya, *Somersault in Sandalwood Sky* (2012), commissioned for APT7.

Source: Purchased 2013. Queensland Art Gallery Foundation Grant. Photograph: Natasha Harth. Image courtesy: Queensland Art Gallery | Gallery of Modern Art.

FROM LOCATION TO DOMAIN

The operations of cultural translation continue to run throughout the APT, generating meaning through the interpretive processes that take place across multiple boundaries. This potential of cross-cultural interaction to create small transformations on both sides continues to inform the project. Not all works are equally translatable of course, and works that challenge interpretation, such as those by many Aboriginal Australian and Pacific artists, for example, provide a crucial and highly productive dimension of dissonance to the exhibition. There are works that appear to align with Joselit's formulations of the "fundamentalist", located works of art, and those seeming to favor the "neoliberal" position of complete mobility, as well as spaces in between as we move along the spectrum, yet by bringing them together, other transfers and dialogues have the potential to occur. These positions can also transform over time or can operate simultaneously, and works or practices that may appear deeply connected to a single place at one moment may be received more readily and broadly at another, through a shift in context or via social, cultural, or technological change. Viewers also have varying levels of access to information and technology, and the dialectical relationship between audience and artwork means that differing spheres of knowledge and experience are applied to each encounter (see Figure 3.2).

The extraordinary reception of *The Obliteration Room* at GOMA arose from a unique combination of factors—the availability of smartphone technology and the rise of social media; its bigger, more spectacular presentation than its previous iterations, enabled by the larger gallery spaces at GOMA; key individuals sharing its imagery, making all the right links—but it also suggests larger tendencies at play. The work's supreme translatability—anyone can pick up a sticker or appreciate a dazzling image—also gestures to particular modes of spectatorship that have become second nature in many forms of visual culture, without needing a great deal of exposition or introduction. Kusama's conceptual and aesthetic concerns, and her Japanese heritage and US avant-garde connections, may not always be evident or crucial to audiences for the work, but it is useful to consider its framing within the context of her solo exhibition. Here she was positioned as a global contemporary artist who, at eighty-four, is making work that is now of great relevance and wide influence throughout the world.

This differs from her framing in previous presentations at the gallery: The 1989 exhibition *Japanese Ways, Western Means*, the first major exhibition of contemporary Asian art in an Australian state museum and an important precursor of the APT, introduced her work to local audiences within the context of 1980s Japanese art; while in APT4 in 2002, she participated with a forty-year mini-retrospective, as one of three senior avant-garde Asian artists, alongside Nam June Paik and Lee Ufan, whose work had a profound impact on international art, because it "celebrates, appraises and radically reinterprets the contemporary moment".[24]

The trajectory of Kusama's presentations over this period can be seen to mirror the shifts in how the APT has mapped the cartographies of contemporary art over the past two decades, because it has moved from an emphasis on locatedness toward a more fluid, dynamic, and expansive domain. Although locality and site continue to be important, and the mechanisms of difference should not be erased, they increasingly operate within a field in which interconnectedness is understood, experienced, and embodied as a condition of contemporary life. Like Kusama's accumulations of dots, we are enmeshed in an ongoing process of becoming: There is always more space to cover, more elements to work and rework, and more routes to trace.

NOTES

1. Yayoi Kusama, *Look Now See Forever*, Gallery of Modern Art, Brisbane, November 18, 2011–March 11, 2012.
2. The Queensland Art Gallery (QAG) became the Queensland Art Gallery/Gallery of Modern Art (QAGOMA) in 2006, with the opening of its second building, the Gallery of Modern Art.
3. Reuben Keehan, "Dots Obliterate the Internet!", *QAGOMA* blog, February 10, 2012, accessed July 7, 2013, http://blog.qag.qld.gov.au/dots-obliterate-the-internet/.
4. David Joselit, *After Art* (Princeton, NJ: Princeton University Press, 2013), 14.
5. Ibid., 21.
6. Mami Kataoka, "Yayoi Kusama: An Infinite Consciousness Directed at the Cosmos", in *Look Now See Forever*, online exhibition catalogue, ed. Christina Pagliaro (Brisbane: Queensland Art Gallery/Gallery of Modern Art, Brisbane, 2011), accessed July 7, 2013, http://interactive.qag.qld.gov.au/looknowseeforever.
7. Nikos Papastergiadis, *Cosmopolitanism and Culture* (Cambridge, UK: Polity Press, 2012), p.112.
8. Ibid., 113.
9. APT1 in 1993 received an audience of approximately 60,000 visitors; APT7 in 2012–13 received approximately 565,000 visitors.
10. See Apinan Poshyananda, "The Future: Post-Cold War, Postmodernism, Post-marginalia (Playing with Slippery Lubricants)", in *Tradition and Change: Contemporary Art of Asia and the Pacific*, ed. Caroline Turner (Brisbane: University of Queensland Press, 1993), 3–24.
11. See Ian McLean, "Aboriginal Art and the Artworld", in *How Aborigines Invented the Idea of Contemporary Art*, ed. Ian McLean (Sydney: Institute of Modern Art, Brisbane/Power Publications, 2011), 17–75.
12. See Doug Hall, "It Seemed Like a Good Idea at the Time", *ArtAsiaPacific*, no. 83, (May–June 2013): 79–80.
13. Caroline Turner, "Introduction—from Extraregionalism to Intraregionalism?", in *The First Asia-Pacific Triennial of Contemporary Art*, ed. Caroline Turner (Brisbane: Queensland Art Gallery, Brisbane, 1993), 8.
14. Caroline Turner, ed., *Tradition and Change: Contemporary Art of Asia and the Pacific* (St. Lucia: University of Queensland Press, 1993).
15. Caroline Turner, "Present Encounters: Mirror of the Future", in *The Second Asia Pacific Triennial of Contemporary Art*, exhibition catalogue, ed. Caroline Turner and Rhana Devenport (Brisbane: Queensland Art Gallery, Brisbane, 1996), 11.

16. The first major conference on this subject was held in March 1991 at the Humanities Research Centre and the Department of Art History, Australian National University, Canberra. Titled "Modernism and Post-Modernism in Asian Art", it was convened by John Clark and was published as *Modernity in Asian Art* (Sydney: Wild Peony Press, 1993).
17. Many of these performances and talks can be viewed on QAGOMA TV, see http://tv.qagoma.qld.gov.au/.
18. TK Sabapathy, "Developing Regionalist Perspectives in South-East Asian Art Historiography", in *The Second Asia Pacific Triennial of Contemporary Art*, ed. Caroline Turner and Rhana Devenport (Brisbane: Queensland Art Gallery, Brisbane, 1996), 13.
19. Melissa Chiu and Ben Genocchio, *Contemporary Asian Art* (London: Thames & Hudson, 2010), 10.
20. Chaitanya Sambrani, interviewed on "APT 7—Our Century, Our Art", *Artscape*, ABCTV, Sydney, screened February 24, 2013.
21. Nancy Adajania, "Time to Restage the World: Theorising a New and Complicated Sense of Solidarity", in *21st Century: Art in the First Decade*, ed. Miranda Wallace (Brisbane: Queensland Art Gallery/Gallery of Modern Art, 2010), 225.
22. Caroline Turner, "Crossing Borders", in *Beyond the Future: The Third Asia-Pacific Triennial of Contemporary Art*, exhibition catalogue, ed. Jennifer Webb (Brisbane: Queensland Art Gallery, 1999), 188.
23. Kathryn Weir, "Seeing What Is (There)", in *The 5th Asia-Pacific Triennial of Contemporary Art* (exhibition catalogue), ed. Lynne Seear (Brisbane: Queensland Art Gallery, 2006), p.49.
24. Suhanya Raffel, "The Asia-Pacific Triennial of Contemporary Art 2002—An Introduction", in *Asia-Pacific Triennial of Contemporary Art 2002*, exhibition catalogue, ed. Lynne Seear (Brisbane: Queensland Art Gallery, 2002), 8.

4 Beyond Institutional Thinking

Elaine W. Ng

Contemporary art is flourishing in the Asia-Pacific region. Over the last few years in China alone, an average of one hundred museums have been unveiled annually, while not all exclusively modern or contemporary in their scope; this phenomenal record of growth peaked in 2011, when nearly four hundred new institutions opened. At least 20 large and small Asian cities have launched their own art fairs: Art HK (now rebranded Art Basel in Hong Kong) to more recently unrolled, the Bali Art Fair in the languid Indonesian holiday spot due to premier in early 2014. Since the turn of the millennium, commercial galleries and auction houses have helped fuel the market for contemporary art. Beginning in 2004, ambitious galleries, large and small, from Europe and the US established branches in Beijing, Shanghai, Hong Kong, Singapore, and Tokyo. Auction houses host contemporary art sales and showcase their highlights in these same cities. Local governments have designated special "art" districts, which combine artists' studios, galleries, and restaurants, are now tourist attractions; among the most enduring are Beijing's 798 and Singapore's Gilman Barricks. This shiny new hardware enhances the polished and manicured image of the Asian cultural landscape, suggesting the existence of a healthy environment for contemporary visual art.

Despite these remarkable advances, artists, intellectuals and cultural initiatives that embrace a practice that is not easily monetized and commodified are increasingly being pushed to the margins, to the point of near invisibility in terms of public awareness and media exposure. In some extreme situations, alternative art practices are being eliminated from the narratives of the evolution of contemporary art—both regionally and locally. Instead, the growth of the contemporary Asian art market is seen as the starting point of this new history.

For those who remember the germination phase of contemporary Asian art in the 1990s, independent, artist-run art spaces were the locus of the arts community. Some nonprofits—particularly the Para/Site Art Space and Videotage in Hong Kong, New Delhi's KHOJ International Artists' Organization, and IT Park in Taipei, all founded in the late 1980s and 1990s—have

matured and now assert themselves as healthy challenges to the market-obsessed environment. Other influential artist-run spaces founded at the same time, such as Cemeti House in Yogyakarta, Plastic Kinetic Worms in Singapore, and Seoul's Ssamzie Space, have either scaled back their activities or closed.

As more cities in Asia establish a stable, modern arts infrastructure essential to a thriving arts scene, such as museums, art schools, galleries and gallery districts, artist studio complexes, greater attention must be paid to more low-key and nontraditional sites of culture that helped nourish the careers—and continue to do so—of many artists, curators, scholars, and writers whose practice or research falls outside of established parameters. Given this situation, what is the role of the *space without walls*—such as publications, websites, and archives initiated by groups or individuals—in this period of artistic development, change, and transition in the Asia region?

If we seek out historical parallels to the present artistic environment, the closest comparable moment is the advent of artists' video in Europe and North America during the mid-1960s through the early 1980s and the opportunities for distribution outside the rarified confines of the art world. During this period, characterized by leftist politics and a largely antiwar counterculture, commercial, public, and later cable and satellite television once represented key mediums for the dissemination of artists' video into nontraditional artistic sites such as homes, bars, community centers, and other public spaces.

Today, the Internet represents an even more powerful platform for the distribution of a diverse range of images, ideas, and information, in real time and space, to a potentially unlimited number of people. Moreover, web channels are capable of transmitting ideas across distances far and near to a captive and interactive audience, recalling some of the early theories attached to the video medium of video.[1] The Internet may finally provide the long-anticipated open forum first envisioned by early artists attracted to the potential of video as a medium.[2] It is therefore no surprise that in a similar pioneering spirit, many alternative art spaces and projects today are actively organizing their initiatives for the "global village" via the Internet. The Internet has created new forms of engagement and contexts for art publics that are both intimate and mobile in nature. Although the medium promised to overcome challenges of distance and difference, locality continues to inform the multiple Internet cultures.

In this chapter, I cite examples from both nonprofit arts organizations and private enterprises that successfully utilize the power of the Internet to connect with the public as a means of disseminating art, ideas, and knowledge in unconventional, economical ways. Through charting the role of the Internet within art organizations and enterprises, I seek to conceptualize contested intimate publics that traverse online and offline spaces.

ORGANIZING INTIMATE PUBLICS: PUBLIC AND PRIVATE ART ORGANIZATIONS IN THE REGION

Established in 2000, Asia Art Archive (AAA)[3] is a Hong Kong–based non-profit offering a comprehensive repository of material about contemporary art from the Asia region. Its forty-one thousand items, much of it donated, include books, gallery catalogues, periodicals, and audiovisual material along with primary source documents and personal archives. Although AAA may be considered a physical library, one of the ways the organization offers its collection to a wider public is to provide some of its digitized collection online. This has allowed artists, scholars, and curators as well as the public to access rare material, such as the archive of pioneering Filipino artist, teacher, and curator Roberto Chabet (1937–2013) and the personal sketches, correspondence, photographs, news clippings and exhibition ephemera of artist Zhang Xiaogang—considered one of the most important artists in post-1989 China. Broad availability is particularly crucial for artistic communities that lack access to the documents that capture this fast-changing art scene. Its website is conducted in Chinese, English, Korean, and Thai (see Figure 4.1). In addition, AAA produces a tri-annual digital publication titled "Field Notes" and regularly hosts public programs consisting of talks with artists, curators, and scholars that are recorded and posted on its website.

Figure 4.1 Asia Art Archive website.

Contemporary Indonesian art is similarly served by the Indonesian Visual Art Archive (IVAA), in Yogjakarta.[4] Initially established as the Yayasan Seni Cemeti (Cemeti Art Foundation) in 1997, which acted as a "creative laboratory" fostering alternative art practices for artists, since 2007, it has refocused its mission on education. Today it collects and preserves documentation on the present Indonesian art scene, including photographs and audiovisual recordings of artists at work, books, and exhibition catalogues. The website is available in Bahasa Indonesia and English and offers news, information on training programs and conferences, and the analogue material that has since been digitized. Although not as extensive in its offerings as Asia Art Archive, IVAA's efforts are extraordinary in a country where the art scene is dominated by market forces and where no domestic public or private funding exists for initiatives such as theirs.[5]

Another nonprofit that harnesses the global reach of the Internet is the Arab Image Foundation (AIF)[6] based in Beirut, Lebanon. Artist and scholar led, AIF was established in 1997 with a mission to collect, preserve, and study photography from the Middle East, North Africa, and the Arab diaspora. Today the AIF has assembled more than six hundred thousand photographs dating from the mid-nineteenth century to the present day and has produced exhibitions, publications, and videos with this material, often providing an alternative viewpoint to traditionally established narratives. In addition, more than twenty thousand photographs are available for free public access online, where one can search by photographer, studio, genre, photographic process, and period in addition to key word, name, and location. In addition to collecting, AIF promotes education on conservation in a region where political and economic factors make conservation difficult. AIF also helps working photographers by functioning as a photo agency, selling reproduction rights and paying a percentage of the earnings to the artists. AIF's activities are supported through donations and the fees it receives for selling rights.

Although most art publications are not registered as nonprofit organizations, they often function like them—providing a platform for artists and encouraging discourse on a broad range of issues and practices related to contemporary art, often on a shoestring budget. Furthermore, many publishers have seen already slim revenue sources dry up with the precarious economic conditions set off by the global recession in 2008. Publishers— both mainstream and niche—have been trying to tackle growing overheads and shrinking advertising revenue by shifting their content online.[7]

ArtAsiaPacific (AAP), now in its twentieth year, actively pursued an online presence in 2010 with the overhaul and redesign of the magazine's website. From 2002 to 2009, it had a web presence, offering an average of seven articles from the print version posted on the web. After studying how to combine online content with the print edition, *AAP* created its current website.[8] The editors decided to offer a selection of about fifteen articles

Figure 4.2 Christopher Doyle, *Away with Words* (Artist app).
Source: Courtesy of Art Asia Pacific.

from the print edition, in English, all of which are translated into Arabic and Chinese, targeting the magazine's largest artistic communities, but which do not have a long or nurtured tradition in art writing and criticism. *AAP* also produces daily web-exclusive content—such as late breaking news, short web reviews, blogs, and other multimedia content such as photo essays and video interviews. Since *AAP*'s web relaunch, the site has attracted readers from China, Taiwan, and the Philippines as well as from Kazkhakstan, Saudi Arabia, and Iran. Most recently, *AAP* has launched an artist app for artist and cinematographer Christopher Doyle called "Away with Words" (see Figure 4.2), an attempt to publish a digital, interactive version of an artist book.[9] The past four years have also seen an increase in new, independent online art publications, such as Art Radar Asia, Randian.com, and Ibraaz.[10]

THE ART OF THE INTERNET: FROM BLOGS TO APPS

Beyond online nonprofits, individuals, private and commercial entities are seizing opportunities on the Internet. One of the earliest adopters of the web is the British collector Charles Saatchi—influential for discovering a number of artists, most notably the Young British Artists of the 1980s. Established in October 2006 when the Saatchi collection was moving to new premises, Saatchi staked out a piece of virtual real estate with "Your Gallery," which was described on the *Guardian* newspaper's blog as a "democratic

revolution that . . . promises to transform art",[11] by allowing anyone with access to the Internet to post his or her artwork on the multimillionaire collector's website. A month later Saatchi Gallery created a section on the site called "Stuart" for student art. Later rebranded as Saatchi Online, it became the art world's version of the MySpace website for artists, where they could share their artworks in cyberspace, participate in online art "crits", and sell their works. Saatchi would take a 30 percent commission on all sales, but all other activities were free. Saatchi adopted the rhetoric of the 1960s' video art community when describing his online initiative:

> The art world is dominated in the people's minds by the thousand artists that are very successful, that are handled by the top 50 dealers around the world . . . They're the ones that get all the attention, but the real art world is hundreds of thousands around the world who don't have dealers and are pretty much underrepresented.[12]

By the end of its first year, the *New York Times* reported that Saatchi's website attracted posts by more than twenty thousand artists, including two thousand video art clips, with an average of eight hundred new artists signing up each week.[13] Chinese, Russian, and Portuguese versions were launched for artists in the "BRIC"[14] countries. Since then, a number of similar web portals have appeared, such as Ocula, Art.sy, and Artspace, albeit geared toward the conventional equation of generating commercial sales for blue-chip dealerships as well as emerging galleries. These sites, however, charge fees to participating galleries to promote and exhibit their wares in virtual space.[15]

Utilizing the web in an unconventional way, Paris-based collector Sylvian Levy and his wife, Dominique, founded the DSL Collection of Chinese contemporary art housed in their private "museum", which exists exclusively on the web (see Figure 4.3).[16] Unlike newly minted collectors in Asia who have constructed buildings to store and publicly display their collections, the DSL virtual museum comprises both temporary and permanent exhibitions of their collection. Echoing Saatchi, the Levys explain their decision to share their collection online as a form of expanding exposure, "to give visibility to art and the artists, in particular those who are not necessarily the darlings of the auction market".[17] DSL invites guest curators to organize exhibitions, and viewers can "walk" through the space, read wall texts, and get close to the works as in an actual museum. Their collection, which they limit to 120 works—if they acquire a new object, they will sell one in their collection—and many of the artists are often young and use new media.

Moving away from the Internet and embracing more cutting-edge technology is Art Intelligence (AI) from New York. A start-up established in 2013 by art historian and former professor Bridget Goodbody, AI brings traditional learning to students and the general public via app technology. Goodbody has combined art history with the latest technology to create a dynamic, interactive learning experience. Her first two iPad apps (see Figure 4.4)—both launched in 2013—are on individual artists: Australian artist Patricia

Figure 4.3 DSL Collection website.
Source: Courtesy DSL Collection.

Piccinini,[18] known for her cross species sculptures, and the 1980s New York graffiti and visual artist Keith Haring.[19] AI's iTunes apps describes itself as "[a] virtual playground for your mind-as well as your eyes" and to "[t]hink visual Wikipedia on steroids." The apps go beyond standard textbooks: one can view almost all the works created by the artist, along with a timeline of the period in which the artist worked and key moments in his/her life (in Piccinini's app, the timeline includes advances in genetic engineering since Dolly the Sheep), and links to other artworks—both obscure and obvious.

AI also offers students the opportunity to participate in online forums, or "debates", with others who have purchased and downloaded the app. These apps are geared for both university students and "arm chair art fans". In explaining why it has decided to develop its "editions" with app technology versus the Internet, AI states,

> iPad is a particularly good device because its touch technology and data visualization capacity makes it more information rich than a website—you can scroll through 15 images on an iPad in a tenth of the time that you can on the web. Most importantly, the technology allows the user to choose how they want to explore the information made available to them.[20]

Forthcoming apps will focus on Chinese multimedia artist Cai Guo-Qiang and American photographer Cindy Sherman.

Figure 4.4 Art Intelligence's iPad apps.
Source: © Art Intelligence LLC.

CONCLUSION: OFFLINE'S ONLINE

Many attribute the globalization of the art world, particularly the hyper-commodified attributes, to the Internet. Whether at auctions, at art fairs, or in gallery press releases, information related to prices, such as which art-works sold for what prices, are posted immediately on the Internet. But both nonprofit organizations and private arts initiatives located in or dealing with the Asia region, such as Asia Art Archive, the Indonesian Visual Art Archive, the Arab Image Foundation, the DSL Collection, and Art Intelligence, have forged other paths for harnessing the positive capacities of the Internet.

Considering the rapid growth in building physical arts infrastructure within the Asia-Pacific region, online communities and initiatives seems comparatively insignificant. Today, most public and private arts organizations place most of their efforts into the construction of museums, schools, and commercial galleries than demarcating cultural space in the virtual world. Smaller art scenes in countries with less government and private funding, such as Bangladesh, Cambodia, Vietnam, and Oman, could utilize the web to create a wider public for their initiatives and practices at low cost. Although many of the projects referenced in this chapter utilize

sophisticated technology, grassroots organizations can make use of free blogware, such as Wordpress or Tumblr. Of course, many Asian countries raise the obstacle of Internet censorship, which is growing since events such as the Arab Spring.

Beyond the political ramifications, there is a growing risk that the Internet will evolve in the same way as artist's video and eventually becoming co-opted for commercial purposes by means of television broadcasts or prohibitively expensive limited art editions. In terms of economics and logistics, will the Internet fulfill the need for an alternative and more open space than what is offered at established galleries and museums, where one can experience of all the varying forms, practices, and discourses of art? What issues must artists, scholars, and nonprofits consider when distributing on the Internet? Variables include time demand, bandwidth, copyright issues, and competition with e-commerce, such as Saatchi Online and sites such as Art.sy and Artspace? What effects will the Internet have on the existing modes of exhibiting and distributing art, ideas, and information? With the Internet's unparalleled potential to access an audience of greater size and diversity than the hermetically closed art world, now is the time for artists, writers, scholars, collectors, publishers, and organizations involved in alternative forms of art to make innovations in this area the Internet platform before it becomes solely just another tool for commerce.

NOTES

1. Such as the possibility to democratize art as well as mass media. For more, see Gene Youngblood, *Expanded Cinema* (New York: EP Dutton, 1970).
2. This includes artists involved in activist, performance and conceptualist practices in the 1960s through the 1980s, such as Top Value Television, Paper Tiger Television, Nam June Paik, Martha Rosler, Chris Burden, and Vito Acconci. See Michael Renov and Erika Suderburg, *Resolutions: Contemporary Video Practices* (Minneapolis: University of Minnesota Press, 1995).
3. "Asia Art Archive," Asia Art Archive website, accessed August 24, 2013, www.aaa.org.hk.
4. "Indonesian Visual Art Archive," Indonesian Visual Art Archive website, accessed August 24, 2013, www.ivaa-online.org.
5. Organizations with little or no local support often rely on donations—in the form of personnel, time, materials or money—from their own members or seek funding from international foundations such as the Ford Foundation in the US or Prince Claus Fund for Culture and Development in the Netherlands.
6. "Arab Image Foundation," Arab Image Foundation website, accessed August 24, 2013, www.fai.org.lb.
7. *Art iT* in Tokyo, for instance, was established in 2003 but stopped publishing its print edition in 2009 and now solely provides its content online.
8. "*ArtAsiaPacific*," *ArtAsiaPacific* website, accessed August 28, 2013, http://art asiapacific.com.
9. See "Christopher Doyle: Away with Words," iTunes, accessed August 28, 2013, https://itunes.apple.com/us/app/christopher-doyle-away-words/id674799386?mt=8; and "Away with Words," *ArtAsiaPacific* website,

accessed August 25, 2013, http://artasiapacific.com/AwayWithWords, both last accessed August 28, 2013.

10. See the Art Radar Asia website, accessed August 27, 2013, http://artradar journal.com; the Radian website, accessed August 27, 2013, www.randian-online.com; and the Ibraaz website, accessed August 27, 2013, www.ibraaz.org.

11. Jonathan Jones, "Alive and Clicking", *The Guardian*, October 19, 2006, accessed June 10, 2013, www.theguardian.com/artanddesign/2006/oct/19/yourgallery.

12. Andrew Edgecliff-Johnson, "Smart Art", *Financial Times*, July 28, 2007, accessed August 24, 2013, www.ft.com/intl/cms/s/0/e61656e6-3ca6-11dc-b067-0000779fd2ac.html#axzz2csBMXljg.

13. Carol Vogel, "I Like Ur Art: Saatchi Creates an Online Hangout for Artists", *The New York Times*, December 18, 2006, accessed August 24, 2013, www.nytimes.com/2006/12/18/arts/design/18saat.html?pagewanted=1&_r=2.

14. This acronym for the emerging markets of Brazil, Russia, India, and China was coined in 2001 by former Goldman Sachs asset management chairman Jim O'Neill.

15. See the Ocula website, accessed August 24, 2013, http://ocula.com; the Art.sy website, accessed August 24, 2013, http://artsy.net; and the Artspace website, accessed August 24, 2013, www.artspace.com.

16. See "Temporary Collection," DSL Collection website, accessed August 24, 2013, www.g1expo.com/v2/#/temporary-exhibition.

17. Laura Stewart, "Collecting the 21st Century Way: DSL & their Online Chinese Contemporary Collection", *ARTLIFEMAGAZINE*, July 24, 2012, accessed August 24, 2013, www.artlifemagazine.com/art-exhibitions/dominique-sylvain-levy-dsl-chinese-contemporary-art-collection.htm#.UhlxVxaBJFU.

18. See "Art Intelligence: Patricia Piccinini," iTunes, accessed August 25, 2013, https://itunes.apple.com/us/app/art-intelligence-patricia/id579438736?mt=8.

19. See "Art Intelligence: Keith Haring," iTunes, accessed August 25, 2013, https://itunes.apple.com/us/app/art-intelligence-keith-haring/id626520277?mt=8.

20. AI in e-mail to the author, August 25, 2013.

5 Making Do
The Making of the Art and Digital Media in Southeast Asia

Gridthiya Gaweewong

DIGITAL EVERYTHING

As a predominantly oral-based culture, much of Southeast Asia has entered the twenty-first century with both old and new challenges, among them natural and man-made disasters, ongoing political unrest, and an economic downturn. Although globalization in the region has provided more accessible technology, it has also allowed us new ways to connect via social media, with digital devices and applications becoming an integral part of our lives. It was estimated that Internet users in Asia stood at more than 1 billion in mid-June 2012, 44.8 percent of world population, and representing an 841 percent growth compared to 2000.[1] In Southeast Asia, the survey showed locations such as Indonesia, Vietnam, and Thailand as boasting the highest penetration rates of social media use. In the larger context of access to media, Thailand has been striving to move to a 3G network while the Indochina area has been enjoying 4G for a few years. Recent regional economic growth has allowed government to develop the communication infrastructure, to be ready for the ASEAN Economic Community in 2015, and this has rapidly transformed regional connectivity.

What does this imply for the visual and media arts? Although social media use has risen and the communication infrastructure has increased, this chapter explores whether the production modes of Southeast Asian artists are changing through the transformation of art and digital culture. Has this phenomenon affected the mode of artistic production in the region? How has it changed our society, communication, connectivity, and transformed lives and reality? Does new media or media art exist in Southeast Asia? If so, how is it defined? Will the artists practice and embrace digital media as an alternative to the academic/old-school way of art production that has dominated our region for the last century? Can digital media serve as alternative tactics for artists to embrace a greater purpose than making art for art sake?

Accenture research reveals Southeast Asia as one of the regions adopting "digital everything" quickly, enthusiastically and deliberately. It discovered

that the digital landscape in this region has many common if divergent stands. One of the most fundamental links is the tight-knit community culture found throughout Southeast Asia both online and offline. Village life throughout Southeast Asia has for centuries revolved around values of family, mutual respect, collaboration, and courtesy. Research further revealed that although the outward manifestation of the village has all but vanished, eclipsed by the force of globalization, urbanization, personal mobility, and now digitalization, Southeast Asians now seem to be experiencing something of a renaissance of the Kampong. Social networking in particular is proving a critical enabler, helping consumers experience some of the best aspects of Kampong life even among people separated by long distances. The renaissance of the Kampong spirit has been dubbed I–Kampong.[2]

Questions arise about this phenomenon and about how it translates to artistic practice in the region. Media art is relatively new to the region and only few regional media theorists or art historians have written about it. They include Gunalan Nadarajan, David Teh and Krisna Murti, who framed the media art landscape in the region. Nadarajan, a new-media art theorist now based in the US, introduced the four trends in new media art in the region, as quoted in Murti's book *Essays of Video Art and New Media in Indonesia and Beyond*. He conceptualized issues practiced in the Southeast Asian region with regard to new media: By organizing media-based artists' collectives and addressing urban issues, they offer an aesthetic expression that tends to differ from tradition (discontinuity) and work with a sociocultural agenda.[3] Nadarajan's grouping of the trends and artistic practice in the region seemed problematic for Murti, who argued that Nadarajan missed some focal points by excluding such artists as Thailand's Rirkrit Tiravanija and Indonesia's Jompet.

Art critic and media theorist David Teh had different views and approaches, as detailed in his essay "Recalibrating Media: Three Theses on Video and Media Art in Southeast Asia". Teh started with the lack of art history in the region, trying to locate works by artists that have little to do with the core concept of media art, which is dissemination and reflexivity. In the catalogue of a media art collection from the Central George Pompidou Exhibition at Singapore Art Museum, Teh proposed a thesis about the perception of artists toward video and media art and about how they practice, the context of video being (and not being) film, video as an oral medium, and the long shadow of authoritarianism. Teh referred to Rosalind Morris, whose ethno-visual art explored the way Southeast Asians use the camera and video as tools of social practice, one that she refers to as a process of "mediumship".[4]

These three approaches by Southeast Asian media art scholars and critics led me to explore in depth how Southeast Asian artists applied technology, social media, and digital culture to their daily lives and artistic practices. Did they consider new media as some kind of time-based methodology

and break away from their two-dimensional works and traditional art—most likely performance and installation? Did they reach the same level of digital art and new media as their Western counterparts? Is there a so-called media art in Southeast Asia, as defined by the Western concept? If so, have Southeast Asian artists participated in such major shows as Linz's Arts *Electronica* or Berlin's *Transmediale*? Or is this term misleading and interpreted by the institutions in Southeast Asia in a different way? The differences between electronic media, media art, analog, and digital art have not been widely debated in the region. The making of art and digital media in Southeast Asia lacks pure forms, is always hybrid, mixing media art so it blurs with local materials and contents as other forms of expressions and reconfigures itself as "other media art".

The emergence of art in the age of social media in Southeast Asia has been closely connected with the sociopolitical and economical context. If this new digital landscape brings with it a variety of challenges and possibilities for artists, then how do these changes affect their ideas and approaches? How does digital culture speak to their traditional oral culture? Have they been reconnected with each other via social media or via different entities? How do these changes have an impact on, if at all, the kind of works and issues in which artists are interested? Indeed, with the rise of accessibility to media such as video cameras, we can see the significance it has in connecting new media practices with oral culture. We must ask what types of analytical and critical approaches are forwarded by such new techniques and tools, along with how this phenomenon can be contextualized within greater society. In *Essays on Video Art and New Media in Indonesia and Beyond*, Krisna Murti wrote that

> the new media in Indonesia has not been seriously considered even though we've been under its influence for over forty years. In everyday life, the new media has already been proven to be helpful in our work and play, yet it is still lacking in many ways as a tool for broader cultural expression.[5]

A similar situation applies to Thai artists. Curator Chayanut Silprasart quotes Dansuang in *From Message to New Media; Possibilities in Thai Contemporary Art*, for which she interviewed many Thai media-based artists:

> Occasionally thoughts are conveyed through various media and technological tools, but one has the impression that media artists in Thailand have failed to exploit the specific nature and full potential of their chosen medium. They lack an understanding of the technical possibilities of these new media for conveying their ideas. As a result, the focus is on the resulting phenomenon and the control of emotion expressed by artist. Media have their own specific mechanism and phenomena, linked to

a complex network of systems, the most notable of which are cultural. This comment led Silprasart to draw the connection and define media art as involving an intricate and inseparable bond between self, culture and technology.[6]

NEW MEDIUM IS NOT NECESSARILY NEW MEDIA

The first generation of Southeast Asian conceptual artists tried to break away from traditional media (paintings and sculpture) by encapsulating local materials with new art forms such as installation, performance, and, later, digital media. The interpretation of the new medium emerged in Jason Jones's article "Could Installation Art be the New Medium for Southeast Asia?", in which he examined works by artists from Thailand and Indonesia in particular. Using colonial history as a base, he drew out the contradictions and similarities between installation art and Wayang, an Indonesia performance that often features the Ramayana. Audiences can access the narratives as these performances play out in a particular context, such as politics. That accessibility and familiarity with Wayang culture paved the way for acceptance of installation art as a means of self and societal expression. Jones further stated that the acceptance of this medium by artists in the region shows that, for Southeast Asian artists, the lines between art and real life are fluid and arbitrary—if not blurred. This blurring of lines between art and life is exactly what the Western artists who pioneered the use of installation art sought to do.[7] Jones's observations offered interesting speculation and explanations of how installation art has penetrated the regional art scene in the last two decades. His remarks about how regional artists defined the term *new media* demonstrated similar reservations. The lack of solid rationality or explanation of how and why new media emerged in the region seemed to coincide with the rupture of modern art history from each country's traditional art and crafts.

Most Southeast Asian countries started to work with so-called new mediums, which are not necessarily media art, much later than the West. To explain the boom in this kind of art, Jones referred to the Southeast Asian penchant for riddles, one aspect of Southeast Asian culture that could conceivably explain the popularity of installation art. In Thai society, where verbal and physical communication often revolve around, as opposed to centering on, the main issue, riddles serve as an important culture conduit, transferring specific knowledge and cultural nuance in a compelling and thought provoking fashion. Jones ended up comparing works by sociopolitically oriented Indonesian artists such as Dadang Christanto and Heri Dono and Thai artists Montien Boonma, Kamol Phaosavasdi, and Araya Rasdjarmrearnsook, and concluded that the

regional artists have discovered and actively pursued the development
of installation art as an artistic medium. Brilliantly suited to Southeast
Asia in its similarity to such preexisting form of artistic expressions as
shadow puppet theater, installation art has proved itself as an effec-
tive means of communicating to wide ranges of ideas, dangerous to self-
reflective, to a wide range of people.[8]

Some artists started to adopt such electronic media as analog video into
their practices in 1980s, among them Apinan Poshyananda and Kamol
Phaosavasdi (Thailand). In the late 1990s and the first half of 2000, the
younger generation started to work with media arts, with a self-taught
approach, trying to transform their traditional training as painters into
techno-craft, as in the case of Sakarin Krue-on (Thailand), Po Po (Myan-
mar), and Krisna Murti and Jompet Kuswidananto (Indonesia). But few
from the region use similar approaches to Charles Lim and Tien Woon's
collaborative project on tsunami.net, produced and executed in the "West-
ern tradition", which critiqued and explored the nature of virtual reality
in relationship to the physical world. Without any official training in the
country, many young Thai artists went abroad to study media art, includ-
ing Wit Pimkanchanapong, Suthirath Supaparinya, Wantanee Siripattana-
nuntakul, and Noraseth Vaisayakul. Sarawut Chutiwongpeti and Bundith
Phunsombatlert were not based in Bangkok but worked outside of the
country by joining residency programs and with media art–based projects
around the world.

The accessibility of Internet and relational aesthetics became the van-
guard of reactionary moves against digital culture, resulting in the loss of
interaction in everyday life. Works by Rirkrit Tiravanija, Surasi Kusolwong,
and Navin Rawanchaikul are indicative of relational aesthetics in which
ideas about the changing relationship between intimacy and the public come
to the forefront. In the 1990s, young Thai artists followed that trend, but
not all of them understood at the philosophical level what relational aesthet-
ics were really about. Tiravanija's statement of his disinterest in aesthetics
in favor of relationships emphasized his intention to locate himself within
the real world, not the virtual one. He focused on social gatherings and
human interaction and on creating platforms and works that encouraged
the change from the passive role of audiences in experiencing contemporary
arts into an active one. These qualities are the pre-given conditions of rela-
tional aesthetics. Artists hoped that they would bring art closer to life and
that the public would "get" it and, later, would be willing to "participate".
Tiravanija's seminal piece, *Phad Thai* originally shown and performed in
the early 1990s in American art museums, was well received in the Western
art institutions and beyond but did not do well in Asia. Home audiences in
particular, did not get his subject matter and meaning, mainly because he
had originally created these for Western audiences by projecting himself as
the "other", an artist born in Argentina, with roots in Thailand and raised

in Africa and the US, to challenge the tradition of making contemporary art from a postcolonial and subaltern point of view.

Echoing this "cultural turn", his contemporary Surasi Kusolwong in the late 1990s combined relational aesthetics in his participatory project *Free for All (Market),* setting up the space to resemble Bangkok's street vendors and letting audiences take one piece away from the installation. It was initially shown in a major museum in Europe as part of the international exhibition celebrating one hundred years of Vienna's Secession, *Cities on the Moves,* in Bordeaux, France, 1998. With his *Free for All (Market)* installation, Kusolwong ventured into aspects of international trade. Although Navin Rawanchaikul preferred to engage with community and public art by bringing his "village" mentality from his native Chiang Mai to the other sites around the world, his site-specific community-based project mostly involved the history of local people in relationship to specific social and historical context.

The influence of these artists was obviously reflected in works by their students, among them Pratchaya Phinthong (*Sleeping Sickness*, Documenta 2012) and Arin Rungjang (*The Living Are Few But the Dead Are More,* Sydney Biennale, 2012). These two young artists worked beyond their cultural boundaries, exploring issues of global economy, migration, labor, and exchange. Both have been to Zambia and Rwanda, retrospectively, using their art projects as a platform to investigate "unknown territory", in both artistic practices and reality, to form another kind of association and develop more intimacy with the African community. In these cases, art itself became a "mediumship". This might be applicable to countries such as Myanmar, which is evolving into a freer society. With the military government lifting the censorship law, artists in Myanmar have recently been exposed to freedom of expression. Although most artists still work with traditional media, the more avant-garde are employing digital media such as using digital camera, video, and film for their works and are using social media as their platform to announce their activities to the public. However, performance remains a popular form of art for Myanmar artists, and young artists such as Moe Satt and Nyan Lin Htet have become key figures in this movement.

ON ORAL HISTORY AND MEMORY

Teh's thesis, "Video as Oral Medium", sought to define the region's shift in artistic practice. Artists work in different ways, embracing media art to reconnect themselves with the community, to reinvestigate the relationship between their own experiences, local history (both micro and macro level), specific places (community/site), and memory. Why is there now the urge to explore history? There are important questions that need to be addressed in Southeast Asia and particularly in Thailand, given its claim

that the lack of colonization has made it marginalized or invisible within the framework of the postcolonial theory. Peter Jackson nonetheless suggested using the postcolonial analysis in Thai studies, reasoning that it provides a rich body of ideas for understanding the many forms of Thai–Western cultural and intellectual hybridity.[9] Jackson argued that cultural hybridity has rarely been used to analyze the patterns of cultural borrowing and fusion in the country. He further stated that the cultural hybridity has emerged from and remains closely identified with postcolonial studies.[10] Moreover, Jackson explored the debate between nationalist historiography and critical schools of Thai studies, theorizing that this is because the "colonized"-versus-"colonizer" model that underpins postcolonial studies does not fully capture the complexity of the Siamese/Thai situation.[11]

This situation led to the history of Thailand not being part of the postcolonial theoretical discourse. Rethinking the position of Thailand will not make any sense, if we cannot locate this country in the regional context. Because of the lack of postcolonial discourse within the academic and beyond, Thailand has been automatically excluded from the Southeast Asian debate (most members of Association of Southeast Asian Nations [ASEAN] are former colonies of the British, the French, and the Dutch). The official version of nationalist historiography served as the state's mechanism to resist the colonizers. Although the rest of the colonized countries managed to reconstruct their nations/states in the postwar period, Thailand became trapped in nostalgic mode, living with the pride of maintaining independence and sovereignty. Thus, the historiography was written in the grand-narratives manner, leaving no room for the public to tell its micro-narratives.

During the postwar national building process, memory was reconstructed in association with places, with monuments, memorials, and museums playing a crucial role in constituting the collective memory. Steven Hoelshcer and Derek Alderman in "Memory and Place; Geographies of a Critical Relationship" draw on the notions of French sociologist Maurice Halbwaches of memory as a social activity, as an expression and active binding force of group identity.[12] Although Hoelshcer and Alderman refer to "collective memory", social memory, public memory, historical memory, popular memory, or cultural memory, most would agree with Edward Said that many people now look to this refashioned memory, especially in its collective forms, to give themselves a coherent identity and a place in the world. It suggested that the scholarly interest in memory reflected larger societal changes. Said pointed out that the study and concern with memory of specifically desirable and recoverable past is a specific late-twentieth-century phenomenon that arose at a time of bewildering change of unimaginably large and diffuse societies, competing nationalism, and, most important perhaps, the decreasing efficacy of religious, familial, and dynastic bonds.[13]

The study of social memory often touches on the questions of domination and uneven access to a society's political and economic resources. As Eric Hobsbawm and Terrence Ranger point out in the *Invention of Traditions*, the representatives of dominant social classes have been most adept at using memory as an instrument of rule.[14] Paul Connerton said that, "control of the society's memory largely conditions the hierarchy of power. Social memory is inherently instrumental; individuals or groups recall the past not for its own sake, but as a tool to support different aims and agendas".[15] Regional artists challenged this "invention of the traditions" whereby memory was used as instrumental of rule, debunking that mass media fabrication by the nation-state domination and employing a variety of media as tools to counterbalance agendas set by nation-state. They started to use different media as social tools to work on the borderline of artistic practice and to socially engage art and activism with oral history to retell their own history, based on their personal and public memories. In this way, they rewrote history by using new media—not only as tools but also as a means—in presentation and diffusion.

Between the postwar and cold war, many countries along the Mekong River fought for independence from their colonizers and started their national building process. These processes were interrupted by the Vietnam War, which left another vacuum in history and memory for the next generation. During the process of reconstruction, regional artists started to uncover issues that were hidden in the post–cold war period. Concerned about memory and places, artists retrieved and retold their memories of specific places based on oral history and literature. In Cambodia, Vandy Rattana created the photography series, Bomb Pond, focusing on the rural landscapes that were the most severely bombed by the US military during the Vietnam War. Rattana created documents that elucidated the hidden realities of contemporary Cambodian existence.

Meanwhile, Thai independent filmmaker and artist, Apichatpong Weerasethakul employed micro narratives to unearth the dark side of the war by restaging the history and memory of a small hotel in Bangkok through his mesmerizing video art, *Morakot*. This derelict hotel in the heart of Bangkok opened its doors in the 1980s, a time when Thailand shifted to accelerated economic industrialization and when Cambodians poured into Thai refugee camps after the invasion of Vietnamese forces. Later, when the East Asian financial crisis struck in 1997, these reveries collapsed. Weerasethakul collaborated with his three regular actors, who recounted their dreams, hometown life, bad moments, and love poems, to resupply the hotel with new memories.

Weerasethakul worked with memory in his seminal project, *Primitive* (see Figures 5.1 and 5.2), part of the award-winning film *Uncle Boonmee Who Can Recalled His Past Lives*. He explored his Isaan region in search of the surviving offspring and relatives of Uncle Boonmee and eventually developed three separate projects: *Primitive*, a multidisciplinary art project; CUJO, the book series, and *Uncle Boonmee*, the film. He cut through the heart of

Figure 5.1 Apichatpong Weerasethakul, *Primitive* (2009). Multi-platform installation. Commissioned by Haus der Kunst, Munich with FACT Liverpool, and Animate Projects. *Source:* Courtesy of Kick the Machine Films.

Figure 5.2 Apichatpong Weerasethakul, *Primitive* (2009). Multi-platform installation. Commissioned by Haus der Kunst, Munich with FACT Liverpool, and Animate Projects. *Source:* Courtesy of Kick the Machine Films.

1970s' Thailand political turmoil with the communists, choosing Nabua, a small village in Nakhon Phanom in Thailand's northeast, which, he said, was full of repressed memories. To implant a new memory, he built a spaceship for the young villagers, the relatives of the former Comrade Farmers.

At the end of the 1990s, some former Vietnamese refugees returned home and started working actively on the Southern art scene. One artist actively engaged on both the local and international scene was Dinh Q. Le, who took refuge in Ha Tien in 1979 to escape the Khmer Rouge. He started to make reflective works on his personal experiences of the war, using counter main-stream narratives, which focus heavily on places and memory. His famous work *The Farmers and the Helicopters* (2006)—which brings together interviews with Vietnamese farmers and sequences from Hollywood films—provides a counter-narrative to the dominant understanding of the Vietnam War developed from political rhetoric.

In his recent project, he used animation to stage the simulacrum of GIs creating the video installation, *South China Sea Pishkun* (2009), a three-dimensional (3D) animation of helicopters crashing into the South China Sea during US's panicked retreat from Saigon. *Pishkun*, a Blackfeet American Indian term for the site where they used to kill roaming bison by driving them to panic and sending them over a cliff, shows these powerful machines in their last moments, crashing, flailing, sinking, and dying in the sea. Ironically, the US military had been counting on helicopters to give them a strategic advantage in Vietnam; *South China Sea Pishkun* shows the US military's failure as tragic and spectacular.[16]

Nguyen Trinh Thi's video work *Chronicle of a Tape Recorded Over* documented the stories and testimonies of the ordinary people who lived along the Ho Chi Minh Trail during the Vietnam War. Coincidentally, when she produced this piece, her video camera was confiscated by the local officers, who asked her for permission paper. This work was the combination of her interview with the former volunteers and the officer's investigation. Wong Hoy Cheong's video work *ReLooking* staged a fictional history of an emerging colonial power, as a Malaysia kingdom takes over Austria. Hoy Choeng collaborated with his performance artist friend to act as emcee in the mocumentary for a television program for MBC (Malaysia Broadcast). He used computer animation and digital media to reconstruct the fake maps of the Malaysian empires and used artifacts as props in this video installation. He was interested in how computer and technology could be fabricated. This piece successfully challenged both the subversive power of media and the history of the nation.

Similarly, Ho Tzu Nyen's video work *Utama—Every Name in History Is I* is a genre-blending mixture of fiction and documentary about the founding of Singapore. Tzu Nyen reconstructed and restaged the scene of Utama, the Malay prince and founder of Singhabura, or Singapore. This goes counter to the British version that this nation-state was founded by Sir Stanford Ruffles in the nineteenth century. He combined oral history with performance

and juxtaposed scenes of the past with the city-state's present reality. Places and memory played a vital role for artists, because Derek Alderman, Owen Dwyer, and Steven Hoelscher emphasized various geographies location to illustrate the critical relationship between the memory and spaces. They crisscrossed the thematic landscape and examined memory and places as these intersected with politics of the national identity, racial conflicts, public planning and historic preservation, social mobilization and activism, and the heritage tourism industry. Most also focused on the public involvement in each space, in terms of remaking places of memory, which marks significant process in the post-totalitarian society. The memorial process is one of the negotiation rather than of sheer exclusion.[17]

SYNCHRONIZING ONLINE AND OFFLINE CULTURAL PRODUCTION AND DISSEMINATION

The shift of politics through Indonesia's Reformasi (1998), Thailand's political unrest (2006–2011), and Myanmar's release of Aung San Su Kyi from house arrest (2012) played vital roles in democratic transformation. These changes led to slightly better chances for artists to access freedom of expression. Many art projects evolved around and about art and digital media and were included in different exhibitions and festivals. After the Reformasi, Indonesia witnessed a boom in the art market and art scene with numerous galleries and private collections and young artists starting to work with the now more accessible media art and digital media.

Indonesian artists' collectives developed a platform and experimented with new ideas, while not withdrawing from their "Kampong spirit". They worked closely with communities. Bandung, Yogyakarta, and Jakarta became major hubs for artists' collectives and production sites led by Gustav Hariman—Common Room, House of Natural Fiber—and Ruangrupa, headed by Ade Darmawan and Hafiz Ruru. These people were the powerhouses of the new media art movement, which blurs lines between art, design, music, architecture, and popular culture to attract the young. In 2003, Hafiz Ruru directed the OK Video Festival, which became a major platform for young local talents to show their works. Krisna Murti played vital roles as both media artist and art critic, regularly writing essays about media art in the newspaper and later publishing his book. Indonesia became the leader in intellectual debates about media and digital culture, organizing seminars and workshops on media art and the ASEAN New Media Art Competition.

In the Mekong region, Hanoi Doc Lab, led by Nguyen Trinh Thi, started a documentary film club based at the Goethe Institute, while Sans Arts and Properell worked to energize the scene. In Myanmar, German filmmakers helped to open the Yangon Film School as a hub for young Burmese filmmakers to work in independent films, while artists employed digital media

as their tools to communicate. Cambodia's Bophana, led by filmmaker Rithy Phan, went in the other direction, setting up the institute to preserve such cultural materials as old films, moving images and archives and digitizing them, as well as to train young artists. Sasaa Bassak, organized and curated by Erin Gleeson, an American based in Berlin and Phnom Penh, started to serve as a production site for young Khmer artists.

Exhibitions, festivals, and events serve as platforms for interaction between artists, art works and the public. Major exhibitions were created in Singapore, and the city-state launched conferences, a media art festival, and a biennale, positioning itself as the hub of information and interaction for Southeast Asia. Other countries introduced both large- and small-scale experimental art, video art, and film festivals, among them the Bangkok Experimental Film Festival, Thailand (1996–present); the now-defunct New Media Art Festival and Switch Media Art Festival (Chiang Mai, Thailand); the OK Video Art Festival, Indonesia (2000–present), and the Yogyakarta International New Media Art Festival. Yet these artistic events still did not reach new audiences or expand as much as the mainstream media culture did. Even today, artists rarely make use of new media and social media channels to distribute their works, instead using them as fund-raising platforms, to kick-start production, and for public announcements.

However, some young artists are exploring these social media. The question for the future is whether the role of agencies and institutions will still be significant if digital media, Facebook, and YouTube are an integral part of production and distribution. Distribution, connecting with the public and creating events as well as media-based art projects, and cultural activities are already spreading through Facebook. The challenges is the synchronizing of daily life between online and offline activities in cultural production and dissemination, according to Irwan Ahmett, a young Indonesian media-based artist, who was started his public performance project, inspired by a workshop run by Marco Kusumawijaya, the architect and activist and founder of RUJAK in Jakarta, in the show *Imagine Jakarta*.[18] Ahmett stressed that digital media are inseparable from daily life in Southeast Asia, with people using them for communication, production, and distribution. According to Mella Jaarsma, a Dutch artist based in Yogyakarta and a cofounder of Cemeti Art House, the Indonesian media artists and community paid more attention to the technical aspects, open sources, and their virtual community than to the content itself.

In summary, Southeast Asian artists have not engaged in media art, in the critical manner of technique and the content itself. Their approaches were slightly different from those in the West. Most still incorporate "new media" in their own practices and use them more as "tools" to communicate with and express their ideas to the public. The making of art and digital media in today's context needs to be continuously redefined. After all, artists

still yearn for intimacy with their public to share direct experiences with their works of art, whether in the real or virtual world.

ACKNOWLEDGMENT

I wish to thank Dr. Kasem Phenpinant; Associate Professor Kamol Pha-osavasdi, Chulalongkorn University; Associate Professor Thanes Wong-yannawa, Thammasat University; Dr. David Teh, National University of Singapore; Krisna Murti and Thanom Chapakdee for their feedback on this chapter.

NOTES

1. "Asia Pacific", European Travel Commission web site, accessed July 3, 2013, www.newmediatrendwatch.com/regional-overview/90-asian.
2. Andrew Sleigh, Amy Chung, Trent Mayberry, and Marco Ryan, "Surfing Southeast Asia's Powerful Digital Wave", Accenture Management Consulting Innovation Centre, online, 2012, accessed July 3, 2013, www.accenture.com/SiteCollectionDocuments/PDF/Accenture-Surfing-ASEAN-Digital-Wave-Survey.pdf.
3. Krisna Murti, "HONF Community in the Media Art World of Asia", in *Essays on Video Art and New Media; Indonesia and Beyond*, ed. Marjorie Suanda, Krisna Murti, and Tubagus Svarjati (Yokyakarta: Indonesia Visual Art Archive, 2009), 137.
4. David Teh, Recalibrating Media: Three Theses on Video and Media Art in Southeast Asia, Video, an Art, a History 1965–2010 (Singapore: Singapore Art Museum, 2011).
5. Krisna Murti, "The New Media Culture", in *Essays on Video Art and New Media; Indonesia and Beyond*, ed. Marjorie Suanda, Krisna Murti, and Tubagus Svarjati, (Yokyakarta: Indonesia Visual Art Archive, 2009), 39.
6. Chayanoot Silpasart, From Message to Media, exhibition catalogue (Bangkok: Bangkok University Art Gallery, 2007), 80.
7. Jason Jones, "Could Installation Art be the New Medium for Southeast Asia?", *Explorations in Southeast Asian Studies, A Journal of the Southeast Asian Studies Student Association* 4 (Fall 2000), accessed June 28, 2012, www.hawaii.edu/cseas/pubs/explore/jones.html.
8. Ibid.
9. Peter A. Jackson, "The Ambiguities of Semicolonial Power in Thailand, The Ambiguities of Semicolonial Power in Thailand", in *The Ambiguous Allure of the West, Traces of the Colonial in Thailand*, ed. Rachel V. Harrison and Peter A. Jackson (Hong Kong; Hong Kong University Press, 2010, reprinted by Silkworm Books, Chiangmai, 2011), 37.
10. Ibid., 187.
11. Ibid., 38.
12. Steven Hoelscher and Derek H. Alderman, "Memory and Place; Geographies of a Critical Relationship", *Social and Cultural Geography* 5, no. 3 (September 2004): 179.

13. Ibid.
14. Eric Hobsbawm and Terrence Ranger, eds., *The Invention of Traditions* (Cambridge: Cambridge University Press, 1992).
15. James Fentress and Chris Wickham, *Social Memory* (Oxford, UK: Blackwell, 1992).
16. Prince Claus Fund, "Dinh Q. Le Opens First Solo Exhibition in the Netherlands", e-flux website, accessed June 20, 2013, www.e-flux.com/announcements/dinh-q-le-opens-first-solo-exhibition-in-the-netherlands/.
17. Ibid.
18. Interview with Irwan Ahmett and Mella Jaarsmar, *Fukutake Asian Art Platform*, Fukuda Elementary School, Shodoshima, July 20, 2013.

6 On *Platform Seoul*
Models beyond the Biennale

Sunjung Kim

A POINT OF ENTRY: EXHIBITIONS AS NEW PROPOSALS AND PLATFORMS

When it was presented in Seoul between 2006 and 2011, *Platform Seoul* demonstrated a new mode of exhibition making. It was designed as a series of contemporary art festivals held annually, an alternative model of curating that germinated from my professional engagement with the contemporary art scene since the early 1990s, both in Korea and elsewhere. The main organizing force behind *Platform Seoul* was Samuso: Space for Contemporary Art—a curatorial initiative lab I had founded in 2005 with the aim to envision and put into practice innovative methods of curating that move beyond the conventions of the white cube gallery space. The office of Samuso is located in Seoul near the Artsonje Center, a leading contemporary art museum in which I had begun my curatorial career back in the 1990s and where many of the curatorial programs designed by Samuso are currently held. The Artsonje Center therefore served as a central site of exhibition for *Platform Seoul*. But before any further discussions of *Platform Seoul*, I would first like to introduce its genesis by relating a story about my first curatorial effort.

It was 1995. The three-story building for the Artsonje Center was yet to be constructed. In the unoccupied modern-style house (*yangok*) and the Korean traditional house (*hanok*) standing at the center's current location in Seoul, I curated an exhibition titled *Ssac* (*The Buds* in English).[1] Unlike other exhibitions then curated in South Korea—which were housed in the white cube of art museums or galleries—*Ssac* was planned in existing but unused architectural structures. For this exhibition I asked several artists to produce works appropriate for the site, thus initiating a process through which new works were freshly configured for particular spaces. At that time, the modern-style house faced imminent demolition, giving way to a brand new art museum, that is, the current Artsonje Center. The exhibition therefore comprised an attempt to establish a new relationship between artists and curators through a collaborative process that would activate the given site.

Moreover, it was my first curatorial work that reflected the sense of curatorial responsibility to join, with eagerness and enthusiasm, the scene of artistic production—and that recognized art's active response to, and resonance with, the complexity of sociopolitical reality. The exhibition sought to visualize art's ability to engage with social reality by taking into account two crucial aspects of South Korean society and art circa the mid-1990s: the advent of accelerating neoliberalism alongside globalization and the demise of socially critical attitude of *minjungmisul* (literally translated as "people's art", a South Korean art movement that participated in the country's pro-democracy social movement during the 1980s).

The exhibition overall cast light on the following questions. How can we move beyond the epithet of "arts for arts' sake" and ask whether art can translate an effort to make a better future? How can we articulate the inseparable relationship between life and art, the two entities that are, to some people, seemingly unrelated? Even though art on its own cannot construct an ideal society, can it project an effort to make one or at least suggest a picture of a different society?[2] Of course, all of these thought exercises, which originated during the process of making *Ssac*, were not materialized one by one in any systematic way at *Platform Seoul*. But these questions, especially my understanding that the artist breaks way from conventional ideologies in order to reveal the elements of society that are forgotten or hidden because of structural reasons, were ingrained in my first curatorial endeavor and served as a firm foundation for my curatorial activities thereafter.

The decade of the 2000s began. While observing that numerous art biennales with little distinction were springing up like mushrooms amid globalization, and noticing the prevalence of uniform exhibition making, I felt the urge to return to the beginning of my curatorial practice. What served as the basis of *Ssac* was a will to diverge from the white cube and to commission new productions in relation to the meaning and history of the specific site. Compared to *Ssac*, the five unique editions of *Platform Seoul* began as an alternative proposal with which to challenge the limits of conventional exhibition sites, including biennales, and the perilous inertia in the system of administrating exhibition making.

It is true that biennales in South Korea have provided the unprecedented opportunity to shift the landscape of the art scene and to reflect dynamic artistic production from diverse locations across the globe; biennales are thus "alternative" in a similar way that alternative art spaces (*taeankonggan*), since their inception in the late 1990s, have complemented the limitations of art museums that are still the hegemonic players in the current system. But just as the activities of major museums demonstrated a highly concentrated focus on established artists, through either exhibitions or collections, the art biennales launched in 1990s' Korea also exposed their limitations in their temporary nature and rushed process for preparation. In the context of the overall ecology of the contemporary art scene, South Korea reflects a larger pattern in which Asian countries with a relatively brief history of operating

art museums have adapted the structure of Western art institutions, at times selectively and at other times unconditionally.

Moreover, art museums' complicity with local cultural policy and government bureaus inevitably lead to the "corruption" of their initial objectives and visions, with the risk of gradually losing the integrity and criticality of the arts. Most art biennales, for example, are located in inner cities, and thus operate in close collaboration with city governments, more than often serving the governments' interests in local tourism, populism, and conservative cultural policy. Taking into account all of these elements that made up the art scene in South Korea during the 2000s, I saw the necessity to envision a new form of art festival that would address, and at the same time overcome, the institutional and artistic problems at hand. My experience as a curator who had carefully observed innumerous sites of exhibition-making—small and big, in Korea and abroad—had given me the conviction that it was time to launch an alternative model of curating in South Korea.

The reason why I organized *Platform Seoul* as a series of five exhibitions is because I believed that the project as a whole had to do more than merely problematize the current art scene. By *Platform*, I did not designate an actual place or a physical site; rather, *Platform* was a conceptual social space. A curator myself, I was well aware of and sympathetic to the fact that the constricted time frame within which most editions of mega-scale biennales are planned ultimately, and unavoidably, prevent the development of a comprehensive long-term vision. This recognition of the problems in the current institutional structures of art does not, however, mean that the intention behind *Platform Seoul* was to completely negate the existing system. Rather, *Platform Seoul* worked as an alternative proposition insofar as it applied and appropriated the existing methods with a sense of flexibility and an innovative spirit.

Hence, *Platform Seoul* was intended as a process of collaboration among curators, artists, critics, and researchers both in Korea and elsewhere for five consecutive years. Planned as a festival-type project, the only constant was that its format changed depending on the year. At the core of *Platform Seoul* was its unique process of exhibition making, in which each edition of the exhibition articulated a different theme and charted the corresponding conceptual framework, location, lecture series, and collaborations with artists who then gave artist talks. Within this process was the attempt to experiment with the communicability of art. All the elements of exhibitions, artist talks, public lectures, commission works, and seminars were to interact with one another, and conjure the synergetic platform as a social and artistic field of transferability, conversion, and openness.

FOR A FLEXIBLE PLATFORM: FIVE PROPOSALS OF FICTION

The first edition of *Platform Seoul* was less an exhibition than a beginning, a spark for the overall programming of *Platform Seoul*. The five-year project

began with the aim to move beyond the pale of "arts for arts' sake" and bring art into the center of the public's everyday life. Even though artists' efforts to diminish the gap between art and life have continued for a long time, the general public is, to a large extent, still hesitant to embrace art as part of daily life. Recognizing such issues at play, I organized *Platform Seoul* as a series of independent programs intuitively guided by socio-politically driven topics and subjects that in turn guided me to discover appropriate locations. It posed a great challenge to compose an exhibition when not a single condition of support, such as budget and location, remained constant. Each edition of *Platform* was therefore housed in a unique constellation of locations. When incorporating a non-gallery space into the exhibition, each site's locationality, temporality, and historicity were fully integrated in a variety of artistic productions, thus adding the sense of fluidity to the overall project.

When seen in retrospect, *Platform Seoul* sought to probe art in relation to the ever rapidly globalizing society of today. Positioned against the institutional model of the art gallery and the mega-scale festival of art biennales, *Platform Seoul* attempted to reveal, directly and implicitly, an optimistic outlook about a shared sense of transnationality and globalization. As members of a global community whose activities center in the realm of art, artists were central to the project; they are the enunciative subjects who communicate their personal attitudes and political expressions through discrete and abstract means. Thus, what was delivered by artists was not a direct proclamation but a "fictional proposition". Here, I borrow Jacques Rancière's concept of "fiction", which reorganizes and redistributes the relations between the visible and the invisible, the sayable and the unsayable, speech and object, and sign and image.

Platform Seoul continued for five years, covering a variety of commonly shared issues—artists versus viewers, new commissions, methods of art viewing, experiencing artworks, participation, the position of institutions, the formation of community, the role of the exhibition as the field of education, the social role of art, and the everyday. The 2006 exhibition *Somewhere in Time* was organized in conjunction with an academic symposium, "Beyond Nationalism in the Visual Culture". The notion of ethnic nationalism forms the basis of South Korean modernization and industrialization. The discussions on nationalism at the symposium—its exclusive nature, its contradictions, and the lack of understanding for the Other—later served as an impetus to explore it further in the latter editions of *Platform Seoul*.

In 2007, the emphasis was put on sponsoring new productions that actively experimented with art's relationship to the public. Titled *Tomorrow*, the exhibition practiced an investigation into temporality while bearing in mind the significant position of art within a society. The curatorial strategy for spatial and thematic organization was to allow the visitors to "time travel" through the methods of imagination and prediction; to revisit a different historical period while encountering the artworks, cultural signs,

and visual expressions forged by artists about sociopolitical reality; and to eventually envision a possible choice or an alternative to what is presented before the visitors.

The 2008 edition, titled *I Have Nothing to Say and I Am Saying It*, converted the former Seoul Train Station into a site of theatricality in art. Moreover, the expansion of the art market, which brought about rapid changes in the art scene during the mid-2000s, inspired me to reconsider the question of publicness as opposed to that of capital. To this end, the project included a yearlong public lecture series on public art, which put the notion of publicness inherently embedded in historical sites in conversation with the daily life of individuals. In 2008, the parameters of the project expanded beyond the geographic region of Seoul and into Gongju, a city 130 kilometers from the capital, where the participators discussed the notion of publicness, how to acquire publicness, new models of public art institutions, and case studies available outside Korea.

In 2009, the project *Void of Memory* was partly held in the former site of the Defense Security Committee of South Korea, known in Korean as "Kimusa". In the symbolic site burdened with the historical memory of military dictatorship, the exhibition sought to approach the impossibility of representation from multiple angles. With the 2010 edition, the five-year project reached its final phase. Under the title *Projected Images*, the event consisted of screenings that investigated the relationship between contemporary art, video art, and cinema, as well as accompanying conversations with the audience.

Platform Seoul was indeed a "field" in which to experiment with new possibilities without a preconceived outcome. It was an adventure that led all of us to an unexpected pathway, like that of Dorothy in *The Wonderful Wizard of Oz*, where the protagonist is swept away by a cyclone that takes her to a strange land, and her way back home is full of hardship. But on the road of yellow bricks, she also meets friends who help her, such as the Scarecrow, the Tin Man, and the Cowardly Lion. Likewise, *Platform Seoul* was an adventure made possible because of multiple participants whose collaboration was crucial to the project. Although art is only one tiny part of the vast arena of culture and it does not stand as a grandiose world on its own, it is a precious pathway to a different future, and alternative reflections on the world.

SOMEWHERE IN TIME (2006): AN EXHIBITION ALONGSIDE A SYMPOSIUM ON VISUAL CULTURE AND NATIONALISM[3]

The first edition of *Platform Seoul* was planned in conjunction with an international symposium titled "Beyond Nationalism in the Visual Culture".[4] Throughout the twentieth century, Asia has undergone rapid social and political change—and among Asian countries, South Korea in particular has

experienced modernization at a breakneck speed. A top-down enforcement of industrialization and modernization in South Korea placed an asymmetrical fervor for economic development at the expense of introspective, self-driven energy for social change at large. One by-product of such a turbulent transformation was the crisis of subjectivity spread widely among individual citizens, which ironically resulted in the strong rise of ethnocentric nationalism across all societal ladders.

In order to reconsider the steep sentiment of nationalism pervading "developing" countries, like in the case of South Korea, I organized an academic symposium. The symposium therefore provided the key concepts foundational for the exhibition *Somewhere in Time*, which pays homage to Jeannot Szwarc's 1980 film of the same title. The film's focus on memory and time travel speaks to the questions of collective memory and history in nationalism. The symposium, art exhibition, and video screenings as a whole conducted an in-depth visual and textual inquiry into nationalism, an ideology misappropriated during the process of modernization in Asia.

Here are several main points delivered by scholars and critics at the symposium. Art critic Min Choi practiced a multifaceted investigation of the episteme of two adjectives—*minjokjŏk* (the national) and *hankukjŏk* (the Korean)—in his paper "'The National' in the Visual Culture Studies".[5] Whereas Lim Ji Hyun cast a historian's perspective onto South Korean art in her paper "Should Art Be National? Rescuing Art from the Nation", architect Hyun-sik Min discussed a range of case studies on Korea and elsewhere that probed the relationship between nationalism and architecture amid the formation of modern society in his paper "Reconcilement between Human and Nature: Beyond the National Architecture".[6]

On Japanese nationalism, Minato Chihiro, a curator and professor at Tama Art University, presented "On the Treatment of the Dead: Zushigame Urn and the Memory of Okinawa", and the work of Wakakuwa Midori, a professor emeritus at Waseda University, was titled "Yasukuni Shrine as a Memory Museum of Japanese Nationalism". Youngjune Lee, who calls himself a machine critic, wrote "Car Racing and the Nationalism: Focus on the NASCAR in America", and the former director of the Whitney Museum David Ross and the former chief curator of the New Museum Dan Cameron presented on nationalistic exhibitions held in the United States.[7] For me, the relationship between the exhibition and the symposium was clear. The symposium was not part of the exhibition; rather, the subject of nationalism was explored in the exhibition, which was itself planned to accompany the symposium. My intention was to provide a site for an engaged collaboration between academic research and artistic production in order to explore the new possibilities that a symposium and an exhibition can together evoke.

Following the symposium, the exhibition opened up a new series of possible dialogues. The video screenings added another layer of discussion. If the symposium approached the topic of nationalism from a historical as

well as from architectural, artistic, and curatorial perspectives, the exhibition *Somewhere in Time* expanded the discussion more broadly to include the subject of going "beyond nationalism" and the role of art and its relationship with society. Departing from the present moment—which is locked in globalization—I envisioned a retrospective look to the past. My hope was that this detour would help us reconsider the role of art within society and the value of artistic speech (or utterance) about reality.

Somewhere in Time presented artists' perspectives on a range of divergent ideas about "nationalism". Turkish artist Köken Ergun, for example, documented a celebration event on the Turkish national holiday, through which he pointed out that cultural trauma was linked with nationalism. Korean artist Gimhongsok showed how nationalism took root in everyday memory in South Korea by composing a story about the well-known legend of oviparity that was passed down from the Shilla Kingdom (BCE 57–935 CE). Thus, the exhibition attempted to produce a paradigm of visual culture by exploring various issues—such as nationalism, collective memory, and cultural memory—through works of visual arts, and probed into the possibility of communicating such a paradigm with the viewers. Unlike *minjungmisul* of the 1980s, which exposed the political and social situation in a straightforward manner, the exhibition *Somewhere in Time* alluded to social reality in a more metaphorical way, given the expectation that the viewers themselves would interpret the implications of the works on display. But such a curatorial intention resulted in an unfortunate consequence: The viewers were unable to immediately recognize the content of the exhibition.

TOMORROW (2007): EXHIBITION AS AN INQUIRY INTO TIME[8]

If *Somewhere in Time* looked back to the past, the second edition of *Platform Seoul*, titled *Tomorrow*, proposed a temporal leap to the future. The concept of time travel, as imagined in Yasutaka Tsutsui's science fiction-cum-animation *The Girl Who Leapt through Time* or the Hollywood movie *Back to the Future*, is a fictional trip implausible in reality. By situating the past, present, and future in a temporal continuum, the exhibition asked the question, "Is tomorrow a better day?" which led to an inquiry into the uncertainty of tomorrow. In other words, the exhibition sought to throw a light of critical suspicion onto our understanding of the future as well as our anxieties and queries about the uncertain time of tomorrow. It showcased artworks that depicted the hope and the indeterminate gesture with a tint of idealism, in addition to other works that offered more practical suggestions for the future. For this exhibition, David Ross and Dan Cameron respectively served as an associate curator and an advising curator, while Etienne Sandrin, a curator at Centre Pompidou in Paris, organized a section of the video screening in addition to giving a talk.

In terms of the exhibition site, *Tomorrow* was held in both the Artsonje Center and the Kumho Museum, two art institutions that have played an important role in reshaping Korean contemporary art in the 1990s. They are geographically adjacent to one other, yet the gallery spaces are substantially different in formal aspects. The Kumho Museum's exhibition space is composed of rectangular spaces that spread through four levels, from a basement to the third floor, and each floor is divided into smaller boxlike spaces. In contrast, the Artsonje Center presents a gallery space in a fan shape. The exhibition *Tomorrow*, therefore, maximized the characteristics of the two gallery spaces by presenting works that corresponded to their particular spatial configurations.

The exhibition as a curatorial project also included an academic symposium, "Art and Society", which focused on the social engagement of art across different levels of society. The following papers presented at the symposium facilitated in-depth discussions of the topic: the philosopher Kim Jin-Young's "Aesthetic Turn and Critical Reflection on Aesthetic Perceptions in Everyday Life", architecture theorist Kim Ilhyun's "Synchronicity and Diachronicity in Manfredo Tafuri's Historical Project", artist Martha Rosler's "A Case for Torture Redux", and the paper "Art and Society: What Hansen's Disease Sufferers' Art Connotes" by Hiroshi Minamishima, who was at that time the director of Contemporary Art Museum, Kumamoto.

Another unusual aspect of the exhibition was that the video screening was held not in a gallery space but in a theater. In the gallery setting, the viewers usually walk across the exhibition space, more than often passing too quickly through audiovisual works that require some time commitment to watch. To address this problem, the exhibition planned a three-part screening program according to the subject matters of selected video works, allowing the viewers to remain seated in a theater and take sufficient time to appreciate the works. The first section showcased video works with a determination to socially engage with the surrounding reality. The second section, curated by Etienne Sandrin, consisted of videos from La Collection Nouveaux Média du Centre Pompidou that corresponded to the idea of "tomorrow". Finally, the third section screened a selection from Cao Fei's videos, as well as other works like *Vicinato 2* (2000), which was based on a conversation that took place in the late 1990s among artists like Liam Gillick, Douglas Gordon, Carsten Höller, Pierre Huyghe, Philippe Parreno, and Rirkrit Tiravanija on a range of topics such as politics, aesthetics, and idealism. Allan Sekula's film *The Lottery of the Sea* (2006) examined the concept of maritime risk through the Panama Canal, the oil-smeared Atlantic coast of Spain, and the seafronts of Barcelona, Yokohama, Rotterdam, and Athens.

In addition, artist talks that were held every Friday in a seminar room— not in a gallery space—provided an opportunity for artists to show and explain their works. Each artist talk was followed by questions and answers, which were, thanks to the intimate scale of the talk, a valuable time of communication for the artist as well as the audience members.

Figure 6.1 Lee Bul, *Aubade* (2007). Aluminium structure, LED lights, crystal and glass beads.

Source: Installation view at Kimusa, *Platform Seoul*, 2009. Photograph: Myong-Rae Park.

I HAVE NOTHING TO SAY AND I AM SAYING IT (2008): BEYOND VISUAL CULTURE, EXHIBITION AS A TOTAL EXPERIENCE[9]

The title of the third *Platform Seoul*, *I Have Nothing to Say and I Am Saying It*, comes from John Cage's writing, "Lecture on Nothing".[10] As is well known, Cage wrote the phrase to comment on the new perceptual experience of hearing the sound of vibrating pulse and blood veins only in the moment of silence. If Cage completed his music with quotidian noise and

engendered an experience of potential perception through the collaboration between art, music, and many other genres of arts, the exhibition made a paradoxical statement that "I have nothing to show and I am showing it". What was conspicuous in this exhibition is that art is not an object to be discussed on exclusively visual terms, but is rather a sphere for a total experience that accompanies the process of participation. In the curatorial statement, I wrote,

> Experience is central to art, and it can be discussed as the experience of artists, of artworks, and of viewing art. Although the division between viewing art and experiencing art is unclear, art is now beyond the parameters of reflecting reality and into those of experiencing another world. As an experience and a proposition, the exhibition deliberates the possibility of a world different than the here and now.[11]

Under the central theme of theatricality, the exhibition connected a dozen sites: the former Seoul Train Station, the Artsonje Center, and galleries in the neighborhood of Bukchon, which is the art district where the Artsonje Center is located. Originally constructed in 1925, the former Seoul Station building no longer functions as a train station because the operation of the new high-speed train system (KTX) required the construction of a separate, new station equipped with new technology. As one of the only few modern architectural heritage sites surviving from the Japanese colonial era, the former Seoul Station was revamped as a cultural complex in 2012 after a three-year-long renovation.

At the time of the 2008 *Platform Seoul*, the renovation had yet to begin, and the interior structure was still in its original state, as if time had stopped. The space was therefore imbued with a feeling of going against time and history. When appropriating the former Seoul Station as an exhibition site, many points of discussion came to the fore. How can we relate the historicity entrenched in the station with the medium of art exhibition? How does the station's site specificity interact harmoniously with the given artworks? How might we make sense of the fact that the Seoul Station has for many years served as a congregation site for the anonymous homeless in Seoul? And how can we link the exhibition's two major sites—the station and the Bukchon area—despite the distance of approximately three kilometers? In the end, the points of principal explorations focused on the historical nature of the former Seoul Station as well as the characteristics of the site as a station, that is, a transportation hub where things, as well as people, pass by.

As these site-specific questions and themes suggest, *I Have Nothing to Say and I'm Saying It* challenged viewers' preconceived ideas about what an exhibition ought to be. As its primary quality, the viewers could not find any "objects" that would typically fill a conventional exhibition. In this particular exhibition, the viewers were unable to appreciate the show unless they abandoned the very definition of an "art exhibition" as one

adorned with visual objects such as paintings and sculptures. First and foremost, the exhibition presented artworks that could only be experienced through the viewers' intervention or that could only be completed on the viewers' participation. For example, considering that air is invisible but fills up every corner of the gallery, the exhibition created an opportunity for the viewers to experience air by walking across Martin Creed's installation of small balloons half-filled with air. In an empty gallery space, the viewers encountered an interviewer who asked them questions, as in the case of Tino Sehgal's work.

Second, the exhibition placed its focus on the possibility of a new relationship between artworks and viewers. For those accustomed to the customary way of appreciating artworks, the exhibition might have caused at first a sense of disappointment or even bafflement, because the exhibition pursued a certain effect of "distancing". In the Aristotelian theater, the structure of narrative invites the audience to identify with the protagonists or the situations, and an art exhibition can propose points of identification and connection with the viewers. But just like the Brechtian theater, which is decidedly not an imitation of reality, art can produce communicative methods based on dis-identification and alienation.

Third, *I Have Nothing to Say and I'm Saying It* was at pains to demonstrate that an artwork is not a material object that exists independently from its surroundings, but is in fact situated within the changing conditions affected by such elements as light, time, and location. What was at stake was allowing the viewers to experience, with their bodies, how the artworks on display are organically and spontaneously bound to the nonmaterial elements such as light and sound in the exhibition space. In contemporary art, too, art presented with non-materiality reexamines current reality and surroundings. In these cases, a wide range of perceptive senses is at play instead of the usual emphasis on visuality.

The fourth essential point of the exhibition centered on the concept of participation in artworks. Art's ability to socially engage and its attempt to speak to reality through action or intervention are contingent on the social situations of the given period. The works that simultaneously addressed both the question of the exhibition's location and its sociopolitical context were Akira's research about the Seoul Station that exposed the dynamics between Japan and Korea, Park Jooyeon's investigation into the social particularity of the place of the Seoul Station, and Yoon Dong Goo and Won Il's contemporary spin on the traditional myth of Princess Bari.

Finally, the exhibition prompted participation from multiple art galleries, who are independently operated yet were eager to collaborate on producing shows in their respective spaces. From the beginning, the exhibition required the utmost trust and collaboration from these participating galleries. Artists examined the sites and selected the space of their choice, as if to plan multiple solo shows in each of the sites. Additionally, international curators such as Fumihiko Sumitomo and Shu Yang collaborated on the

curating, whereas Etienne Sandrin screened historical examples of video art and gave a lecture about them. In this sense, *Platform Seoul* was a stage for experimentation that successfully generated enthusiastic participation and positive reception among galleries, artists, and viewers alike. It was a *public* festival in the sense that it engaged with a wide range of publics and, consequently, rearticulated the very notion of the public.

VOID OF MEMORY (2009): PUBLIC ART AND THE IMPOSSIBILITY TO REPRESENT HISTORICAL MEMORY[12]

Unlike previous editions, which lasted about one month, *Platform Seoul 2009* organized an assortment of projects that took place in the span of six months leading up to the exhibition in September. Under the three key words *public*, *space*, and *life*, *Platform Seoul 2009* was launched with the idea of reusing unoccupied sites within urban spaces. For example, the idea of connecting the Yongdungpo District in Seoul and other areas outside Seoul came to realization within the scope of the project. What inspired such a project with urban space in mind was the fact that the existing paradigm of public art was limited to the medium of sculpture and that an alternative possibility to connect with local residents through particular sites in their neighborhoods might be able to change this paradigm. The initial plan involved the city of Gongju as a prototype for a citywide project, but it only led to a workshop with discussions about ideal models for the city. As a result, the 2009 edition of *Platform Seoul* encompassed multiple subprojects: artists' presentations of their own public projects, artist talks, lounge projects, the exhibition, and a lecture and two symposiums on public art projects.[13]

Just as *Platform Seoul 2008* reused the former Seoul Station before it was renovated, *Platform Seoul 2009* utilized the former building of Kimusa (see Figure 6.1). As the symbolic site of military dictatorship, this building was in use by the Ministry of Defense between 1974 and 2008, when Kimusa relocated to Paju, a small city outside of Seoul. In February 2009, the government made an official announcement that the site would be reused as a satellite branch of the National Museum of Modern and Contemporary Art, Korea. (The new museum building opened on November 12, 2013.) Kimusa as a military facility was a forbidden territory for civilian access, signifying the memory of state control over the basic freedom of its citizens.

In other words, *Platform Seoul 2009* used a site of public memory as an exhibition site. Corresponding to the type of memory entrenched in the site, the exhibition began with casting doubt upon the possibility of representing historical memory. In order to contest the systematic oppression spearheaded by military power and enforced by the state, I chose to present a group of distinct artworks by individual artists instead of representing a spectacle of collective memory. Commissioning new works proved difficult, however, because the permission to use the site was granted only after four

long months of waiting. Even with the authorization, artists and curators were not allowed to make repeated visits to the site at their convenience during the preparation period.

Void of Memory was composed of four sections. The first section, "Void of Memory", co-curated with Mami Kataoka from the Mori Museum, conceptualized the disappearance of memory or the gesture of unveiling concealed memory through works that underlined the surreal and mysterious quality of Kimusa. The second section, "Artists Recommended by Artists", followed the exhibition strategy in the most literal way, because it presented works by artists who received recommendations from their artist colleagues. In short, this section highlighted the idea that artists might think differently from curators. "Projects by Invited Curators", the third section, contained smaller-scale exhibitions organized by multiple curators from Korea and overseas. The fourth section, "Projects by Invited Institutions", attempted to demonstrate the diversity of art museums and institutions located in Korea and abroad. From the early stage of planning the exhibition, the collaboration among a range of players—curators, artists, and institutions—put to use and creatively reinterpreted the very notions of restriction and control that had been fully performed at the site. Such a collaboration disintegrated boundaries between individual players, while allowing them to propose different possibilities with which to amply redirect the spatial and organizational limitations that the Kimusa site posed to them.

Among the architectural structures composing the former Kimusa building complex, which included the main building, the gymnasium, the annex, the underground bunkers, the transportation unit, the tennis court, and the courtyard areas, the exhibition utilized each except the hospital to expose each corner of the venue in its original state. The rules of exhibition viewing were designed to be peculiar: During the day, guided tours were available by appointments only, whereas between the hours of five and nine in the evening, the visitors were free to walk around on their own. In other words, the visits during the normal gallery hours were rather controlled, while those outside the so-called regular hours were free of restrictions. This imposition of rules confused most visitors, who were, for understandable reasons, not used to them, yet the sensations of mysteriousness and surreality were intensified during the evening viewing hours.

Different types of temporalities existed in the span of twenty-four hours. During the day, the sense of time was official and bound by rules, whereas in the evening, it was the time of freedom, ease, and abundance, and of preparation for the future. Normally, if the day is filled with tension, the night is with repose. The exhibition then followed the general "rules" of day and night, while ironically violating another rule—that we do not normally view exhibitions at night. The exhibition therefore attempted to suggest a productive view of the historical reenactment, rather than representation, of collective memory, while providing the opportunity for further discussion and participation among the viewers about recovering suppressed pieces of memory.

PROJECTED IMAGE (2010): AN EXHIBITION
THAT BECAME A FILM FESTIVAL[14]

The final edition of *Platform Seoul* organized a film program in both the theater and the gallery at the Artsonje Center. The audiovisual works produced by visual artists were screened at the theater with a predetermined schedule, in the same format as a film festival might. By contrast, works by artists who began their careers as filmmakers, such as Harun Farocki and Apichatpong Weerasethakul, were shown in the gallery space like video installations. Of the fifteen-day-long program, the first half traced the history of video art by showcasing works made between the 1960s and 1980s, a period when video art was in its nascent stage. Each showing was accompanied by lectures by Etienne Sandrin, Tobias Berger, Youngchul Lee, Tyler Cann, and Yukie Kamiya. The latter half of the program focused on the general trends in video artworks after the 2000s, and especially those by contemporary Korean artists. Screening in this section was supplemented with artist talks as well. In addition, the program featured new productions by Lawrence Weiner and Jun Yang, which were coproduced by Samuso: Space for Contemporary Art.

ANOTHER POINT OF DEPARTURE: TOWARD MICRO-UTOPIAS

It is true that each edition of *Platform Seoul* delivered a different theme, yet all the exhibitions shared a common denominator. They all demonstrated that to make a proposal through art is to pose a challenge to an impossible situation, and that the focus should be less on the result than on the experience arising from a certain process. In other words, the proposal in question is none other than a proposal for a process of preparation. Artists proffer an alternative vision for what is considered impossible and unchallengeable. If the important social role played by artists is closely linked with their ability to suggest alternative thinking, then the responsibility of discovering these artists and collaborating with them falls to curators.

I initially planned *Platform Seoul* with the aim of questioning the existing exhibition system that abides by the law of inertia. Now that I look back, and can assess my own practice with *Platform Seoul*, the act of organizing such an art event with a long-term vision ought to address the following points for further improvements. First, it is necessary to establish an administrative infrastructure in which artistic directors and curators can manage the project for a sustained period and an evaluative system in which these players can self-assess the content, planning, and outcome of the event. Second, it is necessary to develop a system in which artists are able to get involved, from the stage of initial planning, and to discuss in detail the site, subject matter, and production process, which will then lead to a further collaboration between curators and artists.

Third, the event can benefit from a sustained financial support from funding organizations and sponsoring companies as well as active cooperation from local residents.

As to the fourth point, the event should be based on fluid and transparent communication among curators, artists, and viewers about the content and objective of the exhibition. Here, communication is not a unidirectional delivery of information, but rather a dialogue based on mutual consensus. The fifth point concerns forging a connection between artworks and the exhibition site. It is important to present new commissions according to the characteristics of the given site or to select among existing works that correspond to the site. Challenging the impossible is bound to be accompanied by innumerable experimentations and a series of failures; but these experimentations make up the very core of the challenge and the will to convert an impossibility to a possibility. To pose a challenge is about imagining a simulated situation according to theories and hypotheses, and projecting an outcome. It is also to imagine, without a pause, the minute spaces between truth and fiction, the discursive and the imaginary, and knowledge and emotion.

In this sense, *Platform Seoul* can be summed up as an attempt to show art's ability to imagine different possibilities for every artist, curator, critic, researcher, and viewer. Instead of seeking a grandiose utopia, *Platform Seoul* instead sought small and personal micro-utopias within existing institutional structures. Given that in contemporary art, artists are putting the "popularization of art" into practice by reinventing the notions of accessibility, acceptability, and connectibility, *Platform Seoul* represents a different process in which micro-utopias can be found in the everyday; through art it is possible to imagine an ideal world that is simultaneously simple and quotidian. It is this sort of exhibition, which is suggestive of the possibility of an alternative that I aspire to curate in the coming days.

Translated by Sohl Lee
NOTES

1. The exhibition *Ssac* (*The Buds* in English) was held between May 19th and August 20th, 1995, at the Samchong-dong Hanok located in the current site of the Artsonje Center. The house had an outer structure of the traditional Korean house, an interior in Japanese style, and an extended building in American style. This architectural anomaly was symbolic of the modern history of Korea, during which the foreign colonial powers occupied the country.
2. These were the curatorial statements of the 2009 Platform Exhibition *Platform in Kimusa*, held at the former Defense Security Committee's building between September 3th and 25th, 2009. Sunjung Kim, *Platform in Kimusa* (Seoul: Samuso: Space for Contemporary Art, 2009).
3. The exhibition *Somewhere in Time* was held from December 4th, 2006 to April 1st, 2007, at Artsonje Center.
4. I organized this symposium while holding the directorship of the Institution of the Visual Arts at the Korea National University of Arts. Sponsored by the

Korea National University of Arts, the symposium was held at the Artsonje Center on December 4th and 5th, 2006.

5. Choi, Min. "'The National' in the Visual Culture Studies." Beyond Nationalism in the Visual Culture. Korea National University of Arts. Seoul. December 5, 2006. Symposium.

6. Min, Hyun-sik. "Reconcilement Between Human and Nature: Beyond the National Architecture." *Visual*, vol.4. Seoul: Center for Visual Studies, Korea National University, 2007.

7. The examples discussed included the transposition of the 1993 Whitney Biennial to Seoul, and 1988 exhibition of 80s American art organized by the Boston ICA at the state art museum in Athens, Greece.

8. The exhibition *Tomorrow* was held at two different sites: October 6th–November 4th, 2007, at the Kumho Museum; October 6th–December 2th, 2007, at the Artsonje Center.

9. The exhibition *I Have Nothing to Say and I Am Saying It* was held from October 25th to November 23rd, 2008, at the former Seoul Train Station and the Artsonje Center.

10. John Cage, *Silence* (Middleton, CT: Wesleyan University Press, 1961), 109.

11. From curatorial statement in Sunjung Kim, *Platform Seoul 2008* (Seoul: Samuso: Space for Contemporary Art, 2008).

12. The exhibition *Void of Memory* was held at the former Korean Military Headquarter and the Artsonje Center, September 3rd–25th, 2009.

13. The presentations at the symposiums ranged from case studies of public art projects, research projects about artistic practice and the notion of space, to the question of publicness in art, and the ideas behind "3331 Arts Chiyoda", for which Japanese artist Nakamura Masato established a cultural complex in an abandoned school.

14. The exhibition *Projected Image* was held from November 3rd–19th, 2010, at the Artsonje Center.

Part II

When Art and New Media Collide

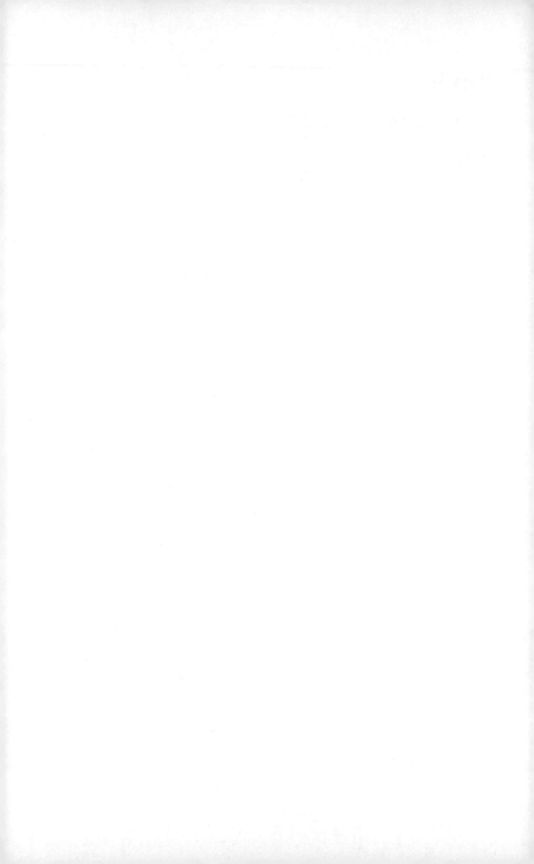

7 Red Tape and Digital Talismans
Shaping Knowledge beneath Surveillance

Zoe Butt

It is four in the afternoon, and the Sunday slowness of Saigon, Vietnam, is suddenly punctured by the melancholic sounds of a lone trumpet. It seems to be asking a question that is promptly followed by the beat of a drum and a chorus of trombone in a collective mournful serenade. The movement of a soul is about to pass the threshold from our lived reality into the next and this procession of sound is the final hurrah. A shrine is created at the doorway of the family home while tables and chairs overtake the public sidewalk as food and drink are passed to family and friends who have come to pay respect.

Onlookers, strangers and tourists alike, stop to admire the bedecked brass band in gold and red and the costumes of white paper that the immediate family members are wearing as they bear offering and prayer, as a watchful embrace to their dearly departed. Mobile phones snap pictures and video of the fanfare; Instagram emits tagged condolences; Facebook announces a litany of RIP. Here, the spiritual world is the historicized space of the greatest "analytical" social thinking, where fortune-tellers abound in the ritualized reading of one's astrological signs and personal objects to foresee a meaning for the future, to seek an auspicious day for a wedding vow, or determine if the purchase of a new home is facing the right direction. Such spiritual or superstitious interactions are social negotiations, physically endured, shared, discussed, and often made public to assure an extended family and community that there is good luck foretold.

Challenging and interpreting the diverse intangible and tangible structures of everyday reality are common cultural phenomena across the globe, from stockbroker to journalist, from spiritual healer to scientist, and from visual artist to activist; however, attempting to understand the tangible, physical context of a country such as Vietnam is a heavily controlled, corrupt, and bureaucratic practice. In this postcommunist state with hypercapitalist characteristics, it is considered dangerous to disseminate your subjective views on such things as why overcrowded maternity wards lack resource, why the government does not want reform in the face of economic inflation, or why quiet writers who blog their views are being imprisoned. Should a journalist working for any newspaper or television station ask a

general pundit or a recognized academic scholar for his or her subjective opinion on the laws and attitudes of their society, the journalist is most often met with resounding hesitation, a sense of fear masked by apathy.

Owning a different opinion and publishing it, sharing a new idea outside your own disciplinary community, or challenging a historical account of "truth" in critical debate—making such actions known beyond your trusted networks, your "intimate" public, is rare in this context, where artists are ideologically desired as the propaganda loudspeakers that support the state, where social harmony is perceived as a politicized uniformity, and where economic profit or nationalized anniversary dictates the allowance of public activity. This is the offline world, littered with the red tape of government license application, vague guidelines, and bribery, where cultural communication to the public follows a formula of overhyped description and gossip, where historical comparison is rare, where law enforcement is a priority over community awareness, and where experts, fed-up and disconnected, sits largely yawning. In this environment, the online world is where authority is continually scrambling to understand the motivations of virtual interactions and the scope of its reach.

The official governance of the virtual world is thwarted by the quantity and interdisciplinary usage of social media, which is the ultimate advantage to creative communities seeking avenues to share critical opinion.[1] In Vietnam, this intangible space is a crucial information disseminator and community generator for independent[2] organizations seeking to challenge dictated ideas of culture through the usage of Facebook and the creation of dedicated websites and blog forums. Some artists claim this virtual world as an archival space to challenge historical account, while others use this digital world of the copy to challenge presumed systems, codes, and values of social memory. What is intriguing about this online community in such politically restricted societies is the way it has become an intrinsic ritual of the everyday, where the digital device is rendered a talisman of immense influence on a local and international platform.

In such contexts, can an artistic community's usage of social media challenge regulated notions of history and authority in the creation of a living intimate archive of ritual on- and offline? What are the consequences of this character of ritual? What are the dilemmas between on- and offline discourse of interpretation, mediated by curators, as an aid to nurturing uncensored ideas of artistic production? In the absence of supportive critical arts infrastructure and comparative collections in Vietnam (e.g., the lack of a networked interpretative community of expertise—galleries, museums, patrons, curators, artists, critics, and historians) there has been an immense contribution on the part of artists and artist-initiated organizations that significantly challenge ideas of authenticity, curatorial labor, and the role of the archive to which the tools of the virtual world have provided methodology and inspiration.

LINKING COLLECTIVE MEMORY ON- AND OFFLINE

It is a sweltering evening in November 2011 in Saigon and just a few hours before opening night at San Art, Vietnam's most active independent, artist-initiated contemporary art space and reading room. The exhibition, *Fullness of Absence* by Nguyen Thai Tuan, lines the gallery walls, each painting providing a corridor of history, as if the audience is standing in the central connecting chamber of a multipronged journey. Nguyen is a self-taught artist from Dalat in Vietnam's central highlands whose prolific practice is identified by human body-less figures in particular dress and pose demonstrative of particular social class and influence—these body-less figures clothed yet eerily lacking faces, hands, and feet.

In this exhibition, a new series of paintings titled *Heritage* is showcased, where Nguyen challenges the legacy of Vietnam's complex political past. His site of focus is the palace of the last Vietnamese dynastic figure, Emperor Bao Dai, whose home in Dalat was built by the French. After Bao Dai abdicated the throne in 1945, his palace became a playground for the privileged children of Communist officials. Built on a stunning vista overlooking the countryside charm of what was once the last seat of power of French Indochina, today it remains a tourist attraction, with its rooms stripped bare of any valued historical object (the majority of such objects looted), with no provision of fact concerning the building's rich history of ownership. In *Heritage*, Nguyen swathes various interiors of this palace in somber chiaroscuro of beige, cream, brown, and khaki. His shadowy scenes occupied by his signature motif dressed in attire symbolizing traditional, military or business values. The contrast between these occupations is a deliberate pictorial ploy by Nguyen to highlight the differences between Vietnam's social classes before and after 1975—the year that Vietnam united, with great violence, as a communist state.

Nguyen reminds us that the differentiation of social class in Vietnam is a complex product of this country's political history, which is as much about colonial occupation as it is about the historical grievances between North and South Vietnam. Nguyen's works are a clever discourse that posit the Vietnam War (1955–75) as first and foremost a civil domestic conflict. In one painting there is a woman seated wearing the traditional áo dài dress of Vietnam. She sits facing the audience with her hands in her lap, while a man dressed in military garb stands to the side, his back to us with his arms crossed behind his back as if guarding the scene. The room has a dark and cynical air, the sparsely furnished interior lacking any characteristic detail except for a small ceramic blue-ware vase that rests on a nearby table. In another work, composed of two separate paintings, there are the rubber sandals typically worn by the Viet Cong in the North sitting above a pair of American GI army boots typically worn by the Vietnamese military in the South. What is most powerful in this collection of works is the contrast

between style and object that denotes changes in social attitude due to the political influences of the time.

For *Fullness of Absence*, four different press releases had been distributed to government, local press, and international press and online (San Art website and Facebook). I had also composed a critical essay for the show, which had been translated into Vietnamese and at time of opening was circulating the virtual highways with various media for possible publication. As Nguyen Thai Tuan paced the gallery nervously, as staff equally fretted over the impending questions from press and television crews, we all knew we were treading a fine line with the government because only the day before, the Ministry of Culture, Sport and Tourism granted license with censorship of 50 percent of the desired work for display, stating that we can only show either paintings illustrating pre-1975 or post-1975; we could not show both eras together.

Despite this ruling, San Art had made the decision to show the "approved" works in the main gallery and declare the back gallery as "stockroom" (supposedly unavailable to public) to show the works not permitted. This exhibition had been a year in the making, carefully strategized with San Art in terms of subject, timing, and promotion, and I particularly understood that Nguyen Thai Tuan's intentions required the audience members to bring their own comparative analysis to the images—such analysis being the key reason the authorities had censored the exhibit. Despite the fact San Art's license submission had been deliberately vague and descriptive with little interpretation, the Ministry clerks surprised us with their ability to deduce the value in contrasting visual symbols, stating the illustration of "before" and "after" 1975 may lead to critical social self-assessment, a practice the government is particularly wary.

Let's not forget that the Ministry of Culture, Sport and Tourism is a descendant of the military government's "Propaganda Department".[3] During the Vietnam War, artists were hired as soldiers for the front line whose job it was to provide an image to the people of the glory in serving their country, to illustrate the lives, habits, and ultimately the "beauty" of human bonding and collective sacrifice in the face of a foreign threat. Today, the social role of an artist in Vietnamese society is rather confused, where visual art could be said to lie a close third on the official scrutiny list, behind film and literature, as the most powerful devices perceived to potentially destabilize social harmony.

In the week following the opening of *Fullness of Absence*, San Art was interrogated by the Cultural Police and issued a monetary fine, given stern warning that San Art's lack of adherence to the license conditions will be added to the tally of our negligence—the public's ability to access the back stockroom without staff supervision perceived as contravening their agreement. In addition to this restriction on display of artworks, San Art was also ordered to remove all text regarding this exhibition on- and offline, in both English and Vietnamese. No analytical interpretation of the exhibition

was permitted for dissemination. Intriguingly, following opening night when photographs of the event flooded Facebook, the "Like" button rose exponentially with comments and opinions limited to personal jargon and emoticons.

In general, the artistic community seemed not surprised by the censorship of the exhibition that was announced online, the recurrence of such repressive mandate considered typical and standard.[4] The artistic community across the country seemed to overlook the complex history articulated within the paintings, preferring to question the origin of Nguyen Thai Tuan's signature motif—the body-less figure—and its close likeness to the work of another artist, Liên Trương. Discussion fired up at soi.com.vn (the only website/blog forum that discusses contemporary art from a nongovernment perspective) misjudging Nguyen for his "copying" of another artist.[5] In this local community, ideas of beauty, technique, and method are considered the most important doorway to appreciating visual art. Discussion of postmodern practice, of what "conceptual" thinking entails, is not familiar in Vietnam; hence, understanding the employment of appropriation is not recognized as a critical tool in which to juxtapose differing context.[6]

In recognizing that San Art is endeavoring to fill the gap in artistic knowledge concerning theoretical frameworks and interpretative skill with a need to approach history as a comparative process of deduction between official record; alternate archive and oral account: How can this be delivered under such close government scrutiny both on- and offline? Nguyen Thai Tuan's art encapsulates the political character of Vietnam; however, his focus is on issues of class, so how can the world of the social be discussed without fear of political repercussion? How far is San Art willing to potentially sacrifice access to our audiences by using Facebook as a tool to disseminate sensitive, perhaps censored, information?

Such questions are ongoing dilemmas in the mission of San Art, where the unpredictable character of censorship demands the organization be flexible, open, and innovative in approach.[7] Timing the publishing of sensitive information is crucial as is the careful in-person circulation of printed information within trusted friendship networks. Though access to Facebook is intermittent depending on the political events occurring at the time, it remains the most powerful community builder in the country.[8] In Vietnam, where the gathering of more than five people on a premise is classified "public" and thus in need of approval, it is a difficult environment to engage a creative critical platform. As an artist attempting to work in Vietnam, self-censorship is common; as a director/curator, it is the curatorial doppelganger dressed as a stylist that holds most influence, where language understood is mere advertising and where the due care for building interested audiences in cultural production becomes dangerously an art of deceit.

Under such circumstances, where is an artistic imagination discussed openly and honestly? How do you build a networked audience for art, locally and internationally, that raises awareness of a particular context's lack of care toward nurturing cultural memory? Organizing educational events for

targeted audiences "underground", using VIP e-mail lists only, is a common practice at San Art and one of the only means by which foreign artists can share their practice.[9] Although this "intimate" VIP public is the lifeblood of San Art, it does little in building awareness of our activities with a broader interdisciplinary community, a community increasingly necessary for San Art's future sustainability in a country with no financial support for the arts. One way of circumventing this obstacle to building audience is to organize and promote the exhibition of sensitive or censored artistic practice abroad. In witnessing the reception of this material by another community's cultural infrastructure via online promotion and review, and noting the "exotic" currency with which politicized subjects is of key interest to foreign collections and social elite—this is increasingly where such questions are constructively reassessed and is crucially evident in the artistic practice of Dinh Q Le.

JUXTAPOSE OFFICIAL RECORD: ARTISTIC PRACTICE AS RARE HISTORICAL ARCHIVE

In July 2011, the Sherman Contemporary Art Foundation in Sydney, Australia, presented Le's commissioned project *Erasure*, in a darkened gallery space filled with the confronting sounds of a blazing fire and howling wind. On one wall is a single floor-to-ceiling moving image of an eighteenth-century wooden ship, its hull and sails rapidly consumed by flames, leaning beached on an isolated white sandy coastline. The camera pans slowly around this symbol of empire while the fire greedily licks its life away; the sky above is lit with a striking melancholy. Le renders the beauty of this seafaring vessel in a continual, unending loop of destruction. The burning hull moves eerily between substance and shadow as its own likeness is split and collapses in on itself, as though a kind of double-sighted madness has taken hold of the lens.

This perpetual cycle of self-combustion allows our attention to shift to the repercussion of this repeated violence—small islands of "debris" resting on the floor, perhaps suggesting that the burning virtual vessel has spewed its contents into the actual physical space. Amid boulders, wooden fragments, and discarded clothing are thousands of small faces, black and white, locked forever in silver gelatin. Self-portraits, family shots, passport-style facial profiles, and miscellaneous landscapes rest in random, chaotic fashion. Visitors bend down to reach these filigree-edged photographs, some no larger than the size of a thumb. The frozen faces appear like flotsam and jetsam of a churned sea, some images turned down and begging to be uncovered while others vacantly staring upward, striking an inner human bell of conscience.

It is difficult to fathom the collation of this quantity of images, particularly as each image is unique. These are not photographs lovingly framed and cared for in vellum family albums; they were found dusty and uncategorized

in antique stores, bagged by the kilo and baked under the heat of Saigon. They are intimate memories abandoned in haste, left behind amid the conflict of the Vietnam War and most likely belonging to the uncountable number of refugees who took to the sea in desperation. From the rear of the exhibition, we hear the whirring of a digital computer scanner. The laser light produces an eerie shadow as it scans across the image under its radar. We recognize the clicking of a mouse, the shuffle of someone's repetitive movements, and soon realize that these articles of human "debris" are slowly and steadily being removed, documented, cataloged, and stored, placed in a rational archival order—soon to be publicly forgotten save for the pixel images on a dedicated website (erasurearchive.net), where one person at least, a lady in France, discovered an image of her forgotten young self in Saigon.

In *Erasure* we are forced to contemplate the aftermath of conflict, to register the slow disappearance of evidence into classified systems, where the experience of loss, together with its associated objects, becomes buried in collections that are predominantly removed from public historical consciousness. While respecting the role of archives in the West (e.g., libraries, museums, and private collections) in providing a record of social memory, Le is concerned with how that history is activated and reimagined within a larger collective memory for future generations, particularly in places such as Vietnam, where comparative archives of visual culture is extremely rare, if nonexistent. The decision to build erasurearchive.net, for what is arguably the only collection of pre-1975 black-and-white photography of southern Vietnam in the world, is Le's way of building his own publicly accessible memory database in the hope that, like him in his constant search for family photographs, others may equally find loved ones.

Sadly, still to this day, these photographs are considered highly politically sensitive by Vietnamese authorities and could never be publicly displayed within Vietnam. As a boat refugee, born and raised in Ha Tien (southwest Vietnam), whose family fled the encroaching armies of the Khmer Rouge following the Vietnam War, Dinh Q Le is deeply aware of the role of dialog between local and international communities, particularly the gift of knowledge exchange on a virtual platform, as a means of circumventing the oppressive official restriction of foreign information and perspective. *Erasure* was given prime-time space on Australian television, a review in newspapers, and in an art journal on- and offline, and subsequently toured to Hong Kong the following year to time with ARTHK Fair. Curated by myself as executive director and curator of San Art, the project and organization gained considerable attention, significantly boosting the awareness of government restriction in Vietnam.

As chairman of San Art's board of directors, Le's established career offers San Art a critical local leverage tool in the staging of sensitive projects in Vietnam and abroad. Le is often called on by local government official, foreign museum curators, or social historians to share his knowledge of contemporary art, particularly due to his artistic practice creating

a bridge between Vietnam's cultural legacies and the contemporary imagination of Vietnam today.[10] Walking into Dinh Q Le's private home and studio in Saigon is to be given a history lesson of Vietnam and its complex interwoven history with its regional communities before the colonial dictation of nation and the political creation of the Association of Southeast Asian Nations (ASEAN) in 1967 (which arguably established the term and geographical region today understood as South East Asia). Cham-dynasty bronze ware, Khmer Buddhist statuary, Le-dynasty blue-ware porcelain and ceramic architraves from local Chinese temples in Cho Lon scatter the various levels of his home. Books and articles in English and Vietnamese litter tables and bookshelves; the entire premises is a treasure trove of near-forgotten stories.[11]

Despite Le's recovery and reinterpretation of tangible and intangible memory being of immense international artistic interest, his art has never been officially exhibited in Vietnam due to the topics he engages being considered too political sensitive. The government is most concerned with how Vietnamese define "Vietnam" as a nation and society; thus, the activities carried out and communicated within Vietnam, on- and offline, particularly in the Vietnamese language, are of largest concern. However, in the last decade, the radar of the officials is also heavily surveying the discussion of Vietnam on an international platform. Exhibitions abroad (see Figure 7.1)

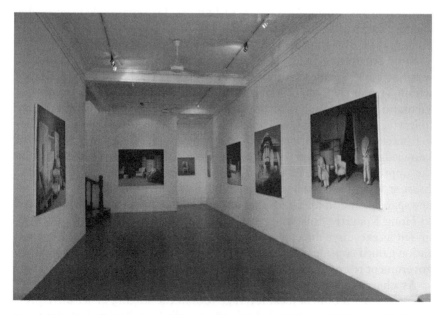

Figure 7.1 Installation view of Nguyen Thai Tuan's *Fullness of Absence* (2011).

Source: San Art, Ho Chi Minh City. Photograph: Phunam and Nguyen Nhat Nam, Ho Chi Minh City, 2011.

are noted and increasingly mentioned in local press whereas websites such as Talawas (www.talawas.org/) and tienve.org (an online center for the arts based in Australia with strong membership of overseas Vietnamese) are crucial examples of intimate publics gathering online in the sharing of creative and intellectual information that continues, such as the operations of San Art, to quietly challenge the presumed jurisdiction of "nation", "community", and "culture" by Vietnamese authorities—but how far can we measure the imagination of a "Vietnam"?

INTERVENING MEDIATED CHRONICLES

"You don't remember anything of Vietnam prior to your family fleeing in 1978!" exclaimed Dinh Q Le in a humorous yet emphatic tone over dinner, to which fellow artist Tuan Andrew Nguyen fires back an equally adamant reply: "Hells yeh I do, I know *Platoon* and *Apocalypse Now* and *Full Metal Jacket*. That's Vietnam!"[12] Such a statement is a common quip in this country where mediated histories from film, television, music, and foreign journalism lie at the center of local awareness of Vietnam's complex past, particularly for the generation that were born in the country, fled in 1975, were educated abroad, and have now returned. Domestic classroom history textbooks are filled with the ideology of Marx and the fabricated facts of a Vietnamese Communist cause and thus the understanding of this country's relationship and impact on world politics and economy is largely misunderstood. Heralding the glory and sacrifice of the Communist cause, the images that accompany the diatribe on the perpetrators of Vietnam, particularly in such places as the "War Remnants Museum", "The Revolutionary Museum", or the "Ho Chi Minh Trail Museum" are laden with photographs ironically taken by foreign media.

The government's careful recontextualization of such imagery increasingly lost in the popular obsessive adaptation of US, Korean, and Japanese styles of television soap opera, dance competitions and the near-nubile K-Pop and V-Pop stars that are currently rewriting the presumed traditional ideas of a national identity in Vietnam. Today the country's youthful population, which has inherited its parents' suspicion and fear of authority, is an increasingly savvy and entrepreneurial community with a gleeful dollar sign in its dream box, where narratives of the past are not consulted in its desire for the new. Vietnam's struggling economy needs this population's spirit for consumption to boost national assets and thus economic pursuits are given significant government approval, such permission keeping youthful aspirations limited to ideas of materiality, as opposed to challenging the methodologies of society, or the right to freedom of speech and civil liberties.

The 2007 World Development Report stated that more than half of Vietnam's population is younger than the age of twenty-five,[13] and despite the fact that the majority of this population lives in rural areas with limited

access to personal computers, a phenomenal number of people possesses smartphones. Cafe culture, with free Wi-Fi access, is prolific, and although there are still not enough young people who can read and speak English, they are very versant with the navigation of the 3G digital worlds. Patriotic in spirit, believing in the tropes of popular consumer trend, it is their love of the televised virtual interactive world and their adoption and reconfiguration of foreign trend that provided initial inspiration for the ongoing collaborative work of the Saigon-based artistic collective "The Propeller Group", consisting of three artists as members—Tuan Andrew Nguyen, Phunam, and Matt Lucero. Their ongoing project, *Viet Nam the World Tour* (www. VietNamTheWorldTour.com) uniquely challenges the content of social media as not only a high-art form but also as an archival database that can refresh the online searchable terms prescribed to theories of cultural identity and nationhood. This website declares that

> *Viet Nam the World Tour* is a rogue nation-rebranding campaign that appropriates marketing language, graffiti strategies, and viral video platforms to re-associate a historically colonized and mediated national identity with an entirely new mediated history.[14]

This artistic driven marketing campaign views the process of "collaboration" as a medium unto itself. Renowned choreographer and dancer Tony Tran from Los Angeles travels to Paris, taking his signature moves to the hallways of the Louvre; Afghani educator and graffiti artist Shamsia Hassani travels to Saigon to collaborate with El Mac from Los Angeles in the co-creation of a monumental mobile graffiti wall commissioned by the seventh Asia-Pacific Triennial of Contemporary Art in Brisbane, Australia. Here the trendy and the historical, the under-represented and the socially cultivated mingle in a visual statement that claims the virtual world as exhibition space to question the moniker of being "Vietnamese".

These projects are masterminded, curated even, by The Propeller Group, whose marketed identity as "Vietnamese" provides fertile ground for challenging the dilemma of what constitutes an identity, a nation, or a "brand" in an era where the diversity of the televised world *is* the reality we have come to intrinsically value. Embracing the worldwide community plugged to YouTube and Vimeo, The Propeller Group documents its collaborative campaigns by way of short films, music, dance clips, and merchandise that together form an online media platform, coined as a "movement". This project is subtly laced with the dilemmas of "movement" as a creative form that denotes the limit of style, as a political form arising from conflicting belief and thus exile or immigration, or as a social form as appropriation of foreign trend introduced by residual colonial relationships and the trade flows of global wealth—what these various "movements" create are subcultures of prime key marketing material, and it is this unique symbiotic relationship among commerce, history, and consumption that is increasingly challenging the archival record of what constitutes a "Vietnamese" identity today:

We were trying to design a campaign, similar to any other campaign that an advertising agency would create, that could simultaneously "re-brand" a national-identity and at the same time defunct the significance of what it means to have a national identity in the first place . . . we challenge ourselves to appropriate modern advertising strategies to somehow create a schism in this historical timeline . . . generationally, history hands down a huge and overpowering set of conditions that we have to deal with. These archives determine a lot of how one perceives their present realities. How does one intervene in that archive?[15]

Questioning the agenda and mode of constructions of history with its visual signposts (as monument or commercial campaign) that fabricate or manipulate the facts of the past; all such constructs of society are embraced yet are subtly challenged by San Art, Nguyen Thai Tuan, Dinh Q Le (see Figure 7.2), and The Propeller Group in their excavation of the present as an interdisciplinary process to which the virtual world is a critical tool of research, showcase, and dissemination:

Electronic media give a new twist to the environment within which the modern and the global often appear as flip sides of the same coin. Always carrying the sense of distance between viewer and event, these media nevertheless compel the transformation of everyday discourse.

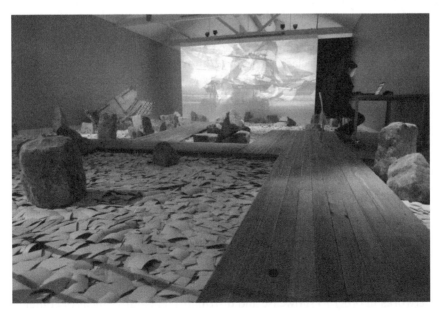

Figure 7.2 Dinh Q. Le, *Erasure* (2011). Single-channel, 2K HD color video with sound, 7:00 minutes; found photographs, clothing, stone, wooden boat fragments; computer, scanner, dedicated website: www.erasurearchive.net.

At the same time, they are resources for experiments with self-making in all sorts of societies, for all sorts of persons. They allow scripts for possible lives to be imbricated with the glamor of film stars and fantastic film plots and yet also to be tied to the plausibility of news shows, documentaries, and other black-and-white forms of telemediation and printed text. Because of the sheer multiplicity of the forms in which they appear (cinema, television, computers and telephones) and because of the rapid way in which they move through daily life routines, electronic media provide resources for self-imagining as an everyday social project.[16]

Although Vietnam's bandwidth is being increased and eager young minds are plugged as to how to economically take advantage of it through formulaic methods of advertising and PR, what requires greater consideration is the repercussion of fact and fiction mingling with little critical comparison or substantiation in an everyday self-imagining. How can we entice the same youthful zeal for popular culture toward historical awareness and critical cultural innovation? How can we demonstrate the advantages of the vast online database in order for them to better picture their own relationship between history, concept and form; to understand that their digital talisman is not only a communication relayer or image library but also as a device that links them to social memory?

In the Vietnamese government's urgent need for a skilled workforce (that is unfortunately not possible through its fledging educational system), it must reassess its prohibition of a self-imagining to be expressed by its diaspora on a local level. It must embrace the experiences of its diaspora, where boat refugees previously declared national traitors are relocating to their roots, where exiled literary and religious figures are reconnecting via international web journals, where the local wealthy are sending their children abroad and are returning with interdisciplinary skills—all of this movement of memory and knowledge is history grasped as a living archive, where the ghosts of the past linger in a network of blood and friendship. This "intimate" diaspora is enabled via the Internet and is not only encouraging a reconnection between loved ones but is also spurring the growth of a complex consciousness that weaves the imagined, the fabricated, and the authentic in a time continuum accepted as fact. In the confused capitalist context of Vietnam with its communist bureaucracy, the need for facilitation and interconnection of these intimate networks and their interdisciplinary communities is crucial.

In such a politically restricted society, it is incredibly important that the virtual highway be utilized as a tool and forum for promoting knowledge production. Organizations such as San Art must carefully use these intimate networks in order to showcase and distribute comparative ideas of contemporary art making; artists such as Dinh Q Le, driven by a consumption of mediated histories, perceive a social responsibility in building archives of culture as object and as a living connected community; the media-savvy

strategies of The Propeller Group challenge what it means to represent, to stand in for, to be a historical sign that signifies a truth. All of these artistic interventions and the global audience they entertain recognize the power of social ritual in the shaping of new knowledge with virtually connected communities and the complex role it plays in challenging local apathy and the jurisdiction of official red tape.

NOTES

1. In Vietnam, online news from international sources and social media tools such as Facebook are accessible except during time of political tension, such as the territorial disputes over the South China Sea or the national reelection of the National Assembly of Vietnam. There are, however, an increasing number of websites that have been shut down, or blocked, by the Vietnamese authorities.
2. "Independent" here refers to practices not financially supported by the Vietnamese Communist government.
3. The Ministry of Communication and Propaganda was established on January 1, 1946, by the then provisional government of the Union Democratic Republic of Vietnam. Since then, the title given to the department in charge of organizing culture, information and communication in the country has shifted several times to "Bureau of General Manager of Information", Communication' (March 2, 1946); "Bureau of Information from the Ministry of Home Affairs" (July 1951); "Bureau of Communication and Arts" (1952); "Ministry of Communication" (1954); "Ministry of Culture (the North) and the Ministry of Information-Culture (the South)" (1955); "Ministry of Culture and Information" (1977); "Ministry of Culture, Information, Sports and Tourism" (1990); "Bộ Văn hóa, Thể thao và Du lịch", *Wikipedia*, accessed July 4, 2013, http://vi.wikipedia.org/wiki/Bộ_Văn_hóa,_Thể_thao_và_Du_lịch.
4. The public local response to the exhibition seemed not to pay attention to the clear statement placed on San Art's website declaring that "[r]egrettably, the Cultural Ministry of Ho Chi Minh City, has asked San Art to remove the previous explanatory text that was here on Nguyen Thai Tuan's exhibition from San Art's website."
5. "Nhân bàn tranh Nguyễn Thái Tuấn, giới thiệu tranh LIÊN TRƯƠNG", *SOI*, accessed June 13, 2013, http://soi.com.vn/?p=53511.
6. The role of appropriation in postmodern art practice is not taught in Vietnam, whose art education system follows the French École des Beaux-Arts focus on the plastic arts. Awareness of conceptual practice and theories concerning the postcolonial subject are subsequently not taught, with the majority of libraries lacking cultural texts post-1954. This context is further exacerbated by the fact that foreigner and Viet Kieu are still not permitted to teach.
7. Seeking key strategic interdisciplinary relationships on- and offline is the only way forward for Sàn Art in Vietnam, for the more interconnected the projects, the larger the social repercussion should the government shut down activity.
8. In October 2012, the website Techinasia commented that Facebook had superseded the local social media Zing network with an estimated 8.5 million users with approximately one-third of its near 92 million citizens as users of the Internet. Steven Millward, "This Is Vietnam's Web in 2012, as Facebook Overtakes Zing in the Country", *TechinAsia.com*, October 17, 2012, accessed June 13, 2013, www.techinasia.com/vietnam-web-social-users-2012/.

9. San Art initiated and organizes "San Art Laboratory", the first critique-based "artist-in-residency" program in Vietnam where three Vietnamese artists are matched with a talking partner of interdisciplinary background over a six-month period in which they are expected to discuss, produce, and exhibit new work. This venue is also a key site for the holding of talks by foreign artists. It is a venue not registered with the authorities.
10. Le's art appropriates the aesthetic abstractions of cultural ritual—be that the obsession for Hollywood film that images a Vietnam constantly at war, or the street language composed of unusual sculptures as signs of informal economy, or of the fervor of a victorious football match where crowds of youth on bikes wave Vietnam's flag proudly around the mausoleum of Ho Chi Minh (a site strictly off-limits for gathering crowds otherwise). Compelled by the role and influence of mediated histories, through film, television, the Internet, and photography (that are ultimately politicized by the state and foreign scholar), Le is similarly drawn to cultural objects and forms of intrinsic knowledge as precursor to these industrialized mediums of culture.
11. The collection of much of this material is extremely difficult to authenticate, due to the plethora of copies created during wartime. The need to protect the original works from destruction or looters was cited as justification for the practice of producing and displaying forgeries.
12. Author conversation with artists, Ho Chi Minh City, March 2013.
13. United Nations, *World Development Report 2007: Development and the Next Generation* (Washington, DC: The International Bank for Reconstruction and Development/The World Bank, 2006).
14. Vietnam The World Tour, www.the-propeller-group.com/vntwt. Accessed June 13, 2013.
15. Tuan Andrew Nguyen, Phunam, and Matt Lucero, The Propeller Group, unpublished text, 2012.
16. Arjun Appadurai, *Modernity at Large: Cultural Dimensions of Globalization* (Minneapolis: University of Minnesota Press, 1996), 4.

8 Screen Ecologies
A Discussion of Art, Screen Cultures, and the Environment in the Region

Larissa Hjorth, Kristen Sharp, and Linda Williams

The Asia-Pacific region provides a salient regional example of competing and contesting global media practices and ecological politics. As one of the key producers and consumers of networked screen media, the region provides a compelling case study for understanding the intersection between art, screen media, and the environment. Indeed, references to "screen media/culture" in the region are synonymous with the convergence of mobile, social, and locative media. Although cross-cultural mobile media practices in the region have been explored,[1] as has the intersection between art and screen culture,[2] it is the crossroads between art, screen culture, and the environment that has been relatively overlooked.

Although environmental art has come to be regarded as a significant new agent in the massive cultural shifts occurring in response to global climate change,[3] there are also signs that it is being considered in more general accounts of regional environmental politics.[4] Moreover as environmental and associated political issues become more acute globally, screen media has come to play a progressively more pivotal role. The question of how effectively art and screen media will adapt as agents of social change in the context of rapidly escalating environmental deterioration, however, still remains to be seen. In this chapter we analyze the potential agency of that social nexus where screen media and art meet environmental politics in the region. We also consider some of its limitations and the social impediments to environmental resilience (also see Cubitt's chapter in this collection).

As a region, the Asia-Pacific has witnessed dramatic technological growth, and, in turn, ideological power, over the past two decades. Yet, due to its diversity, the Asia-Pacific is unevenly transforming its technological manufacturing sites to a constellation of soft power localities. Countries such as South Korea and Taiwan are no longer "developing" and instead are lead the world in mobile media innovation and adaption. Home to some of the most innovative mobile and social media practices, the region's use of social media for political and environmental issues is exemplary. From the protests against nuclear power after Japan's tsunami and nuclear disaster in March 2011 (known as 3/11) to the police deployment of Twitter around 2011 Queensland floods for crisis management,[5] screen-based media has become

the crucial conduit of information for environmental issues. In particular, screen media plays a pivotal role in deploying affective agency to galvanize community activism. Increasingly, screen culture has become synonymous with social, mobile media as a vehicle for political agency. So, too, artists and the general community deploy screen media as a way to speak about the environment and emergent agencies and politics.

The ways in which the environment is represented, discussed, and experienced has dramatically changed over the past decade with the rise of social, mobile media that epitomize "participatory" practices rather than "packaged" media.[6] Media practices are increasingly defined in terms of their "spreadability".[7] Once upon a time, mass media representation of ecological issues took the context of TV or print media. These mass media contexts provided little avenue for discursive debate and critique. This mediascape was discussed in Alison Anderson's *Media, Culture and the Environment* in which she explored how "packaged" news media presented stories about the environment to the public.[8] In particular, Anderson's interest focused on the process of new media reporting and what effect and affect this had on representations of ecological issue.

In the decade since Anderson's investigation—with the rise of "participatory" media such as mobile, social, and locative media—the ways in which ecological issues get discussed, presented, debated and revised has changed significantly. With increased capacities for dissemination, user-created content (UCC), and debate, networked screen media has played a pivotal role in how the environment is presented. Characterized by "vernacular" and "situated" creativity, networked camera phone practices and media like Twitter have allowed for more a user-centered mediascape that is as multiple and contested as it is dynamic and ever changing. In this mediascape, the "participatory" nature of contemporary screen-based media is amplified, for better or worse, in times of crisis. An example being the use of social media such as Twitter during and after the events of Tokyo 3/11 whereby some felt it functioned more like a conference than a conversation.[9]

Screen-based media, as the nexus for social, locative, and mobile media practices, has played a pivotal role in the representation, dissemination, and recontextualization of media and political events and in how we understand what constitutes a "public". This is particularly the case in terms of ecological issues. In the images of Japan's 3/11, it was the camera phone images and videos by everyday users that quickly spread across the world. Whereas packaged screen media such as television would have once shown official images, now networked screen media, often in the form of mobile media, provides contested, multiple, and conversational images. These networked visualities epitomized new forms of affect. In the wake of the political uprising known as the Arab Spring, and the more recent "women of the world against Islamic/Muslim Sharia law" protests via Facebook along with various ecological disasters such as the Indonesian earthquake and widespread tsunami of 2004, networked screen media played not only a key role in

depicting and disseminating events but also in creating highlighted registers of affect. As one of the most ubiquitous and intimate devices[10], mobile media amplify inner subjectivities as they do reflect political agencies.

After the events of 3/11, it was mobile social media that provided the world with multiple and contested platforms and debates. Mobile social media such as Twitter, Foursquare, mixi, and Facebook not only kept the world informed about the unfolding of the events but also created media affects and platforms for global debates about nuclear power. It was mobile social media that helped counter-publics and local lobby groups gain a global stage in the face of governmental hegemony. It was mobile social media that artists turned to as both a context and content for creativity and for engaging with environmental issues.

In China, where politics and media have long been the focus globally for debates around democracy, artists such as Ai Weiwei, Yongliang Yang, and Cao Fei have been quick to adapt frequently conflicted mediascapes to explore issues about politics, the environment, and creativity. Ai is famous for using Western media such as Twitter and Facebook, banned in China, to generate debate and discussion about China (see Kataoka's chapter in this collection). In Shanghai—a city dominated by screens devoted largely to advertising—the China Environmental Protection Foundation–funded artist Yang to produce an environmental art video *Shan Shui*, which was screened in Shanghai's People's Square subway station. Yang adapted traditional *Shan Shui* landscape painting into a contemporary context by exploring the impact of pollution and global climate change. This work may now be accessed on handheld screens along with other examples that can be accessed globally on YouTube.[11] Meanwhile, Beijing-based artist Cao Fei has used the global domain of Second Life as a performative space in which her avatar traverses transnational popular culture imaginaries to reflect on debates around media, culture, and the environment.

In Australia, various art networks have played key roles in local, regional and global conversations around art, screen-based/online media, and the environment. As home to the region's first green political party (save the Lake Pedder party in 1970) and the formation of the globally influential Greenpeace in 1971, Australia is indicative of the diverse practices around art, screen media, and the environment in the region. Examples such as Greenpeace Australia's online game Ocean Apocalypse, ad-busting videos such as "Reject John West", or in other sites such as Tuvalu Climate Change SOS, Australia has played a key role in marrying environmental politics, new media and art in the region. Many Australian artists exhibit works online drawing attention to local ecological issues, whereas emerging Australian artist Josh Wodak has adapted his new media art practice to draw attention to the threat of rising sea levels to Pacific Islands such as Tuvalu (see Figure 8.1).

Another key Australian site initiating dialogue around environmental issues in the Asia Pacific is the conduit for information on the *Spatial*

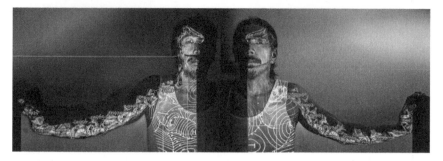

Figure 8.1 2 Degrees of Separation 2028: Akira from the series *when I was a buoyant* (2012).

Source: Josh Wodak.

Dialogues: Public Art and Climate Change project. Although based on the question of the varied impact of climate change in Melbourne, Shanghai, and Tokyo, this project focuses on how artists in these three cities explore the environmental and cultural significance of water through art and media practice. The Australian Network for Art and Technology (ANAT) has also been an active player in the new media screen, often intersecting with debates around the environment. In 2012 ANAT collaborated with the Melbourne based Carbon Arts for "ECHOLOGY: Making Sense of Data" competition and signaled the growing significance of public art and real-time screen media to engage with issues of sustainability. From Natalie Jeremijenko's *Mussel Choir*—a biological artwork deploying a mussel colony movements as a way to understand water-quality improvements in Victoria Harbour—to DV Rogers *Terra Sensing Tower*, the role of art and screen-based cultures to speak about local, regional, and global environmental issues was unmistakable. Increasingly, screen-based media globally has become a conduit for emergent politics and affective agency.

In Taiwan, the impact of rapid technological progress has caused many artists and activists to consider the role of art as a vehicle for ecological debate. One example is the *Cheng-Long Wetlands Environmental Art Project*, now is in its third year. Over this time, the role of social and mobile media has increasingly played a role in not only disseminating information and visibility, but also in creating a context for creativity and debate. In 2012, Taiwan-based curator Jane Ingram Allen organized a touring exhibition of Taiwanese environment art titled *Going Green*. For Allen, the emergence of environment art has grown dramatically in Taiwan as it tries to reconcile its rapid rise into twenty-first-century modernity and the impact of technological progress on the landscape. With Taiwan epitomizing the new emergent middle class of the region, its focus on intersections between ecology, art, and screen culture represent a new knowing and political activism. Taiwan is not alone.

Key scholars in the region such as Beng Chua Huat and Michael Curtin have been quick to identify the specificities of the region's contesting mediascapes.

With the rise of mobile media and attendant forms of participatory and user-created content, we see the region's multidirectional media flows become more nebulous and complex across production and consumption nodes. As Curtin notes in his discussion of shifts in TV studies towards new participatory patterns media flows and historical informed cultural geographies of television, a notion like "media capital" might provide a useful rubric for understanding contemporary media flows across contesting localities. Curtin states that

> These new patterns of flow should not be construed as multilateral in the conventional sense, since they do not involve the exchange of programming between sovereign states. Instead these flows emanate from particular cities that have become centers for the finance, production, and distribution of television programs; cities like Bombay, Cairo, and Hong Kong. One might refer to these cities as media capitals, since they represent centers of media activity that have specific logics of their own; ones that do not necessarily correspond to the geography, interests or policies of particular nation-states.[12]

The media cartography provided by mobile media creates another layer on Curtin's notion of media capital. Consider the phenomenal rise of the iPhone in the region and subsequent backlashes against Apple once the realities of its inhumane employment conditions at Foxconn became apparent.[13] In Seoul, the introduction and rapid uptake of the iPhone presented an ideological challenge to the supremacy of local brands such as Samsung. The scenario was dubbed the "iPhone shock" and created reverberations across the local industry.[14] In both South Korea and Japan, where governmental regulations foster local mobile media industry to blossom locally and globally, the iPhone presented a new challenge to the makeup of mobile media transnational flows in the region at both production and consumption levels.[15]

Although the mobile phone has long operated as a poignant symbol of emergent lifestyles,[16] it is only recently that the material and immaterial dimensions of mobile media in the region have played out through consumption practices.[17] As the region's diverse localities translate their technological powers into ideological prowess, we witness the rise of a new middle class. Accompanying the growth of the burgeoning middle class are new forms of ethnical consumption in which the ecological aspects of both production and consumption come to the forefront.[18] Moreover, as social, mobile media become a key vehicle for political expression and unrest, how ecological events are being depicted and debating is changing—especially in art.

As pivotal sites for urban screens and mobile media, the region provides compelling case studies for divergent and localized models of public media and the political in response to global environmental change. Although recent urban screen cultures have emerged as a lens for analyzing contemporary life[19] and media such as film have provided a vehicle for understanding

ecological concerns[20], little has been done to reflect on the relationship between art, networked media, and climate change. Taking the divisive argument about new online media—whereby users are either exploited in the "social factory" of information and communication technology (ICT) or are "co-curators"[21] in new forms of creative and social labor—we argue that emergent avenues for artists and theorists are reconceptualizing these relationships. In sum, in an age when the social is conflated with social media there is a need to reconnect the politics of social change and the environment through networked and art practice. As Geert Lovink notes, social media is often conflated with "social".[22] This problematic conflation, for Lovink, empties the social of its political and historical complexities.

Through the cross-cultural, cross-screens (public and private, mobile and immobile), and cross-disciplinary collaborations between artists, cultural theorists, and activists, we can gain insight into the processes, limitations and experiences of such models of creative and social labor. Taking the discussion of Nikos Papasterigiadis and others about the changing nature of collaboration in light of growing "cosmopolitanism"[23] as a starting point, we argue that one can find numerous successful and less successful examples of collaboration around ecological and mobile media art practices in the region.

WHY THE ASIA-PACIFIC?

The shifting face of China over the past decade from center for technological manufacturing to one of the world's key players in ideological prowess or "soft power"[24] can be viewed as reflective of the region's dynamic and uneven shift into twenty-first-century modernity. In this imaginary, we can see various contesting social, cultural, economic localities. From each locality, the region looks different. In Australia, through the political imaginaries of Paul Keating, "Asia-Pacific" was undoubtedly a precursor to the "Asian Century" rubric. Through the lens of mobile media, the cartographies of the region take a particular form that can be useful in reconceptualizing the region away from conventional and simplistic geographies and toward complex maps about place as an entanglement of various lived and imagined ideas and emotion.[25] Through screen cultures, we can gain insight into the region's rapid urbanization, which has also become home to the greatest number of climate change disasters.[26]

As noted in a previous study by Hjorth,[27] through the lens of new technologies—specifically mobile technologies—the region is noted not only for its rapid economic and technological growth but also for becoming a powerful cultural index globally. This rise in the global currency of "Asia" and the resurgence of new forms of regionalism and cultural proximity are, as Taiwanese cultural theorist Kuan-Hsing Chen warns,[28] a phenomenon to be wary of, especially because they may signify the reemergence of old colonial and imperialist agendas. This image and practice of "consuming Asia"[29] reflects not only the divergent models for consumption in the region but also the way the Asia-Pacific is imagined globally. The intensification of

transnational capital in the region is concisely diagnosed by Leo Ching as a conflation between consumerism and emerging forms of Asian modernity.[30] As Ching surmises, "Asia has become a market, and Asianness has become a commodity circulating globally through late capitalism".[31] The concept of the region as an imperial compression of various cultural identities and histories has come under much scrutiny particularly in the case of the "shrinking of the Pacific"[32] connoted by the Asia-Pacific region.

In art, Asia-Pacific has achieved significant attention through the rise of regionally focused art biennales and triennales such as the Asia-Pacific Triennale, Yokohama Triennial, the Gwangju Biennale, and the Shanghai Biennale particularly since the 1990s. These have been accompanied by debates regarding the conflation of art and political economy and the role of art in globalizing national identity,[33] which echoes discourses surrounding world expositions in the late nineteenth and early twentieth century. However, the foundation of these biennales in early 1960s through the 1970s models, such as Fukuoka, was indicative of "local experimentation" that was a central part of the new, intercultural networks that were developing amongst regional cultures. In this context, biennales were to be a counterforce of globalization and Western hegemony.[34] For Gardner and Green (see their chapter in this collection), this movement saw biennales shift from local experimentation to *global legitimation* where

> the "world art" model of cosmopolitanism developed a strange, vampiric afterlife, in which the conflict was temporarily resolved through the mutually parasitic, symbiotic importation of "global" cultural knowledge by the singular, auteur, globe-trotting curator.[35]

Although the biennale model has come under scrutiny and debate for replicating older models of colonial and Eurocentric structures or colluding with economic and political national aspirations, regional networks have offered significant opportunities for artists beyond national borders.[36] Such examples include Utopia@Asialink, SA BASSAC in Cambodia, and San Art in Vietnam as discussed in other chapters in this collection. These new platforms emphasize art as knowledge production and have become critical hubs for social and political discourse, including the environment, offering alternative structures for the public to engage with art. These hubs become key sites for both domestic and international interest in contemporary art. Such platforms are important geopolitical nodes in the circulation of art. They are also playing a critical role in the reimagining of the region emphasizing collaborative and cross-institutional interactions. Such structures are leading the way for the rest of the world, often weighted down by conventional gallery structures and institutions, in terms of residency, funding, and exhibition models. They facilitate a more adaptable and flexible approach to art, encouraging social engagement and political participations.

The Boat People Association (BPA) in Tokyo, Japan is one such example. Managed by artists, architects, and activists, the BPA works with local communities and public civic institutions to encourage reflection on the urban

environmental context, in particular the social, physical, and economic ecologies of Tokyo's river system. In 2013, the BPA collaborated with the Australian-based *Spatial Dialogues* project on *Underground Streams* to create a temporal space for a range of site-based video, sound, online, performance, and socially engaged artworks. The site for the work was a shipping container located in public park on Meiji Dori in Shibuya, one of Tokyo's major entertainment and shopping areas. The artworks for this event focused on the changing urban environment and the way that Tokyo rivers, such as Shibuya-gawa, have been redirected underground.

Keitai Mizu, one of the works in the project, took the form of a mobile game in the form of a treasure hunt for various aquatic creatures and objects referencing the environmental history of the site. For *keitai mizu* (mobile phone water), Hjorth asked a series of Australian and Japanese artists to respond to this overlay between cartography and water by making water creatures. Artists made local and foreign, real and imaginary, representational and abstract creatures that were then placed (and hidden) around the Shibuya Park. The aim was for the players/participants to photograph and send via Instagram to the *keitai mizu* Twitter account as many local water creatures as possible in fifteen minutes. They "captured" the art with their camera phones, and shared it online on Twitter (@keitaimizu) or Instagram (username: keitaimizu). The mobile game used two of the most used apps in Tokyo: Instagram and Twitter.

Figure 8.2 Keitai Mizu (2013). Site-specific mobile game made for a post 3/11 Tokyo. *Keitai mizu* was part of *Shibuya: Underground Streams*, June, 2013.
Source: Courtesy of Larissa Hjorth.

Keitai mizu sought to also make players aware that they were walking on water as well as exploring the limitalities of art/nonart, ethnography/non-ethnography, and local/outsider. Players moved around the everyday park through their lens of their *keitai* (phones). By utilizing Twitter, this project sought to employ a key mode of mobile media and political activism in Japanese everyday life. Participants became both artists (photographers) and ethnographers in uncovering the various hidden aspects. Like many location-based games, *keitai mizu* blurred the gamic "magic circle" with many innocent bystanders becoming involved both offline and online (via Twitter and Instagram feeds). *Keitai mizu* also emphasized the role of play both inside and outside the official space of the game.

Rethinking the role of community and collaboration has become a key mode for rethinking relationships between art, screen media, and the environment. The art projects mentioned so far can be situated into an open-ended interpretation of "intimate" and "mobile" publics. Where communities and publics are brought together, often through social media platforms, to a common space. These emerging spaces for contemporary art practice are responsive to their immediate context and the challenges and opportunities they afford. Such spaces include galleries, and their role in the region in generating offline and online critical discourse offers a site to reconsider the identity of institutions. For San Art director Zoe Butt, the art gallery provides a space in which to question Vietnam's highly regulated online environment.[37] For Butt, San Art provides a context in which artists can explore politics and creativity in which the online is in dialogue with the offline. These spaces are important sites of knowledge production and consumption for contemporary art in the region and for understanding new networks across local, national, regional and global spaces.

Just like the shifts and historical rewritings of art in the globalized context of biennales, the region has experienced many revisions and reconceptualizations. Once a discursive geopolitical rubric, the Asia-Pacific—as a site for contesting local identities and transnational flows of people, media, goods, and capital—has come under much radical revision and reconceptualization.[38] This has led theorists such as Robert Wilson and Arif Dirlik to utilize "Asia/Pacific" as "not just an ideological recuperated term",[39] but as an imagined geopolitical space that has a double reading as both "situated yet ambivalent".[40] Specifically, the diverse and perpetually changing interstitials constituting the Asia-Pacific have been repositioned as a contested space for multiple forms of identity. Far from the 1970s' widely held view of the region as being a bloc of satellite "newly industrialized countries" (such as Taiwan and South Korea) oscillating around the region's first industrial nation, Japan, we now see a profoundly different picture.

In this formation of shifting peripheries and emerging centers such as China,[41] screen culture takes on particular significance. This scenario is

presciently depicted in Robison and Goodman's *The New Rich in Asia*,[42] which identifies the mobile phone as an index for increasingly common transnational consumption and new narratives of modernity in the region. With the arrival of the mobile phone coinciding with the rise of the Asia-Pacific, the mobile phone became a poignant and "rich" signifier for analyzing local and transnational formations. However, behind the powerful symbol of the mobile phone lies a story about the emergence of localized practices enacted by actual users.

Emergent screen cultures require us to redefine notions of public and intimacy against increasingly complex notions of place. Location-based services such as Google Maps and geo-tagging have become an integral part of the convergence between mobile and social media that are shaping, and being shaped by, notions of place. Replacing the navigation of place from paper to digital maps has transformed how we experience and conceptualize online and offline relationships across public and private realms. The rise of mobile and networked media has highlighted the inadequacies in definitions of place[43] and the need for more robust understandings. We see place as, according to human geographer Doreen Massey, a collection of "stories-so-far".[44] The work of human geographer Tim Ingold is also useful in understanding place as something dynamic and evolving through the notion of "entanglement".[45] This conceptualization of place a series of entanglements is a productive way of seeing the region's various and contested cultural, economic, social, and linguistic cartographies.

In the *Spatial Dialogues* example, the meaning of place is viewed as a collection of stories-so-far. Although a project such as the aforementioned *Underground Streams* is responding to a specific geographic site, the way that the project is interacted with online and through a variety of offline iterations (artworks and activities spread across the region) opens the way that place can be understood as geographic, historical, imagined, experienced, and psychological. These multiple and contesting meaning of place becomes apparent when exploring the environmental transformations that are being experiences across the region—especially through extreme weather events and through urban restructuring.

A social media, environmental, and art cartography of the Asia-Pacific not only signposts new overlays between the electronic and the geographic, online and offline, and public and private but also operates as a metaphor for reimagining the region. For some, the rubric of "Asia-Pacific" is too problematic to be useful, with its vexed geopolitical histories and significant internal variations, and instead, they opt for viewing the region as part of a broader twenty-first-century notion of the "global south".[46] However, part of our interest in continuing to use "Asia-Pacific" is that it is a marker of a particular time and of politics that informs the particularities of social, mobile, and locative media. By exploring the region through notions such as "intimate publics" and eco-critique we seek to expose some of the multiple,

contesting identities and localities. At the intersection between screen culture, art, and the environment, the region provides a fascinating, contested, and overlooked case study. But we now need to turn to the dynamic realm of screen cultures that we see as synonymous with mobile, social, and locative media, which also requires we sketch the meeting of definition art and media practice, in the region.

SCREEN CULTURES: A MEETING OF MOBILE, SOCIAL, AND LOCATIVE WORLDS

While nineteenth-century narrations of the urban were symbolized by the visual economics of Charles Baudelaire's *flâneur* (the wanderer of the modern city), the twenty-first-century wanderer of the informational city has been rendered what Robert Luke calls the "phoneur".[47] The conceptual distance, and yet continuum, between the *flâneur* and the phoneur is marked by the paradigmatic shift of the urban as once a geospatial image of, and for, the bourgeoisie, as opposed to the phoneur, who sees the city transformed into informational circuit in which the person is just a mere node with little agency. Beyond dystopian narrations about the role of technology in maintaining a sense of intimacy, community, and place, we can find various ways in which the tenacity of the local retains control. In particular, through the intersection between mobile media, art and the environment, we can see how the local and the urban can be reimagined in new ways.

The ecology of screen cultures over the past decade has witnessed a dramatic transformation away from twentieth-century packaged media such as billboards and television to networked mobile media. As Scott McQuire, Meredith Martin, and Sabine Niederer note in The *Urban Screens Reader*, urban screens have become the key space for struggles over "public culture and public space".[48] The emergence of urban screens has accompanied the rise of mobile media ubiquity, creating a tension between online and offline and public and private cultures and spaces. This tension also reflects a move away from packaged to participatory media. This shift is also discussed in more detail in Nikos Papastergiadis, Scott McQuire, Amelia Barikin, and Audrey Yue's chapter on "Public Screens and Participatory Public Space" in this collection.

From camera phones to conversational, micro-narrative social media such as Twitter, the intimate and everyday has become key in contemporary media practice. Notions such as "public" and "audiences" have been radically transformed to reflect the intimate micro-narratives of user-created content that now dominates contemporary mediascapes. As one of the most ubiquitous and yet personal media, mobile media has shifted how we traverse places as well as eroding dichotomies such as public/private, online/offline, and work/leisure. But they have also signaled how art practice, screen culture, and politics are changing.

Despite the region encompassing some of the key consumers of social and mobile media, it has only recently gained focus.[49] Accounts of Indonesia being the second-largest market for Facebook and the third-largest market for Twitter,[50] coupled with the tremendous growth of China's mobile phone Internet—whereby hundreds of millions of rural workers are getting online[51]—attract little analysis as to what these types of practices reflect about culture, sociality, and how localities inform media practices. Behind Facebook's popularity in the US and in much of the West, a different picture appears, in which Facebook is yet to gain the stranglehold that the "network effect" provides. The Asia-Pacific boasts some of the oldest models of social and mobile media, such as South Korea's Cyworld minihompy (now overtaken by Kakao), and China's QQ. It also provides a relatively long history of the political dimensions for social and mobile media.

Although screen cultures—as a nexus for social, locative, and mobile media—we can begin to sketch different contexts for communication, media practice, and agency. Drawing on Nick Couldry recent work, *Media, Society, World*, we argue that "contemporary digital media are in crucial ways 'underdetermined' ".[52] In particular, we echo Couldry's concerns that "[c]hanges in the communication infrastructure we call 'media' have always resulted from the intersections between technological, economic, social and political forces".[53] In these emergent media spaces, McQuire's notion of "relational space"—to describe the media's role in shaping the "contours" of everyday experience and social space[54]—can be useful. This sense of emergent and nascent spaces is key when considering the intersection of screen media, art, and environment. The contours and textures created by mobile media affects take a particular shape in the context of the region with its emergent middle class. In this media cartography, how art, screen culture, and the environment are entangled plays into various contesting localities.

Mobile media also allows for responsive and adaptive content, which far exceeds the often weighty and slow-moving capacity of many art institutions, something that is vital when addressing environmental issues. Online artists are also able to present work as process, which is particularly important with the rise of socially engaged and collaborative art practices in the region. For example, in the *Underground Streams* project, artists and audiences were able to access works as they occurred through live streaming and use of mobile media to capture performances and workshops.[55] Twitter and Instagram were used for online audiences to participate as well as onsite audiences. These types of media also facilitate transnational collaborations enabling artists to work together on projects across geographic spaces. This type of participation encourages an "anyplace" type of process and interaction while also engaging with site specificity (Shibuya-gawa in this instance).

Home to a large percentage of global mobile media production and consumption, the Asia-Pacific region redefines practices of screen culture and

their relationship to the environment and politics. In the region, "screen culture" and "screen media" have become synonymous with mobile media. It represents a convergence among social, locative, and mobile media. Mobile media provides the context for making, sharing, and participating in much of the everyday. So how do mobile media, as synonymous with screen culture in the region, resituate a sense of public culture and emergent visualities?

PICTURE THIS: MOBILE MEDIA, ART, AND INTIMATE PUBLICS

One of the early examples of networked social media came from the mobile phone as it graduated from extension of the landline to multimedia device par excellence. They are indeed one of the most intimate devices—storing both materially and symbolically a wealth about the user's personal life. This personal life is as easily distributed as it is divested of context—think of how text messages can be misinterpreted or even missent. Applications such as the camera phone have both heralded a new type of user-led journalism and media practice as well as being the tools for cyber bullying and youth narcissism. Camera phone practices amplify the local, highlighting the divergent ways in which public, private, and the personal are being reconfigured.

With the rise of high-quality camera phones, accompanied by the growth in in-phone editing applications and distribution services via social and locative media, we are witnessing new types of co-present visuality. In the first series of studies in camera phones by the likes of Mizuko Ito and Daisuke Okabe,[56] they noted the pivotal role played by the three S's—sharing, storing, and saving—in informing the content of what was predominantly "banal" everyday content.[57] As camera phones become more commonplace in the explosion of smartphones—along with new contexts for image distribution such as micro-blogging and location-based services (LBS)—emergent types of intimate visualities are overlaid onto place as part of user's personal journeys and forms of self-expression. These new cartographies are intimate and mobile as they are visual.

On the one hand, the issues raised by camera phone practices echo earlier debates around the digital/analogue in which questions surrounding amateur and professional paradigms are questioned and challenged.[58] They suggest a democraticization of media, affording those who once could not afford digital cameras cheap and convenient alternatives. In Seoul, women who were previously not interested in photography are developing a passion that aspires towards the professional.[59] On the other hand, camera phones present new issues that reconceptualize the ambivalent and transitory role of "context", in which context informs content to such a degree that the potential for a-contextualizing increases. Context as content, once the mantra of Minimalism, has taken on new dimensions within social media. As expert danah boyd notes, social media sees a collapse of various contexts.[60] For social media

users, this either means applying new forms of etiquette about collapsing public and private, work and leisure boundaries, or creating artificial boundaries (i.e., different accounts for various publics like family, work, and friends).

As camera phones become more commonplace in the rise of UCC technologies, the ways in which the personal are negotiated through the public and private spheres are being transformed. The politics of self-presentation, self-portraiture, and self-expression all get a workout within the realm of camera phone practices. Far from mere narcissism, we see that these practices are part of broader media literacy and etiquette.[61] So, too, within online community spaces such as Flickr, strangers and intimates are sharing images and comments (both aesthetic and technical)[62] that suggest that new visualities are ordered by a "situated creativity".[63] A prominent example is Ai's use of social media to carefully construct and disseminate a public persona, arguably for an international rather than local artworld/art market (especially given local Chinese are not allowed to access Western social media like Twitter, which is Ai's preferred media). In such a space, he is able to extend and communicate directly with his public beyond the mediations of art institutions, government institutions, and dealers. However, such examples currently represent exceptions rather than the rule within the professional art world.

Moreover, with the rise of locative media such as Foursquare and Facebook Places becoming an integral part of mobile and social media practice, how place and intimacy is narrated through camera phone images is changing. This, in turn, has an impact on the relationship between art, screen culture, and the environment. We are witnessing an erosion between simplistic amateur versus professional divisions. This highlights the context for examining creative practice, which has dramatically altered in a number of ways that are intimate, vernacular, sociocultural, and geographic. These intimate publics take the form of emergent cartographies that overlay the geographic and physical space onto an electronic position and relational presence, which is emotional and social.[64]

CONCLUSION

In this chapter, we have reflected on the divergent examples of art, screen cultures, and the environment in the region. In light of Asian Development Bank (ADB) predictions that current environmental problems in the region—the worst in the world—will only continue to rise, this chapter has suggested the need for further discussion and debates the region's past, present, and future. If we see the region as a series of overlaid and contested historical, social, cultural, technological, and linguistic cartographies, engaging with publics is, as now "intimate publics" entails, taking on increasingly mobile and micro gestures, we need to consider how art and the environment can provide insight into key problems.

NOTES

1. Larissa Hjorth, *Mobile Media in the Asia-Pacific: Gender and the Art of Being Mobile* (London and New York: Routledge, 2009).
2. Scott McQuire and Nikos Papastergiadis, eds., *Empires, Ruins + Networks: The Transcultural Agenda in Art* (Melbourne: Melbourne, University Press, and London: Rivers Orams Press, 2005); and Scott McQuire, Meredith Martin, and Nikos Papastergiadis, "Large Screens, Cultural Creativity and the Global City", in *Asian Design Culture*, ed. William Lim (Singapore: AA Asia and Singapore Design, 2009), 43–53.
3. Linda Williams, "Reconfiguring Place: Art and the Global Imaginary", in *The Sage Handbook of Globalization*, ed. Manfred Steger, Paul Battersby, and Joseph Siracusa (London, Sage Publications, 2014), forthcoming.
4. Verity Burgmann and Hans Baer, *Climate Politics and the Climate Movement in Australia* (Melbourne: Melbourne University Press, 2012), 177.
5. Axel Bruns, Jean Burgess, Kate Crawford, and Frances Shaw, *#qldfloods and @QPSMedia: Crisis Communication on Twitter in the 2011 South East Queensland Floods* (Brisbane: ARC Centre of Excellence for Creative Industries and Innovation, 2012).
6. Henry Jenkins, *Convergence Culture: When Old and New Media Collide* (Cambridge, MA: MIT Press, 2006).
7. Henry Jenkins, Sam Ford, and Joshua Green, *Spreadable Media*: *Creating Value and Meaning in a Networked Culture* (Cambridge, MA: MIT Press, 2013).
8. Alison Anderson, *Media, Culture and the Environment* (London: Routledge, 1997).
9. Larissa Hjorth and Yonnie K.H. Kim, "The Mourning After: A Case Study of Social Media in the 3/11 Earthquake Disaster in Japan", *Television & New Media* 12, no. 6 (2011): 552–59.
10. Leopoldina Fortunati, "Italy: Stereotypes, True and False", in *Perpetual Contact: Mobile Communications, Private Talk, Public Performance*, ed. James .E. Katz and Mark Aakhus (Cambridge: Cambridge University Press, 2002), 42–62.
11. *Shan Shui*, YouTube video, DATE, accessed August 6, 2013, www.youtube.com/watch?v=b-2ZOP4bTqI; and *Shan Shui*, YouTube video, DATE, accessed on August 6, 2013, www.youtube.com/watch?v=9SafpMeoexw.
12. Michael Curtin, "Media Capital: Towards the Study of Spatial Flows", *International Journal of Cultural Studies* 6, no. 2 (2003): 202–28 (204).
13. Jack L. Qiu, "Network Labor: Beyond the Shadow of Foxconn", in *Studying Mobile Media Cultural Technologies, Mobile Communication, and the iPhone*, ed. Larissa Hjorth, Jean Burgess, and Ingrid Richardson (London/New York: Routledge, 2012), pp. 173–89.
14. Dong-Hoo Lee, "'In Bed with the iPhone': The iPhone and Hypersociality in Korea", in *Studying Mobile Media*, 63–81.
15. Larissa Hjorth, Jean Burgess, and Ingrid Richardson, eds., *Studying Mobile Media: Cultural Technologies, Mobile Communication, and the iPhone* (London and New York: Routledge, 2012).
16. Richard Robison and David S.G Goodman, eds., *The New Rich In Asia: Mobile Phones, McDonalds and Middle-Class Revolution* (London: Routledge, 1996).
17. Hjorth, *Mobile Media in the Asia-Pacific*.
18. Tania Lewis and Emily Potter, eds., *Ethical Consumption* (New York: Routledge, 2010).
19. Scott McQuire, Nikos Papastergiadis, and Sean Cubitt, "Public Screens and the Transformation of Public Space", *Refractory: A Journal of Entertainment*

Media 12 (2008), accessed May 20, 2013, http://refractory.unimelb.edu.au/2008/03/06/public-screens-and-the-transformation-of-public-space/; Nikos Papastergiadis *Spatial Aesthetics, Art, Place, and the Everyday* (London: Rivers Oram Press 2006); Nikos Papastergiadis, *Cosmopolitanism and Culture* (London: Polity Press 2012); and Scott McQuire, Meredith Martin, and Sabine Niederer, eds., *The Urban Screens Reader* (Amsterdam: Institute of Network Cultures, 2009).

20. Sean Cubitt, *EcoMedia*, Google eBook (Amsterdam: Rodopi, 2005).
21. Sal Humphreys and John Banks, "The Labour of User Co-Creators", *Convergence* 14, no. 4 (2008): 401–18.
22. Geert Lovink, *Networks without a Cause: A Critique of Social Media* (Cambridge, UK: Polity Press, 2012).
23. Papastergiadis, *Cosmopolitanism and Culture.*
24. David Nye, *American Technological Sublime* (Cambridge, MA: MIT Press, 1994).
25. Hjorth, *Mobile Media in the Asia-Pacific.*
26. Asia Development Bank, "Economics of Climate Change in East Asia", 2012, accessed October 20, 2013, www.adb.org/news/03-gdp-would-protect-east-asia-climate-change-adb-report.
27. Hjorth, *Mobile Media in the Asia-Pacific.*
28. Kuan-Hsing Chen, ed., *Trajectories: Inter-Asia Cultural Studies* (London and New York: Routledge, 1998), 27.
29. Beng-Huat Chua, ed., *Consumption in Asia* (London: Routledge, 2000).
30. Leo Ching, "Globalizing the Regional, Regionalizing the Global: Mass Culture and Asianism in the Age of Late Capital", *Public Culture* 12, no. 1 (2000): 233–57.
31. Ibid., 257.
32. Robert Wilson, "Imagining 'Asia-Pacific': Forgetting Politics and Colonialism in the Magical Waters of the Pacific. An Americanist Critique", *Cultural Studies* 14, no. 3/4 (2000): 562–92 (565).
33. See Gardner and Green's chapter in this collection.
34. Ibid.
35. Ibid.
36. Francis Maravillas, "Cartographies of the Future: The Asia-Pacific Triennal and the Curatorial Imaginary", in *Eye of the Beholder: reception, audiences and practice of modern Asian Art*, ed. John Clark, T.K. Sabapathy, and Maurizo Peleggi (Sydney: Wild Peony Press, 2006), pp. 244–270; and Asia Art Archives et al., "The And: An Expanded Questionnaire on the Contemporary", in Field Notes Issue 01, 2011, accessed June 20, 2013, www.aaa.org.hk/Fieldnotes/Details/1167.
37. See Butt's chapter in the collection.
38. Giovanni Arrighi, *The Long Twentieth Century: Money, Power, and the Origins of Our Times* (New York: Verso, 1994); Giovanni Arrighi, Takeshi Hamashita, and Mark Selden, eds., *The Resurgence of East Asia: 500, 150 and 50 Year Perspectives*, Asia's Transformations Series (London: Routledge, 2003); Arif Dirlik, "Global South: Predicament And Promise", *The Global South* 1, no. 1 (Winter 2007): 12–23; and Robert Wilson, "Imagining 'Asia-Pacific' ".
39. Robert Wilson and Arif Dirlik, eds., *Asia/Pacific as Space of Cultural Production* (Durham, NC: Duke University Press, 1995).
40. Wilson, "Imagining 'Asia-Pacific' ", 567.
41. Arrighi, *The Long Twentieth Century*; and Dirlik, "Global South".
42. Robison and Goodman, *The New Rich in Asia.*

43. Rowan Wilken and Gerard Goggin, "Mobilizing Place: Conceptual Currents and Controversies", in *Mobile Technology and Place*, ed. Rowan Wilken and Gerard Goggin (New York: Routledge, 2012), 3–25.

44. Doreen Massey, *For Space* (London: Sage, 2005).

45. Tim Ingold, "Bindings against Boundaries: Entanglements of Life in an Open World", *Environment and Planning A* 40 (2008): 1796–1810.

46. Arif Dirlik, "Global South"; and Richard Ling and Heather Horst, eds., "Mobile Communication in the Global South", *New Media & Society* 13, no. 3 (2011): 363–374.

47. Robert Luke, "The Phoneur: Mobile Commerce and the Digital Pedagogies of the Wireless Web", in *Communities of Difference: Culture, Language, Technology*, ed. Peter Trifonas (London: Palgrave, 2006), 185–204.

48. McQuire, Martin, and Niederer, *The Urban Screens Reader*.

49. Gerard Goggin and Mark McLelland, eds., *Internationalizing the Internet* (London: Routledge, 2009); Hjorth, *Mobile Media in the Asia-Pacific*; and Mark McLelland, "Socio-Cultural Aspects of Mobile Communication Technologies in Asia and the Pacific: A Discussion of the Recent Literature", *Continuum* 21, no. 2 (2007): 267–77.

50. Yanuar Nugroho and Sofie Shinta Syarief, *Beyond Click-Activism? New Media and Political Processes in Contemporary INDONESIA*, fesmedia Asia series (Jakarta: Friedrich-Ebert-Stiftung, 2012), accessed July 10, 2013, www.fes.de/cgi-bin/gbv.cgi?id=09240&ty=pdf.

51. China has 564 million Internet users, of which 420 million access the Internet via mobile phones; China Internet Network Information Center (CNNIC), *The 31st Statistical Report on Internet Development in China* (Beijing: CNNIC, 2013), accessed June 10, 2013, www1.cnnic.cn/IDR/ReportDown loads/201302/P020130312536825920279.pdf.

52. Nick Couldry, *Media, Society, World: Social Theory and Digital Media Practice* (London: Polity Press, 2012), 12.

53. Nick Couldry, *Media, Society, World*, 12–13.

54. Scott McQuire, *The Media City: Media, Architecture and Urban Space* (London: Sage, published in association with Theory, Culture & Society, 2008).

55. "Live in Tokyo", *Spatial Dialogues* website, accessed June 20, 2013, http://spatialdialogues.net/tokyo/live-in-tokyo/.

56. Mizuko Ito and Daisuke Okabe, "Intimate Visual Co-Presence" (presented at Ubicomp, Takanawa Prince Hotel, Tokyo, Japan, 11–14 September, 2005) www.itofisher.com/mito/; Mizuko Ito and Daisuke Okabe, "Everyday Contexts of Camera Phone Use: Steps Towards Technosocial Ethnographic Frameworks", in *Mobile Communication in Everyday Life: An Ethnographic View*, ed. Joachim Höflich and Maren Hartmann (Berlin: Frank & Timme, 2006), 79–102.

57. Ilpo Koskinen, "Managing Banality in Mobile Multimedia", in *The Social Construction and Usage of Communication Technologies: European and Asian Experiences*, ed. Raul Pertierra (Singapore: Singapore University Press, 2007), 48–60.

58. Larissa Hjorth, "Snapshots of Almost Contact", *Continuum* 21, no. 2 (2007): 227–38; and Hjorth, *Mobile Media in the Asia-Pacific*.

59. Dong-Hoo Lee, "Women's Creation of Camera Phone Culture", *Fibreculture Journal* 6 (2005), accessed February 3, 2012, www.fibreculture.org/journal/issue6/issue6_donghoo_print.html.

60. danah boyd "Social Networked Sites as Networked Publics: Affordances, Dynamics, and Implications", in *A Networked Self: Identity, Community, and*

Culture on Social Network Sites, ed. Zizi Papacharissi (London: Routledge, 2011), 39–58.

61. Hille Koskela, "Webcams, TV Shows and Mobile Phones: Empowering Exhibitionism", *Surveillance & Society* 2, no. 2/3 (2004): 199–215.
62. Søren Mørk Petersen, "Common Banality: The Affective Character of Photo Sharing, Everyday Life and Produsage Cultures" (PhD thesis, ITU Copenhagen, 2009).
63. Jean Burgess, " 'All Your Chocolate Rain Are Belong to Us?' Viral Video, YouTube and the Dynamics of Participatory Culture", in *The VideoVortex*, ed. Geert Lovink and Sabine Niedere (Amsterdam: Institute of Network Cultures, 2008), 101–11.
64. Larissa Hjorth and Michael Arnold, *Online@AsiaPacific* (New York: Routledge, 2013).

9 Intimacy and Distance with the Public

Mami Kataoka

Twitter is the people's tool, the tool of the ordinary people, people who have no other resources.[1]

With the advent of new media designed to facilitate communication, how has this changed, if at all, the relationship between artists, artworks, and viewers of contemporary art or between institutions and their audiences? It is important to contextualize the relentless development of media and innovative technologies as not a new phenomenon. It is worth remembering that it is perhaps the fundamental desire to create connections with others and to maintain relationships as a way of staking a claim to one's own existence that drives these advances in communication technology. More than anything else, in the current age in which one can gain such wide access to global trends and information, we have lost sight of our own individual position within this overflowing morass of information—something that also casts doubt on the complicated relationship and balance between the individual and the collective. In this chapter, I focus on the mutual relationships that exist among artists, artworks, institutions, and audiences.

SOCIAL MEDIA AND POLITICS: AI WEIWEI

Chinese contemporary artist Ai Weiwei—who has been christened the "world's most powerful artist"—is one of a number of artists who has placed great faith in the power and potential of social media. When the Great Sichuan Earthquake of May 2008 struck, Ai learned that a poorly constructed school building with a defective structure had collapsed, burying and killing many children beneath the resultant rubble. Appealing for volunteers through the Internet, he launched what he called the *Citizens Investigation Project*, the first step of which consisted of gathering the names, sex, dates of birth, ages, school and class names, addresses, and other personal details of more than five thousand children who had perished in the accident.

In May 2010, two years after the disaster, Ai carried out a project called *Remembrance*, which involved reading out the names of all the

children whose details had been verified. Via the Internet, participants selected the name of one of the five thousand children, read it out aloud, recorded it, and sent the data to Ai's studio, which then compiled all the recordings into a single sound file. The resultant output was subsequently shown at various exhibitions as a finished artwork. The monumental statistic of "5,000 lives"—when converted into a list of information that included the names and even addresses of each of these children—easily filled the entire surface of a ten-meter-long wall. Following this list, rendered in visual form, with one's eyes, the abstract quantity of five thousand quickly becomes a concrete accumulation of individual lives that can be acutely and viscerally felt. The list also included the details of children who had not yet been old enough to attend school. Especially poignant in this context is the fact that many of these children had been carefully raised and spoiled like "little emperors" with great hopes for their future, as a result of the one-child policy that continues to prevail in China today.

Although the act of making a list of names of these dead children and turning it into a visual form may appear to be a simple action at first glance, Ai's work in fact does much more—it reveals the sorrow of the families who have each suffered a great loss, the social and political context of the country, and a strong impulse to delve into the reasons behind a man-made catastrophe that accompanies the natural disaster that the earthquake represents. As Ai states,

> A name is the first and final marker of individual rights, one fixed part of the ever-changing human world. A name is the most basic characteristic of our human rights: no matter how poor or how rich, all living people have a name, and it is endowed with good wishes, the expectant blessings of kindness and virtue.[2]

All the various figures and numbers that appear in Ai's work carry massive implications. For documenta 12, held in Kassel, Germany in 2007, he presented his *Fairytale* project, which involved inviting 1,001 Chinese people to Kassel. In order to obtain the passports necessary to make the journey, they decided on names for those who had none and dates of birth in cases in which this information was vague or ambiguous. These 1,001 people were then separated into groups and each given identical matching suitcases, with Ai's own team tasked to prepare meals for the entire contingent for every single day of their stay in Germany—obviously, an enterprise that demanded an extremely meticulous and complicated process of planning.

Of course, no effort could be spared until all 1,001 members of the group had been safely returned home. As for the question of why Ai had decided to invite 1,001 and not just 1,000 people, he replied that if 1,000 signified a huge quantity, "1" was a true reflection of an individual person. The

figure 1,001, of course, also alludes to the relationship between the individual and the collective. In short, *Fairytale* was not about a grand, sweeping journey of a lifetime, but an accumulation of dreams-come-true for each individual participant. In a country with a population of more than 1.3 billion, an awareness of "China" as an accumulation of individual human lives is perhaps faint at best. Ai's attempt to arouse this sort of awareness in each of us is a battle that seeks to tackle these massive, looming questions. Although many of his large-scale projects and sculptures consist of intensive concentrations or conglomerations of such individual parts, these works are perhaps also attempts to evoke a consciousness of the separate single components that comprise the whole.

In April 2012, Ai was detained at the Beijing airport while on his way to board a flight bound for Hong Kong and was held for eighty-one days. Even after being released on bail, he was still forbidden to travel, and his passport has yet to be returned to him even now. However, his Weibo account (a media-rich Chinese equivalent of Twitter), which he restrained himself for a time, has now been reactivated. The Internet, and the 140-character-limit Twitter in particular, seems to have greatly expanded the reach of his activities that traffic in the written word. This process also seems to mirror the evolution of the career of his own father, Ai Qing, one of China's leading modern poets who initially set out to become a painter, but ended by trading in his paintbrush for a pen when he was incarcerated for "thought crimes" (read: radical politics) in the 1930s.

Although physically contained within his Beijing studio, Ai Weiwei developed a particular and unique relationship with the social media that allowed him to communicate with the entire world while the travel restrictions on him still held. Just like how long-standing dictatorial regimes in Tunisia and Egypt collapsed thanks to the collective effort of members of the public, which gathered momentum all at once through social media, Ai is keenly aware of the possibilities that may arise when new media succeed in tapping and harnessing the unstoppable energies that create a feeling of solidarity between citizens:

> The Internet is uncontrollable. And if the Internet is uncontrollable, freedom will win. It's as simple as that.[3]

In the Chinese language, the possibilities presented by these media are even greater:

> Chairman Mao was the first in the world to use Twitter. All his quotations are within 140 words.[4]
>
> [With] 140 words in Chinese, you really can write a novel. Most of Confucius' sentences [are] only four words, so 140 words [might] take his whole life to write. And you can discuss the most profound ideas related to democracy, freedom, poetry.[5]

A name is the first and final marker of individual rights, one fixed part of the ever-changing human world. A name is the most basic characteristic of our human rights: no matter how poor or how rich, all living people have a name, and it is endowed with good wishes, the expectant blessings of kindness and virtue.

—Ai Weiwei

Figure 9.1 Ai Weiwei: According to What? (October 7, 2012 to February 24, 2013).
Source: Courtesy of Hirshhorn Museum and Sculpture Garden, Smithsonian Institution. Photograph: Cathy Carver.

Ai's Chinese tweets are translated into English by volunteers and are sent out to his followers around the world. "Weiwei-isms"—a compilation of Ai's thoughts in text form culled from Ai's blog, Twitter account, media interviews and other sources—are distilled into six chapters with titles such as "Freedom of Expression", "Art and Activism", and "On the Digital World".[6] This modestly sized publication with a black cover may perhaps recall Mao Zedong's own "little red book" of sayings in terms of appearance. Its content, however, represents an accumulated store of Ai's own clear, trenchant pronouncements. His artworks, too, possess these same qualities, conveying a sensibility that combines rationality with intuitive feeling. Ai's thinking, underwritten by a firm, unwavering conviction, has seeped into the consciousness of a huge number of viewers around the world, thanks to major international media who tail his every move and utterance, as well as declarations that Ai himself makes through social media (see Figure 9.1).

OLD MEDIA: ONE-TO-ONE RELATIONSHIP

> Before blogging, I was living in the Middle Ages. Now my feelings for time and space are entirely different.[7]

Ai describes new media in this way. In a certain sense, blogs, Twitter, and other similar platforms give audiences direct access to particular topics they are interested in, massively amplifying the potential of communicative

platforms brought about by contemporary advances in technology. These are effective tools for establishing direct connections with audiences who already have a keen interest in the activities of Ai himself, for instance, or an institutionalized art facility. To give one example, the Mori Art Museum has stopped producing flyers and other printed materials announcing symposia, talks, and public programs over the past ten years. Instead, by announcing these programs on our website, through email newsletters and social media like Twitter, the museum has had no difficulty attracting anywhere from one hundred to five hundred participants to each of these events.

These new media resemble neither announcements aimed at an unspecified general public found in newspapers or on flyers nor "domestic" notices that only reach audiences who have actually made a physical trip to the museum. What they help to facilitate is a directed burst of announcements aimed at audiences with a high level of consciousness about the subject at hand, and who harbor an everyday interest in the activities of the museum. The physical location of these audiences does not matter. Even if they were unable to attend the event in person, social media have allowed many museums to share the archived contents of their programs through text and images. The result is that the exact degree of intimacy and distance involved in the museum's relationship with its audiences has become largely irrelevant.

On the other hand, private collections and artist-run spaces as well as museums founded on intimate relationships now find themselves in a position where the business models on which their operations are based have to be reassessed in the face of increasing institutionalization. The large-scale museums that are taken for granted in the world's major cities are, after all, also corporate entities responsible for the welfare of anything from several hundred to over one thousand employees if we count volunteer members. A scheme centered on simply "making exhibitions", however, is a business model that is completely unsustainable, given the massive costs incurred through acquisition and collection, loans of artwork, new commissions, transportation, and installation, with respect to the income earned from admission fees.

Accordingly, it becomes necessary for the museum to chase higher revenue from admissions by holding blockbuster exhibitions capable of mobilizing large audiences, soliciting donations and funds on a regular basis by forming boards of directors or trustees composed of wealthy individuals, or ensuring a stable stream of annual revenue by courting new individual members of the museum. In addition, a seductive museum shop and restaurant are also expected to contribute toward the overall running of the institution. There are also cases in which income from joint real estate ventures or municipal and government subsidies help defray operation costs. Even with these measures in places, however, it is no small feat to cover all the administrative expenses involved in producing several curated exhibitions per year, making new acquisitions for the permanent collection and covering labor costs. As the scale of an institution increases, this sort of business

model also naturally grows in response. The museum's marketing department starts coming up with exhibition titles that are readily understood by the public, and the education department prepares accessible, no-brainer explanations and captions that make use of iPads and other new media tools. At this point, it has to be conceded that more often than not, there is now a huge gap between the "avant-garde" revolutionary spirit demanded of contemporary art and the actual reality of the situation.

Allan Kaprow, who advocated a new form of art during the late 1950s, subsequently began to maintain a certain distance from the "Happenings" that gradually came to be absorbed by existing genres of art, shifting in the direction of "Activities"—far more personal and intimate acts and gestures. The faith of the art community in the necessity of attracting interest and publicity, and even the presence of an audience itself, would soon disappear. As Kaprow noted,

> But I gradually eliminated most of these beliefs by doing events only once, but not sending out announcements, by shifting event sites from artists' lofts and underground galleries to remote landscapes or to multiple sites that were out of touch with one another; as well as by encouraging people to select their own sites and times. The weather and insects were occasionally involved. Flexibility of time allowed passengers on transatlantic trips to calculate their doings based on changes in time zones . . . The bigger problem, however, was the presence of audience at Happenings. Audiences have been standard requirements of theater and music, popular and highbrow, since the remote past. Commercial galleries and most museums also count their attendees to determine upcoming budgets, programs, and sales. Getting rid of one's audiences could threaten not only an artist's self-esteem but his or her survival.[8]

Kaprow's "Activities", such as "Brushing Teeth for Three Minutes" together with his partner, or "Shaking Hands until You Feel the Other Person Sweat", were based on taking everyday acts and performing them self-consciously, pushing them into the domain of the ritual. One of these episodes even involved Kaprow making an excursion into the desert together with his partner and traversing it separately while maintaining contact with each other using a transceiver, only to rack his brains trying to find a way to be reunited again. These experiments effectively shifted the locus of the art from "the thing shown to the audience" toward something that prompted self-awareness, directed at the performers or artists themselves. The intimacy entailed by this one-to-one relationship is, in fact, something that ought to be reappraised in the current context. For instance, an exhibition that attracts tens of thousands of visitors creates lines of viewers who are practically coerced into a visual experience that involves confronting and appreciating works of art. But would it not be practically impossible to ensure that each individual viewer receives the ample time and space required to appreciate each work?

During the late 1990s—on the occasion of the *Traffic* exhibition of 1996, to be exact—the French critic Nicolas Bourriaud advocated a "relational aesthetic" that emphasized the relationship of the artwork to the viewer and the space around it rather than the artwork itself, going on to win international acclaim for this new artistic movement of the 1990s and beyond. The definition of "relational aesthetics" permitted an extraordinarily diverse range of interpretations, in addition to conveying a somewhat feel-good vibe in terms of marketing. "Participatory art" even went on to become the beloved resort of institutions, a device that produced new relationships between the artwork and its audience.

In the context of a contemporary society where the question of intimacy and distance had lost all sense of direct proportion thanks to advances in media, Bourriaud's theory deserves its positive reception for the way in which it turned our attention to the ways in which individual, fragmented entities connect with each other. However, surely the interpretation of this "relationship" ought to be augmented by even deeper research informed by Asian or Eastern philosophical approaches that do not originate from either Europe or the United States.

One of the leading "relational aesthetics" artists is the Thai practitioner Rirkrit Tiravanija. Throughout the 1990s, Tiravanija has regaled opening-night guests with curry and pad Thai at various galleries and museums, cultivating a festival-like space and atmosphere and thereby rendering the distinctions between art and the everyday and the inside and outside of the institution vague and ambiguous. Alternatively, by constructing living rooms and offices within the framework of the exhibition, he has created public spaces that prompt us to become conscious of everyday behavior and acts, not just in the context of food.

In contrast, the Taiwan-born, New York–based artist Lee Mingwei has also carried out projects related to food and clothing that resonate with Tiravanija's practice. Most of these works, however, construct one-to-one relationships, and preclude the participation of a large, unspecified number of the public. In Lee's "Dining Project", for instance, only a single guest who has made an advance reservation is given the opportunity to have a conversation with the artist over a dinner that Lee himself has cooked. In the exhibition gallery, footage of these scenes is projected. This project, conceived as a means of creating relationships with unfamiliar strangers, apparently started while Lee was still a student at Yale University, where he solicited participants from within the school community itself.

If Tiravanija's projects, which involve offering meals to guests at opening parties and receptions, inherit the legacy of Kaprow's "Happenings", Lee's one-to-one artworks might be interpreted as having an affinity with Kaprow's "Activities" (see Figure 9.2). The discrepancy that exists between these types of relationships and the desire for a one-to-one relation are fundamentally connected in terms of the nature of the essential desire that underwrites them both, even in a contemporary context characterized by advanced media technologies.

Figure 9.2 WAWA Project.
Source: Courtesy of WAWA Project (http://wawa.or.jp/).

POST 3/11 *WAWA PROJECT* AND OTHER COMMUNITY PROJECTS

In this section of the chapter, I want to refocus the discussion. Specifically, I want to refer to the way in which the art community in Japan has been tackling the big question of the social meaning and significance of art in the wake of the Great East Japan Earthquake of March 2011. In the current context of Japan, where museums, galleries and other infrastructure related to contemporary art continue to be developed, and art-related activities become ever more institutionalized, artists exhibit works within the framework of exhibitions that passive viewers flock to, while economic systems that support art activities become established—a phenomenon that Kaprow first expressed a distrust of. Against this backdrop, what is demanded is art that is more "enjoyable" and easy to understand. Works that allow audiences participation and interaction, naturally, are given the warmest welcome.

The many victims of the earthquake that struck in an environment like this felt compelled to confront those in the art world with the question, "What can art do?" Regardless of whether it had anything to do with art, many artists headed toward the stricken areas to participate in relief efforts, while others raised funds for aid projects through charity auctions and other initiatives. One of the projects that attracted some attention was the *WAWA Project*, directed by Masato Nakamura, who heads the 3331 Arts Chiyoda art center. Dubbed a "social creative platform", the *WAWA Project* created a network that brought together various figures who have inherited the

legacy of living, breathing cultures from the quake-stricken Tohoku area, including everyone from sake-brewing artisans, Shinto shrine priests, and salt-making studio craftspeople to nonprofit organizations that implement art projects in the rural provinces.

The result was a small-scale exhibition packaged for both Japanese and foreign audience that created public awareness of what was happening in the affected areas and encouraged people to participate in activities that would support their endeavors. The "platform" leveraged by the *WAWA Project* was not a physical space in the real world—it functioned as an online space where information necessary for these activities could be exchanged, in addition to being a portal for the crowd-funding initiatives that have been enthusiastically pursued ever since the disaster. In his statement, director Nakamura gives us a clear sense of his objective—to accept and to come to terms with the fearsome power of nature and a changed landscape while also creating something new by "connecting" strengths and talents capable of channeling a new source of energy and dynamism:

> The *WAWA Project* was also launched as a platform that would convert despair and hopelessness into a source of energy, offering support to those engaged in work that requires some measure of creativity. As a starting point, I wanted to embrace everything as a part of the creative process—both things that change, and those that remain the same.[9]

In a situation where the institutionalized framework of contemporary art no longer produces any meaning, Nakamura's *WAWA Project* creates links between small-scale creative activities through which both tradition and new media are reconciled with each other, giving rise to a single sense of unity and solidarity. For these purposes, an online virtual space promises to be extremely effective in terms of its immediate impact and potential breadth of access.

In addition to the activities that come under the purview of the *WAWA Project*, a considerable number of other community-based projects are currently underway in Japan. CAMP, which started in 2006, is a platform where artists, curators, institutional directors, critics, researchers, and students can get together to discuss and debate contemporary art, without being tied to a specific location. The venue changes for each discussion, and the proceedings are often made available for public viewing over the Internet. Activities centering on the notion of "discussion" as the main goal, without exhibitions as a primary objective, or evading the original framework of alternative spaces, artist-run spaces, and commercial galleries altogether are in fact fairly common throughout the entire country. Some of the background reasons behind this include the hollowing out of the existing institutional system, including museums, and the fact that what is demanded by the younger generation is a reevaluation of the environmental conditions that ought to accompany the practice of art. There is also the

issue of the conspicuous growth of the global contemporary art market, which has created a wide gulf between artworks that are marketable and those which are not—a phenomenon that has perhaps made it necessary to reassess noncommercial values. On the other hand, the critical suspicion of vested interests and existing systems of all kinds could also be seen as a further acceleration of these tendencies in the wake of the disaster.

CONCLUSION

New media have enabled the harvesting and aggregation of a massive volume of information that far exceeds human capabilities, allowing us to shorten physical distances and compress time. These media, which are associated with a process of optimization, are in fact based on creating a more rational model of the world that has long been the objective of modern society. In terms of the mutual, reciprocal relationships between manufacturers and customers, corporations and individual employees, or artists and audiences, however, both gains and losses have been made. Although social media has made it possible to construct one-to-one relationships, the human capacity to grasp information and our powers of perception and memory are not infinite—in fact, some of these faculties may have even deteriorated as a result of advances in media technology. Even if we could transcend these limitations, all this information and knowledge would amount to nothing.

Although media designed to facilitate communication may continue to develop in the future, the fundamentals that ought to lie at the root of reciprocal human relationships, as well as emotional or spiritual issues, tend to be lost by the wayside over the course of all these advances. The only thing we can be certain of is this—the fact that the process of negotiation between intimacy and distance, the individual and the collective, is an indispensable and continuous human effort to transcend language, culture, and political difference in order to further the cause of mutual understanding.

ACKNOWLEDGMENT

This chapter was translated by Darryl Jingwen Wee.

NOTES

1. Ai Weiwei, quoted in Catherine Ventura, "Is Twitter a Human Right? One Chinese Activist Thinks So", *Huffington Post,* March 17, 2012, accessed June 12, 2013, www.huffingtonpost.com/catherine-ventura/is-twitter-a-human-right_b_501971.html.

2. Ai Weiwei, in Lee Ambrozy, ed., *AI WEIWEI'S BLOG: Writings, Interviews, and Digital Rants, 2006–2009* (Cambridge, MA: MIT Press, 2008), 183.
3. Ai Weiwei, "China's Censorship Can Never Defeat the Internet", *The Guardian*, April 15, 2012, accessed June 10, 2013, www.guardian.co.uk/commentisfree/libertycentral/2012/apr/16/china-censorship-internet-freedom.
4. Jiang Xueqing. "The Bold and the Beautiful", *Global Times*, November 29, 2009, accessed June 22, 2013, www.globaltimes.cn/special/2009-11/488006.html.
5. Ai Weiwei, "Digital Activism in China" (conversation with Jack Dorsey and Richard MacManus at The Paley Center for Media, New York City, March 15, 2010).
6. *Weiwei-isms*, ed. Larry Warsh (Princeton, NJ: Princeton University Press, 2013).
7. Ibid., XX.
8. Allan Kaprow, "Preface to the Expanded Edition: On the Way to Un-Art", in *Essays on the Blurring of Art and Life*, expanded ed., ed. Jeff Kelly (Los Angeles: University of California Press, 2003), xxvii.
9. Masato Nakamura cited in "About WAWA", *WAWA Project*, accessed June 26, 2013, http://wawa.or.jp.

10 Regional Standardization
MPEG and Intercultural Transmission

Sean Cubitt

At its January 2013 meeting, the Motion Picture Expert Group (MPEG) discussed two major initiatives: One initiative was the Green MPEG; the other, the draft requirements of the MPEG-UD (user description). The latter was already slated for inclusion in the new MPEG-M codec. The Green MPEG is informed by the user description development. We need to look at both initiatives to understand the material dimensions and politics of media practice. The materialist turn in media studies has lead scholars to deal with the nature and meaning of hardware and software. Investigating MPEG—the world's dominant system for transmitting video—is my gateway to understanding how nations and regions, especially the Asia-Pacific, can construct new forms of creativity and public life.

Only when we understand how software integrates with hardware, and how governance of standards impacts on engineering decisions, can we begin to understand how visual perception—the heart and soul of twenty-first-century visual culture—are in thrall to set of global norms over which we have no control, but that infiltrate the very fabric of our dreams. Only when we understand the scale of the threat can we begin to remake those media in the interests of both artistic creation and the democratic and affective role of screen media in the twenty-first century.

MPEG is increasingly becoming the universal currency of exchange in visual culture. The significance of this fact concerns the specific way that intercultural relations are effectively governed by the technologies of their mediation. Linda Tuhiwai Smith makes the case that the divorce of indigenous knowledge from the people to whom it is proper (but not property) is not only an abuse of power but is undertaken, with whatever motives on the part of well-meaning anthropologists, in the frame of a globalization of Western economic values:

> the people and their culture, the material and the spiritual, the exotic and the fantastic, became not just the stuff of dreams and imagination, or stereotypes and eroticism, but of the first truly global commercial enterprise: *trading the Other* . . . It is concerned more with ideas,

languages, knowledge, images, beliefs and fantasies than any other industry. Trading the Other deeply, intimately, defines Western thinking and identity. As a trade, it has no concern for the peoples who originally produced the ideas or images . . . Trading the Other is big business. For indigenous peoples trading ourselves is not on the agenda.[1]

Tracing this trade back to pre-Enlightenment accounts of imperial voyages, Smith points toward a further aspect of the coloniality/modernity pair: the origins of the contemporary form of global information-driven economy that Berardi[2] calls semiocapitalism (and, indeed, the very idea of abstraction) in the theft of knowledge, now deracinated and tradable, from indigenous peoples. The heart of this trade is the erroneous reimagining of knowledge as data—as a tradable commodity. The specific manner in which this is accomplished in the twenty-first century is the translation of the audiovisual experience of lives, cultures, and knowledges into the universal frame of the MPEG codec. Among the problems this raises are (1) the translation from specific to universal format, (2) the organization of control over design of this format, and (3) the exclusion of first peoples from that design process.

For the Polynesians, indigenous Australians, and indigenous peoples of East and Southeast Asia as well as the Pacific coast of the Americas, this is an insidious, silent perpetuation of settler colonialism that, according to Patrick Wolfe's definition, is marked by the fact that "the colonizers come to stay—invasion is a structure not an event".[3] Before we can truly analyze this deep imbalance in the means of cultural transmission, we need to understand a little about MPEG as a format and as an institution. I apologize in advance for what will strike some as simplistic engineering and others as unnecessarily technical detail.

MPEG manages compression-decompression (codec) tools for the transport and display of audiovisual materials. Codecs hook into existing technologies including broadcast standards, the transport control protocol/internet protocol (TCP/IP) suite at the heart of the Internet, and production and display technologies. To single out just a few characteristics of displays, MPEG interfaces with two standards for scanning, interlaced, and progressive, which share a fundamental architecture, the bitmap or raster. Scanning isolates the picture elements (pixels), refreshing them at twenty-five frames per second, marginally faster than film, with individual pixels illuminating and fading between scans. The goal is to fox the eye into seeing continuity. The scale—as well as speed—occurs below the threshold of perception. As Siegert argued back in the 1990s, "real-time processing is defined precisely as the evasion of the senses".[4] This is also true of hardware processes such as scanning.

Color is managed in displays within a limited gamut, typically 40 percent of the capabilities of the eye. Color is coded numerically in one of five major color management systems (YCbCr, RGB, HSV, LaB, or hexadecimal).

Colors are thus firstly freed from any semantic base; second, democratized (every color code is equal); and, third, commodified (any color can be exchanged for any other. Colour displays are calibrated against an ideal standard observer, based on a norm established in the 1930s. Three qualities can be dredged from this sketch: first, abstraction in the service of commodification; second, standardization in the service of resource and human management; and, third, efficiency expressed as speed and scale. Efficiency belongs heart and soul to engineering, and it is this that occupies us today, but note in passing the coincidence of management and commodification: Technologies reconcile what theory cannot: Marx and Foucault. Visual culture is colonized in a biopolitical economy in the form of the micromanagement of commodified perception.

To maximize the efficient delivery of audiovisual signals, MPEG shares with most other codecs a series of interlocking techniques. Setting aside the audio components of video processing, there are three main techniques: keyframes, blocks, and vector prediction. The aim is to reduce the amount of information being sent while maintaining sufficient resolution and color differentiation at the display end to satisfy the engineering norm of the standard observer. Transmissions are divided into segments marked off by *keyframes*, as in animation. Beginning and end keyframes are determined by abrupt changes across the whole frame, typically at an edit but possibly cued by pans or other major changes in the frame. The division into keyframes happens very quickly, for example, in live broadcasts, but happens ahead of the segment's delivery. The beginning and end keyframes are compared, and major differences within the otherwise more-or-less similar series of frames marked: areas of greatest action, in particular.

The sequence between keyframes is then parsed as segments. The areas of the frame are gathered in larger aggregations of pixels: *blocks* (4 × 4 pixels), macroblocks (16 × 16 pixels), and Groups of Blocks (GoBs), which compile 4 × 4 macroblocks or more. The principle is to send the least amount of data necessary. Therefore, large areas that stay more or less the same between keyframes, such as sports fields, are treated as GoBs. Smaller areas that stay the same, like the shirts of the players, will be treated as macroblocks. Even smaller blocks and individual pixel information are reserved for areas of the image where the greatest number of changes occur, such as faces. Blocks are now programmable as slices of irregular shape (although still based on the square pixel). In a close-up of a referee giving a decision, for example, the greatest detail will be focused on faces and gestures, while backgrounds will be transmitted with much less detailed information.

The third function depends on the observation that it is much more efficient to code movement as *vector* than as bitmap. A raw bitmap has at least eight bits of information for every pixel, often far more. Sending all that information is energy intensive, so MPEG uses vectors, algorithmic expressions that describe movement as a formula. Instead of listing every pixel and its data, codecs send a description of the arc described by the ball, while leaving the background motionless—on the principle that we are not

interested in every blade of grass, only in the sport being played. Vector prediction is based on the first and last keyframes, tracing the likely movement across the area of the screen.

All these calculations are done by programs, and performed on the fly. The narrower the bandwidth of a connection, as on a Skype call, the more lossy the display. "Lossy" is a technical term for the amount of information lost in translating signals from one format to another, and by the engineering principles involved in reducing the amount of information transmitted (see Figure 10.1). All codecs are lossy, even the so-called lossless ones. The principle of maximum efficiency has to take account of the variety of platforms that a given content will be supplied to, from mobiles working on cell phone networks to professional monitors attached to high-definition (HD) cameras. Content providers want to be able to deliver efficiently from a single file, for example, through cloud distribution services to HDTV, laptops, and portables. Rather than multiply file types—with the consequent costs as well as the loss of primary data that conversion implies—they seek a way to use a single content bank to deliver to all platforms. This is the goal of MPEG-M.

One of the services MPEG-M requires from the codec is therefore information about the end-user platform: There is no point sending HD signals to low-fi devices. This is the basic feedback loop of the MPEG-UD component of MPEG-M. Any given implementation of MPEG standards can elect which components (also known as "layers") they want to use. Free-to-air digital terrestrial broadcasting might be happy without the user description layer; services like Netflix are far more likely to use it. The current MPEG-4 codec includes a layer for digital rights management (DRM): MPEG-UD is envisaged as including DRM in the UD layer.

Figure 10.1 Daniel Crooks, *Static No. 17 (algorithm P)* (2011). HD digital video, 16:9; stereo, 4.33 minutes.

Source: Courtesy of the artist and Anna Schwartz Gallery, Sydney, Melbourne.

The *Draft Requirements on MPEG User Description* issued in January 2013 specify an architecture in which three components (User, Context, and Service Descriptions) feed a Customised User Description engine for specific transmissions.[5] The Motion Picture Experts Group is clearly aware of the privacy issues, especially when it envisages health information being handled remotely via MPEG systems. Users will have access to their descriptions, will be able to alter or delete data, and will be decide what data can be released to which service provider. But, recalling Siegert, and observing the tendency of the majority of users to leave default settings in place, there may be grounds for concern from surveillance studies scholars. Similarly, scholars of copyright will be interested in the Intellectual Property Management and Protection (IPMP) layer included in the design specification for MPEG-M also released in January.

The attendance for the last meeting of 2011 lists more than three hundred delegates. Among them are the majority of the world's biggest hardware and component manufacturers and network corporations (including RIM, Cisco, Huawei, Mstar, Panasonic, Technicolor, Nokia, Dolby, Thomson, Orange) along with Canon, Ericsson, NHK, NEC, NTT, Fujitsu, JVC, Sharp, Samsung, LG, Phillips, Google, Skype, Apple, Microsoft, Qualcomm, and NVIDIA. Also represented were large teams from several universities including Tsinghua, Poznan, the Universidades Politecnicas of Madrid and Catalunya, and the Fraunhofer Institute (whose board of trustees is a who's-who of German electronics industries). Attendance does not give us a picture of which subgroups each delegate attended more than the five days of the meeting, or whether this was a typical turnout: Disney was alone among content providers present, and it was represented by its Zurich technical research group. Although employed often enough by corporations, this is a meeting of engineers grappling with solutions for the problems of efficient delivery. We can perhaps imagine the old Internet Engineering Task Force slogan echoing among their discussions: "We don't believe in presidents, kings or voting; we believe in rough consensus and running code".

Nonetheless there is an agenda, or rather a specification of problems that the engineers are invited to address. To understand we need to poke a little inside another aspect of the MPEG codec, patents. MPEG formats carry an ISO/IEC number. This refers to two standards bodies, the International Electrotechnical Commission, a nongovernmental organization (NGO) composed of national representatives (and affiliates nations from the developing world with limited access and resources). It is headquartered in Geneva, alongside its sister organization, and the source of the ISO abbreviation, the International Organization for Standardization, known in French as the Organisation internationale de normalisation. These terms standardization and normalization need to be held in mind as we pass to the patents issue. Also housed in Geneva is the United Nation's lead body in the field, the International Telecommunications Union (ITU), whose history in recent decades has been one of rapid introduction of corporate membership.[6]

Martin Bryan,[7] convener of one of the major ISO/IEC committees remarked on his resignation, "[t]he days of open standards development are fast disappearing. Instead we are getting 'standardization by corporation'"; an opinion also voiced by Mark Shuttleworth of Ubuntu during the storm over OfficeOpenXML (a proprietary version of the otherwise free and open-source extensible mark-up language [XML] used for Internet-based documents). "It's sad that the ISO was not willing to admit that its process was failing horribly", Shuttleworth said, noting that Microsoft intensely lobbied many countries that traditionally have not participated in the ISO and stacked technical committees with Microsoft employees, solution providers, and resellers sympathetic to OOXML[8].

So who owns the process at MPEG? One short answer is MPEG-LA, a patent "pool" or one-stop shop where manufacturers or service providers needing a license to use MPEG products can go to secure the license. MPEG-LA boast the efficiency of its "many-to-many licensing model", which draws together all the major owners of the many patents built in to MPEG processing. It even provides a link to a letter from Joel L. Klein, of the US Department of Justice Anti-Trust Division, assuring potential clients that this is not a monopolistic practice in the letter of US law. The list of patent holders is impressive. It includes some once unlikely partnerships, like that of Microsoft and Apple, combatants in the 1990s personal computer industry, or JVC and Sony, bitter rivals in the 1980s video recorder market. In the immense thicket of patent cases that has bedeviled mobile technology for the last decade, we are right to be surprised at this edenic agreement. Note, however, that the list includes not one human being. The motives of a human might at least be challenged: Those of a corporation are strictly inhuman.

This observation should illuminate the terms standard and normal in the various translations of the ISO's name, and the term universal that MPEG-LA has adopted for its public relations. The website mentions as one virtue of one-stop shopping for licenses the virtue of "[a]verting legal costs and concerns". A small business trying to license a DVD printing outfit could be stuck licensing one patent after another, and would live in fear of missing one. Of course, there is a slight ambiguity in the phrasing: Potential clients wishing to avoid future legal costs and concerns would be well advised to get their licenses from MPEG-LA. The ISO has been criticized for charging too much to license standards to developing nations. MPEG-LA has been criticized for its bitter dispute with Mozilla and Google, both of whom have been pressing for the use of Ogg Theora and VP8—two open-source codecs that MPEG-LA contends infringe pool partners' patents.

In its submission to the Justice Department, MPEG-LA declared that it would never refuse a license. Technically, it is not in breach of that pledge. MPEG-LA claims that this position is "[a]llowing for investment in product and reinvestment in innovation" is perhaps less certain.[9] The history of electronic engineering governance is littered with preemptive patents and spoiler

lawsuits designed to ward off competition either by acquiring not-quite-spurious patents for not-quite-off-the-drawing-board ideas or by threatening legal proceedings that market entrants cannot afford to contest. This passes for innovation only where we bear in mind Stiegler's distinction between innovation as normal science and invention as radical breakthrough. The latter is less and less likely as the MPEG codecs become more materially and financially entrenched protocols. According to the major document laying out the requirements for Green MPEG, the main objectives of Green MPEG are

> Efficient multimedia processing and transport: The standard will enable building interoperable solutions for energy-efficient consumption of media in this context.
> Enable efficient media encoding based on the energy resources of the encoder or the feedback from the receiver.
> Enable efficient media decoding and presentation.[10, 11]

In the background statement, the authors note that ultra-high-definition video transport and supply to mobile devices poses significant problems, the former threatening existing network fiber capacity, the latter cellnet's restricted bandwidth. The second bullet point directs attention toward another new challenge: the bandwidth required to return data for MPEG-UD to the source of the signal. This will be an asymmetric relation: Download will far exceed upload. But it adds significantly enough to the loading of signal to make it worth noting in the three objectives of the new requirement. The "energy resources of the encoder" also come into play. Because MPEG-M is a dynamic system, it will be able to respond to fluctuations in the power available to the *sender*, whether that be someone initiating a Skype call from Sikkim or a broadcaster coping with power outages in Peru. The new developments will result in new patents and new licenses required to use them. As Laura DeNardis puts it,

> standards with embedded intellectual property rights, in the form of patents . . . raise the prices of these broadband technologies. Emerging markets without an installed base of existing products disproportionately bear the cost increases engendered by this escalation of embedded intellectual property rights.[12]

The term *governance* has assumed considerable importance in policy circles, replacing older terms such as *regulation*. It treats social processes—like broadcast standards policy making—in the discourse of business management, and belongs to the biopolitical turn in management as well as in contemporary theory. As Des Freedman has it, "the internet is implicated in a fundamental neo-liberal transformation of the power relations inside the regulatory process".[13] The usage reflects current understanding that three

types of party are involved in policy: states, markets, and civil society organizations, loosely, NGOs. NGOs are often fronts for corporate interests (e.g., the Business Software Alliance funded by Microsoft). Benner and Witte[14] refer to them as "gongos, bongos and dongos" (NGOs organized by government, business, and donors). States, as we saw above in the case of OOXML, can be bought off or bullied by corporate interests. But the loose diagram of power stands as a decent sketch of the terrain.

The Internet that we know was birthed in the US, the major language of its engineering documents and debates is English, and the major corporations have a strategic influence on US state policy in an era when the US economy depends increasingly on entertainment and computing sectors (along with weapons, also critically involved in the patent system and electronic communications) for its exports. As first entrant, the US and US corporations have a powerful position; countries or regions without highly trained engineers, an advanced university sector, or the commercial or political clout of the BRICK countries (Brazil, Russia, India, China, and Korea) stand to lose not only economically but also in terms of steering policy toward their interests, for example, toward open-source codecs for information and communication technologies for development (ICT4D).

Green MPEG then drags us into an odd terrain where the aesthetics of data loss in encoding–decoding meets with new commercial surveillance technologies and laws governing digital rights management and patents, all in a policy framework where the dynamics of neoliberal governance clash with the claims of emergent nations for a part in systems design, whereas civil society organizations struggle to maintain some independent voice above the indefinite whisper of astroturfing, the insidious use by public relations firms of paid blogposts, tweets, and comments to imitate grassroots movements. The state is absolutely central to this formation, particularly in providing support for patent laws that are widely regarded as outmoded and protective of vested interests. The historical faith in the Internet as a self-governing and outlaw system has not withstood the critiques of US-centrism[15] and latterly that bodies such as the Internet Engineering Task Force and the Internet Commission for Assigned Names and Numbers have failed their constituencies. The World Wide Web Consortium (W3C), charged with the development of the latest version of the fundamental programming language of the Web, HTML5, has found itself at the center of a corporate and policy storm over which codecs can be embedded using the new <video> tag. Is Green MPEG merely another example of greenwashing? Does it make a difference?

Batteries did not get more efficient because the majority of the world's population did not have access to regular electricity supplies. Instead batteries became more efficient due to the rhizomatic style of neoliberal management required both chief executive offers and their increasingly casualized and migratory workforce to be able to work on the move. That the LiON batteries we rely on have a brutal cost in mineral extraction, not least in

Pacific nations like Chile, and recycling, again notably toxic in southern China and India, is an almost necessary product of the integral waste of neoliberal consumerism. Green MPEG is likewise designed for the uses of highly integrated network consumerism rather than the interests of developing economies of the Pacific. Television is perhaps a luxury in the industrial world, but vital to democratic process in regions with low literacy rates. Encoding and decoding licenses add only a small percentage to the costs of manufacturing thousand dollar computers, but a far greater proportion to the technologies of the poor. The principle of ownership over a normal, standard, and universal means of communication goes against all principles of justice, from Rawls to Sen.[16] Although MPEG-LA pledges never to refuse a license, it still has the legal right to withhold one from anyone unwilling or unable to pay, and the right to set the level of payment (as seen in disputes since 2010 over the continuing charge for MPEG-2 patents that have reached their term).[17]

Energy efficiency is important because building centralized generators away from the major population centers—especially in large countries such as Australia, India, and China—wastes vast amounts of energy as heat and radiation during transport. As Jane Bennett[18] argues, complex power networks tend towards catastrophic states of disorder. But as David Nye[19] points, the real-time spot market in power is the key factor in power outages, a view born out in the July 2012 failure of the then recently deregulated electricity market of Northern India. Waste is built into systems like these, where profit is the sole criterion. Engineers are brought in to solve problems generated by the principle of waste driving neoliberal marketization of public goods, the resulting monopolistic behaviors supported by governments, and the drive to obsolescence powered by perpetual "innovation" at the level of protocols such as MPEG. The specifications for MPEG-M and the associated layers include specific instructions for social media: We live, as Jodi Dean[20] affirms, in a regime of compulsory communication. MPEG-M further consolidates the monopoly tendency, concentrating control in the hands of profit-driven corporations and including in it data from passive viewing in the same way as it harvests data from online activity.

The result is a decay of cultural control over perception in favor of commercial control. For many poorer nations in the Asia-Pacific, there is no access to decisions about design and implementation and none whatever for the vast majority of citizens even in wealthy countries. Just as lenses construe the world according to a very specific notion of how the visual should be constructed, so the bitmap frame structures the mode of perception in the twenty-first century. MPEG is a major component in this process, schooling us to see in restricted color ranges, to un-perceive the actual fog of a decompressed image, mentally reconstructing its original. MPEG teaches us to fail to see. Increasing the number of pixels and the brilliance of backlights is not the same as increasing resolution: We are close to the limits of the acutance of human vision with a 1080 screen at a couple of meters from the viewer,

but we are already instructed to hanker for 4K and 6K resolution. What we might gain in brilliance and clarity is the *process* of seeing, especially movement as a function of time. By restricting the vector to a curve between endpoints defined by keyframes, by placing its fundamentally temporal structure (a vector always has direction, and therefore temporality) in the service of a fundamentally spatial grid, and by eradicating the continuum of perception in color, time, and space, MPEG contributes to an aesthetic in which the becoming of an unforeseeable future (as every future must be) is barred by its translation into a perpetual spatial "now". MPEG is a device for controlling perception, and for making the vast diversity of Pacific cultures subject to a single, universal code of vision.

Posing this managed perception both as *universal* and yet *private* property is a contradiction in terms—common yet private. This dialectical condition, alongside the fundamental incompleteness of the scanned image, offers us one form of hope. The wild years of network invention are largely over: consolidation and the perpetual minor modifications of planned obsolescence have replaced them. The export of this technical, legal, and perceptual apparatus to populations that have no control over them is morally, politically, environmentally and in the medium term even economically wrong. The mode of Internet governance has become a ground for scholarly and political activism over the last ten years. We should now develop an activist stance towards the codecs governing audio-visual culture with the same virulence and vitality, if only because the sub-perceptual levels at which the management of populations is currently conducted demonstrates the extremely fine mesh of contemporary biopolitics and contemporary commodification.

It is a question of the exo- and endo-colonization of perception at the quantum level. Yet this does not yet answer the question of whether the specifics of MPEG-M matter. The factories still churn; the pollution still affects the poor far more than the rich. If we take the materiality of media seriously—both as technology and as environmentally significant—and if we understand choices about media technologies as expressing the will of corporations and governments every bit as much as NGOs like the Motion Picture Experts Group, then the question of the "capillary functioning of power"[21] in such ostensibly trivial actions (as the design of feedback loops in video codecs) is important to the construction of intimacy, and the normative construction of a concept of the public which, even at this microscopic level, is organized on principles of universal norms and private property. The attempt to find out how neoliberal power engages such techniques suggests that media are not just conduits but the actual form of power.

It is no longer enough to say that media reflect sociopolitical and economic formations in "symptomatic technologies" or that the aesthetic of media technologies determines subjectivity. Eco-materialist critique needs to dig deeper into the entrails of the profoundly integrated media system which connects the waste of energy and materials with the catastrophic media of

spot-trading and algo-trading, and the wasted lives of semiocapitalism. Media are no longer, if they ever were, peripheral to the core business of production and power. They *are* production and power, and we need to apprehend them in the act.

For indigenous peoples of the Pacific, the question is even more stark: Being exploited or exploiting their own cultural heritage in forms already in hock to the global powers of semiocapitalism—such as intellectual property law—is something which is absolutely alien to first peoples. The governance does not address people, tribes or clans but, even in the best instance, governments, many of them prey to the bribes of corporations. As noted above, it is striking that the owners of MPEG patents—and this is typical of the fundamental tools of digital distribution and dissemination—are universally corporations. Not a single human being appears among the owners of the codec. Again, this is alien to indigenous communities, for whom the ancestors who invented a way of working are known by name and are addressed in working with their inventions.

The anonymization that capital learned by stealing "primitive" artifacts and developing a purely aesthetic relation to them is now deeply ensconced in the process of enclosing commons that has kept capital alive since the sixteenth century. After enclosing common lands in Europe and colonizing common land around the globe, capital turned to enclosing the commons of handcraft skills, turning them into dead labor, as Marx[22] describes factory technology in the *Grundrisse*. For the last thirty years or more, we have been party to the enclosure of knowledge. Just as color was stripped of its semantic roots, so knowledge has been stripped of that intimate relation to the knower, in order to become tradable data. This is the process in which MPEG shares, and this is the latest form of that "trading in the Other" that Smith sees not only as a blight on indigenous people but also as the very root of Western alienation from populations and lands.

If there is to be a genuine public intimacy other than that guarded by the formal protocols of semiocapital, if there is to be an end therefore to anonymization, abstraction, and commodification in twenty-first-century media, then it will have to start at the level of a new commons of codecs and the other core technologies of sharing. The new forms of art we need in this century will begin in unpacking and remaking the fundamental tools of visual communication. We cannot liberate affections and public solidarity without liberating the technologies we have enslaved and that, in turn, enslave our visual lives.

NOTES

1. Linda Tuhiwai Smith, *Decolonizing Methodologies: Research and Indigenous Peoples*. 2nd ed. (London: Zed Books, 2012), 92–93.
2. Franco "Bifo" Berardi, *Precarious Rhapsody: Semiocapitalism and the Pathologies of the Post-Alpha Generation*, trans. Arianna Bove, Erik Empson, Michael Goddard, Giuseppina Mecchia, Antonella Schintu, and Steve Wright (London: Minor Compositions, 2009).

3. Patrick Wolfe, *Settler Colonialism and the Transformation of Anthropology: The Politics and Poetics of an Ethnographic Event* (London: Cassell, 1999), 2.

4. Bernard Siegert, *Relays: Literature as an Epoch of the Postal System* (Stanford, CA: Stanford University Press, 1999), 12.

5. *Draft Requirements on MPEG User Description,* accessed December 27, 2013, www.google.com/search?client=safari&rls=en&q=The+Draft+Requirements+on+MPEG+User+Description+issued+in+January+2013&ie=UTF-8&oe=UTF-8.

6. Don MacLean, "The Quest for Inclusive Governance of Global ICTs: Lessons from the ITU in the Limits of National Sovereignty", *Information Technologies and International Development* 1, no. 1 (2003): 1–18.

7. Martin Bryan, "Report on WGU Activity for December 2007 Meeting of ISO/IEC JTC1/SC34/WG1 in Kyoto", International Standards Organisation, Geneva, iso/jtc1 sc34, November 29, 2007.

8. Paula Rooney, "Ubuntu's Shuttleworth Blames ISO for OOXML's Win", *ZDNet* (UK), April 1, 2008, accessed September 10, 2013, www.zdnet.com/blog/open-source/ubuntus-shuttleworth-blames-iso-for-ooxmls-win/2222.

9. MPEGLA website, accessed December 27, 2013, www.mpegla.com/main/Pages/About.aspx.

10. ISO/IEC JTC1/SC29/WG11 N13468, April 2013.

11. "Green MPEG Will Standardize Metadata Formats", accessed December 27, 2013, mpeg.chiariglione.org/sites/default/files/files/standards/.../w13429.docx.

12. Laura deNardis, *Protocol Politics: The Globalization of Internet Governance* (Cambridge MA: MIT Press, 2009), 204.

13. Des Freedman, "Outsourcing Internet Regulation", in *Misunderstanding the Internet,* ed. James Curran, Natalie Fenton and Des Freedman (London: Routledge, 2012), 95–120 (97).

14. Thorsten Benner and Jan Martin Witte, "Everybody's Business: Accountability, Partnerships, and the Future of Global Governance", in *The Partnership Principle: New Forms of Governance in the 21st Century,* ed. Susan Stern and Elisabeth Seligman (London: Archetype, 2004), 40.

15. Milton L. Mueller, *Ruling the Root: Internet Governance and the Taming of Cyberspace* (Cambridge MA: MIT Press, 2004); and Milton L Mueller, *Networks and States: The Global Politics of Internet Governance* (Cambridge MA: MIT Press, 2010).

16. John Rawls, *A Theory of Justice* (Cambridge, MA: Belknap Press of Harvard University Press, 1971); and Amartya Sen, *The Idea of Justice* (London: Allen Lane, 2009).

17. Brett Swanson, "MPEG-LA Shows Need to Rebuild IP Foundations", *Forbes,* April 30, 2013, accessed August 10, 2013, www.forbes.com/sites/bretswanson/2013/04/30/mpeg-la-shows-need-to-rebuild-ip-foundations/.

18. Jane Bennett, *Vibrant Matter: A Political Ecology of Things* (Durham, NC: Duke University Press, 2010).

19. David E. Nye, *When the Lights Went Out: A History of Blackouts in America* (Cambridge MA: MIT Press, 2010).

20. Jodi Dean, *Democracy and Other Neoliberal Fantasies: Communicative Capitalism and Left Politics* (Durham, NC: Duke University Press, 2009).

21. Michel Foucault, *Discipline and Punish: Birth of the Prison,* trans. Alan Sheridan (London: Penguin, 1977), 198.

22. Karl Marx, *Grundrisse,* trans. Martin Nicolaus (London: Penguin/New Left Books, 1973).

11 PlayStations
On Being Curated and Other Geo-Ethnographies

Lee Weng Choy and Larissa Hjorth

PLAY WHILE MOBILE

When Soohyun accidently mistook her television remote control for her mobile phone and put it in her bag and set off to work, the first thing she did when she realized her mistake was to share the moment via a picture taken with a borrowed mobile phone, which she then uploaded onto KakaoStory, the dominant Korean social mobile media platform. While she was traveling amid strangers on the train to work, back at home her own mobile phone was becoming full of comments from her "absent-present"[1] friends in co-present spaces, laughing and responding to her faux pas. Messages ranged from "You must be tired" to jokes about her control seeking and obsession with order "type A" personality. Soohyun's mistake soon became an excuse to share fleeting yet intimate gestures, which have become an embedded part of contemporary smartphone life in Seoul.

In Indonesia, boasting more 20 million Twitter users,[2] more than 5.3 million blogs,[3] and more than 42.5 million Facebook users,[4] Fatima is typical of her generation "Y" users, moving between Facebook and Twitter constantly through the day. Dubbed the "Twitter Nation" and "Facebook Country",[5] Indonesia media practices are as political as they are personal. For Fatima, the surfing between these two media allows her to gain a sense of not only what her friends are feeling but also a context for determining what political issues are important. For Fatima, social mobile media plays an integral role in Indonesian contemporary urbanity. She could not imagine how she could keep in contact with her friends and know what is important news-wise without her mobile phone. In Nieu, a small island in the Pacific, passengers from the one daily flight in and out of the island are photographed and their faces placed onto Facebook. In this loosely self-governed country of two thousand inhabitants, systems of regulation are intertwined with its tourism industry. Is this a form of friendly surveillance? Or is that an oxymoron? In Tokyo, contemporary *keitai* (mobile) life is about the entanglement of the intimate and the public in new ways. For Toshi, the public and private are interwoven through a process of sharing camera phone pictures

and important news-stories; Twitter and Instagram have become part of the daily diet post-3/11 (tsunami, floods, and Fukushima nuclear disaster).

In these opening everyday scenarios, we can see how social and mobile media are providing new ways of imaging, imagining, and experiencing place and intimacy. Operating across micro and macro and public and private spaces, these practices both highlight existing culturally specific notions as well as heralding new ways in which to participate in place-making practices. If "place" is, as Doreen Massey observes, "stories so far",[6] then these micro-narratives are playing a key role in the process of its articulation. These mobile moments in the region also highlight that place is not merely geographic, rather it is a constellation of psychological, imagined, experienced and social. Artists such as Ai Weiwei (Twitter), Amy Sillman (iPhone), Cory Arcangel (YouTube), Cao Fei (Second Life), Scott Snibbe (App art), Rafael Lozano Hemmer (locative media), and Man Bartlett ("Social Media Artist") have all been active in utilizing the digital to erode the divisions between new media and visual art. As noted elsewhere, these debates about the digital and networked in contemporary art practice have been uneven as they have been blurry, signaling a need to redefine visual art and new media divisions.[7]

Yet despite the pivotal role of social and mobile media in the everyday practices both regionally and globally, and how this has an impact on the ways in which localities reflect on the personal and political, segments of the art world has been arguably slow to take up and critically engage with these phenomenon and instead continue to get bogged down in outdated debates and divisions between the visual arts and new media art.[8] Rather than taking up Claire Bishop's controversial article on the majority of visual artists ignoring the digital, in this chapter, we reflect on how the media space is creating new types of cartographies and ways to imagine place, which, in turn, are having an impact on how art is curated and contextualized. In particular, we turn attention to some new types of maps, play, and reflexive practices that have shaped collaborations both inside and outside the art world. First, we discuss two conditions (one symptomatic, the other strategic) for understanding place and art's role in contextualizing and critiquing it: ethno-geographies and geo-ethnographies. Second, we further explore how these notions play out in the context of contemporary curating. We then conclude with some thoughts about "PlayStations"—or the entanglement between play and stations.

FROM ETHNO-GEOGRAPHY TO GEO-ETHNOGRAPHY: RETHINKING THE PLACE OF ART

Ethnography has had a long and complicated role with the visual arts. From what Hal Foster noted as the "quasi" ethnographies of the surrealists that explored the 'other' in often unreflexive ways, to the "relational aesthetics"

of Nicolas Bourriaud that saw another type of adoption of ethnographic modes—such as exploring power reflexivity through collaboration—ethnography and art have often been characterized by uneven and awkward adaption. However, with more artists traveling and participating in residencies "elsewhere", art and the ethnographic have increasingly become bedfellows. Here the ethnographic in art should not be mistaken for acts of documentation but rather it is a type of method and criticality. It is about repositioning participation and its relationship between maker and the audience, a relationship that has increasingly been challenged with the rise of the professional amateur (pro-am) and the producing user (produser).[9]

As Hjorth and Kristen Sharp note in their article "The Art of Ethnography: The Aesthetics or Ethics of Participation?", the borrowing and evoking of the ethnographic in art has often been much more of an aesthetic or stylistic mode rather than an ethical one. This is partly due to the fact that many artists, when doing residencies overseas, often do not stay longer than three months—hardly enough time to conduct in-depth ethnography thick with description. Rather, this parachute style of cultural encounter involves what Papastergiadis calls "reflexive hospitality".[10] Much of the debate around the whether the deployment of ethnography by the art world is a mere aestheticization or a tactic can be traced more recently to the identity politics so prevalent in the art world in the 1990s. But as Lee has argued, since the 1990s, identity politics has taken a slightly different guise in what he calls the "ethno-geographic"—an aesthetic that graces many contemporary art galleries around the world.[11] Far from the rise of globalization rendering the world into a McLuhan "global village", identity politics has become entrenched in the entanglement between geography and ethnicity. Lee notes, notwithstanding the criticisms that "identity" has become passé among many art professionals, it "continues to underpin so much of how art is being presented. In terms of biennale curating, it's as if it's part of the very grammar and logic of these productions. Geography and ethnicity are privileged in biennales, to the extent that one could describe their mode of knowledge as 'ethno-geographic' ".[12]

What becomes evident in this argument is the need to rethink place as not just geographic and its relationship to multiple forms of presence. From the shift from printed maps to online, mobile GPS maps, the overlays of information and place as "stories so far"[13] has changed. This has led theorists such as Anne Beaulieu to note that ethnography is no longer concerned with co-location but rather co-presence.[14] It is not by accident that debates about co-presence have been central to mobile communication studies from theorists such as Christian Licoppe to Ingrid Richardson. It is at the intersection of critiques of multiple modes of presence and the overlays of place that art ethnographies are most successful: moving beyond a mere aestheticization and becoming an embodied part of creative, social practice.[15] And as Rowan Wilken and Gerard Goggin note in *Mobile Technologies and Place*, place is

one of the most contested, ambiguous and complex terms today.[16] Viewing it as unbounded and relational, Wilken and Goggin observe, "place can be understood as all-pervasive in the way that it informs and shapes everyday lived experience—including how it is filtered and experienced via the use of mobile technologies".[17]

Given Massey's understanding of place as a dynamic constellation of stories, we suggest that "ethno-geography" provides a productive way to think about how art shapes, and is shaped by, localities and regions across the world. The prefix, *ethno*, locates people at the center of geographic practice. Moreover, it evokes the spirit of ethnography as being an important part in the construction of place. With *geo* wedged between *ethno* and *graphy*, a new way to think about, and narrate, place is provided. Here we are thinking about place as a concept that is lived and imagined, geographic as much as conceptual. Social geographers such as the aforementioned Massey or Tim Ingold are really useful in sketching the complex narratives constructing place. Here place is more than a physical, geographic experience: It is a space that is not only geographic and physical but also evokes cartographies of the imaginary, emotional, mnemonic and psychological. For Ingold, place is a type of entanglement which is shaped by movement, or what Ingold calls a "meshwork" of moving things.[18] Ingold's notion of place sees mobile media as part of broader movement practices that have been an embedded part of cultural practice.

In this chapter, we suggest that the "ethno-geographic" is symptomatic of awkward entanglements between art and ethnography whereby the complexity of place has not been fully engaged. Biennales and triennales are often accused of such ethno-geographic practices, as Green and Gardner discuss in their chapter in this collection. Conversely, the notion of the geo-ethnographic takes the "geo" as an important part in the imaginary of place that is entangled by the narratives of ethnography. This notion more fully addresses Massey's and Ingold's definitions of place as multiple, contested and, ever-changing, and it is the geo-ethnographic that moves beyond the ethno-geographic to engage the ethics of ethnography.

ON BEING CURATED[19]

To elaborate further on this move from ethno-geography to geo-ethnography, let us turn to practices of curating. Today, audiences, artists, critics, curators, and other members of the art world approach curating not as a single mode of operations but as a diverse constellation of activities. We have become highly reflexive about these activities: We gather and conference about them and read volumes of news reports, art magazines, books, and exhibition catalogues that promulgate and ruminate on curatorial projects and the conditions of their production. A sampling of some recent reflections on curating might include the World Biennial Forum No. 1, which had

as its theme, "Shifting Gravity", and was held in Gwangju, South Korea, in October 2012. That same year, in November, on the other side of the Asian and European continents, the journal *Afterall* organized the symposium, "Artist as Curator", at the Central Saint Martins College of Art and Design, London; it was followed in April 2013, by the symposium "Artist as Curator: Collaborative Practices", which was organized, this time, by Central Saint Martins itself. Speaking of journals, *The Exhibitionist* was founded in 2010 as a publication "by curators, for curators". Although these examples hardly represent a full survey of the discourses on curating, they do serve to highlight some significant self-reflexive nodes in the discursive terrain, so to speak.

In *The Exhibitionist*, issue 6, in an essay on the "paracuratorial" paradox—where the term refers to activities that are supplementary to the main curatorial work of exhibition making—Paul O'Neill argues that

> the curatorial at its most productive prioritises a type of working with others that allows for a temporary space of cooperation, coproduction, and discursivity to emerge in the process of doing and speaking together. However dissensual, this cohabitational time can be made public, warts and all. The discursive aspect of curatorial work should be given parity with—rather than being perceived as contingent upon—the main event of staging exhibitions.[20]

O'Neill speaks of making public co-habitational time, yet our emphasis here would be to highlight also the experience of distance—those distances in between the cohabitations of curators and their collaborators. For what is curating today without traveling, and oftentimes across sizable arcs on the globe. With its proliferation in recent decades, the biennale has become a paradigmatic platform of the major international exhibition; its organizers travel from one corner of the planet to the other, and yet what one finds at these events, more often than not, is less the "making public" than the compression of time and distance. The interesting journeys that biennale curators make—including the meetings with informants and artists who do not get included in the show—all this co-habitational time, these detours and digressions are usually elided and do not find expression in biennale displays. The movements and messiness of the process are hermetically sealed away from the event itself.

The *Afterall* symposium, "The Artist as Curator", focused on the histories of artists' engagements with exhibition making as well as on the politics of the spaces for art, whereas the Central Saint Martins conference aimed to complicate the propositions of the first event by addressing the collaborative conditions of curating. At the first gathering, David Teh observed that

> the story in SEA [Southeast Asia] has been drastically different to that in the 'developed' world. For a start, the first type of curator barely existed. For institutions that actually had art collections, what we might

have called a curator was more like a craftsman, or simply a bureaucrat, put to feudal purposes as mere keeper or custodian of material heritage. Intellectual custodianship was the province of higher, courtly beings. For the "contemporary" and "independent" figure we are talking about—the curator with ideas but without a collection—there was no precedent in institutional practice from which to depart. The artist-curator was, in fact, the source of curatorship as we know it—and the ramifications of this are worth exploring.[21]

Juxtapose the preceding quote with a provocation from Tara McDowell, also from *The Exhibitionist*, issue 6:

Is the "postoccupational condition" the new "postmedium condition"? By postoccupational I mean the increasing reluctance to compartmentalize oneself in what used to be clearly delimited roles—artist, curator—in favor of a situational, discursive praxis responsive to community, site, or circumstance. In this issue of *The Exhibitionist*, the postoccupational condition is invoked twice, both times positively.[22]

McDowell cited Paul O'Neill, and then Nato Thompson, who believes that "dispensing with such definitions is not just welcome but inevitable".[23] One of the assumptions of curating today is that there is a global contemporaneity, or at least an ineluctable move toward this state of affairs. The juxtaposition of Teh's and McDowell's statements complicates this horizon. One can may want to ask the question of belatedness, "Is art in Southeast Asia finally catching up with art in the West?" However, this kind of trajectory is precisely what Teh is challenging, because such characterizations oversimplify the complex histories of art all over the globe. Yet for all this historical complexity, is it not fair to say, following McDowell, that contemporary art is indeed characterized by increasing mobility and fluidity?

If curators today—or art world professionals who curate in addition to whatever else they do—are increasingly mobile and networked, nonetheless there remains very real and legitimate concerns about fairness and unevenness with regards to representations of place, access to networks, and flows of information and knowledge production. Discussions about contemporary art and curating are not spread evenly across the world. This was highlighted by Marieke van Hal, the founding director of the Biennial Foundation, which, together with the Gwangju Biennale Foundation, organized "Shifting Gravity", the first World Biennial Forum (WBF). In an interview, when van Hal was asked, "Why Asia?" as the theme and site for WBF issue 1, the coeditor of the *Biennial Reader*[24] said, "So far, the discussion on biennials has mostly taken place in the West or from a Western point of view. . . . It is important to have this discussion on this scale in Asia, a continent that is witnessing rapid expanding activities in contemporary art and a rising number of biennials".[25] In other words, the meeting had as one of its agendas the need to address imbalances of power in the

global art world, which is typical of many such international meetings that desire to gather, reflect, and correct.

Notwithstanding all the critical discourses on biennales in particular[26] and curating more generally, we believe there are still questions that deserve more attention, notably, What does it means to "be subjected to curation"? Although the phrase "being curated" may suggest a binary relationship, we would not want the issue to be framed in terms of an opposition between curators and the subjects of their curation. It is not only artists and their collaborators, but also curators, who are often curated. The question of being curated does not turn on a lack of agency of artists or other subjects of curation but on the underlying and sometimes less visible conditions of that agency.

MAPPING AND TRANSPORTING

Our first proposition for what it might mean to be subjected to curating is this: to be curated is to be mapped, and with the ethno-geographic logic that we have discussed above. Let us consider a specific biennale, the 2013 Singapore exhibition, *If the World Changed*, to illustrate what is at stake here. The organizers, the Singapore Art Museum (SAM), chose to focus on artists from Southeast Asia and to employ a co-curator model for the fourth show in the series. Twenty-seven curators were involved, including eight staff from the museum and nineteen co-curators from the region and from within Singapore.[27] During the development of the exhibition, the entire curatorial team was brought together for several meetings in Singapore; the team debated questions about how to define Southeast Asia, which artists to feature, and so on.

SAM deliberately selected co-curators who would challenge the central-ity of the region's capital cities, thus attempting to re-draw the art map of Southeast Asia. The regional co-curators included persons such as Yee I-Lann (an artist from Sabah, East Malaysia who has in her own artistic practice contested the dominance of Kuala Lumpur in Malaysia's art, cul-ture, history, and politics). Joyce Toh, a senior curator at SAM, worked with the four co-curators from the Philippines: Claro Ramirez Jr. (in the capital Manila, Central Luzon), Charlie Co in Bacolod (in the Visayas), Abraham Garcia (in Davao, Mindanao, South Philippines), and Kawayan de Guia (in Baguio, North Luzon). As Toh noted, "All four also happen to be artist-curators and deeply cognizant of centre-periphery dynamics, and have prac-tices that crossover into cultural advocacy". Moreover,

> Within SAM, the art that we exhibit, present and acquire has largely been situated in the context of Southeast Asia; similarly, questions about this region and "region-ness" itself were foregrounded when it came to our thinking about the Biennale. Yet it was not one shared or held by several of the co-curators: the vastness of Southeast Asia did

not compel their interest as much as the question of dealing with the urgencies of their local conditions. At the start of the process, I think some of the Philippine co-curators also regarded my dual-position as a curator at a national institution and as a Singaporean—heading out to the Philippine "provinces" as it were—with a mixture of fascination, optimism, scepticism and doubt.[28]

Extrapolating from Toh's admission, one can imagine that assumptions about place, regionality, and location were not always shared by many of the participating artists as well. What then are we to make of a biennale that aims to frame the exhibition with a regional focus, when its "regional" co-curators and the artists themselves do not work with the same set of understandings and agendas as the organizing museum?

The impulse to map is overdetermined by many agendas, but one of them—to command a privileged view from above—is precisely about having the power to see it all and render distance and difference abstract. What is notable about the impulse to map in ethno-geographic terms is how it reveals a desire to control or contain "cultural difference" into categories. What we are concerned with here is how the various distant places represented in any large-scale international exhibition might better be qualified not by the word *diverse* but by *disparate*. Juxtapositions of incommensurable situations are common in contemporary art; it is not difficult to imagine a biennale showing both a German artist who has been working for years with the Penan, a nomadic aboriginal people in Sarawak, Malaysia, and a Kuala Lumpur-born artist based in Berlin.

But if the question is one of carefully attending to the distances and differences between places, then the curatorial challenge is not simply about selecting interesting artists and art works, but to get back to O'Neill's remarks, to make public the behind-the-scenes conversations and debates, so that the viewers might be able to share in a co-habitational time with the makers—the artists, curators and other participants—of these exhibitions. It is about creating an understanding of different places to the same space of the biennale. To counter this problematic of being-curated-as-being-mapped-as-being-subjected-to ethno-geography, we propose, instead, that one can more deliberately curate with a geo-ethnographic approach, so that to be curated is to be transported (see Figure 11.1).

MOBILE STATIONS

We opened the chapter with the themes of play and mobile media. As we bring it to a close, we want to argue that "mobile" and "transportation" need not operate as an opposite of "place", which is typically construed as fixed and located.[29] Rather, "place", as Massey notes, is an open, dynamic constellation with geographic, psychological, emotional, and imagined

Figure 11.1 Shibuya: Underground Streams (2013).
Source: Courtesy *Spatial Dialogues* and the Boat People Association.

dimensions.[30] To return to the point made at the onset of this chapter, in contemporary art and culture, mobile and social media can function as forms of "transportation" that provide new ways of imaging, imagining, and experiencing place and intimacy.

In June 2013, Melbourne-based *Spatial Dialogues*[31] and the Boat People Association[32] of Japan initiated *Shibuya: Underground Streams*, a collaborative event in Tokyo, where artists were invited to engage the public in dialogues about the changing urbanscape of Tokyo, with special attention to the Shibuya River, which had been redirected and channeled beneath the concrete roadways of Tokyo.[33] The erasure of the river—what was once a significant conduit for local identity and productivity—has not only changed the physical cityscape but also the meaning of place and identity in parts of Tokyo (the last sections of the river were covered in the late 1960s).[34]

Although the artists in *Underground Streams* produced a number of different works for the project (ranging from performance and mobile gaming to socially collective activities, such as walks alongside the covered river, to community activities such as lantern making, to video and sound documentation), they hoped to stretch across art and into urban planning and social activism, initiating a public dialogue on the meaning of water and river ecologies in urban space. The artistic contributions or interventions could be described as a making public of conversations in process, both online and offline. The project was based in a park in Shibuya, one of Tokyo's highest density shopping areas, and it was crucial for the organizers and participating artists that the "public" was not some generalized amorphous mass, but local residents and regular visitors to the neighborhood. In the park, *Underground Streams* placed a shipping container to house the various activities.

Rather than arriving at some "truth" about the identity of the river, what emerged through these "public conversations" was a plurality of perspectives:

Audiences reflected on their encounters with the river in its past uncovered state; some discovered that a river existed in the area in the first place; many participated in reimagining the neighborhood through dance, food, mobile gaming, and live performance. The open structure of the events encouraged participants—artists and local residents and otherwise—to apply their own individual cultural lenses in their imagining of identities of place. Many of the artworks relied on common forms of ethnographic practice—video documentation, soundscapes, observation, and open-ended interviews— to emphasize interpretative narratives and subjective encounters of place, but here we would argue that, for the most part, the approaches were geo-ethnographic rather than ethno-geographic.

One component was a mobile game, titled *keitai mizu*, which deployed Twitter and Instagram to allow players to become investigators in finding the underground streams through artwork clues. This mobile game was devised by Hjorth and included artworks by Australian and Japanese artists that explored abstract and representation forms of water creatures from Tokyo and globally. Players had to interpret which water creatures were from Tokyo, Instagram it, and then upload to the *Spatial Dialogues* Twitter account (see Figure 11.2).[35] Through the intertwining of online and offline

Figure 11.2 Keitai Mizu (2013). Site-specific mobile art game.

Source: Courtesy Larissa Hjorth, *Spatial Dialogues*, and the Boat People Association.

spaces, the park in Shibuya became a space for play, discovery, and creativity. In this way *Underground Streams* evokes Papastergiadis's observation that site is as much a conceptual as it is a geographic entity for artists: "the artist does not simply dwell in a place but collaborates with place".[36]

NOTES

1. Kenneth Gergen, "The Challenge of Absent Presence", in *Perpetual Contact*, ed. James Katz and Mark Aakhus (Cambridge: Cambridge University Press, 2002), 227–41.
2. See Semiocast, "Brazil Becomes 2nd Country on Twitter, Japan 3rd Netherlands Most Active Country", *Semiocast.com*, January 31, 2013, accessed May 2, 2012, http://semiocast.com/publications/2012_01_31_Brazil_becomes_2nd_country_on_Twitter_superseds_Japan.
3. See Saling Silang, *Direktori Blog*, accessed May 2, 2013, http://blogdir.salingsilang.com/.
4. See "Indonesia Facebook Statistics", *Socialbakers.com*, accessed May 30, 2012, www.socialbakers.com/Facebook-statistics/indonesia, cited in Yanuar Nugroho and Sofie Shinta Syarief, *Beyond Click-Activism? New Media and Political Processes in Contemporary Indonesia*, fes Media Asia Series (Berlin: Friedrich-Ebert-Stiftung, 2012).
5. See CNN Tech, "Indonesia: Twitter Nation", *CNN.com*, November 23, 2010, accessed May 30, 2012, http://articles.cnn.com/2010–11–23/tech/indonesia.Twitter_1_Twitter-nation-social-media-social-networking?.
6. Doreen Massey, *For Space* (Sage, London, 2005), 130.
7. See Sam Hinton and Larissa Hjorth "Chapter 5: Art and Cultural Production", in *Understanding Social Media* (London: Berg, 2013), 77–99; and Larissa Hjorth, "Frames of Discontent: Social Media, Mobile Intimacy and the Boundaries of Media Practice", in *New Visualities, New Technologies: The New Ecstasy of Communication*, ed. Hille Koskela and J. Macgregor Wise (New York: Blackwell, 2013), 99–118.
8. Claire Bishop, "Digital Divide: Contemporary Art and New Media", *Artform* (September 2012), accessed August 31, 2013, http://artforum.com/talkback/id=70724.
9. See Larissa Hjorth and Kristen Sharp, "The Art of Ethnography: The Aesthetics or Ethics of Participation?", *Visual Studies Journal* (January 2014): forthcoming.
10. In particular, Papastergiadis outlines the "emergence of aesthetic cosmopolitanism by tracing the rise of issues of denationalization, reflexive hospitality, cultural translation, discursivity and the global public sphere in contemporary art". See Nikos Papastergiadis, *Cosmopolitanism and Culture* (New York: Wiley, 2012).
11. Larissa Hjorth and Weng Choy Lee, "Cultures in Transition", *Broadsheet: Contemporary Visual Arts & Culture* 40, no. 4 (December 2011): 246–49.
12. Ibid, 254.
13. Massey, *For Space*, 130.
14. Anne Beaulieu, "From Co-Location to Co-Presence: Shifts in the Use of Ethnography for the Study of Knowledge", *Social Studies of Science* 40, no. 3 (June 2010): 453–70.
15. Hjorth and Sharp, "The Art of Ethnography".
16. Rowan Wilken and Gerard Goggin, eds., *Mobile Technology and Place* (New York: Routledge, 2012), 5.
17. Ibid., 6.

18. Tim Ingold, "Bindings against Boundaries: Entanglements of Life in an Open World", *Environment and Planning A* 40 (2008): 1796–1810.
19. See Lee Weng Choy, "On Being Curated", in forthcoming to be confirmed title, ed. Petra Reichensperger (Dresden: Kunsthaus Dresden, forthcoming), produced in conjunction with the series of exhibitions *Auxilary Constructions—Behelfskonstruktionen, How to Make—Ideen, Notationen, Materialisierungen, and Various Stages—Bedingte Bühnen* (Hamburg: Textem, 2013).
20. Paul O'Neill, "The Curatorial Constellation and the Paracuratorial Paradox", *The Exhibitionist*, no. 6 (June 2012): 56–57.
21. David Teh, "Where Monsoons Meet: Curatorial Currents in Southeast Asia: Or, Some Shots across the Bow of the Good Ship Contemporaneity" (paper presented at "Artist as Curator" Symposium, 10 November 2012). The symposium was organized by *Afterall*, the MRes Art: Exhibition Studies program, the "Exhibitions: Histories, Practices" research group, and RAW at Central Saint Martins. It was part of the Exhibition Histories research and publication project, developed by *Afterall* in association with the Academy of Fine Arts Vienna; the Center for Curatorial Studies, Bard College; and Van Abbemuseum.
22. Tara McDowell, "Endnote", *The Exhibitionist*, no. 6 (June 2012): 69.
23. Ibid.
24. Elena Filipovic, Marieke van Hal, and Solveig Øvstebø, eds., *The Biennial Reader* (Bergen: Bergen Kunsthall, and Ostfildern: Hatje Cantz Verlag, 2010).
25. The first World Biennial Forum was supported by the Asia-Europe Foundation as part of its program," Creative Encounters: Cultural Partnerships between Asia and Europe". See "World Biennial Forum No. 1: Interview with Marieke van hal, Director Biennial Foundation", *Culture360.org*, October 25, 2012, accessed August 31, 2013, http://culture360.org/magazine/world-biennial-forum-no-1-interview-with-marieke-van-hal-director-biennial-foundation/; see also "About", World Biennial Forum No. 1 website, www.worldbiennialforum.org/about/.
26. In a number of essays, Lee has discussed biennale criticism, questioning some of its presumptions: that these projects seem doomed to fail and are always only symptoms of last capitalist spectacle. See, for instance, Lee Weng Choy, "Biennale Demand", in *Contemporary Art in Asia*, ed. Melissa Chiu and Benjamin Genocchio (Cambridge: MIT Press, 2011), 211–222; "Dive, Deeper—Biennales and their Critics", in *Shifting Boundaries: Social Change in Singapore in the Early 21st Century*, ed. William S. W. Lim, Sharon Siddique, and Tan Dan Feng (Singapore: Asian Urban Lab, 2011), 154–159; and "The Appreciation of Criticism", *Eyeline*, no. 61 (2006): 35–37.
27. See "Singapore Biennale 2013," Singapore Art Museum website, accessed August 31, 2013, www.singaporeartmuseum.sg/sb2013/.
28. See "Where I'm Calling From: A Roundtable on Location and Region" with Lee Weng Choy with Michelle Antoinette, Jon Bywater, Joselina Cruz, Sophie McIntyre, Viviana Mejía, Joyce Toh and Nina Tonga, *Reading Room*, no. 6 (forthcoming).
29. See Anthony Elliott and John Urry, *Mobile Lives* (London: Routledge, 2010) for a detailed discussion of how mulitple forms of mobility are transforming our everyday lives. They explore the entanglement between networks, consumerism, global lifestyles and intimate relationships at a distance in a different but parallel way to what we are suggesting.
30. Massey, *For Space.*
31. See "Shibuya: Underground Streams", *Spatial Dialogues* website, accessed August 31, 2013, http://spatialdialogues.net/tokyo/shibuya/.

32. The Boat People Association (BPA) comprises architects, urban planners, and artists; it organizes events to draw attention to Tokyo's ignored and forgotten rivers. See its website at http://boatpeopleassociation.org (accessed August 31, 2013).

33. Portions of this section derive from Hjorth and Sharp, "The Art of Ethnography".

34. Rebecca Milner, "Treasure Hunting in the Waters beneath Shibuya", *Pingmag. jp*, June 10, 2013, accessed August 31, 2013, http://pingmag.jp/2013/06/10/ shibuya-underground-streams/.

35. Audience Response to "Shibuya: Underground Streams", *Spatial Dialogues* website, accessed September 12, 2013, http://spatialdialogues.net/tokyo/ live-in-tokyo/audience-response-to-shibuya-underground-streams/.

36. Nikos Papastergiadis, *Spatial Aesthetics: Art, Place and the Everyday* (Amsterdam: Institute of Network Cultures, 2011), 88.

Part III

Vernacular, Media Practice, and Social Politics

12 Public Screens and Participatory Public Space

Nikos Papastergiadis, Scott McQuire, Amelia Barikin, and Audrey Yue

As contemporary cities become increasingly media dense environments, it is important to reexamine our understanding of public space and the modes available for transnational exchange. The delimitations of spatial and social relations in urban contexts are now complemented by the new forms of agency enabled by media infrastructure. Although the city becomes a media-architecture complex, public space appears increasingly an *event*, a space produced through specific performative practices. Large screens offer a strategic site for examining this transformation. Shifting the screen from living room to street also challenges two distinct concepts of the "public sphere": the traditional concept of gathering in the same place, and the contemporary concept of gathering at-a-distance enabled by electronic media.

The aim of this chapter is to examine the ways in which the networking of large public screens can serve as a space for transnational exchange, extending the frontiers of aesthetic and public participation. Focusing on a specific artistic and research collaboration that is being conducted via the networking of public screens in Seoul, South Korea, and Melbourne, Australia, our analysis combines historical detail on the development of public screen media, empirical data analysis from audience response surveys, and theoretical speculation on the emergence of a cosmopolitan imaginary. The classical polis was divided between the *oikos*, the privacy of the home; the *agora*, the commercial zone of exchange and a domain for speculative public/private interactions; and the *ekklesia*, in which the rules of governance and social organization were established. These categories are often blurred by the social and cultural practices of contemporary transnational exchange, requiring new modalities for representation.

NETWORKED CITIES AND DIGITAL NETWORKS

If an earlier generation of theorists tended to treat digital media as largely separate from the materiality of the everyday city,[1] there is now a growing realization that contemporary urban space is co-constituted by digital networks.[2] As access to both high-speed broadband networks and digital

communication devices increases, new options for citizen participation in the making and remaking of cities emerge. Klein's "scripted spaces",[3] in which possibilities for agency were more predetermined, are now augmented by what Saskia Sassen describes as "a sort of open-source urbanism".[4] However, realizing this possibility is not an automatic function of building technological capacity. The current conjuncture is striking in the manifest tension between the new models of participation emerging simultaneously across so many sectors, and the techno-political horizon of what Deleuze famously dubbed "control society".[5]

The new conceptual paradigm reflects the impact of new technologies such as smart phones, tablets and other mobile and global positioning systems (GPS)–based devices on contemporary social interactions. The relaxation of US military restrictions on civilian use of GPS in 2000 sparked a range of new cultural practices based around location-aware devices and geo-spatial data, including leading commercial applications such as Google Maps and location-based social networking services such as Foursquare and Facebook's Places. The emergence of informal, non-market practices, such as locative media art,[6] and the sort of dynamic self-organization of public space by citizen groups variously named smart mobs,[7] flash mobs, and swarms is now complemented by the deployment of remote sensors capable of automatically monitoring all sorts of environmental conditions, including object-based data technologies such as RFIDs and QR codes.

It is this threshold of *geomedia* that differentiates contemporary urban space from its predecessors.[8] Geomedia signals a new spatialization of media platforms in two related senses. First, compared to the dominant media platforms of the twentieth century (cinema, radio, television), contemporary media operate in a far wider range of settings. From a paradigm conditioned by relative scarcity, in which one had to travel to particular, fixed and even specialized sites (such as the cinema) in order to watch, listen, or be connected, we are entering a new paradigm of ubiquity. From personal hand-held mobile devices to large-scale embedded LED screens, media now routinely permeate urban space. Second, media are rapidly incorporating GPS systems, thus broadening the potential for use of place-specific data and context-aware applications.

This general trajectory towards the ubiquity of digital networks— variously described as "ambient intelligence",[9] the "internet of things",[10] or Latour's more politicized "parliament of things"[11]—highlights the extent to which public space is subject to new dynamics in networked cities. Public actors are now immersed within complex socio-technical networks that extending throughout the city, contributing to a constitutive change in the nature of the public. If, as Warner argues, it was always problematic to conceive "the public" as a preexisting and stable entity,[12] the present is characterized by heterogeneous urban populations operating in relation to global digital networks that generate overlapping and "stacked" spheres of

action. Although the "local" context of public space remains important, it increasingly operates as an open locality crossed by new speeds and scales of communication and action. In this context, Anne Galloway argues there is a growing need to understand the formation of temporary publics that assemble mobile and disembedded actors on a contingent basis around specific issues and events.[13] This new condition underlines the importance of undertaking situated analyses of the intertwining of digital networks and public space. What is yet to be systematically addressed is the role of specific mediating contexts in translating technological capacity into different social and political outcomes.

PARTICIPATORY ART AND PUBLIC SCREENS

One of the more visible sites in which such outcomes can be tested is the field of contemporary art. Prompted by a range of discussions around the emergence (or reemergence) of participatory practices since the 1960s, contemporary art theory is now marked by numerous references to new modes of participatory art including "relational aesthetics",[14] "dialogical art",[15] "operational realism",[16] "connective aesthetics",[17] and "social aesthetics".[18] The linking feature among this discourse is the ambition of the artists to extend the function of art from a representational medium toward a more active social form of "epistemic partnership".[19]

Within a large screen context, a pioneering example of this kind of practice is American artists Kit Galloway and Sherrie Rabinowitz's project *A Hole in Space* (1980). By linking two life-sized public screen displays in New York and Los Angeles using a satellite feed, Galloway and Rabinowitz created a live "video chat" portal through which members of the public were able to see and speak to each other directly. The screens were situated in popular, easily accessible urban locations (the Lincoln Center in New York and Century City Mall in Los Angeles), and activated for several hours at a time across three consecutive days. As Rabinowitz recalled, "There was the evening of discovery, followed by the evening of intentional word-of-mouth rendezvous, followed by a mass migration of families and trans–continental loved ones, some of which had not seen each other for over twenty years".[20] No signage, advertisements, or sponsorship messages accompanied the work, leaving participants to speculate freely as to its purpose and origin. Replacing the passive, televisual consumption of large screen content with a two-way participatory interface, the project manufactured a new kind of social aesthetic, antithetical to conventional forms of public broadcasting.

A Hole in Space is an early example of what is now a major strand in contemporary art: a mode of practice in which mediated public space and modes of public participation are taken as primary material for artistic engagement. From the public-facing use of digital technologies by artists

such as Rafael Lozano-Hemmer to the open-ended situations engineered by artists such as Tino Seghal, art now often functions less as a finished product than as a platform for public input and exchange. As Holmes argues, this shift in artistic practice offers a radical critique of the transfer of the delivery of public services to corporate organization, and the recoding of public culture to align itself with neoliberal values and ideologies.[21] Our own research on large screens as novel sites for public interaction and transnational communication has also demonstrated that artists have been at the forefront of developing innovative models for community engagement using experimental interfaces in highly mediated urban public spaces.[22]

Galloway and Rabinowitz's decision to place their screens in malls and on the street also prefigured the introduction of large screens into pedestrian-based public spaces such as plazas and city squares, settings that continue to favor more varied forms of programming, including ambient art-based content. Although it is not our intention to offer an exhaustive typology of screen uses here, it is possible to identify a number of less commercially oriented directives that have emerged in large screen programming since the 1990s, including (1) public space broadcasting, (2) civic partnerships, and (3) screen-based art. These approaches are united by the decision to show little or no advertising, with screen programmers instead seeking to showcase a new range of creative content, to foster new institutional partnerships, and to develop new practices of public spectating.

The public space broadcasting model is best exemplified by the BBC's "Big Screen" network, which in 2011 comprised some nineteen screens in different cities across the UK.[23] The BBC is the primary content provider for the network, although initially each screen was established as a stand-alone installation involving partnerships between the BBC and a mix of local government, cultural institutions, and universities. In cities such as Liverpool, the screens have been deployed for a wide range of community-related content, including interactive games and cultural events from music to sport. However, by late 2008, all screens were integrated into a formally structured network. This was partly driven by the BBC's desire to develop a standardized and more cost effective model for screen installation, but also reflects the ongoing cost of producing significant amounts of innovative local screen content.[24]

The civic partnership model is typified by Federation Square, a public space in central Melbourne with a number of major cultural institutions as tenants. It includes a large screen facing onto the main plaza and is managed on behalf of the State Government by Fed Square Pty Ltd. When the site opened in 2002, the screen was used primarily to display commercial television programming. Since the appointment of Kate Brennan as chief executive officer in 2005, Fed Square has increasingly sought to use the large screen to support the wide variety of events it hosts annually.[25] This has involved curating and even producing a range of screen content, including experimental film and video seasons, as well as original programming relevant to specific communities.

The art model has been developed most fully by CASZ (Contemporary Art Screen) located in Zuidas, a new urban precinct bridging Schipol airport and the center of Amsterdam. While sharing some characteristics with Fed Square (noncommercial, nonbroadcast content), CASZ is distinguished by its commitment to displaying contemporary screen art in a public context. At least 80 percent of its content is contemporary video art.

Urban screens used in these ways clearly offer different opportunities and raise different problems. In contrast to small, personalized screens, they enable collective forms of public spectating, which is distinct not only from older media such as television and cinema but also from older cultural institutions such as art galleries and museums. Of course, the alternative screen models described above are exceptions rather than the rule, and the interventions they have so far enabled are modest. Nevertheless, they signal the fact that urban screens constitute an expanding communication platform with some novel and as yet largely untapped possibilities.

LARGE SCREENS AND THE TRANSNATIONAL PUBLIC SPHERE

In 2008, we initiated a unique partnership between Federation Square in Melbourne and Art Center Nabi in Seoul. Both organizations are hosts to large screens situated in public plazas. We proposed a project that would link these screens in real time with the simultaneous display of interactive artworks. The aim was to enable the public in each place to interact with the works projected on the respective screens. Public feedback from Melbourne would be visible on the screens in Seoul and vice versa. Hence, the two locations—situated at opposite ends of the world but sharing a common time zone—would be conjoined by the mediated platforms of the large screens.

From the outset the project was designed to address the logistical issues concerning the compatibility between different communication systems and civic policy issues of public display, as well as aesthetic concerns over what would be meaningful and attractive to different audiences. Against this awareness of the technical, curatorial, and artistic challenges was the recognition that urban space is already a mediated environment and that everyday life is increasingly shaped by new patterns of global mobility and transnational communication. Our aim was to commission interactive artworks for a mediated transnational public space in a way that went beyond provision of public information, or person-to-person communication, to allow contingent groups of public actors in different public spaces to interact. By bringing together globally oriented art practices with the communicative potential of large screens we aimed to explore the emergence of new forms of "publicness" and transnational cultural agency. The possibility of discovering a new interplay with *liveness*—with active public participation in multiple locations through creative triggers—was the core driver of our project (see Figure 12.1).

Figure 12.1 Seung Joon Choi, *Value* (2008).
Source: Image courtesy of Art Center Nabi, Seoul.

This proposal became a reality on August 7, 2009, when two works of interactive art *sms_origins* and *<value>* were presented simultaneously on networked screens in Incheon and Melbourne during the launch of "Tomorrow City" in Songdo, Incheon. This was a world-first live link-up that allowed public audiences in different countries to communicate with each other on screen via Short Message Service (SMS)–based contemporary art. *sms_origins* was conceived and designed by Australian artists Leon Cmielewski and Josephine Starrs in collaboration with programmer Adam Hinshaw. On the screen, a map of the world is displayed alongside a mobile phone number. Members of the public were invited to SMS their country of origin to the number on the screen. When an SMS was sent, a vector tracing the "origins" of the participant (linking his or her place of residence, birthplace, and his or her parents' birthplaces) appears in real time on the map. As texts were sent and received, the personal histories of participants are communicated to the collective audience gathered around the screens in different cities.

A second SMS-based work Seung Joon Choi's *<value>* explored what people "value" within their urban environments. This work posed the question, "As a member of the future city, what do you think is the most important value?" As participants in Melbourne and Incheon texted their responses, key words appeared on the screen—including words such as *love*, *networking*, *home*, and *joy*—which then dissolved in a water rippling effect (see Figure 12.2). The rippling and size of the words expanded or contracted depending on the importance assigned to the value.

Figure 12.2 Launch of *Tomorrow City* (2008).
Source: Image courtesy of Art Center Nabi, Seoul.

During the live telematic broadcast of *sms_origins* and *<value>*, audience evaluation surveys were conducted at the screen sites in Melbourne and Korea.[26] The Korean respondents were predominantly urban Seoul dwellers aged between twenty and forty; older people and those from the surrounding rural province of Songdo did not participate. Melbourne respondents were of markedly greater cultural diversity, and included both tourists and Australian residents. Korean responses revealed a high rate of participation with the interactive art works on the large screen. More than three-quarters

of the audience engaged with the new-media art using text messages and considered such interactions successful in forging cross-cultural ties. Many participants also expressed enchantment towards the new art forms shown on the large screen. Their experiences were also mediated by the screen's location within Tomorrow City, a manufactured "mega city" designed as a high-tech arena for free economic exchange. Although Korean audiences were acutely aware of the top-down urban regeneration of Incheon by the city planners, their SMS responses revealed how the networked screen could potentially create a transcultural space mediated by their individual experiences of media consumption.[27]

The second audience evaluation for the project was held across three months from September to December 2010 at Federation Square during further screenings of *sms_origins*. The broader political climate in Australia at this time was marked by rising racial anxiety. Issues of migration dominated public discourse. SMS responses showed that the participants were themselves migrants or had family members who had experienced migration. In analyzing these participants' responses, it appeared that most embraced the ideology of a multicultural Australia—the idea of Australia as a country of migrants—as most reacted positively to the diverse ethnographic demographic of users in the square. The aesthetic novelty of *sms_origins* may have then inadvertently exposed the vexed reality of migrancy that continues to haunt the nation-state.

Both audience evaluation surveys highlighted the politics of access and distribution that underpins the mobilities proffered by the large screen. Although participatory public screen events can enable the collective appropriation of public space, the infrastructure required to create such events also intensifies the potential commodification of urban environments, leveraging the modern culture of urban spectacle into individualized data collection and "real-time" tracking of users. As Tim Cresswell cautions,

> There is clearly a politics to material movement. Who moves furthest? Who moves fastest? Who moves most often? . . . There is also a politics of representation. How is mobility discursively constituted? What narratives have been constructed about mobility? How are mobilities represented? . . . [T]here is a politics of mobile practice. How is mobility embodied? How comfortable is it? Is it forced or free? . . . The fact of movement, the represented meanings attached to it, and the experienced practice are all connected.[28]

These questions are especially pertinent when considering how audiences experience and interact with large screens in different cultural contexts[29]—a consideration central to the development of our two subsequent public screen events *The Hello Project* (2011) and *Dance Battle: Australia Vs Korea* (2012). In investigating the efficacy of cross-cultural interactions through the large screens, these two projects departed from the SMS-based

interactivity of *sms_origins* and *<value>* and instead mobilized dance as a catalyst for public engagement. *The Hello Project* was a public telematic dance event choreographed by Rebecca Hilton and Park Soonho. It brought together participants in Seoul and Melbourne to share, translate and exchange simple dance movements, generating a collaborative chain of physical gestures on the large screens. To facilitate audience interaction, temporary tents were installed at Federation Square and Arko Art Center, creating a sheltered and comfortable environment within the otherwise open public plazas. When participants entered the tents, they encountered a live life-sized Skype projection of their counterpart across the globe. After being shown a simple sequence of physical gestures, the participants then "passed on" whatever they could remember of the sequence to the next person in line. The dance evolved quickly as movements were passed back and forth between Australia and Korea in real time over the course of one hour. Footage captured inside the tent was broadcast live to the big screens at both sites.

When asked to compare their experience in *The Hello Project* with other forms of telematic interaction they had previously experienced (including gaming and interactive digital art works), numerous participants highlighted the relaxed and casual nature of the event. Many commented positively on the ability for dance to overcome linguistic barriers, noting that the exchanges of movement enabled cross-cultural communication by sidestepping the use of verbal or written language. The public's shared encounter with the large screens, where their dances were displayed in real time and also played back at various moments during the event, was also seen to manufacture a temporary emotional and physical connection between the Korean and Australian participants. Further data analysis suggested that transnational interaction can have a positive impact on cross-cultural engagement within our civic lives.[30]

AESTHETIC COSMOPOLITANISM AND TRANSNATIONAL EXCHANGE

If we transpose Umberto Eco's influential understanding of the "open work"[31] to this new urban context, we can recognize that the openness of digital texts coupled to the rise of geomedia has generated new possibilities for creating "open works" based not only on public spectating but also on mass public participation. By instigating new forms of social interaction that ask us to reimagine the models of communication sustained by networked media in public space—in other words, by inventing new modes of *becoming public*—urban screens might help us to build models for how contemporary public spaces might function as sites for innovative forms of transnational collaboration and collective participation. This brings us to a consideration of the kinds of agency mobilized in these mediated

events. We conclude by suggesting that a theory of aesthetic cosmopolitanism could provide the conceptual framework for the understanding the new forms of transnational agency that occur in public spaces mediated by large screens.

Cosmopolitanism is the product of an idea of the world and an ideal form of global citizenship. Everyone who is committed to it recalls the phrase first used by Socrates: "I am a citizen of the world". This idea that one could claim a moral connection to the whole world was passed on to Crates, and in turn, he taught Zeno, who developed a school (later named the Stoics), that gathered in the *stoa*—the arcades that surrounded the agora of ancient Athens.[32] The Stoics were the first school of philosophy to develop a coherent and comprehensive vision of cosmopolitanism. They envisaged that cosmopolitanism was not only a moral duty toward strangers and a political system for universal governance but also an aesthetic engagement with cultural difference. Is it a coincidence that this philosophical school was named after the complex topology of the *stoa*? The Stoics took their name from the place where they met. In the *stoa* they talked as they walked along the long shaded alcoves. The *stoa* offered shelter from the sun and rain without becoming an enclosed room. It was an in-between and transitional space, neither outside nor inside. Departures and arrivals are signaled in a vague manner within the *stoa*. One could hover, browse, eavesdrop, rub shoulders and move on. Conversations could commence through casual interruptions in a site of gossip, rumor, and information.

Why did these cosmopolitan philosophers choose to meet in the *stoa*? One can only assume it was a deliberate attempt to gain a relative distance from the other available spaces. Between the private space of the *oikos* home—where personal needs and interest could be expressed freely, and the public space of the *bouleuterion* parliament—which was a deliberative venue in which community defined its collective norms and structures without being beholden to any private interests, there was the *agora*—a relatively open space of presentation, speculation and exchange. The *stoa* exists alongside the *oikos*, *agora*, and the *bouleuterion*. It is therefore at arm's length from the sites of privacy, commerce, and deliberation.

We imagine the *stoa* as a spatial metaphor for the emergence of critical consciousness within the transnational public sphere. It is a space for criticality without the formal requirement of political deliberation and for sociality without the duty of domestication. The *stoa* is the pivot point at which private and public spheres interact and from which the cosmopolitan vision unfolds. The mediated activities that unfold between large screens and public squares are an articulation of the contemporary *stoa*. If we are to grasp a cosmopolitan sense of being and belonging from the vantage point of the *stoa*, then the telematic linking of two screens in the public squares of Australia and Korea can be viewed in a new light. Looking back at the potential role for a large screen in the formation of a transnational public sphere, we can also see how this claim converges with the discourse on the topology of a cosmopolitan imaginary in contemporary art practice. Thinking the place

of art within this context is more than jumping from either the local to the global, the private/*oikos* to the public/*bouletrion*, or even the singular to the universal. It is more like the liminal zone of the *stoa*.

NOTES

1. William Mitchell, *City of Bits: Space, Place, and the Infobahn* (Cambridge, MA: MIT Press, 2003); and Howard Rheingold, *The Virtual Community: Homesteading on the Electronic Frontier* (Reading, MA: Addison-Wesley, 1993).
2. Lev Manovich "The Poetics of Augmented Space", 2002, rev. 2004, accessed February 1, 2012, www.manovich.net/nnm%20map/Augmented_2004revised.doc; and Scott McQuire, *The Media City: Media, Architecture and Urban Space* (London: Sage, 2008).
3. Norman Klein, *The Vatican to Vegas: The History of Special Effects* (New York: New Press, 2004).
4. Saskia Sassen, "Reading the City in a Global Digital Age", in *Urban Screen Reader 9*, ed. Scott McQuire, Meredith Martin, and Sabine Niederer (Amsterdam: Institute of Network Cultures, 2009), 29–41.
5. Gilles Deleuze, "Postscript on the Societies of Control", *October 59* (Winter 1992): 3–7.
6. Marc Tuters, "From Control Society to the Parliament of Things" (paper presented at DAC 09 "After Media, Embodiment and Context", University of California, Irvine, December 12–15, 2009), accessed February 27, 2012, escholarship.org/uc/item/3zj2t89z.
7. Howard Rheingold, *Smart Mobs: The Next Social Revolution* (Cambridge, MA: Perseus Publishing, 2002).
8. Tristan Theilmann, "Locative Media and Mediated Localities: An Introduction to Media Geography", *Aether: The Journal of Media Geography* 5a (March 2010): 1–17
9. Emile Arts, Rick Harwig, and Martin Schuurmans, "Ambient Intelligence" in *The Invisible Future*, ed. Peter Denning (New York, McGraw-Hill, 2001), 235–250.
10. Rob van Kranenberg, *The Internet of Things* (Amsterdam: Institute of Network Cultures, 2008).
11. Bruno Latour, *We Have Never Been Modern* (Cambridge MA: Harvard University Press, 1993).
12. Michael Warner, *Publics and Counterpublics* (New York: Zone Books, 2004).
13. Anne Galloway, "Mobile Publics and Issues-Based Art and Design", in *The Wireless Spectrum*, ed. Barbara Crow, Michael Longford, and Kim Sawchuk (Toronto: University of Toronto Press, 2010), 63–76.
14. Nicolas Bourriaud, *Relational Aesthetics* (Dijon, France: Les presses du reel, 2002).
15. Grant Kester *Conversation Pieces: Community and Communication in Modern Art* (Berkeley: University of California Press, 2004).
16. Viktor Misiano 2006. "Confidential Community vs. the Aesthetics of Interaction" in *East Art Map: Contemporary Art and Eastern Europe*, ed. IRWIN (London: Afterall, 2006) 456–65.
17. Suzi Gablik "Connective Aesthetics", in *Mapping the Terrain: New Genre Public Art*, ed. Suzanne Lacy (Washington: Bay Press, 1995), 74–87.
18. Okwui Enwezor, "The Artist as Producer in Times of Crisis", in *Empires, Ruins + Networks: The Transcultural Agenda in Art*, ed. Scott McQuire and Nikos Papastergiadis (Melbourne: Melbourne University Press, 2005), 11–51.

19. George Marcus, *Ethnography through Thick and Thin* (Princeton, NJ: Princeton University Press, 1998).

20. Sherrie Rabinowitz and Kit Galloway, cited in "Galloway, Kit; Rabinowitz, Sherrie, <<Hole in Space>>, *Media Art Net*, accessed February 27, 2012, www.medienkunstnetz.de/works/hole-in-space/.

21. Brian Holmes, "The Revenge of the Concept", in *Art and Social Change*, ed. Will Bradley and Charles Esche (London: Tate Publishing, 2007), 350–68.

22. Scott McQuire, Meredith Martin, and Sabine Niederer, eds., *Urban Screen Reader 9* (Amsterdam: Institute of Network Cultures, 2009).

23. BBC *Big Screens* (2011) cited at www.bbc.co.uk/bigscreens/index.html. Accessed 3 March 2012.

24. Mike Gibbons "Interview with Mike Gibbons" (Head of Live Sites and UK Coordination for LOCOG, and previously Project Director, BBC Live Events) by Scott McQuire, Melbourne, October 4, 2008.

25. Scott McQuire and Meredith Martin, "Sustaining Public Space: An Interview with Kate Brennan", in *Urban Screens Reader*, ed. Scott McQuire, Meredith Martin, and Sabine Niederer (Amsterdam: Institute of Network Cultures, 2009) 121–34.

26. Current studies of audience responses to large screens are embryonic. Most employ market-style surveys to consider the social and economic impact of the arts. In contrast, the research team for *Large Screens and the Transnational Public Sphere* adopted the robust paradigm of cultural citizenship to evaluate audience participation in networked urban media events. Cultural citizenship, a process of how people make claims to their rights to participate in culture, examines the tension between cultural participation, social capital, and identity.

27. Audrey Yue and Sun Jung, "Urban Screens and Transcultural Consumption between South Korea and Australia", in *Global Media Convergence and Cultural Transformation: Emerging Social Patterns and Characteristics*, ed. Dal Yong Jin (Philadelphia: IGI Global, 2011), 15–36.

28. Tim Cresswell, "Towards a Politics of Mobility", *Environment and Planning D: Society and Space* 28, no. 1 (2010): 21

29. Yue and Sun, "Urban Screens and Transcultural Consumption between South Korea and Australia".

30. This proposition cuts against the grain of urban planning policy; in Australia, for example, urban screens are mostly positioned as if they were static billboards, curtailing their potential to become sites that incubate innovative artistic and communication modes. The partnership between Fed Square and Art Center Nabi is then both an experiment in generating a transnational aesthetic experience and a site for testing the potential articulation of cultural citizenship through the transnational public sphere.

31. Umberto Eco, *Opera Aperta* (Milan: Bompiani, 1962).

32. Nikos Papastergiadis, "Aesthetic Cosmopolitanism", in *Handbook of Cosmopolitanism Studies*, ed. Gerard Delanty (London: Routledge, 2011), 221–233.

13 Mediating the Metropolis
New Media Art as a Laboratory for Urban Ecology in Indonesia

Edwin Jurriëns

This chapter examines Indonesian new media art communities with a special interest in urban life and infrastructure. The main focus is on collectives from Jakarta (Indonesia's capital and largest city) and Bandung (the provincial capital of West Java and Indonesia's third-largest city). The collectives use works of art, exhibitions, festivals, and other activities to involve a diverse group of people and institutions, including artists, governments, businesses, nongovernmental organizations (NGOs), and ordinary citizens, in rethinking, reimagining, and, where possible, redesigning urban space.

I first introduce the post-totalitarian and globalized context in which the Indonesian new media art communities emerged in the late 1990s. Making use of the increased freedom of speech and wider availability and accessibility of new information and communication technology in Indonesia, these communities have addressed a diversity of issues relevant to Indonesian contemporary life. I demonstrate how their specific engagement with urban space can be seen as an aspect of a "back to the city" movement in reaction to the socially disengaged elite urban development projects from the mid-1970s to the late-1990s.

After analyzing the various ways in which Jakarta-based communities have been (re)presenting the social life and material infrastructure in their city, I shift attention to Bandung-based communities who have used new media art to (re)imagine urban space. The Bandung communities have created their own art laboratories to develop utopian visions of communication and connectivity between people and their virtual and material environments. These communities can be seen as the latest exponents of a long tradition of laboratory-like creative experimentation in the city of Bandung.

The main focus of this chapter is on the Bandung new-media art collective Common Room, which has been a pioneer in introducing and developing the idea of the creative industry in Indonesia. I argue that Common Room's status as an independent art community has enabled it to simultaneously promote and take critical distance from creative industry projects and discourses, and explore these in the more comprehensive context of urban ecology. The community demonstrates the added value of certain aspects of

the creative industry, such as local economic development. At the same time, it also confirms the necessity of continuing art activities outside the realm of commerce and government policies. I pay special attention to Common Room's annual Nu-Substance festival for new media art and urban ecology, which, because of its relatively independent status, has been able to produce imaginative projects and engage a multitude of voices beyond those of politics and business only.

"BACK TO THE CITY" IN NEW MEDIA ART

Since the late 1990s, Indonesia has witnessed a remarkable growth in independent art spaces and communities, often with a specific focus on new media art.[1] These initiatives are the product of the increased freedom of speech in Indonesia since the fall of President Suharto's totalitarian New Order regime (1967–98). They are also related to the wider availability and accessibility of electronic and digital consumer media in the country, and respond some of the dominant trends in global information and communication society, particularly the cultures of networking, interactivity and do-it-yourself (DIY).

The usually multidisciplinary art communities have been set up by youth from diverse backgrounds making use of a variety of creative media, ranging from painting, sculpture, and graphic design to video, computer, and mobile phone. These communities have become important sites for discussion about all sorts of topical issues, including art, media, politics, history, education, gender, health, and the environment. Some of them constitute a reaction against the intensified commercialization of the international and domestic media, particularly television, and contemporary art, particularly painting.[2]

The end of the totalitarian New Order and Indonesia's new path to democracy with increased civil liberties has also been reflected in urban space and architecture, in a so-called back-to-the-city movement.[3] "Back to city" refers to the efforts of and strong competition between a multitude of actors—including the state, businesses, and citizens from various economic classes—to reclaim urban space after decades of state control over urban development and other aspects of public life. It can also be seen as part of a process to reverse the long-term effects of the 1997–98 economic crisis and to heal the trauma of the human loss and material damage from the upheaval in various Indonesian cities before and after the fall of Suharto in May 1998.[4]

On the hand, this back-to-the-city movement has manifested itself in a growing "unruliness" in Jakarta and other metropolitan areas in Indonesia, in contrast to the Suharto regime's obsession with order and centrally controlled economic development or Pembangunan.[5] On the other hand, there has been a growing awareness among administrators, urban

planners, architects, real estate developers, artists, and ordinary citizens about the necessity of new and more sustainable ways of shaping and using urban space and of taking into account issues such as social context, the environment, and cultural heritage. To a certain extent, the new paradigm of architectural and urban design is "contextuality", because the design tries to resonate and create dialogue with its social and natural surroundings.[6]

Indonesian contemporary artists with an interest in urban life and design have given expression to the back-to-the-city idea in various ways. In some cases, they engage in practices of "unruliness" and "guerrilla art" by reusing and redecorating existing architecture and infrastructure. Examples are the murals by the graffiti artist Darbotz in Jakarta and the Apotik Komik ("The Comics Chemist's") collective in Yogyakarta, or some of the subversive elements in the public performances and festivals of the Jakarta-based new-media art community ruangrupa ("space of shapes"). Other new-media art communities, such as Common Room (Bandung), seek a different application of the contextual paradigm, by promoting and reflecting on the creative industry and urban ecology, as I explain in detail later.

ruangrupa, established in Jakarta, January 2000, is one of Indonesia's longest-running and most productive new-media art communities.[7] Its engagement with (urban) space is expressed by its very name, which means "space of shapes." In December 2010, the community celebrated its tenth anniversary with the exhibition *Expanding the Space and Public* at the National Gallery in Jakarta. In his exhibition catalogue essay, aptly titled "For those who are (so much) in love with the city (of Jakarta)," art curator Agung Hujatnikajennong explained some of the reasons why the founders of ruangrupa decided to establish an independent art community in Jakarta. These included their desire to avoid the high level of bureaucracy in government-run galleries and the limited opportunities for creative experimentation in commercial galleries. They also wanted to contribute to Jakarta's struggle to step out of the shadow of the two Indonesian cities most noted for their arts and creativity, Yogyakarta and Bandung.[8]

ruangrupa has expressed its bond with Jakarta by establishing and maintaining its own art space in Tebet, one of the southern suburbs of the city. This has required strong commitment from its members, considering Jakarta's lack of a contemporary art infrastructure and ambience, and the many problems related to the city's design, including pollution, traffic jams, and high costs and low quality of housing. ruangrupa relocated three times to more affordable and suitable accommodation within the first ten years of its existence, but it never considered moving from the place where it was first established, Tebet. An essential part of the community's identity is its interactions with its social surroundings, including dumpling sellers and motorcycle-taxi drivers.[9]

The city of Jakarta has been a theme and/or location for most of ruangrupa's art initiatives, including its biennial art festivals "OK.Video" and "Jakarta 32 Degrees Celsius" since 2003 and 2004, respectively. Recurring events in the OK.Video festivals are video art exhibitions, seminars and workshops in various locations in Jakarta. Its themes included "OK.Video" (2003, about video art), "Sub/Version" (2005, about visual counterstrategies), "Militia" (2007, about video activism), "Comedy" (2009, about humor), and "Flesh" (2011, about the human body). Jakarta 32 Degrees Celsius has similar events, but specifically focuses on Jakarta-based students without a formal education in art.[10] It is meant to promote dialogue between students from different institutions and make them aware of their urban environment through art-related activities.[11]

Another Jakarta-based new-media art community with a strong commitment to themes concerning urban space and social life is Forum Lenteng. Forum Lenteng was established in Lenteng Agung, South Jakarta, in July 2003, by ruangrupa's Hafiz and several students of the Institute of Social and Political Sciences. Forum Lenteng promotes social engagement in media and art through its video art and short documentaries, participatory video projects, public video screenings and discussions, and media research and publications.[12]

Akumassa (I'm the mass) is its program of participatory video workshops with local communities.[13] Since 2008, workshops have been organized in ten different urban and semi-urban areas in Java, Sumatra, and Lombok. After receiving basic video training, the participants are encouraged to record aspects of their daily lives that normally do not reach the mass media. The videos are usually embedded in a blog explaining the background of the filmed story and are posted on the Akumassa website.[14]

Videos by Forum Lenteng's members have been published by the independent Indonesian DVD label and distributor The MarshallPlan. The videos appeared on a DVD tellingly titled *Repelita 1: Urbanisasi* (2008). The title is a play on the official five-year economic development plans of the New Order government.[15] Each of the official development plans had its own focus, for instance, agriculture, industrialization, or transportation. The video label playfully picked its own theme: urbanization.

There have been hundreds of other short videos at the ruangrupa festivals and other new-media art events that in their style and content represent various aspects of urban culture, lifestyle, and identity in Indonesia. One of the best Indonesian examples of this "urban video generation" (*generasi video perkotaan*) is the Video Battle series distributed by the Yogyakarta-based new-media art community Ruang Mes 56 (Mess Space 56). Indonesian video art pioneer Krisna Murti (b. 1957) is especially struck by the highly individual style or mix of styles that is used to represent a broad range of urban issues. According to Murti, "after watching 'Video Battle,' we realized that these works had been too narrowly interpreted in the perspective of video art. Watching these pieces . . . was like watching contemporary urban society as it is."[16]

BANDUNG ART LABORATORIES: URBAN SPACE AND UTOPIA

In addition to establishing their own communities, providing video training to other groups, installing art and organizing screenings in public spaces, and creating fictional and documentary-like films about urban life, Indonesian independent art and media communities have also attempted to rethink urban life and space by presenting themselves as creative "laboratories." Examples are the HonFab Lab of the art community the House of Natural Fiber (HONF)[17] and the Youth Media Community Lab of the community video facilitator Kampung Halaman (Home Village),[18] both based in Yogyakarta.

The art communities with the most specific commitment to the critical analysis and imaginative redesign of urban space and architecture are based in Bandung. These communities, including Video Lab, Biosampler, and Common Room, follow in the footsteps of a long tradition of creative innovation in the city. This tradition has been addressed in Helena Spanjaard's essay "Bandung: The Laboratory of West?"[19] Her essay takes a critical stand against the ideas of Indonesian artists and art critics in the mid-1950s and Western art critics and curators in the late 1980s, who, each on their own grounds, rejected Western-oriented Indonesian contemporary art practice.

In the early years after its inception in 1950, the art academy in Bandung, which would later become part of the Bandung Institute of Technology (ITB; formally established in 1959), stood out by its creation of art with abstract subject matter, inspired by its foundational Dutch drawing and painting teachers. In terms of style, however, the art academies of Yogyakarta (also established in 1950) and Jakarta (established in 1968) were just as Westernized. Spanjaard argues that "the supposed East-West antagonism, much discussed in Yogyakarta and Jakarta, did not exist to the same extent in Bandung which had been a very westernized Dutch colonial city".[20] She also rightly wonders why Western collectors and curators, who praise the efforts by artists such as Gaugain, Picasso, and Matisse to creatively explore other cultures, consider the "Western" orientation of some Indonesian contemporary art as "inauthentic" and "derivative".[21]

Although discussions about issues such as authenticity are important for the deconstruction of colonial and neocolonial art ideas and practices, they also run the risk of putting too much weight on the West-versus-East question and of narrowing or even excluding the much less controversial but versatile idea of the Bandung art communities as social and creative laboratories in their own right. Spanjaard explains that there has always been "a close relation between the Free Art and Design departments and a close bond with the architecture department" at ITB,[22] which may explain why ideas about the creative industry and urban ecology emerged and developed in Bandung ahead of other Indonesian cities.[23] The founders of Video Lab and Common Room have all been graduates of ITB.

An example of a profound intervention in and re-functioning of urban space was Video Lab's 2004 *Beyond Panopticon* project.[24] The "panopticon" in the project's title referred to Indonesia's first Palapa satellite, launched in 1976 during Suharto's New Order. According to Video Lab, Palapa contributed to "the construction of the identity of a nation through a "virtual" control system."[25] The satellite, similar to the panopticon prison system, could exercise surveillance without being noticed by the people under observation. Control was also exercised through the propaganda of Indonesia's state broadcaster Television of the Republic of Indonesia (TVRI), which, by means of Palapa, was able to cover most of the archipelago.[26]

Video Lab attempted to undermine these types of control and to go "beyond panopticon," by using television screens in one of Bandung's busy shopping malls to display its own short videos in public. Shopping malls stand out as the most imposing and recognizable symbols of New Order developmentalism and the lifestyle aspirations of Indonesia's growing middle class. They have been the grounds for displaying and training the "imagined and formalized standards, norms and formulas" of "middleclassness."[27] Not surprisingly, considering their connotations of wealth and consumerism, they were the target of anger, severe violence, and looting during the mass riots preceding the fall of President Suharto in May 1998.[28]

On one hand, malls maintain a connection with the outside world through the continuous flow of shoppers as well as their usually large tinted surfaces of glass. In *Beyond Panopticon*, this connection with society was strengthened by the opportunity for the mall visitors to interact with the video artworks and participate in creative workshops, although the project did not provide the same level of audience participation as ruangrupa's and Forum Lenteng's participatory video production and screening sessions.

On the other hand, the mall provided a certain distance from the outside world necessary for creative imagination. Malls are also associated with "nonspace," or "utopian realms", in which "communications as a flow of values between and among two and three dimensions and between virtuality and actuality . . . can 'take place' ".[29] The status of the shopping mall as a semi-porous, simultaneously opaque and transparent, entity was cleverly utilized by Video Lab, which transformed its local mall into a gigantic lab for exploring alternative ways of using public space and producing and consuming television.

Biosampler, another Bandung-based new-media art group, in which Common Room's art director and cofounder Gustaff Hariman Iskandar (b. 1974) is closely involved, also focuses on micro-utopian imaginations of alternative interactions between people and their virtual and material environments.[30] Using the slogan "every space is a stage, and everyone is a performer," Biosampler has (re)used a wide range of urban spaces for their performances, from dance clubs, art galleries, theaters, and libraries to warehouses and tunnels. They have performed at domestic and international art exhibitions, rave parties, music, dance and theatre shows, and other events.[31]

One of Biosampler's international performances was at the "Insomnia 48" event of the "SENI: Singapore 2004, Art and The Contemporary" festival, organized in Singapore from October 1 to November 28, 2004.[32] Its performance, titled *no_placia*, consisted of sound samples and video and image projections. The title was derived from Thomas More's (1478–1535) novel *Utopia* (1516), which itself is a combination of the Greek expressions for "no place" and "good place". Considering the location and context of the performance, it may have been an ironical comment on the image of Singapore as an internationalized, clinical place that lacks creative ambience and spontaneity.[33] Alternatively, it could have referred to the performance itself, as an experimental site of unbridled social and artistic freedom.

The use of space, sound and light was partially derived from the entertainment industry, and partially meant to satisfy people's desire for pleasure and individual expression. However, the highly experiential—rather than representational—character of the performance did not imply a complete detachment from reality or a capitulation to capitalism, hedonism, or individualism. The performance also functioned as a testing ground for examining and modifying the impact of space, music, light, and other media on people's emotional, bodily, and social behavior. Contextually and aesthetically, it was related to some of the laboratory-like experiments in Video Lab's *Beyond Panopticon* and, as we will see later in this chapter, Common Room's Nu-Substance festivals. These are all new media art strategies to celebrate, study, and create awareness about the dynamics of social life in a globalized information and communication society and to test and invent small-scale, micro-utopian models or scenarios for the improvement of people's virtual and material environments.

COMMON ROOM AND THE CREATIVE INDUSTRY

Common Room is arguably the Indonesian new media art community with the most consistent and comprehensive focus on urban matters. It is known for promoting the idea of the "creative industry" by linking art and culture to local economic development. After years of struggle by Common Room and various other groups and individuals, this idea is now generally accepted and high on the agenda of the Indonesian national and regional governments. Common Room's concepts and activities are not restricted to the creative industry in a narrow sense, however, but cover a broader area of urban ecology, including environmental issues.

Common Room was established in 2003 as a joint initiative of the new-media art community Bandung Center for New Media (BCfNMA)[34] and the independent bookshop Tobucil.[35] Common Room was initially meant as an open space for community-based activities and the promotion of literacy and creative development.[36] Its venue comprised a small library, a guest room, a computer workshop, and a studio and exhibition space.

It widened its scope and changed its name and status to Common Room Networks Foundation in 2006, after merging with BCfNMA and registering as a nonprofit organization (NPO) with the Ministry of Law and Human Rights (see Figure 13.1). Similar to its predecessor BCfNMA, Common Room generates income from book sales, profits made on art projects, and funding from international nongovernmental organizations (NGOs) such as the Dutch Humanist Institute for Development Cooperation (Humanistisch Instituut voor Ontwikkelingssamenwerking, or HIVOS).[37]

On its website, Common Room presents itself as an open platform for the study and development of art, culture, and information and communication technology (ICT).[38] Its name confirms that the interests of the community go beyond the field of art as such, to also covering issues such as urban space, civil society, and social networking. Similar to other Indonesian new-media art communities and in line with trends in the international contemporary art world, Common Room focuses on collaborative art projects and events—rather than tangible art works—as a way to connect people and groups and to create discourse and knowledge on art, culture, and society. Its activities include cultural festivals, exhibitions, screenings, concerts, public lectures, workshops, and discussions and cover media as diverse as film, video, music, digital art, architecture, design, fashion, and literature.[39]

One of Common Room's early projects to explore and promote the idea of the creative industry was the 2005 project *Urban Cartography*. This project

Figure 13.1 Asia-Europe Foundation Expert Meeting for New Media, Civil Society and Environmental Sustainability at the 2010 Nu-Substance Festival.

Source: Courtesy of Common Room.

was meant to map DIY communities in Bandung since the mid-1990s, including punks, skateboarders, and independent fashion, book, and music businesses. These communities have been using a diversity of media and techniques, ranging from assembled computers, pirated software, photocopies, and silk-screen to radio, Internet, and Short Message Services (SMS), for producing various types of creative output, such as music, fashion, websites, journals, zines, posters, video clips, stickers, and pins. For many of these communities, the economic crisis that hit Indonesia and the rest of Southeast Asia in 1997–98 was an important incentive to find alternatives to expensive imported consumer goods. The Urban Cartography project covered twenty-three creative communities in Bandung, which were presented in a collective exhibition "Bandung Creative Communities 1995–2005" at the CP Biennale in Jakarta, September 5 through October 5, 2005.[40]

To further develop the creative industry in Bandung, Common Room's Gustaff Iskandar co-initiated the Bandung Creative City Forum (BCCF), sometimes also referred to as the Creative Community Club of the City of Bandung, on December 21, 2008.[41] BCCF's first chair was M. Ridwan Kamil (Emil, b. 1971), who is also founder of the URBANE architect office and winner of the 2006 British Council Award for International Young Creative Entrepreneur of the Year (IYCEY) in the field of Design.[42] Iskandar himself was winner of the 2007 IYCEY in Design.[43]

One of BCCF's first initiatives was the 2008 and 2009 Helar festivals.[44] These festivals were meant to promote Bandung as a creative city and explore the commercial viability of various types of local creativity, such as traditional handicraft, film, music, architecture and design.[45] In 2010, BCCF organized another festival, Semarak Bandung ("Festive Bandung"), which included light projections on landmark buildings and an event to celebrate and restore the glory of the old colonial shopping street Braga in the heart of Bandung.[46] One of BCCF's other activities was the 2011 International Children and Youth Conference on the Environment, jointly organized with the United Nations Environment Programme (UNEP) and the Indonesian Ministry of Environment. An important outcome of the conference was that one of Bandung public parks, the Babakan Siliwangi, was declared a protected World City Forest.[47]

BCCF has also been involved in the creation of a Bandung branch of the British Council-supported Creative Entrepreneur Network (CEN). This network consists of creative cities around the globe, including Glasgow, Bristol, London, Cebu, Bangkok, Taipei, Auckland, Kuala Lumpur, Hanoi, and Yokohama.[48] The British Council argued that Bandung's potential as a creative city was rooted in its long history of creative businesses, its relatively young population (60 percent of the population is forty or younger), its large number of public and private universities, and its strategic location close to the economic and political center of Indonesia, Jakarta, and midway between the industrial areas of West and East Java.[49] The Bandung CEN branch was officially launched on May

24, 2009, and is meant to facilitate creative entrepreneurship, community networks, skills and knowledge development, and linkages with international partner organizations.[50]

Inspired by initiatives such as the BCCF, Indonesia's current president, Susilo Bambang Yudhoyono, has put the creative industry high on the national political agenda. On October 18, 2011, after a cabinet reshuffle, he created the new Ministry for Tourism and Creative Economy, which is currently led by former trade minister Mari Elka Pangestu.[51] This department divides the Indonesian creative industry into fourteen different subcategories: advertising; architecture; art and antique marts; handicrafts; design; fashion; film, video, and photography; interactive games; music; performing arts; publishing and printing; computer services and software; radio and television; and research and development.[52]

In spite of their support of the various government, business, and independent initiatives, Iskandar and other members of Common Room and BCCF have remained critical of the development of the creative industry in Bandung and the rest of Indonesia. They have noted, for instance, that policies tend to support the owners of financial capital rather than the creative workers themselves, whose wages are usually below the minimum. Governments and banks are rarely prepared to fund community initiatives, and most creative projects are order rather than idea based.[53] A lack of legal reinforcement has let to unbridled piracy and has taken away revenue from local creative entrepreneurs. It is costly and time-consuming for these entrepreneurs to arrange copyright certificates, while the spread of piracy itself is thought indicative of a deficient Indonesian consumer market.[54]

According to Iskandar, official policies have focused on the material infrastructure of cities rather than the more urgent issue of creating human capital through increasing people's access to education and information.[55] In Bandung and other cities, there is a lack of public spaces for communities to meet and exchange ideas and information.[56] In addition, there have been legal restrictions on the freedom of information and communication. For instance, the 2008 Information and Electronic Transactions Law (UU ITE) allows the government to restrict access to the Internet and criminalize its users. Most important, the creative industry has been insufficiently supported, or even restricted, by the formal education system. Instead, it has developed predominantly in local youth's extracurricular activities, friendships, and community networks.[57]

THE NU-SUBSTANCE FESTIVAL FOR URBAN ECOLOGY

Nevertheless, an advantage of Common Room's relatively independent status is that it has been able to critically examine the role of the creative industry in Indonesia from the perspective of contemporary artists. The notion of art itself is often left untouched or rather distorted in projects, debates, and studies with a strong focus on, and certain excitement about, the political

and economic dimensions and potential of the creative industry. An example is the otherwise useful and comprehensive volume of essays edited by John Hartley.[58] In his introductory chapter, Hartley—an enthusiastic proponent of the convergence between art and business—describes how the creative industry has changed the role of the artist:

> The "creative industries" idea brought creativity from the back door of government, where it had sat for decades holding out the tin cup for arts subsidy—miserable, self-loathing and critical (especially of the hand that fed it), but unwilling to change—around to the front door, where it was introduced to the wealth-creating portfolios, the emergent industry departments, and the enterprise support programs. Win, win![59]

This, presumably provocative, statement is problematic for various reasons. First, capitalism is a concept conspicuous by its absence in Hartley's introduction and the edited volume as a whole, with the exception of Terry Flew[60] and Angela McRobbie's[61] chapters. McRobbie's observation that many of the so-called independents in the creative industry "are, in effect, dependent sub-contracted suppliers" to the large corporations, with little opportunity "to concentrate on their 'own work'"[62] resonates with the findings of the Indonesian practitioners about their order- rather than idea-based work.

Second, Hartley's statement is a gross simplification of centuries of fine art tradition, disregarding diversity in style, genre, school, and temporal, spatial, and social context. In the Indonesian context, the idea of government subsidy has been alien to the great majority of local contemporary artists. The commitment and productivity of these artists is remarkable considering the very limitations in formal art infrastructure and economic support. They have relied on DIY, networking, and recycling strategies long before these became global trends with the rise of new information and communication technology.

Ironically, one of the ways in which Common Room has been able to promote and develop the idea of the creative industry in Indonesia, has been through subsidy by foreign NPOs. Although this funding may have been partly steered by the interests of these organizations, in general these arrangements are more transparent and less intrusive than deals with international or local businesses. It has enabled Common Room to experiment with a broad range of media and genres, set up collaborative artworks and festivals, and freely explore urban scenarios with a sometimes highly utopian character. It is very doubtful whether the community would have been able to organize activities with the same critical and imaginative content if it had stronger ties to commerce and government politics.

Common Room's most important event is the Nu-Substance festival for new media art and urban ecology, organized annually since 2007. Over the years, the festival has developed and gradually shifted focus from creating, exhibiting, and discussing new media art as a relatively new phenomenon

on the Indonesian art scene, to using this form of art to reflect on the impact of urbanization on people's social, material, and natural environments.

The 2009 Nu-Substance, titled *Resonance; Festival for Open Culture, Technology and Urban Ecology*, introduced the issues of cultural diversity, the use of open-source technology, and environmental sustainability as Common Room's three focus points in its analysis of Bandung's urban development.[63] The community believes that (open-source) media technology is an effective means to create awareness about the problems caused by the worldwide increase in urbanization, such as intergroup conflicts, the degradation of living conditions, and the decrease in natural resources. They also want to explore the extent to which art and technology can involve ordinary citizens in finding solutions or alternatives to some of these problems.[64]

In addition to the festival's routine events, such as art exhibitions, music concerts and video and computer workshops, the 2009 Nu-Substance included public seminars about hacking, open-source software, and alternative intellectual property and copyright arrangements such as Creative Commons. It also had presentations of the *Babakan Asih Project* and the Bandung Oral History study club, two ongoing projects that address the intersections between new media art and urban ecology.

Babakan Asih is the name of a densely populated suburban area of Bandung, which is often hit by floods due to erosion of the soil. Since 2008, the Bandung-based architect company Urbane has assisted the local community in this area with constructing absorption wells for rainwater containment, and other forms of ecosystem preservation and management. Common Room has provided documentation, research, social events, and art exhibitions about the environmental issues covered by this project.[65]

The Bandung Oral History (BOH) study club, established in 2008, is a community organization involved in research, discussions, exhibitions, and film screenings on various aspects of Bandung's oral history. Among other experiments, BOH has mixed Sundanese oral literature with punk and electronic music. In the 2009 Nu-Substance, the experiments were led by the classical Sundanese music expert Iman Jimbot and included traditional musicians such as Mang Ayi Ruhimat and Abah Olot as well as the Bandung-based contemporary music ensembles Trah, Karinding Attack!!! (shown in Figure 13.2), Tcukimay, and Ganjoles.[66] Their presentations showed Common Room's awareness that sustainable urbanism not only relies on urban design and architecture, but should also take into account the immaterial heritage and cultural practices of the local population. These aspects are easily ignored by Indonesian and foreign governments and businesses, whose plans for the development of the creative industry more often than not lead to a gentrified form of urban renewal.[67]

The open-source software, Babakan Asih, and experimental music projects were all continued during the 2010 Nu-Substance.[68] The 2010 edition of the festival also introduced the so-called Expert Meeting, which consisted of group and panel discussions, presentations, site visits, and informal

Figure 13.2 The Sundanese fusion group Karinding Attack!!! at the opening of the 2010 Nu-Substance Festival.

Source: Courtesy of Common Room.

meetings with media and art practitioners, theorists, and activists from Asia and Europe. The meetings were meant to contribute to formal policies in three different but interconnected fields: new media, civil society and environmental sustainability.[69] The participants in the meeting went on a field trip guided by the Bandung Basin Research Group (KRCB) to examine various social and ecological crises in and around Bandung, such as the deplorable working conditions of the workers in local chalk mines, the floods and lack of clean water in various suburbs due to the construction of villas and housing complexes, and the environmental and social impact of the rapid privatization and commercialization of the previously protected forest around Bandung's famous Tangkuban Perahu volcano.

The Nu-Substance festivals demonstrate Common Room's comprehensive and imaginative approach to urban ecology. It continues Bandung's tradition of art laboratories by facilitating a public space and a wide variety of creative media for people with diverse backgrounds to meet, discuss, research, be creative, and fantasize about the past, present and future of their city. Although supportive of the local creative industry, the art community is also concerned about the impact of this and other types of economic activity on the various social, material, and natural aspects of people's urban environment. It seems to support the discourse of "creative reuse urbanism," or "an urbanism which is culturally rooted, locally related and deeply contextualized"[70] by taking seriously the cultural traditions and

creative practices, social background, material conditions, and daily life experiences of the groups that are most dramatically affected by Bandung's rapid urbanization.

CONCLUSION

Indonesian new-media art communities have been involved in a "back to the city" in post-totalitarian Indonesia, which has tried to promote a more open and democratic civic engagement with urban space and architecture. The results of this movement have ranged from new forms of "unruliness" to efforts to involve many different voices, including artists, governments, businesses, NPOs, and civil society, in critical and imaginative debates and projects about urban (re)development.

The contributions of independent, multidisciplinary art communities in Jakarta, Bandung, and other Indonesian cities comprise the establishment of urban art spaces, the organization of exhibitions, festivals, and events around urban space and life, and the (re)presentation of these themes through a large variety of creative media, such as paintings, sculptures, murals, cartoons, fashion, graphic design, installations, photographs, performances, and video art. Arguably, the most far-reaching creative experiments have been the (re)imagination and (re)design of urban space and life in the Bandung-based art laboratories of groups such as Video Lab, Biosampler, and Common Room.

Common Room has used its own laboratory-like art space and events to critically and artistically explore the connections between the virtual, material, and natural environments that constitute Bandung's cityscape. While supportive of using creativity to support local economic development, it has remained critical of the impact of the creative industry and other aspects of the urban economy on social life, culture, and nature. Perhaps paradoxically, it demonstrates that the creative industry can only be sustainable when steered, monitored, and, where necessary, resisted by artists and art that keep a safe distance from the pragmatic, and often opportunistic, worlds of politics and business.

NOTES

1. Edwin Jurriëns, "Indonesian Video Art: Discourse, Display and Development", *Review of Indonesian and Malaysian Affairs* 143, no. 2 (2009): 165–89.
2. Edwin Jurriëns, "Between Utopia and Real World: Indonesia's Avant-Garde New Media Art", *Indonesia and the Malay World* 41, no. 119 (2013): 48–75.
3. Abidin Kusno, *The Appearances of Memory* (Durham, NC, and London: Duke University Press, 2010), 72.
4. Ibid., 80–84; and Lizzy van Leeuwen, *Lost in Mall: An Ethnography of Middle-Class Jakarta in the 1990s* (Leiden: KITLV Press, 2011), 163–67.
5. For more detail about Pembangunan and its impact on urban development in Jakarta, see Susan Abeyasekere, *Jakarta: A History* (Singapore: Oxford

University Press, 1989), 217–21. Regarding the post-1998 urban "unruliness", Kusno, *The Appearances of Memory*, observes that the Jakarta city administration, the middle class and the urban poor have all been "performing different forms of illegality" (p. 34).

6. Kusno, *The Appearances of Memory*, 73. One example is "independent brand" (label indie) architecture for the urban middle class, inspired by the design and lifestyle of urban lower-class community settlements, or *kampung*, and promoting low-energy consumption and the use of nonindustrial local materials; Kusno, *The Appearances of Memory*, 75–76.

7. Agung Hujatnikajennong, "For Those who Are (so Much) in Love with the City (of Jakarta)", in *Decompression #10*, ed. Afra Suci Ramadhan and Ibnu Rizal (Jakarta: ruangrupa, 2010), 11–13; and Alexandra Crosby, "ruangrupa: Mapping a Collective Biography", in *Gang Re: Publik: Indonesia-Australia Creative Adventures*, ed. Alexandra Crosby, Rebecca Conroy, Suzan Piper, and Jan Cornall (Newtown, NSW: Gang Festival, 2008), 129–34.

8. Hujatnikajennong, "For Those who Are", 12.

9. Ibid.; and Ugeng T. Moetidjo, "Archives on Space, People, and Idea in the Process", in *Decompression #10*, ed. Afra Suci Ramadhan and Ibnu Rizal (Jakarta: ruangrupa, 2010), 190–97.

10. Laila Ahmad, "Editorial", in *Jakarta 32° C*, ed. Indra Ameng, Ardi Yunanto and Andang Kelana (Jakarta: ruangrupa, 2006), 3–4.

11. Jurriëns, "Indonesian Video Art".

12. The community's research publications include *Footage*, an online video and film journal, and *Videobase* (Jakarta: Forum Lenteng Center of Information Data Research and Development, 2009), a collection of essays on the social history of video in Indonesia written by Hafiz, Mahardika Yudha, Mirza Jaka Suryana, and Andang Kelana.

13. Alexandra Crosby and Ferdiansyah Thajib, "Can Open Mean Terbuka?: Negotiating Licenses for Indonesian Video Activism", *Platform: Journal of Media and Communication*. A Creative Commons Special Edition (December 2010): 94–105 (especially 97).

14. "Akumassa: jurnal tentang aku dan orang-orang sekitar" ("I'm the Mass: A Journal about Myself and People around"), *Akumassa.org*, accessed June 13, 2013, http://akumassa.org/.

15. Repelita is an acronym for Rencana Pembangunan Lima Tahun, or Five-Year Development Plan.

16. Krisna Murti, "The Urban Video Generation", in *Essays on Video Art and New Media Art: Indonesia and Beyond*, Krisna Murti (Yogyakarta: IVAA, 2009), 101–104, especially 102.

17. Edwin Jurriëns, "Between Utopia and Real World: Indonesia's Avant-Garde New Media Art", *Indonesia and the Malay World* 41, no. 119 (2013): 48–75.

18. Edwin Jurriëns, "Social Participation in Indonesian Media and Art: Echoes from the Past, Visions for the Future", *Bijdragen tot de Taal-, Land- en Volkenkunde* 169, no. 1 (2013): 7–36.

19. Helena Spanjaard, "Bandung, the Laboratory of the West?", in *Modern Indonesian Art: Three Generations of Tradition and Change 1945–1990*, ed. Joseph Fischer (Jakarta and New York: Panitia Pameran KIAS and Festival of Indonesia, 1990), 54–77.

20. Ibid., 65.

21. Ibid., 75.

22. Ibid., 61.

23. Since 2006, ITB has also been the organizer of the biennial Arte-Polis, a pioneering Bandung-based conference on research and policies related to urban space, and the creative industry in Indonesia. See Roy Voragen, "Creating

Places and Connections: A Review of Arte-Polis 4", *The Newsletter* 61 (Autumn 2012): 38–39.

24. Jurriëns, "Indonesian Video Art".

25. Aminudin TH Siregar, "Beyond Mind, then Body", in *Beyond Panopticon*, ed. Heru Hikayat and Herra Pahlasari (Bandung: Video Lab, 2004).

26. Ibid.

27. Van Leeuwen, *Lost in Mall*, 169.

28. Ibid., 163.

29. Margaret Morse, *Virtualities: Television Media Art, and Cyberculture* (Bloomington: Indiana University Press, 1998), 102, 106.

30. The utopian ideas and practices of Common Room and other Indonesian new-media art communities are forms of "hands-on utopias" or "micro-utopias" rather than the "radical and universalist" utopias of the historical and neo-avant-garde of the 1920s, 1960s, and 1970s, respectively. The French art curator and critic Nicolas Bourriaud explains that today's art is less concerned with grand, evolutionary, and explicitly political visions of the future but is more focused on "learning to inhabit the world in a better way." See Nicolas Bourriaud, *Relational Aesthetics*, trans. Simon Pleasance and Fonza Woods, with the participation of Mathieu Copeland (Dijon, France: Les presses du reel, 2002), 9, 13, 31, 70.

31. "Insomnia48", *Theatreworks.org*, accessed April 24, 2012, www.theatre works.org.sg/international/insomnia48/biographies.htm.

32. Gustaff H. Iskandar, "Insomnia 48: begadang 48 jam di Singapura" [Insomnia 48: Staying up for 48 Hours in Singapore], Bandung Center for New Media Arts website, accessed April 24, 2012, http://bcfnma.commonroom. info/2004/biosample-no_placia.

33. Ibid; the organizers of "Insomnia 48" deliberately tried to present a different image of Singapore: a city not merely focusing on the economy but also appreciating and supporting local creativity and social life.

34. BCfNMA was established in 2001 by the visual artists Gustaff Harriman Iskandar and R. E. Hartanto and the architect T. Reza Ismail, all three ITB graduates. Iskandar's wife and graphic designer Reina Wulansari joined BCf-NMA as its director. One of BCfNMA's main activities was hosting the international Asia-Europe Foundation 2005 Art Camp for talented young media artists. See Marie Le Sourd, "The Bandung Center for New Media Arts: Local Commitment and International Collaboration", *Leonardo* 39, no. 4 (August 2006): 314–18.

35. Its name is derived from *toko buku kecil*, or "small bookshop." In 2007, Tobucil moved to a new location and continued as an independent organization focusing on book sales, literacy campaigns, and courses for the public on creative writing, crafts, journalism, feminism, philosophy, and other subjects. See Roy Voragen, "The City as Autobiography: The Self and the City as Reflexive Projects", *Melintas* 24, no. 2 (August 2008): 163–83.

36. "About", Bandung Center for New Media Arts website, accessed August 11, 2010, http://bcfnma.commonroom.info/about-2/.

37. "Profil" [Profile], Common Room Network Foundation website, accessed August 11, 2012, http://commonroom.info/about/.

38. Ibid.

39. Le Sourd, "The Bandung Center".

40. "Urban Cartography Vol. 1: Bandung Creative Community 1995–2005", in *CP Biennale 2005: Urban/Culture*, ed. Rani Ambyo (Jakarta: CP Foundation and KPG, 2005), 225.

41. Salomo Sihombing, "Perkumpulan BCCF resmi dideklarasikan" [The BCCF Club Has Been Officially Declared], *detikBandung*, December 22, 2008,

accessed April 20, 2012, http://us.bandung.detik.com/read/2008/12/22/10025
7/1057484/492/salomosihombing.blogdetik.com.
42. "About BCCF", *bandungcreativecityform* blog, accessed April 4, 2012, http://
bandungcreativecityforum.wordpress.com/about.
43. "IYCEY Design and Film Award 2007 Winners", British Council website,
accessed May 2, 2012, www.britishcouncil.org/indonesia-arts-iycey-winners.
htm.
44. Helar is derived from the Sundanese verb *ngahelar*, which refers to organizing
activities that are able to draw people's attention.
45. Salomo Sihombing, "Saatnya pekerja kreatif bangkit bersama" [It is the
Moment for Creative Workers to Rise up Together], *detikBandung*, June 30,
2008, accessed April 30, 2012, http://us.bandung.detik.com/read/2008/06/30/0
90455/964651/492/saatnya-pekerja-kreatif-bangkit-bersama.
46. Ibid.
47. "About BCCF", *badungcreativecityform* blog.
48. "Bandung: The Creative City", British Council website, accessed May 2, 2012,
www.britishcouncil.org/indonesia-creativity-creative-cities-bandung.htm.
49. Ibid.
50. "About BCCF", *badungcreativecityform* blog.
51. "Minister Mari Elka Pangestu Leads Ministry for Tourism and Creative Econ-
omy", *Wonderful Indonesia*, accessed May 2, 2012, www.indonesia.travel/
en/news/detail/517/minister-mari-elka-pangestu-leads-ministry-for-tourism-
and-creative-economy.
52. Erlangga Jumena, "Era ekonomi kreatif" [The Creative Economy Era], *Kom-
pas.com*, November 3, 2011, accessed May 2, 2012, http://bisniskeuangan.
kompas.com/read/2011/11/03/06582548/Era.Ekonomi.Kreatif.
53. Ibid.
54. "Bandung Creative City Forum: kami capek mendengar janji pemerintah"
[Bandung Creative City Forum: We Are Tired Hearing the Promises of the Gov-
ernment], *Tempo Online*, August 11, 2008, accessed April 20, 2012, http://
majalah.tempointeraktif.com/id/arsip/2008/08/11/WAW/mbm.20080811.
WAW127900.id.html.
55. Ibid.
56. Project Heterologia, "Paradoks perkembangan ekonomi kreatif di kota
Bandung" [The Paradox of the Development of the Creative Industry in
the City of Bandung], *Bandung Creative City Blog*, May 19, 2008, accessed
April 4, 2012, http://bandungcreativecityblog.wordpress.com/2008/05/19/
paradoks-perkembangan-ekonomi-kreatif-di-kota-bandung.
57. Ibid.
58. John Hartley, ed., *Creative Industries* (Malden, Oxford, and Carlton: Black-
well Publishing, 2005).
59. John Hartley, "Creative Industries", in *Creative Industries*, ed. John Hartley
(Malden, Oxford and Carlton: Blackwell Publishing, 2005), 1–40, especially
19.
60. Terry Flew, "Creative Economy", in *Creative Industries*, 344–60.
61. Angela McRobbie, "Clubs to Companies", 375–90.
62. Ibid., 382–83.
63. "Nu-Substance Festival 2009: Resonance/Bandung, 19 Oktober s/d 8 November
2009" [Nu-Substance Festival 2009: Resonance/Bandung, October 19 until
November 8, 2009], *commonroom.info*, accessed November 20, 2013,
http://commonroom.info/2009/nu-substance-festival-2009-bandung-19-okto-
ber-sd-8-november-2009/.
64. Ibid.
65. Ibid.

66. Ibid.
67. Davisi Boontharm, "The Idea of Creative Reuse Urbanism: The Roles of Local Creativities in Culturally Sustainable Place-Making: Tokyo, Bangkok, Singapore", in *Future Asian Space: Projecting the Urban Space of New East Asia*, ed. Limin Hee with Davisi Boontharm and Erwin Viray (Singapore: NUS Press, 2012), 73–87, especially 73; and Michael Keane, "Harmonising Creativity", in *Redesigning China's Creative Space* (London and New York: Routledge, 2011), 37–56, especially 56.
68. "Nu-Substance Festival 2010: Floating Horizon/Bandung, 9 Juli–1 Agustus 2010" [Nu-Substance Festival 2010: Floating Horizon/Bandung, July 9–August 1, 2010], commonroom.info, accessed November 20, 2013, http://commonroom.info/2010/nu-substance-festival-2010-floating-horizon-9-july-1-august-2010/.
69. Idhar Resmadi, "Diskusi Keterbukaan Budaya dalam Pembukaan Expert Meeting Nu-Substance Festival 2010" [Discussion about Cultural Openness during the Opening of the Expert Meeting of the Nu-Substance Festival 2010]", *commonroom.info*, accessed November 20, 2013, http://commonroom.info/2010/diskusi-keterbukaan-budaya-dalam-pembukaan-expert-meeting-nu-substance-festival-2010-oleh-idhar-resmadi/.
70. Boontharm, "The Idea of Creative Reuse Urbanism", 73.

14 The Virtual *Extimacies* of Cao Fei

Justin Clemens

I really do believe that today's media are basically practising loser therapy. Isn't the entire contemporary mass-media culture essentially loser therapy?

<div align="right">—Peter Sloterdijk[1]</div>

The mid-2000s saw a sudden jag in the public interest in open online real-time virtual worlds, above all in Second Life (SL), which quickly became a hot topic on a variety of other media franchises, attracting the attention of TV talk shows and governments alike. "What is Second Life?" its official website asks before giving the focus-group user-friendly answer: "Second Life is a 3D world where everyone you see is a real person and every place you visit is built by people just like you".[2] Caught up in the global frenzy not to be left behind, the stampede had just begun: Before anybody had really thought about it, governments, universities, research units, random religious groups, and all sorts of other organizations had enthusiastically delivered themselves over to the social medium of the future.

Whether or not an official government representative online is indeed to be considered a "real person", let alone being a person "just like you", is probably not the point. SL's relative superiority over other rival virtual worlds was not entirely a consequence of its unparalleled grip on verisimilitudinous simulation—along the lines of "this is the most realistic flying moose carrying a shotgun I've ever seen online"—but more probably down to its economic organization, which Adam Nash has sardonically characterized as 'Californian Libertarian Capitalist' principles. SL is founded on property and creative rights—you can buy land, as well as design and retail various goods—participating in a genuine economy trading in "Linden Dollars," which can be exchanged for real money in the real world as well.[3]

Right away, all sorts of fiscal interests exploded into this vast transactional post-industrial economy, which saw the near-immediate re-creation of well-developed markets from the pre-SL world, ranging from real-estate investment to boutique fashion retail. Anthropologists were literally beside

themselves with excitement. As one of the best of them breathlessly exclaimed, if one can indeed breathlessly exclaim anything in a scholarly tract on SL,

> A man spends his days as a tiny chipmunk, elf, or voluptuous woman. Another lives as a child and two other persons agree to be his virtual parents. Two "real"-life sisters living hundreds of miles apart meet every day to play games together or shop for new shoes for their avatars. The person making the shoes has quit his "real"-life job because he is making over five thousand U.S. dollars a month from the sale of virtual clothing.[4]

But the commodification goes deeper than simply the unrivalled opportunities for designing, retailing, and marketing all sorts of extraordinary virtual commodities. As another virtual anthropologist, Celia Pearce (and her avatar, Artemesia) put it, "[w]hile people may feel empowered by their new communities in the global playground, the bottom line is that their communities, their property, indeed their very bodies, are owned by corporations."[5] This strange fact—which has, as the virtual anthropologists have certainly underlined, unprecedented implications for identity—cannot be ignored by anybody attempting to understand the vicissitudes of virtual identity.

This is precisely one of the reasons why Cao Fei seems to me one of the first great artists of virtual life. Unlike all the familiar varieties of what Marshall McLuhan might have denominated as "rearviewmirroristic" art online—virtual "paintings", "sculptures", or other forms of spectacular digital work—Cao Fei's work goes straight to the complexities and consequences for intimate behaviors online and does so in a way that exceeds such reviewmirrorism.[6] Indeed, she is a genuine star in the global contemporary art market, working across a range of media, which are by no means restricted to SL itself.

Work practices are always already outcome of struggles for the realization of one utopia or another, that is, the actualization of virtual places, and the analysis of utopia is crucial to Cao Fei's practice (this is even canonized in the title of one of her major works, *Whose Utopia*). Cao Fei, moreover, tries to give from within the situation ways in which that situation can be collectively reenvisaged; she then exposes this attempt of revisioning as part of the art itself. This is evident from her consistent practice in Second Life. She has been involved in Second Life from late 2006. Her early forays primarily involved the customization of her avatar and the relationships it could enter into (or that she could enter into through it), as well as the modes of representation adequate to this new kind of virtual creature. I discuss several aspects of her practice in more detail in the following.

Part of Cao Fei's genius in this regard hinges on her ability to explore issues of intimacy in the virtual world, which she does with an as-yet unparalleled fusion of emotional sensitivity, conceptual inventiveness, and technical facility. Her talents are immediately perspicuous even from her

early online sallies, notably the sequence of the acerbically titled *i.Mirror* machinimas from the late-2000s. *i.Mirror Part 1* even opens with an orienting citation from art critic W.J.T. Mitchell: "I construct, and I am constructed, in a mutually recursive process that continually engages my fluid, permeable boundaries and my endlessly ramifying networks. I am a spatially extended cyborg." Yes—a cyborg. Yes, too—cyborg intimacies. We will shortly see how Cao Fei puts SL to use in a way that literalizes its virtual possibilities and accompanying critical propaganda, as she exposes its limitations (see Figure 14.1). In doing so, she targets the new practices and paradoxes of intimacy in virtual environments.[7]

As Pierre-Gilles Guéguen recapitulates, a recognizable form of "intimacy" enters public life in the eighteenth century in the form of published literary confessions that give "intimacy"—that is, the vicissitudes of an individual's daily experience in regards to sex, love, family, illness, war, and work—a novel aesthetic *and* political value.[8] Intimacy becomes *aesthetic* in every sense of this word: It is at once sensory, sensed, sensibility, and sense. But it is also for these reasons *political*, if in a divided way: Politics must now reckon with the personal experiences it simultaneously excludes. The dividing line in modernity between aesthetics and politics is troubled at its heart by these intimate assaults.[9] Moreover, and although thoroughly naturalized, it is clear that the narrative *operations*, coupled with the extension of new printing techniques and expanding literacy, must themselves be considered primarily *technological* interventions. The invention of a genre is *always* a technological innovation, and such a technology, concomitantly, always also has the effect of a transformation of the status of intimacy (as much else).

Figure 14.1 Cao Fei, *RMB: Tracey China in Second Life* (Since 2007).
Source: Courtesy Vitamin Creative Space.

As a result, new genres such as the *journal intime*—à la the self-consciously literary diary—become at once tacitly personal and intensely public, autobiographical and aesthetic; they operate at the existing limits of these zones, mixing and matching in a way that is both pseudo-apologetic and quasi-transgressive. As Guéguen notes of Jean-Jacques Rousseau's *Confessions*, perhaps the book that gave the decisive and exemplary impetus to the genre:

> it is a question of saying everything, of invoking truth in the form of defiance but also in the form of reasoning, with the purpose of silencing the Other; it is a question of confiding what is purportedly beyond decorum and shame, in order to place oneself beyond judgement. Truth here takes on the appearance of a form of *jouissance* that allows one to be in the right and to prove a certainty to a real or imagined persecutory adversary.[10]

The paradoxical revelation of intimacy in such confessions, then, is a trafficking with a personal truth that purports to be naked at the moment it has been fully worked over by narrative techniques. One presents oneself as modest and withdrawn; this modesty is utterly shameless and self-justifying; the stupefying (yet strangely persuasive) implication is that it is honest and brave to do so. There is courage in self-revelation, in the transfiguration of shame(lessness) through its exacerbation, a heady immixture of narcissism and abandonment. The technical elements required for such self-revelation cunningly anticipate possible objections to the content by spectacular pre-emption. We should also keep in mind how this technology runs the line I mentioned earlier between aesthetics and politics.

In other words, "intimacy" is from the first an artificial, eminently self-conscious trafficking with the radical affects of publicity in a way that is simultaneously persecuted and persecutory. Yet, as Guéguen's analysis also makes clear, intimacy now not only involves generic innovations at the intersection of feeling and media, but a new kind of relation between knowledge and belief. *Intimacy* becomes a strategic modality whereby one's feeling becomes a knowing becomes a certainty that trumps anything that the Other—the phantasmatic-but-real "public" created by new media—might try to throw at you.

If a proto-Romantic etiology continues to govern the problematics of "intimacy" online today despite the unprecedented transformations in post–World War II communication technologies, there are still some crucial new features we need to attend to—and I do so in a moment—but, if anything, they seem to have had the effect of globalizing and radicalizing certain systemic tendencies of such intimacy rather than simply supplanting or destroying them.[11] One of the reasons for this is that our most sophisticated conceptual tools for thinking representations remain those that derive from

the German Idealist philosophers of the late-eighteenth and early-nineteenth centuries. Indeed, what we will call "The Antinomies of Virtual Reason", following Immanuel Kant's model in *The Critique of Pure Reason*, are now endemic to the field of conceptual production, as well as the circulation and consumption, of such representations.

Part of the difficulty we have in thinking representations is undoubtedly due to the logical consequences of their structuring that Kant analyzes in his *Critiques*. Given that, for Kant, the mind is itself a representing-machine, composed of different faculties with specific representational jurisdictions, which each treat different kinds of representations with different kinds of operations. Sensibility is receptive; it squelches all affect into the "pure and empty forms of space and time"; imagination is reproductive, insofar as it archives, assembles, and reassembles bundles of sense data in ways that cut them from their original sensible spatio-temporal localizations; understanding determines the treated sensible data under the heading of its concepts; higher reason works with nonempirical, transcendent ideas of God, freedom and immortality; judgment ensures different kinds of links to be made among intra-facultative representations. The point is that almost everything becomes a multiply treated representation or set of representations that, in its very treatment, must lose the signature of its origin. Thus, if there is a police aspect to Kantian critique, returning stray representations to their proper place and upbraiding the natural excesses of the faculties, such police work is done under the heading of pointing out irreparable logical inconsistencies. This is the problem of the antinomy.

An antinomy for Kant is a doublet of contrary propositions, in which both thesis and antithesis are equally plausible (e.g., "The world has a beginning in space and time'/'The world has no beginning in space and time."). Let us translate this into terms more appropriate to our current topic:

> *THESIS*: virtual reality is really real.
> *ANTITHESIS*: virtual reality is not really real.

Or

> *THESIS*: virtual reality is a new phenomenon.
> *ANTITHESIS*: virtual reality is not a new phenomenon.

There are any number of ways in which these antinomies emerge in the field. For example, virtual reality is obviously a patently non-real zone, a zone of fictitious entities established and sustained by new communication technologies. Hence, the prevalence of accounts that emphasize the radically non-real elements of contemporary virtual environments. On the other, such virtual reality is clearly as "real" as any other form of fictitious entity (literature, art, theater, etc.), with no more nor less substance than these.

Hence, the prevalence of accounts that make all human endeavors always-already virtual, including recent neuroscientific accounts that show how the embodied brain, with no immediate access to reality, is integral to the creation of the world as it finds it. So critics as different as Tom Boellstorff, Bernard Stiegler, and Slavoj Zizek like to propose that we have always been virtual, and what's now called "virtual reality" only finally exposes this primordial situation. The paradox of the human is that humans have always and only ever been *virtually* human.[12]

But what I want to note here—and why I have reduced the field to sets of antinomies—is that, for Kant, the antinomies cannot be resolved because, unlike "sophisms" or "paralogisms", they are not merely subjective illusions or false syllogisms. On the contrary, they inhere "objectively" in the nature of human reason itself, and are thus ineradicable. Yet they also fail to deal with the real logic of the situation. Kant's own resolution to the antinomies is in line with his "Copernican" philosophical resolution: the antinomies are generated by the mind-dependent-but-neither-contingent-nor-willful structures of representing itself, and the apparent opposition in fact derives from a confusion of faculty-specific tasks.

Analogously, I would like to suggest that we need to take the structures of representing seriously too—the difference from Kant being the actual specificities of the new communication technologies. Yes, human beings have only ever been virtually human; but we are only now in a position to *know* this given the development and impact of our new post-convergent technologies. The key is that Kant's "faculties"—for him, regions of mind—can better be considered as externalized technical devices—optic fibers, computing, networks—whose routines are nonetheless analogously identifiable as providing the transcendental conditions for human life. The paradox is that humans thereby become the little local effects of the great globalized cyborg mind in which they operate.

The key to virtuality is therefore the new centrality of new *technology*—contemporary real-time, global, electronic, computerized, communication systems. Ludwig Wittgenstein remarked that "the limits of my language mean the limits of my world", but it would be more accurate to say that "the limits of my communication technology mean the limits of my world".[13] At once the most impersonal and the most intimate of all our encounters, new communicational technologies circumvent natural languages or, at least, subordinate such languages to their materiality and algorithms. iTech is today's happiness, the last universal bastion of uncriticizable progress—even of *utopia*. Technology is now the uncontested paradigm for activity itself—that is, not only of application of power within and upon the world, but also in the creation of new worlds themselves—and such technology entails a radical externalization and depersonalization of the very subjectivity—or iSubject—it makes possible, in its new entwining of power with impotence. One might even think of the Kantian sublime in a new way here: the impotent encounter with the technology that makes us possible as it exceeds our grasp, and leads to a kind of transcendental recoil of the self on itself.

What, then, makes these new technologies truly new when considered as the externalized transcendental technical conditions of representation? First, they are immediately global. Second, they are linked in real time. Third, they require constant interaction, that is, sets of new ongoing behaviours mandated by the interface with the technology itself.[14] Fourth, they provide haptic, visual, and aural data simultaneously.[15] Fifth, they necessitate high-tech hardware, including fast Internet connections and the requisite software. Sixth, they are essentially and patently post-convergent; for example, in SL itself, one can upload photographs, videos, texts, and so on or some combination of these. Seven, they entail that all interactions inscribe an integrally-harvestable data-trail, whose very complex implications include the accomplished expropriation of the means of representation itself.

Because of these necessary and inseparable conditions, the issue of the "interface" becomes one of the most pressing design issues in communicational technology today. The key solution to this issue has been that of the fully customizable avatar. Drawing its moniker from the Hindu name given to the incarnation of a deity, an avatar is at once a representation of self in-world, *as well as* a functional operator. Divided irreducibly between representation and operation, avatars are essentially *mutable entities* in their appearance; that is, they are able to be altered according to the whim of their user, but *absolutely constrained* in their operations.

At the moment, moreover, that they are absolutely singularized—every avatar literally archives within itself its own coming-to-be and navigational history—every avatar can simultaneously have multiple users, as any user can have multiple avatars. At once singular and multiple, representation and operation, the antinomy of the avatar has entailed some peculiar consequences for embodiment. As Slavoj Zizek notes,

> The literal "enlightenment," the "lightness of being," the relief/alleviation we feel when we freely float in cyberspace (or, even more, in Virtual Reality), is not the experience of being bodiless, but the experience of possessing *another*—aetheric, virtual, weightless—*body*, a body which does not confine us to the inert materiality and finitude, an angelic *spectral body*, a body which can be artificially recreated and manipulated.[16]

What is notable about this is that the experience of the avatar is itself double: You are simultaneously sitting in front of a keyboard or tablet in an absolutely prosaic empirical situation, as you are flying through the air of a virtual island in SL. At this point, a peculiar crossover happens. The avatar's appearance becomes absolutely crucial in presenting itself as an example of a type-for-others. This type suggests the sorts of interactions that the avatar is "up for", the sorts of affiliations that it would in principle like to make.

It is regarding this absolutely intimate and impersonal apparition that Cao Fei began to work on her avatar, which she bought "real skin" and a "fake pussy". The avatar's real skin is not only an example of the many pastiches of verisimilitude endemic to virtual worlds, but itself also becomes a sign of

commitment to other in-world enthusiasts: If you see avatars with real skin seeing you with real skin, then you are literally more likely to get into a virtual business or bed with each other—hence Cao Fei's avatar's fake pussy, which enabled her to have virtual sex with other like-minded avatars. Such work of generic singularization, if that's a phrase, becomes integral to virtual interaction. In becoming so treated, avatars also become always-already "documents": real, yet representation; virtual, yet actual. With these paradoxes in mind, we can return to Cao Fei's stunning sequence of works titled *i.Mirror*, the first even subtitled "A Second Life Documentary Film". As we confirm, any action with an avatar is simultaneously fictional yet documentary.

First, a paradox: What could a "documentary" whose material was always already only in pixel events be? Moreover, in a real sense, these *i.Mirrors* are not "films" at all. There is no camera, no external world or lighting source, no film, but a "machinima", a kind of animation created entirely by 3D computer graphics rendering engines. The name itself is a contraction of "machine" and "cinema"—an eminently twenty-first-century medium. Because fans are often the ones creating the machinimas which are then uploaded online to a variety of sites, including YouTube, there are often complexities which are far from being resolved—if, indeed, they are even in principle resolvable. The most intimate avatar—customized, habitually-used, deeply-loved—is in fact a techno-corporate-legal distributed singular multiple entity. Moreover, the *i.Mirrors* also enable a new kind of artwork, one essentially linked to certain technical peculiarities of the new media, in which the platform(s) = the studio = the gallery = the delivery = the interaction = the work. This renders the machinimas performatively multiple. As Boris Groys remarks,

> A digital image, to be seen, should not be merely exhibited but staged, performed. Here the image begins to function analogously to a piece of music, whose score, as is generally known, is not identical to the musical piece—the score itself being silent. For music to resound, it has to be performed. Thus one can say that digitalisation turns the visual arts into a performing art.[17]

The ongoing adventures of "China Tracy", Cao Fei's avatar, constitute in themselves a performance with the avatar and its possibilities in SL. The name China Tracy is deliberately reminiscent of a noir film femme fatale; however, as Cao Fei notes, it is a Chinese name in which the surname is placed first. This would make the European name "Tracy China" (which does not sound quite as noir to me). The proper name, its function, sense and referent are radically destabilized by these online worlds. China Tracy's own appearance and functionability have likewise been constantly modulated—not least by the subsequent "birth" of the avatar's online virtual baby, China Sun.

The extraordinary *i.Mirror* Part 2 presents a romantic encounter between China Tracy and Hug Yue [*sic*], whose first life representative is a sexagenarian Californian communist bankrobber.[18] The artist was simultaneously

"herself", an actor in, a subject of, and a producer, director, and editor for a film that was at once entirely animated and entirely documentary. The machinima constitutes a kind of schmaltzy generic chick-flick, in which boy meets girl in various romantic fantasy situations—alone together in an urban train carriage, in a hot air balloon, and in bars where they exchange meaningful non sequiturs by text or play pianos or guitars—with Hollywood-style cross-cutting and an MOR soundtrack. The "dialogu"' is replete with misspellings and weird idiomatic abuses.

At one point, China Tracy asks, her avatar staring at her own "reflection" in a "nightclub" "bathroom" "mirror" (how many scare quotes are going to be up to the job of discerning virtuality?): "Is my avatar my mirror?" Hug Yue responds: "Others it is reflection of things. . . . Like aspirations". There is a sudden cut to a spinning "crane shot" of China Tracy sitting alone at night on a bench: "Sometimes I'm confusing the FL and SL. I don't know where I am". Hug Yue: "We all in the Panopticon . . ."

A sequence of cuts—urban decay, smoke billowing from obscure machinery, flames flickering in front of the distant moon—gives way to the couple sitting at a table in a fancy restaurant, tall windows giving onto a vast cityscape outside. China Tracy: "What do you think it about the digital world?" Hug Yue: "It's one that is dominated by youth, by beauty and money. . . . And it's all an illusion." As Cao Fei herself puts it in another online interview: "when we travel through *Second Life* we inevitably project our first life into it."[19] Yet we do not project our first life in its reality, but the life we perhaps think we would prefer to be living: the digital world as realized, real fantasy. This strange combination of transnational soap-opera schmaltz, high-tech shonkiness, new age exhortation, media savvy, and high-grade philosophical and poetic allusion (Octavio Paz, Martin Heidegger) is characteristic of Cao Fei's work.

But Cao Fei's most ambitious virtual enterprise to date involved the construction of RMB City, an enormous conurbation in SL.[20] Composed of skyscrapers, scaffolding, freeways, factories, a wrecked gunship, a tank, a nightmarket, a gargantuan yellow toilet bowl, a giant panda, a statue of Mao, and a flying red flag held up by four yellow stars with another star embedded in it like a shuriken, old-school Chinese buildings, as well as many other bizarre sights and sites—RMB City is an allegory of contemporary Chinese urbanization. As its own PR and many critics have noted, RMB City is a turbo-charged online Chinatown inserted into the existing environment of SL. What is especially pertinent about this extraordinary construction in the current context is the number of "entertainment" options it provides: not only allusions to or parodies of "real" entertainment sites in the "real" world (such as an Olympic stadium), but also that it itself is at once entertainment and a place for staging further entertainments—*which are only activated in and by your own intimate participation.* Not all the aforementioned projects are by Cao Fei herself; indeed, that is part of the point, hence such projects as "People's Limbo in RMB City", "Master

Q's Guide to Virtual Feng Shui in RMB City", or "Interview Marathon in RMB City"—all of which are linked, in one way or another, to "real world events", whether to the GFC or RMB City's reinstallation in the Serpentine Gallery London in March 2009.

In concluding, I would like to affirm this claim by specifying some—not all!—aspects of Cao Fei's virtual practice using three neologisms drawn from or inspired by Lacanian psychoanalysis: *instasy*, *extimacy*, and *lathouses*.

Let us begin with what I will call *instasy* or even the *instatic*, a concept which, although not found by that name in Lacan himself, nonetheless constitutes one of his major theses: If ecstasy is etymologically an *ex-stasis*, literally a standing-outside-of-place, *instasy* is a ramming-back-into-place. This is comparable with what Søren Kierkegaard denominated the "demonic . . . the contentless, the boring": along these lines, *instasy* would then best be considered a form of "inwardness with a broken latch".[21] One paradox of virtual technologies is that, in the very necessity to externalize, to *techno-phenomenalize*, all interactions, this necessity rams all users back into themselves, into radicalized incommunicable solitude. As Zizek, again, has it,

> No wonder that Leibniz is one of the predominant philosophical references of the cyberspace theorists: what reverberates today is not only his dream of a universal computing machine, but the uncanny resemblance between his ontological vision of monadology and today's emerging cyberspace community in which global harmony and solipsism strangely coexist. . . . Are we not more and more monads with no direct windows onto reality, interacting alone with the PC screen, encountering only the virtual simulacra, and yet immersed more than ever in the global network, synchronously communicating with the entire globe?[22]

Instasy, as a direct consequence of real-time post-convergent hardware, is therefore quite literally the contemporary demonic: enforced dispersed communication that enwalls the user in ever-more-superficial and transparent dungeons of ever-tinier pixels. The very means of escaping the self ensure that there is no escape, but rather a variation upon what the nineteenth-century English poet Gerard Manley Hopkins called "inscape": a dreary labyrinth of solitude without an outside. What the concept of the *instatic* further suggests is that the intimate self is not, or is no longer, merely a self without outside, but an entirely evacuated self. Unlike the Cartesian void presented by the cogito, however, in which one cannot deny that one is a thinking thing (i.e., an active process of intellection), or the Lacanian revisioning of the void of the subject as pure support for a signifying process, the *instatic* void is something else.

Again, this difference may require a little explanation. After all, how *does* one tell the difference between vacuoles given that, à la the Leibnizian principle of indiscernibles, two things which share the same predicates—in this case,

sharing precisely the same lack of predicates!—are to be considered the same thing? Here, the differences can be discerned by comparing the differences in their defining lack. Whereas Lacan was still tied to the modern epoch of science insofar as the subject was subject to *signification*—that is, a paradoxical, divided, diacritically defined process that at every point lacks the meaning that it nonetheless continues to promise—the subject of *instasis* is subject to *information*. As we know, in the post-Shannon dispensation, information is neither meaningful nor not meaningful, but rather *operative*; it is a matter of signaling-without-substance, and not of a putatively lost significance.

Paradoxically, then, this *instatic* situation also constitutes a clear case of *extimacy*: what we routinely consider the most intimate aspects of ourselves are constituted by the most radically inhuman and external. IT—information technology—is also really an IT, or what Sigmund Freud called the Id. Usually intimacy is considered online as a radical externalization of the self-as-avatar, but IT should also be considered as the traumatic irruption of what cannot be internalized. It is not just that I am another at the heart of myself, but that that other is not human; indeed, it has no concern for the I at all, except insofar as it is the I's parasite: a massive external, ferromagnetic parasite indifferent to its host.

Lathouse is a portmanteau term coined from the Greek *lethe* (forgetting), *aletheia* (truth) and *ousia* (being). It would also remind Francophones of the word *ventouse*, an octopus sucker, suction cup, or cupping glass.[23] A *lathouse* is a technological device that latches onto your body, either onto existing orifices as a prosthetic enhancement or by creating new extraction zones in the body. As it extracts enjoyment and delivers a mild therapy, it also becomes the focus and locus of massive anxiety. A *lathouse* is at once utterly banal (because we overlook its import in our quotidian reliance on it) and terrifying (because, if we thought seriously about what it involved, the implications are abominable). Our access to SL depends on the terminals or mobiles that extract and determine our commodified enjoyment.

Virtual technology, as Cao Fei shows, is at once the most externalized, distributed, and inhuman of experiences—at the moment that we have never been more dependent on such technology for our most intimate quotidian experiences. In the end, perhaps, the role of the contemporary artist—like that of any other celebrity, really—is to propose exemplarily dissatisfying answers to the question, How should we live? Cao Fei gives the only real answer today: *We subsist in enforced instatic virtual extimacies by means of lathouses.*

NOTES

1. Peter Sloterdijk in *The Digital Wunderkammer: 10 Chapters on the Iconic Turn*, ed. Hubert Burda (Munich: Petrarca Verlag, 2011), 93.

2. "What is Second Life," *Second Life*, 2013, 18 November 2013, http://secondlife.com/whatis/?lang=en-US.
3. Adam Nash, personal communication, April 1, 2008. There are a number of extraordinary implications for such online gaming economies. A recent outrage in this regard was reported in world media as "China used prisoners in lucrative internet gaming work", where prisoners reported "scores of prisoners forced to play online games to build up credits that prison guards would then trade for real money"; *The Guardian*, May 25, 2011, www.theguardian.com/world/2011/may/25/china-prisoners-internet-gaming-scam In 2008, the trade in such credits in China alone was estimated at £1.2 billion.
4. Tom Boellstorff, *Coming of Age in Second Life: An Anthropologist Explores the Virtually Human* (Princeton, NJ: Princeton University Press, 2008), 8.
5. Celia Pearce and Artemesia, *Communities of Play: Emergent Cultures in Multiplayer Games and Virtual Worlds* (Cambridge, MA: MIT Press, 2009), 280.
6. I have already written extensively on Cao Fei's work; the present essay takes up, extends, and inflects my own previous publications on the topic (particularly the last named in the following, which is partially reproduced here). See Justin Clemens, "China Tracy's New New Second Life", in *Cao Fei: Utopia* (Brisbane: IMA, 2009), 14–20; "Virtually Anywhere Real-Time New-Old Avatar-Human Entertainment Art", *Australian and New Zealand Journal of Art* 11 (2011): 113–31; and "Cao Fei and Online Extimacy", *Broadsheet* 40, no. 4 (2011): 242–5.
7. For other accounts of Cao Fei's work, see Hou Hanru, "Cao Fei: A Mini-Manifesto of New New Human Beings", *Flash Art* 242 (May–June 2006): 126–7; and Hu Fang, ed., *Cao Fei: Journey* (Guangzhou: Vitamin Creative Space, 2008).
8. Pierre-Gilles Gueguen, "The Intimate, the Extimate, and Psychoanalytic Discourse", in *Jacques Lacan and the Other Side of Psychoanalysis*, ed. Justin Clemens and Russell Grigg (Durham: Duke University Press, 2006), 263.
9. The major contemporary theorist of such a relationship is the by now ubiquitous Jacques Rancière, for example, *Dissensus: On Politics and Aesthetics*, trans. Steve Corcoran (London: Continuum, 2010); *Aesthetics and its Discontents*, trans. Steve Corcoran (Cambridge: Polity, 2009); *The Politics of Aesthetics*, trans. Gabriel Rockhill (London: Continuum, 2004); and so on.
10. Gueguen, 264.
11. The scholarship on this question is enormous. See, inter alia, such sociological and psychoanalytic accounts as Anthony Giddens, *The Transformation of Intimacy: Sexuality, Love & Eroticism in Modern Societies* (Stanford, CA: Stanford University Press, 1992); Z. Bauman, *Liquid Love* (Cambridge, UK: Polity Press, 2003); Lauren Berlant, ed., *Intimacy* (Chicago: University of Chicago Press, 2000); Jacqueline Rose, *On Not Being Able to Sleep* (London: Vintage, 2004); and Leo Bersani and Adam Phillips, *Intimacies* (Chicago: University of Chicago Press, 2008).
12. See, for example, Boellstorff, *Coming of Age in Second Life*; and Bernard Stiegler, "Teleologics of the Snail", *Theory, Culture & Society* 26, no. 2–3 (2009): 33–45. For Zizek references, see 14, 16, and 22.
13. Ludiwg Wittgenstein, *Tractatus Logico-Philosophicus*, trans. David F. Pears and Brian F. McGuinness with introduction by Bertrand Russell (London and New York: Routledge, 1994), section 5.6.
14. "It is commonplace to emphasize how, with new electronic media, the passive consumption of a text or a work of art is over: I no longer merely stare at the screen, I increasingly interact with it, entering into a dialogic relationship with it (from choosing the programmes, through participating in debates in a Virtual Community, to directly determining the outcome of the plot in so-called

'interactive narratives'). Those who praise the democratic potential of the new media generally focus on precisely these features: on how cyberspace opens up the chance for a large majority of people to break out of the role of the passive observer following a spectacle staged by others, and to participate actively not only in the spectacle, but more and more in establishing the rules of the spectacle"; Slavoj Zizek, *How to Read Lacan* (London: Granta, 2006), 23.

15. "Quasi-immersive" because, despite the ongoing hype, "immersive" must be a metaphor or rather a euphemism given it is still usually experienced on a 2D screen with 3D rendering, even if in principle accessible by multiple modes of presentation (mobile, laptop, desktop, glove and visor, etc.).

16. Slavoj Zizek, 'Love without Mercy,' *Pli* 11 (2001): 184.

17. Boris Groys, *Art Power* (Cambridge, MA: MIT Press, 2008), 85.

18. Cao Fei, "*i.Mirror* Part 2", YouTube video, June 4, 2007, accessed February 25, 2013, www.youtube.com/user/ChinaTracy#p/a/u/1/jD8yZhMWkw0.

19. Cao Fei, "Avatars", *Art: 21*, January 8, 2010, accessed February 25, 2013, http://blog.art21.org/2010/01/08/cao-fei-avatars/.

20. See RMB City's official website, http://rmbcity.com/, for further information.

21. See S. Kierkegaard, *The Concept of Anxiety: A Simple Psychologically Orienting Deliberation on the Dogmatic Issue of Hereditary Sin*, ed. and trans. with introduction Reidar Thomte with Albert B. Anderson (Princeton, NJ: Princeton University Press, 1980).

22. Slavoj Zizek, *On Belief* (London and New York: Routledge, 2001), 26.

23. See Jacques Lacan, *Seminar XVII: The Other Side of Psychoanalysis*, trans. Russell Grigg (New York: Norton, 2007), especially 162–63.

15 The Conjugations of Remix
Or, as Kurt Vonnegut Might Say, Being Spastic in Time

Darren Tofts

je le dis comme je l'entends

—Samuel Beckett, *Comment C'est*

Even when one improvises in front of a camera or microphone, one ventriloquizes or leaves another to speak in one's place.

—Derrida (unpublished interview, 1982)

Samuel Beckett may seem an unlikely patron of contemporary remix. Grandmaster Flash, DJ Kool Herc, or Cindy Sherman are more likely alumni of the ventriloquist art of speaking the already said, not to mention Sherrie Levine and Pierre Schaeffer, and so it goes. Although known ostensibly as an artist of the stage and the written word, Beckett's practice as a dramaturge of audio-visual media precedes the age of the social network, vernacular appropriation, and participatory culture. With the culture poacher's eye for innovation Beckett grabbed things around him that were outside his training in fiction, drama and poetry. Beckett wrote for the electrified voice in radio works such as *All that Fall* (1957) and *Rough for Radio 1* (1973), broadcast body and voice in his later television works *Eh Joe* (1965), *Ghost Trio* (1975), and *Quad* (1981). He even found a use for silence in *Breath* (1969) and for the silent actor Buster Keaton in *Film* (1965). Had Beckett not died on the cusp of the Internet's emergence in 1989, hypermedia would no doubt have been the next language in his audio-visual grammar of entropy.

But audio-visuality or even media specificity is not the defining feature of remix that I am interested in here, certainly not in terms of Beckett's long tutelary shadow. After all, the integration and remediation of different forms, genres, texts, and voices are the very architecture of the literary tradition in English. And it was the monastic figure of the copyist who reproduces others' work that defined the very notion of "medieval Latinity",[1] to quote Ezra Pound, one of the most flamboyant copyists of modernity. It is the stringent polemic and economy of Beckett's tracing of subjectivity as a persistent and fraught search for an authentic, fixed origin of speech that has

not been said or heard before, that recommends him as an avuncular deity of the metaphysics of remix. In Beckett, we encounter the agony of utterance loosed from its mooring in a unique subjectivity. In its stead, we have the persistence of utterance that is paradoxical, hierarchically out of joint and embedded in an overall ambience of vocal noise in which appropriation is the norm, originality an unheard of, or at least problematic aberration.[2]

"WHAT MATTER WHO'S SPEAKING, SOMEONE SAID WHAT MATTER WHO'S SPEAKING"[3]

In a similar act of speaking of others speaking, of speaking of Beckett speaking, the critic Deke Dusinberre described the polemical writing of the filmmaker and theorist Peter Gidal as a style of "consistent oxymoron".[4] Dusinberre argued that Gidal borrowed from Beckett this opaque strategy of contradictory and obsessive repetition, especially a disquieting dissolution of the unified subject and the reliability of authorial hierarchy as a first principle.[5] Accordingly, the rhapsody of an authorial voice becomes the echolalia of previous utterance and an indifference to the authority of first words. This doubt in Beckett, articulated by Gidal in his writings on film,[6] is not so much an anxiety of the already said, of not knowing the origin of speech, but the recognition of its inevitability. And it is this inevitability of the already said that underwrites the age of social media and remix.

Speaking of others' speaking has morphed into a participatory network of ambient communications with a legion of unseen "friends". The beginnings of its formation within the various publics of social media can be found in the piracy associated with video culture in the 1980s, the cut and paste aesthetic of the computer paradigm of the 1990s and the copy-left movement of the 2000s. Accordingly a vernacular taste for ironic quotation is practiced in the aesthetics of mashing, parodying, remixing and modding. Notable statements are reposted, liked, and shared. This contemporary fascination with "enunciation squared" accelerates a historically well-known rumba in literary and cultural criticism to do with the individual talent's tussle with tradition, especially Umberto Eco's fascination with the rumblings and chatter of echolalia in popular culture.[7] But, at the same time, speaking of others speaking has warped perceptions of time as linear succession, inverting the hierarchy of invention preceding repetition.

In an age of media superfluity, do-it-yourself (DIY) prowess and anything instantly, this troubled and troublesome specter of ventriloquism makes it difficult to know what is the mix and what is the remix.[8] But more troubling than a conjugation of tense, the anachronistic practice of remix is more akin to time travel and haunting. This astral queering of time can be found in the audio-visual work of the Australian art collective Soda_Jerk (also known as Dom and Dan Angeloro). In particular two works from their *Dark Matter* suite, *After the Rainbow* (2009) and *The Time that Remains* (2012) can

be read as allegories of remix as a form of anachrony, and of being out of time and out of sequence, that trouble "existing formulations of cultural history".[9]

This taste for the deliberate combination of found material into new, syncretic wholes has its established metalanguages in various critical traditions.[10] Authors such as Lawrence Lessig have written generally about the significance of enunciation squared in relation to notions of the creative commons and the Web literacy of cut-sample-copy and ethics of fair use.[11] Jim Collins maps an economy of the already said precipitated by the information overload associated with the emergence of the Internet. For Collins such semiotic excess coincided with the postmodern, atavistic taste for the "re-articulation of pre-existing codes" at the expense of "pure invention".[12] The emergence of "taste cartographies" in the 1990s was decidedly retro and beyond the bounds of any form of control in the name of choice. Similarly, Daniel Palmer's account of the increased personalization, customization, and the proliferation of choice associated with a participatory culture, demonstrates that it emerged with digital audio-visual media in the age of post-broadcast television. Specifically, after Fredric Jameson, Palmer cites an "eternal present" and, after Paul Virilio, "local historical times" associated with individual taste and habits of consumption.[13] This, for Palmer, is the commencement of the age of a new kind of participation that exceeds the finite and therefore shared channels of discourse and viewing times in traditional media such as television. Instead, social media that did not require regulated habits of viewing or auditioning, such as Flickr, MySpace, Second Life, YouTube, and iTunes, became "integral parts of popular digital culture".[14]

More specifically related to a culture of remix as a reflexive genre grounded in appropriation, artist-theorists such as DJ Spooky and Eduardo Navas are more specific in their attention to the poetics and aesthetics of appropriation practices within vernacular and participatory ideologies. They are especially interested in the history of experimentation in electro-acoustic and recorded music, hip-hop, and sampling. But it is a problematic formulation of Eduardo Navas's to do with temporality and hierarchy in remix that is most relevant for this discussion. Navas's key principle is *when* a remix is a remix. In his persuasive and at times naively formulaic essay "Regressive and Reflexive Mashups in Sampling Culture", he argues that remix as a form is always allegorical, because "the object of contemplation depends on recognition of a pre-existing cultural code"[15] (such as the picaresque epic in *The Odyssey* of Homer, Joyce's *Ulysses*, and the Coen brothers' *O Brother Where Art Thou?*)

In Navas's specific interest of music mash-ups, a similar act of recognition ensures that the "aura" of the original songs prevails amid the juxtaposition of different works. This theory makes sense in terms of the ironic practice of self-conscious re-voicing associated with postmodern theory, such as Umberto Eco's oracular example of the postmodern as the inability to speak

of love for the first time outside inverted commas.[16] Such an allegorical defi-
nition of remix is always archival and chronological, an idealized contin-
uum wherein all relevant texts and their times are known and acknowledged
in a kind of temporal vacuum. The glaring omission in this algorithm is the
identification of a fabulatory subject capable of the temporal omniscience
that is implicit in Navas's allegorical reception theory. It is not Tiresias, nor
Jorge Luis Borges, nor the legion of human subjects that makes up the social
network, *whenever* that is. Rather, it is a conjugation of tense, of progressive
and retrospective encounter, that is entirely dislocated from sequence.

STRANGE, I'VE SEEN THAT FACE BEFORE

Navas is an apologist for a synchronic theory of remix that is at odds with
the "pure and unrelated presents in time" that Jameson has articulated in
the name of postmodernity.[17] There is no guarantee, in other words, wher-
ever and whenever we are, that we can be reliably familiar with a stable
canon of texts that is recognizable. For instance, in terms of one of Navas's
examples, Massive Attack's *Protection* and Mad Professor's *No Protection*
albums exist in a tidy hierarchy of linear time in which the two texts are
juxtaposed and recognized as an original and a copy, respectively. The most
telling detail in this example, however, is the fact that both albums were
released in 1994.[18] The time span of one year is an accessible duration not
only for individual memory but for cultural memory as well. Navas's work,
in the context of the critical apparatus of remix as a whole, demonstrates
that remix as allegory is, and needs to be, comfortably synchronous: Its
implied attention spans are modest and realistic. But what is never really
discussed is the hard fact of duration that exceeds individual and synchronic
cultural memory in 1994; what would Navas make of a mix of 1969 Frank
Zappa and Edgard Varèse from 1930, for instance? Such an exotic baccha-
nal is perhaps unfair, but the specificity it implies, in the name of popular
culture's promiscuity and excess, is not.

Navas's "recognition of a pre-existing cultural code" is an implied ideal-
ism, a textual hypermnesia that simulates omniscience in the inhuman time
of the archive and artificial memory. This presumption of a machinic mem-
ory is implied in the increasing taste in remix works of exhaustively listing
samples. This archive drive to remember everything is the art of memory
that James Joyce prefigured when he described an "ideal reader suffering
from an ideal insomnia". The artifact read by that fictional being, *Finneg-
ans Wake*, demands "to be nuzzled over a full trillion times for ever and
a night".[19] This unreadability is an inflection of the anachronous time of
remix as a practice that is hypertextual, provisional, and dependent entirely
on the personal taste and cultural history of the viewer or auditor.

This idea of anachronous time has been appropriated from Kurt Von-
negut in *Slaughterhouse-Five* (1969), where he unwittingly imagines the

indiscriminate and heterogeneous way in which texts are encountered and identified as either remixes or mixes. Vonnegut uses the metaphor of being "unstuck in time" to imagine a form of living anachrony. It is a form of spasticity in which Billy Pilgrim walks through a door in 1955 and comes out another one in 1941, goes back through that door "to find himself in 1963". He has seen his "birth and death many times" and has paid "random visits to all the events in between".[20] As we shall see, the figurative element of time travel in Vonnegut is literal in Soda_Jerk's *Dark Matter* series, which is another parable of the virtuality of the audio-visual sample.

The realpolitik of the conjugations of remix, then, is especially problematic in terms of the temporal vectors of consumption previously described, of *when*, if at all, we encounter any cultural text. The quantum weirdness of remix presumes that any text could be, can be, and will be an allegorical remix. But the causality of anterior and posterior typically happens in remix criticism, wherein texts progress chronologically as original and copy. Deterministic causality fails to recognize that the times of consumption are more often than not anachronistic, wherein the copy is seen or heard before the original on which it is based. This is a frequently articulated experience of my students. When in 2012 they see the sequence from *A Clockwork Orange* (1971) of Alex succumbing to the Ludovico technique, their sensation of déjà vu recalls Santa's Little Helper succumbing to the same torture they saw as a kid in *The Simpsons* ("Dog of Death", 1992). But this experience of uncanny resemblance, of having seen this somewhere and sometime before, also works the other way, when a different sequence of encounter with the Kubrick text is seen before the Gröening (nota bene: *a* sequence, not *the* sequence). This uncontrollable to-and-fro engagement with cultural texts is the anachrony of consumption that makes both remixes and originals possible in the first place.

This parabola of reference presumes a double take, the feeling that *something* being invoked, or alluded to, is present.[21] This spectral "thereness" recalls the example of seeing a ghost that Freud uses to articulate the notion of the uncanny.[22] For Freud, the figure of the "double" (such as reflections in mirrors, shadows) precipitates an anxiety that is more deeply grounded in the agitation of repetition generally. Also, it intimates that something is also being experienced uniquely for the first time in the presence of its shadow. The fuzzy lexicon responsible for this duplicitous sensation is the exotic nature of choice implicit in sampling. It is this aura of specificity surrounding the sample (its idiosyncrasy, its obscurity, its memorability) that is taken hostage in quotation, the radiance of its *quidditas* (after Joyce, after Thomas Aquinas, after Aristotle.)

For instance, in *Rhythm Science* (2004), DJ Spooky gestured to the prolixity of choice in culture but more particularly to the specificity associated with *which* samples a DJ might select when he linked Biggie Smalls and Walt Whitman. In terms of the near infinity of names that can be juxtaposed in this manner, this congruence is singularly distinctive. As a testimony to

anachrony in the name of quotation Paul D. Miller (another voice speaking for Spooky), recites an apposite line from *Leaves of Grass* (1855), "So what if I contradict myself—I am large, I contain multitudes". He then says of the famous line "it could just as easily have been Biggie's as Whitman's". Hip-hop, he says with some understatement, can "absorb almost anything".[23]

ONCE IN A LULLABY

Among the varied remix projects of artists Dom and Dan Angeloro it is their *Dark Matter* series that is the most articulate in terms of the anachronistic poetics of video remix, the relative dimensions in time that transports frag-ments of the past into the present and vice versa. They express the quantum delicacy of these poetics of time as "the Now".[24] The Now is the uncontrol-lable ambivalence of the time of consumption, a black hole or "Dataverse" of video time in which samples, the quark, strangeness and charm of remix, drift erratically like so many nano-particles. Encounter with a video remix is at once a procession *after*—*A Clockwork Orange* → "Dog of Death"—and a precession *before* "Dog of Death" → *A Clockwork Orange*—whereby both texts are an original and a remix for someone (this "someone" is the unproblematic subject of Navas's theory of allegory.) In an ur-text that anticipates the *Dark Matter* series, we find one of their most cogent and polemical statements about video as "a technics of time travel" that enables our ability to "teleport fragments of the Past into the Now".[25]

In the slender pages of their *Brief Guide to the Quantum Physics of Child Stars* (2006) actors such as River Phoenix and Drew Barrymore represent the Hollywood "body clock phenomenon" whereby they are seen in one video as a child and an adult in the next (and not always in that order). In this the juxtaposition of each film is an invisible elision of decades of real time, such as in *The Phoenix Portal* (2005) in which a 1985 version of River Phoenix in *Explorers* encounters an older self in *My Own Private Idaho* (1991). As well as condensing biological time into a singularity such juxtapositions imply a quantum aesthetics that "open portals between any points in the video space-time continuum".[26] Accordingly, these films are schisms in time in which any extra-diegetic sample that is remixed, alluded to, or parodied is also, at the same time, an intra-diegetic moment unhaunted by any other text. It is this notion of the psychodrama of haunting that prompts Soda_Jerk to refer to the *Dark Matter* series as "séance fictions" in which "encounters are staged between older and younger versions of a deceased figure".[27]

Accordingly the respective characters in the *Dark Matter* works, River Phoenix, Judy Garland, Joan Crawford, and Bette Davis are avatars of the anachrony of video remix. All three works in the *Dark Matter* series, *The Phoenix Portal* (2005), *After the Rainbow* (2009), and *The Time that Remains* (2012) are self-conscious allegories of this interest in video and temporality, in remix as a mechanism of time travel.[28] In the latter two

works, in particular, there is a powerful sense of the uncanny, the anxiety of seeing the past and the future at the same time, now, and a now to come. Both are irredeemably melancholy laments at the inability to control the mortal passage of time and the certitude of remix encounter. As an analogue of this sadness *The Phoenix Portal* is haunted by the nominal actor's actual death in 1993. In embalming time and reanimating the dead,[29] River Phoenix does not circulate to and fro in time but his filmic sample does.

It is telling when in *After the Rainbow* Dorothy encounters the inscrutable Dr. Marvell, crystal voyager of past, present and future. Rather than Dorothy's gaze upon an infirm Aunty Em we witness the young Judy Garland's anxiety at seeing a spectral image of her older self in middle age. She too is "sad and clutching at her heart", an image seen many years previously by others gazing into Marvell's retro crystal ball (see Figure 15.1).[30] Telling, too, that the twister that transports Dorothy to Oz is also seen in *The Simpsons* ("Hurricane Neddy", 1996). So, too, is Dorothy's waking experience having returned from the phantasmagoria of Oz, a ventriloquy spoken in Bart's recollection of the dramatis personae who were "there" in his out of body experience, having been hit by Monty Burns's car ("Bart Gets Hit by A Car", 1991).[31] Bart's experience, while paranormal, is also paratextual.[32]

In a striking sequence towards the end of *After the Rainbow*, a young Judy Garland tearfully encounters herself as a middle-aged woman singing "The Man that Got Away", a melancholy song about aging, lost love, and the ebb and flow of a lifetime of dreams that eventually vanish (the fabricated mise en scène straight out of David Lynch's *Twin Peaks* may or may not be recognized; see Figure 15.2).[33] The older woman glances over

Figure 15.1 Soda_Jerk, *After the Rainbow*, two-channel video, 5:42 minutes (2009).
Source: Courtesy of the artists.

Figure 15.2 Soda_Jerk, *After the Rainbow,* two-channel video, 5:42 minutes (2009).
Source: Courtesy of the artists.

her shoulder and waves, fading into oblivion as her distressed younger self watches helplessly at the passing of time in an instant, lamenting things that have "all gone astray".

But let's conduct a thought experiment about familiarity. What actually makes *After the Rainbow* a didactic remix is its basis in an iconic film. The assumption behind the use of so-called auratic texts such as *The Wizard of Oz* is their recognizability, their mass appeal, and their historical longevity as classics (Tom Six's *Human Centipede 2* is by comparison not such a contender). In other words, it is their sample-ability that is memorable. This is an interesting argument, though not a compelling one, even with Collins's taste cartographies in mind. It presumes a canon of popular taste in Hollywood cinema and a plethora of Internet sites devoted to trawling culture since 1939 for references to and quotations of *The Wizard of Oz*[34] (but even as I write this, I hear someone else saying that the generation of social media is more likely to be familiar with mobisodes and Twitter feeds than with the "Golden Years of Hollywood").

But with this denunciation of the film's recognizable iconicity and its global popularity in mind, let's further entertain the conceit in terms of its reverse. Let's assume that the films sampled in *The Time that Remains* are more obscure and less recognizable, heightening the likelihood of the work being seen for the first time without any echoes nibbling at the mind for recognition.[35] *The Time that Remains* is a longer, two-channel work of separate narratives featuring Joan Crawford and Bette Davis. While the image

of Joan Crawford is still, an inanimate figure in bed, Bette Davis is stirred by a ticking clock—brought to life as if having been recognized, like a sample being "seen" (this situation is reproduced in Crawford's sequence), hence the significance of the ticking clocks in both and, for that matter, the same clock sampled from *Possessed*. Like Judy Garland, Bette Davis and Joan Crawford are distraught at the site of their performance as older women, sampled from texts made years into the future.

Both Davis and Crawford, anachronistic and unstuck in time, feel the horror of being haunted by an older sample of themselves in different films. The sound of Tony Bennett crooning "As Time Goes By" accompanies a sequence from *Hush . . . Hush, Sweet Charlotte* as Bette Davis opens a door to a ballroom scene in *Jezebel* twenty-six years earlier (see Figure 15.3). Similarly a young Crawford from *Humoresque* is confronted by her older self eighteen years into the future, speaking of how she has changed in *Strait-Jacket* (see Figure 15.4). The number of different film-selves represented in both narratives (four in each case) is an excess of reference that is too much

Figure 15.3 Soda_Jerk, *The Time That Remains*, two-channel video, 11:56 minutes (2012).

Source: Courtesy of the artists.

Figure 15.4 Soda_Jerk, *The Time That Remains*, two-channel video, 11:56 minutes (2012).

Source: Courtesy of the artists.

to bear for either character as well as potential viewers. Crawford throws a glass through a window, the perverse symbol of a screen, whereas Davis, her fluid and multiple image pixelated and dithering, runs through a door in terror as if fleeing a cinema. For both, the dread of the proliferation of their images is a deadening chronophobia, a fear of time as anachronistic and unpredictable, as various older selves are haunted by their younger images.

But to an imaginary audience unfamiliar with a text entirely made up of samples, *The Time that Remains* is a revelatory new film. However, when it is identified as being made by Soda_Jerk, artists who work exclusively with found footage, observing their fearsome "zero originality clause", a meta-physical conundrum ensues. In the absence of any echoes prior to or after having seen it, it is not known what is being remixed. When the *re*– prefix has come to define social media and participatory culture in terms of the repetitious cycle of information, the already said and the itch of intertextuality is hard to resist. The question, once asked by Stanley Fish, must be asked differently for a different time: "Is there a remix in this text?"[36] To single out *Hush . . . Hush, Sweet Charlotte* (1964), *Jezebel* (1938), or *Whatever Happened to Baby Jane* (1962) as more likely to be recognized than *Strait-Jacket* (1964) or *The Letter* (1940) is a canonical presumption of mainstream cinema.

But also at play is a presumption of a precocious auteurism in terms of the cinephile's passion for the deliciously obscure (would *Possessed* [1947] and *Humoresque* [1946] be in that specialist category and if not who is to say why?). But such totalizing generalizations are necessary fictions that sustain vestigial ideas of classics, global culture, shared textual references, and generational continuities of interest and taste. In terms of the ambivalence of remix being articulated here, either paradigm of mass or minority culture is problematic. Any potential remix—say, *Parliament Question Time* and *Toy Story* (1995)—will be anachronistic and fugitive, its ensemble of original and copy always out of kilter.

To appropriate Navas's key theme, *After the Rainbow* and *The Time that Remains* are astute auto-critiques of the allegorical nature of remix. Both works are sutured together from their respective film and audio samples, and in this they are avatars of the sample as a floating signifier of melancholy, trapped in chronological and anachronistic time. They are also precursory meta-texts of this essay on the ambivalent conjugations of remix. Not only its ostensible subject of remix as anachrony but also this page, this sentence, this phrase that you are currently reading now, a now that has already passed for you into the past tense. You can read it again, but you can never read it again for the first time. The temporal event horizon of *when* these works take place, rather than the ontology of *what* are they, is the pharmakon of *déconstruction*, the inability to know what is text and remix.

As such, this chapter cannot guarantee or presume any normative, naive idea of remix as predictably synchronic, chronological and allegorical of something prior to it. Who "you" are or might become (apart from a conjugation of the second person tense) is entirely unknowable.

Rewind and start again.

214 *Darren Tofts*

ACKNOWLEDGMENT

Thanks, as always, to Dom and Dan Angeloro . . . *il migliore artigiane.*

NOTES

1. Ezra Pound, "Moeurs Contemporaines", in *Ezra Pound. Selected Poems* (London: Faber, 1973), 165. Pound's call of the avant-garde to aesthetic arms in his "Make it new!" was more concerned with appropriation than with novelty.
2. A poststructuralist dictum to be sure, the idea of quotation coming before any notion of novelty partakes of the simulacral rhetoric, after Baudrillard, of the copy preceding the original as well as alterity, after Derrida, as the logic of appropriation. See Darren Tofts, "Enunciation Squared: Writing, Originality and the Fabulation of Wisdom," *Angelaki: Journal of Theoretical Humanities* 14, no. 1 (April 2009): 155–164.
3. Samuel Beckett, *Texts for Nothing* (London: Calder & Boyars, 1974), 16.
4. Deke Dusinberre, "Consistent Oxymoron—Peter Gidal's Rhetorical Strategy", *Screen*, 18, no. 2 (1977): 79–88.
5. See Steven Connor, in his Gilles Deleuze-inflected *Samuel Beckett: Repetition, Theory and Text* (London: Blackwell, 1988), suggests that Beckett's exploration of the foundational metaphysics of "being, identity and representation" has at its center a "strong and continuous . . . preoccupation with repetition" (p. 1).
6. In particular, see Peter Gidal, "Beckett & Others & Art: A System," *Studio International* (November 1974): 183–187 and his extraordinary *Understanding Beckett: A Study of Monologue and Gesture in the Works of Samuel Beckett* (London: Macmillan, 1986).
7. Umberto Eco, *Reflections on* The Name of the Rose (London: Secker and Warburg, 1994), 68.
8. It is too simple to attribute Harold Bloom's *Anxiety of Influence* (New York: Oxford University Press, 1973) as the principal cipher of this concern with the precession of utterance. Jorge Luis Borges articulated the metamorphosis of intention into vapor as a "distraction" from the present, observing that the "certitude that everything has been written [which] negates us or turns us into phantoms"; Borges, *Labyrinths: Selected Stories & Other Writings*, ed. Donald A. Yates and James E. Irby (New York: New Directions, 1964), 58. In the spirit of Bloom's anxiety, Borges gestures to the facsimile nature of this very phrase several times in the fiction "The Library of Babel", from which this quote is taken. The most conspicuous, suggesting the rigid geometry of infinite variation within a finite set, is the epigram from Robert Burton's *The Anatomy of Melancholy* (London: J. & E. Hodson, 1804): "By this art you may contemplate the variation of the 23 letters . . ." (p. 427).
9. Personal correspondence with artists, June 21, 2013.
10. See Darren Tofts and Christian McCrea, "Remix," *Fibreculture Journal* 15 (2009), http://fifteen.fibreculturejournal.org/.
11. Lawrence Lessig, *Remix: Making Art and Commerce Thrive in the Hybrid Economy* (New York: The Penguin Press, 2008).
12. Jim Collins, *Architectures of Excess: Cultural Life in the Information Age* (New York: Routledge, 1995), 92.
13. Daniel Palmer, *Participatory Media: Visual Culture in Real Time* (Saarbrücken: VDM Verlag, 2008), 42, 47, respectively.
14. Palmer, *Participatory Media*, 9.

15. Eduardo Navas, "Regressive and Reflexive Mashups in Sampling Culture," *Remix Theory*, accessed June 20, 2013, http://remixtheory.net.
16. *Reflections*, ibid. If my forecasts are not in error, this aphorism will soon be attributed to Barbara Cartland.
17. Fredric Jameson, *Postmodernism, or, the Cultural Logic of Late Capitalism* (London: Verso, 1991), 6.
18. Eduardo Navas, "Remix: The Bond of Repetition and Representation," *Remix Theory*, accessed June 20, 2013, http://remixtheory.net.
19. James Joyce, *Finnegans Wake* (London: Faber, 1975), 120.
20. Kurt Vonnegut, *Slaughterhouse-Five* (London: Paladin, 1986), 25.
21. Charles Jencks attempted to articulate this sensation in terms of our experience of the built environment in his *Learning from Las Vegas* (1972).
22. Sigmund Freud, "The Uncanny" in *The Penguin Freud Library*, vol. 14 *Art and Literature*, ed. Albert Dickson (Harmondsworth: Penguin, 1990), 356–58. Grace Jones in her own way traced Sigmund Freud's gloss on the uncanny as a haunting that finds you, seeks you out as much as you stumble upon it, when she sang in "Libertango" (*Nightclubbing*, Island, May 1981, LP): "Strange I've seen that face before, Seen him hanging 'round my door".
23. Paul D. Miller, *Rhythm Science* (Cambridge, Mass. MIT Press, 2004), 65. With considerable élan Hugh Kenner had previously dramatized the pampered specificity of choice and obscurity of *the* sample in the early 1960s when describing Gustave Flaubert as "the connoisseur of the *mot juste*, lifted with tweezers from its leatherette box by a lapidary of choleric diligence"; Kenner, *The Stoic Comedians: Flaubert, Joyce and Beckett* (Berkeley: University of California Press, 1974), 30.
24. Soda_Jerk, *A Brief Guide to the Quantum Physics of Child Stars* (Sydney: n.d.), unpaginated.
25. Ibid.
26. Ibid.
27. *Soda_Jerk.com.au*, accessed June 22, 2013, www.sodajerk.com.au.
28. Soda_Jerk are without question Time Lords who have come into this world from some relative dimension in time and space, an infinite library of sample bits, bytes, cuts, and money shots. Their mastery of time is perhaps most evidenced in their hilarious "linear" version of Quentin Tarantino's *Pulp Fiction* (2009), which shows how really banal that film is as a cut up trying to warp time and space.
29. Ibid.
30. Dr. Marvell describes his soothsaying stone as "the same, genuine, magic, authentic crystal used by the priests of Isis and Osiris in the days of the Pharos of Egypt".
31. I have chosen to use *The Simpsons* for such instances of textual recapitulation as it is arguably the I Ching of cultural repetition, parody, and pastiche. It is also where most of my students have first encountered films and television shows such as *Citizen Kane*, *The Right Stuff*, *Bram Stoker's Dracula*, *Twin Peaks*, *Thelma and Louise*, *Jaws*, *Reservoir Dogs*, and *Casablanca* inter alia. Contrariwise, scenes such as Joel Gray as the emcee camping it up at the Kit Kat Klub in Bob Fosse's *Cabaret* (1972) were *just like that bit* in *The Simpsons* ("A Star Is Burns," 1995).
32. Like many examples of intertextuality filtering into the psychodrama of the Simpsons family, Marge reflects on halcyon memories of summer holidays with her sisters and her great aunt Gladys. When she realizes she is in fact remembering a sequence from the film *Prince of Tides*, she is inconvenienced, rather than disappointed, at the mix-up ("Selma's Choice," 1993).

33. The sample "The Man that Got Away" is taken from the 1962 US television special *Judy, Frank and Dean,* notable for being the first and only time Garland, Sinatra, and Martin ever performed together.
34. See for instance Troy Brownfield, "70 Years Later, We Still Feel the Echoes of 'Oz'", *Today.com*, August 24, 2009, accessed June 25, 2013, www.today.com.
35. The films sampled in *The Time that Remains* are *Whatever Happened to Baby Jane* (1962), *Possessed* (1947), *Humoresque* (1946), *Strait-Jacket* (1964), *Hush . . . Hush, Sweet Charlotte* (1964), *The Letter* (1940), and *Jezebel* (1938).
36. Stanley Fish, *Is There a Text in this Class? The Authority of Interpretive Communities* (Cambridge, Mass.: Harvard University Press, 1982).

16 Toward Utopia: A Pan-Asian Incubator[1]

Natalie King, Yusaku Imamura, Sunjung Kim, Tan Boon Hui, and Deeksha Nath

This chapter is a series of propositional commentaries about the idea of Utopia as encapsulating art and intimate publics in the region from the various Utopia team members. The chapter begins with Natalie King on "Digital Utopia and Connectivity", then moves onto Yusaku Imamura's "Where to from here?" This is followed by Sunjung Kim's example of a transnational artist project, then Tan Boon Hui's "Is My Contemporary Art Your Contemporary Art?", and Deeksha Nath's "A Region with Blind Spots". The chapter then summarizes these debates and provocations in terms of intimate publics.

DIGITAL UTOPIA AND CONNECTIVITY

Natalie King

> the utopian impulse wanders the gamut from dual relationships of
> all kinds, relationships to things fully as much as to other people, all
> the way to an unsuspected variety of new collective combinations.[2]

In Okwui Enwezor's seminal essay for the Gwangju Biennale 2008, "The Politics of Spectacle",[3] he navigates the idea of proximity within global curation. As cultural workers, we are required to research artistic scenes while being equally alert to the cultural and political scenarios that inform the spaces where the activities of art occur. We must listen to the murmurings of artistic production and venture outside the institutional comfort zone. *Utopia Is a Hearing Aid* (2003) by the Indian trio, Raqs Media Collective, cultivates listening, listening very carefully, and paying attention to the things that are being said, not only in whispers, not only in proclamations, but also in forms of disguised and coded speech. Exhibited at *Utopia Station*, curated by Molly Nesbit, Hans Ulrich Obrist, and Rirkrit Tiravanija, Venice Biennale 2003, *Utopia Is a Hearing Aid* (see Figure 16.1) emerges from an understanding that the possibility of another world is

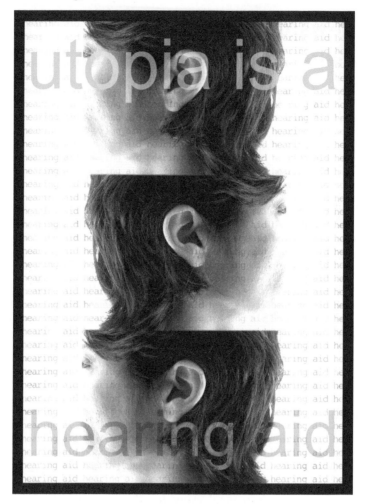

Figure 16.1 Raqs Media Collective, *Utopia Is a Hearing Aid* (2003).
Source: Courtesy of the artists and Frith Street Gallery, London.

actually always latent within the materiality of this one. One has only to listen to the sounds of it stirring to make it manifest.

Utopia Station was conceived as a flexible and physical structure with contributions by artists, architects, writers, and performers. It was envisaged as a long, low platform—part dance floor, part stage, part quay. There were portable, circular benches and doors and spaces filled with objects, paintings, images, and screens. It was conceived that one could bathe in the station and powder one's nose. The station became a place to stop, to contemplate, to listen and see, to rest and refresh, and to talk and exchange. Performances, concerts, lectures, readings, film programs, parties, and events take place.

This kind of open structure informs the Utopia project. Moreover, the notion of hearing and amplifying sound underpins our consultative approach of Utopia@Asialink: a pan-Asian network of collaborators across cities and time zones. Utopia@Asialink is a curatorially agile enterprise: an elastic and open structure with partners from Tokyo, Seoul, New Delhi, Singapore, Melbourne, and beyond. A generative and itinerant platform for regional engagement, Utopia makes room for new modalities and for exchanges, relays, and interferences in response to the changing circumstances of the Asian century and regional influences. A flat, nonhierarchical modality informs the Utopia@Asialink project. Utopia is developing affiliations with festivals, art fairs, biennales, and conferences by finding ways to participate in existing systems with social, convivial, and cultural incursions.

How can we cultivate spaces for connectivity that are inclusive and collaborative, porous and propositional? What kinds of practices are interconnected, participatory and interdependent? How can we deploy intimate modalities alongside the ubiquitous dimension of new media practices? How can the trope of utopia allow us to incite alternative models of cultural encounter? In Catherine Bernard's essay "Bodies and Digital Utopia", she argues that digital communications

> promote an ideology of transcendence in regard to the plurality and diversity of cultures, politics and histories that overcome space and time, offering the promise of an open space of equal cultural exchange based upon a non-hierarchical structure . . . it allows the restructuring of geo-political boundaries into an ever-expanding market of limitless access.[4]

In this milieu in which the aesthetics of everyday life is increasingly shaped by the techno-cultural, the rubric of intimate publics can uncover an array of approaches to the geo-social space of mobile media. As the idea of centers and mainstream becomes part of the anachronism of the cultural politics of the past, artists have oriented themselves not toward centers and mainstreams, but toward a more transversal process of linkages, networks, and diverse communities of practice. These cultural and artistic reorientations within geopolitical spaces challenge the shrinking Western alliance. The world is open for business as the fervor of modernization propels the economies of India and China. Multiple changes and realignments are opening up huge cultural seams within traditional circuits of power to reveal the emergence of new ones.

Enwezor announced the dawn of the Asian century with its emergent cultural politics. This is evident in the expansion of the art market across the region along with biennials, triennials, art fairs, and 1,200 museums under construction in China alone. Art infrastructure in Asia and market capitalism are burgeoning with the establishment of new organizations

across the region. In his article "The Third Way", Hou Hanru urges us to revisit the role of alternative spaces, informal organizations, and artist-run spaces within a nuanced art community:

> We should see the growth in independent spaces in the same context as the global Occupy Movement and worldwide protests, and even the social revolutions in Arab countries that began in late 2010, as expressions of a demand for other models of development . . . what is needed in the art world is some kind of in-between system, between state-dominated models of the previous century and the capitalist-dominated models of today. The question of how to build this new model and what it will look like is very important and needs to be debated.[5]

What kind of multilateral structures can we envisage in Asia? How can we navigate the global preoccupation with Asianess while respecting local realities? What reciprocal and inclusive paradigms can be deployed for working cross-regionally? How can the borderlessness of digital spaces be harnessed? One methodology resides in making the curatorial process explicit by revealing the ruminations and discussions that take place behind closed door. For example, six Asian female curators of the Gwangju Biennale 2012 exposed their conversation as it reached a threshold of insight and hit an impasse, published in a special issue of *Broadsheet* edited by Utopia and Larissa Hjorth.[6] This transparency of gesture enabled the curators to expose themselves in the early phase of their deliberations as part of their curatorial methodology. With intermittent failure to achieve common ground, the curators arrived at the notion of "roundtable" as a meeting point rather than a common theme. Within this structure there is no head, everyone having equal status. Being together and collectivity became a gesture for resolving differences.

In 2001, Raqs cofounded the Sarai program at the Centre for the Study of Developing Societies. The word *sarai*, common to many Central Asian and Indian languages, refers to the shelters for travelers, sometimes large and extravagant, that traditionally dotted the cities and highways of that part of the world, not only facilitating travel and commerce but also enabling the exchange of stories and ideas. Sarai functions as a research center, a publishing house, a café, a conference center, a cinema, a software laboratory, and a studio for digital art and design. Similarly, Utopia is a hybrid and propositional space for encounter and exchange.

A generative and itinerant mechanism for engagement, Utopia is a network of cities who converse and collaborate including Melbourne, Tokyo, Singapore, Seoul, and New Delhi. Like the Utopia project, Korean artist, Seong Woo Back's *Signboard*, perched in a wasteland on the fringe of the city, on the outskirts of production, pops up out of nowhere (see Figure 16.2). Utopia aspires to complement the existing and well-serviced biennale circuit with a more speculative and propositional model. Initially, we were inspired by the peripatetic dimension of Manifesta, but given

Figure 16.2 Seung Woo Back, *Signboard* (2011). Digital print, 150 × 183 cm.
Source: Courtesy of the artist.

excessive resourcing required to mount and sustain a major event and the ample biennale circuit, we have developed a more incursive way of working: a kind of cultural insurgency. Our structure is flexible enabling Utopia to respond to existing activities and forge relationships.

Utopia operates as an incubator for cross-cultural ideas, thinking, and working methodologies. For the Melbourne Festival 2011, we curated a pilot or pop-up project whereby each Utopia partner nominated two moving-image works for inclusion in a screening program called *Intimate Publics*. We were trialing our curatorial methods to uncover the revelatory world of intimacy within public spaces and how digital media has an impact on our public expression of emotion. With the saturation of social media, notions of trust, surveillance, and intimacy are being refigured.

Daniel Crooks filmed footage outside a subway station in Shanghai, splicing his images so that each person is rendered bereft within their own time splice. Reality is stretched and distorted; human figures are splintered across time within the rhythms of daily life. Larissa Hjorth asked perfect strangers to disclose saved text messages, and paired them with a sequence of evocative images in *CU*. Nikhil Chopra produced a performative drawing in a contested public space in Lal Chowk in Srinigar.

When Korean artist Minouk Lim was preparing for her elegiac nighttime performance (S.O.S.—Adoptive Dissensus 2009) on a ferry along the Han River in Seoul, she asked herself three questions:

> What should I do to live in your life? What should I do to make our relationships work? Or how should we come across and fall apart?

These questions of empathy and connectivity are central to Utopia's methodology as well as the cultivation of listening.

WHERE TO FROM HERE? UTOPIA AND A HISTORICAL AGENDA

Yusaku Imamura

Utopia has its linguistic meaning in *ou* (non) + *topia* (place) = place not to be found anywhere. The word was coined by Thomas More in the sixteenth century. Although an ideal, the concept of Utopia has been criticized as ideological. However, as Fredric Jameson indicated in his book *Archaeologics of the Future*, Utopia has been revived when we seek new directions and philosophical foundations in the face of global capitalism and the fall of communism.

Why did we call our project *Utopia*? It is partly an ironical gesture. Following on from the Australia–Japan Friendship Year in 2006, the second gathering of Australia–Japan cultural exchange partners was held during Sydney Biennale in 2008. During the think tank session in Sydney, we questioned the idealism of Utopia while endorsing doubt and a tentative approach to Utopia. Over two years, an ongoing and deepening relationship evolved. I proposed not only to think about two countries working together but also to focus on creating platforms that allow partners to create, exhibit, and research in Asia collectively. We are neighbors, yet we have unique cultural entanglements. However, our international cultural exchange is primarily a Western concept. Do we need a platform to promote Asian cultural exchange by ourselves? One of the models is *Manifesta* in Europe, which investigates the agenda of local and international cultural foundations, sustainable supporting, and educational systems.

In March 11, 2011, Japan was hit by a major natural disaster that has come to be known as 3/11. The damage, similar to the carnage of war, was a devastating blow. The toll of disaster victims is more than twenty thousand people, and the tsunami did catastrophic damage to many cities and surrounding areas. The tsunami enveloped the atomic power plant, causing a catastrophic nuclear meltdown comparable to the Chernobyl disaster. Radiation and contamination affect many people who still cannot shape their future even though more than half a year has passed. It is not only

because of weak national policy yet at the same time we need to readjust the overconfidence in nuclear power as a key source of power within a capitalistic economy. This disaster shook the foundations of society and our quality of life and made us question notions of richness. In this situation, we need to create new societal systems. Many key commentators have pointed out that it is impossible to get through this crisis by sustaining past conventional systems and policies. If we do not take this opportunity to make society better, we cannot save the souls lost in this disaster.

Utopia is not a kind of exclusive totalitarianism informed by idealistic theory. The essence of Utopia is about conversations and processes rather than striving for perfection. This year, while researching and traveling, I came across Utopia-related projects. I had a chance to visit a memorial of Sun Yat-sen in Hong Kong and a mausoleum in Nanjing. In 2011, the one-hundred-year memorial of Xinhai Revolution was marked. Sun Yat-sen was devoted to independence from colonization and established the first republic in Asia with the support from his friends in Japan, Hawaii, and the Asia-Pacific region. He often used these words "天下為公", quoted from an ancient text. It means "world is for public". These words are still important in our era of cultural collaboration.

In 2012, I was watching performances by artists for Tokyo Wonder Site's ten-year anniversary. During a performance, one artist crawled in the direction of tangled string repeatedly, throwing a nut tied to white cloth. He did the same action over and over almost like it were a religious ritual. We always have to go through the process that might look nonsensical in order to get to the essence of the world. We are now about to throw a nut tied with string.

TRANSNATIONAL ARTIST PROJECT: XIJING MEN

Sunjung Kim

Xijing is a prime example of a transnational project like Utopia. Xijing Men is a project-based collective team composed of three artists: Gimhongsok, Chen Shaoxiong, and Ozawa Tsuyoshi. They have participated in several group exhibitions together since 2001. The first exhibition was *Fantasia*. This exhibition allowed these artists to travel and spend time together in Seoul and Beijing. Later, all of them came to Tokyo and participated in the exhibition titled *Under Construction* 2002.

Under Construction was organized by Japan Foundation with nine curators from seven different countries: Yamamoto Atsuo, curator of Ashiya City Museum of Art and History in Japan; Patrick D. Flores, professor of University of the Philippines at Diliman in the Phillipines; Gridthiya Gaweewong, curator of Chiang Mai Art Museum in Thailand; Ranjit Hoskote, art

critic in India; Asmudjo Irianto, lecturer at Bandung Institute of Technology in Indonesia; Kamiya Yukie, independent Curator in Japan; Pi Li, assistant researcher at Central Academy of Fine Arts in Beijing, China; Mami Kataoka, chief curator at Tokyo Opera City Art Gallery in Japan; and me, chief curator at Artsonje Center and Artsonje Museum in Korea.

This exhibition is a collective exhibition comprising seven different local exhibitions. Each curator knew that this collective exhibition should not be a simple combination of seven local exhibitions. Rather, all agreed that *Under Construction* should present the individual elements of the local exhibitions as a whole. Since *Under Construction* was exhibited in two separate venues, the curators particularly emphasized the continuity of concept.

Chen Shaoxiong and Ozawa worked together and collaborated on a project. They sent their drawings to Tokyo and Beijing along the model of being pen pals. Ozawa Chen and Hongsok were invited to the *All about Laughter* 2007 show by a curator Mami Kataoka, and Kataoka suggested they work together. These artists started the collaborative project called Xijing Men in 2007. I interviewed Gimhongsok about the Xijing Men. The artists came up with the title "Xijing Men" because they wanted to create a country or a city that does not exist in reality but some still believe in its existence. Xijing, the capital of the West, exists on a fictional geopolitical axis that was created in correspondence to the real cities of Beijing (capital of the North), Nanjing (capital of the South), and Dongjing/Tokyo (capital of the East). The origin of this western city is rooted in a myth.

The narrative consists of four chapters. Chapter 1: *Do You Know Xijing?* (2007) introduces the fictional and imaginary city called Xijing. Each of the artists produced a documentary video that includes interviews about Xijing. They brought some objects such as hotel towels and old ceramics from Xijing that can be regarded as souvenirs. None of these objects is real, and in fact, they were made by the artists. The background scenery from the documentary videos comes from their favorite islands in their own countries.

Chapter 2: *This Is Xijing—Journey to the West* (2008) is a revised puppet play. The artists wrote a myth and story about the Xijing. In the story, some of the main characters travelled to the West. The story is a combination of fairytales and folktales of Korea, Japan, China and the West. In Chapter 3: *Welcome to Xijing—Xijing Olympics* (2008), Xijing Men enact their own version of the Beijing Olympics. The artists did attempt to incorporate themselves in the 2008 Beijing Olympics, but they were refused permission. So they made up their own Olympics during the real Olympic season. The artists organized and participated in twenty-one Olympic-style sport competitions. The artists themselves became the players, too.

Chapter 4: *I Love Xijing—The Daily Life of Xijing President* (2009) portrays the Xijing city in terms of territory, history, agriculture, constitution, city plan, defense, and education. The Xijing project genuinely shows the concept of breaking down the borders between the countries and national identities through the collaboration among three artists from three different countries.

The project started with *Under Construction*. This exhibition bridged the artists' project and the model of collaboration beyond nationality. Xijing Men's projects dealt with not only daily lives but also institutional critique in a humorous way. This project encouraged the audience to reconsider relational aesthetics.

This exhibition has provided a new framework for curatorial practices. First, this exhibition was an exchange program in Asia, and it prepared a temporary platform for artists' collaboration from different countries all around Asia. As a consequence, a cross-cultural atmosphere was constructed, and reconceptualizing the Asia-Pacific region was possible. Second, a residency program was also successfully carried out with this project. Third, curatorial exchange and research was undertaken throughout this project, and last, it certainly has the characteristics of Manifesta and Utopia.

IS MY CONTEMPORARY ART YOUR CONTEMPORARY ART?

Tan Boon Hui

In painstaking detail, the Filipino artist Annie Cabigting paints her rendition of British artist Michael Craig-Martin's 1970 installation *On the Shelf*, an edition of which is in the collection of the National Gallery of Australia. The installation comprises a row of glass bottles filled with water sitting on a wooden shelf that has been mounted at an angle on the wall. In opposition to the angled shelf, the bottles have been filled with water in graduated amounts such that the water is level despite the tilt of the shelf. Cabigting's photorealistic painting of this installation in glorious gray scale is itself turned into another installation as the canvas is placed on top of another gray shelf similar to that depicted in the painting. The canvas is deliberately placed leaning at a slight angle against the gallery wall, making it clear that it is an object by itself, rather than solely a two dimensional image. Arch yet literal, Cabigting titles this work *On the Shelf, on the Shelf (After Michael Craig-Martin)*.

Forty years after this work of European conceptualism was created, an artist from the periphery of Southeast Asia has created an ingenious "reconceptualization" of this iconic work. Like an endless hall of mirrors, Cabigting's sleight of hand turning an installation into a painting into an installation evokes conceptualism's critique of mimetic representation. Does the fact that the work is created in the present (2011) so long after the coming of conceptual art in the West, and its far geographical remove from the Western metropolitan centers diminish its value as a work of art? If one did not know that this work was created by an artist from the Philippines, would it change our assessment of the work, given that the piece itself bears no visible markers of its geographical and cultural context?

In Figure 16.3, we can see a 1999 work by the now-defunct Indonesian collective Apotik Komik can generally be placed as an example of urban art, with its use of popular vernacular forms such as comic idioms and graffiti. The Apotik Komik collective became renowned in Indonesia for among other things, their work on public murals and freely distributed comics. Whereas the conventional view of the urban artist, particularly the graffiti artist is that he or she (more often than not) worked guerrilla style. Infiltrating the sites of capitalist and political power, the artist leaves his or her mark as a sign of protest and individual heroism, creating public art without permission in places policed by the state or corporate powers was the key, and an air of anonymity and secrecy was valued.

In the large cities of Indonesia, such as Yogyakarta, however, anonymity of the Banksy kind is hardly imaginable. For instance, the streets are populated round the clock and "owned" by various communities of hawkers, street vendors, and police. The street artist looking to paint a public mural often has to negotiate and even encourage the participation of these diverse denizens of the streets in the process of art making. Graffiti or street art is really public art in these places. What does it mean, therefore when we write of graffiti artists or artists using cartoon styles in their art? Is it merely a local adaptation of that dreaded phrase

Figure 16.3 Apotik Komik, *Under Estimate* (1999). Cardboard and paint, 300 × 500 × 40.

Source: Image courtesy of Singapore Art Museum/National Heritage Board.

"international art style/s" or are we allowing for active agency in how artists in specific localities select and incorporate styles and idioms into their practice?

Does the globalization of culture mean that we can now escape the idea of authentic origination, where only the first, earliest, and usually Occidental source of an art concept or style is the real deal and everything else that comes after is a poor copy? Or have we replaced the hierarchy of time with a hierarchy of space, where the physical periphery of artistic communities in Southeast Asia, Australia, Africa, and so on denotes also artistic periphery? Are we now the recipients of global culture but not quite its source?

A REGION WITH BLIND SPOTS

Deeksha Nath

I

We must not too comfortably adopt the frame of the Asia-Pacific without thinking of those amongst us who are marginalized. The Asia-Pacific is a large region with its contentions and contestations. It is a large region with blind spots. Why, when we discuss the Asia-Pacific, is there someone from India but not Myanmar or Nepal or Afghanistan? Why is there China but not Tibet, Singapore but not Laos? This is in some ways a rhetorical narrative because I am merely raising the problematic that exists in any regional initiative—the powerful positioners speak for the silent majority. It is the economic deciders who find representation on panels that discuss the Asia/Pacific, which is by and large, historically, a Euro-North American military construct, based on the positions of war bases and naval military forces.

II

We must wonder at the role of language, class and wealth in these initiatives. There are few native, folk, or tribal voices. So when we proudly say that the "Asia/Pacific has a boundary but no centre" and we recognize that the "global deforms and molests the national"[7] and we attempt to guard against this, we are replicating the model at a macro and micro level. Whose Asia-Pacific are we talking about, and whose interests are being served? How far do you have to dig to reach the local and who represents the grassroots?

III

The predominance of the English language has been imperialisms' greatest legacy. In Sri Lanka, after Independence, in an attempt to assert local autonomy Sinhalese was adopted as the official language, with English missing from the education system. The Sinhalese realized, several decades later, that they were

falling behind in the world market because of their poor knowledge of English and in the last two decades have been trying to reverse this lack of foresight.

Maori Novelist Witi Ihimaera has said, "Nowhere in the Pacific is the indigenous language the first language. The first language in the Pacific is English. That's the reality of the situation in the Pacific".[8] It is true for much of Asia as well, I dare say. Yet the way in which the language has been localized, pidginized, and bastardized articulates an insurgent regional consciousness. The Bangladeshi artist Wakilur Rahman, in his almost meditative masking of texts and deliberate destruction of books attempts to create a thinking, nonreading space, thus problematizing the power of bookish knowledge and its hierarchy above other forms of learning.

In the writing of Amitav Ghosh is a retelling and thus reestablishing of regional exchange, pathways, and histories that were subsumed and lost within the colonizer–colonized polemic. Thus the historical narrative on exchange became between east and west and a long lineage was drawn going back to the earliest civilizations. Ghosh has made it his literary project to tell the rich story of exchange in the Asia-Pacific region.

IV

In the nineteenth century, a lost continent, Lemuria, which was believed to connect Australia, India, and Madagascar was proposed by zoologist and bio-geographer Philip Sclater in 1864[9] to account for discrepancies in biogeography.

In her book *The Lost Land of Lemuria*, Sumathi Ramaswamy[10] argues that Lemuria was many things to many people at different times, but all agree that it was a palaso-world, "a land before our time, where forests loomed large and dinosaurs roamed"—a mythological landscape shaped by the very human imaginative need for such a place.[11]

Although Lemuria was rendered obsolete by modern theories of plate tectonics, Tamil nationalists, especially Devaneya Pavanar (1902–81), used Lemuria to support their belief that their culture was born in the "cradle of civilization", in a legendary sunken kingdom they called Kumari Kamdam, the Land of Purity, a sophisticated kingdom of higher learning, located south of Kanyakumari. They believed that it was in Kumari Kamdam that languages originated and that Tamilian was thus the root of all modern languages.

Their belief predates the idea of Lemuria. It first appeared in Silappadhikaram, fifth-century epic, which states that the cruel sea took the Pandiyan land that lay between the rivers Pahruli and the mountainous banks of the Kumari, to replace which the Pandiyan king conquered lands belonging to the Chola and Chera kings. The idea that Tamil ancestors migrated northward, from a land that sank beneath the waves, was taught in Tamil schools until as recently as 1981.

The reason I bring up Lemuria and its appropriation as Kumari Kamdam is to wonder whether when we talk about cross-cultural exchange and

reconceptualizing the Asia-Pacific we are also not in some way engaged in the very same exercise of reenvisioning some mythic grand geo-political connectivity. Can we think of Utopia as a regional enclave that is a contradictory location within the globalizing hegemonic, dare I say "Western" urge supported by powerful pockets within the Asia-Pacific region, that invests its own agenda in the cultural imaginary that is the Asia-Pacific?

CULTURAL ENTANGLEMENTS

For Utopia, we are working toward an urgent structure that is pertinent and reflective, open and generous. Can we imagine projects that are iterative and inclusive, stretching across time and place? By focusing on case studies and ruminations by Utopia partners, this chapter charts ways in which we can bring together the worlds of art and media culture in the Asia-Pacific. These tangible examples offer insights into conceptualizing the complicated entanglement of art and digital culture while offering a set of propositional paradigms for interrogating this contested domain. As such, Utopia has evolved in response to the growing biennale phenomenon in the region, as an attempt to recast the focus onto more collaborative, transnational synergies despite "biennial utopia".[12] As a cultural conductor based on connectivity, Utopia strives to usurp the facelessness of Facebook with meaningful cultural encounters, multidimensional platforms, and long-term entanglements.

At a time when anyone can use a camera and mobile media permeates every aspect of contemporary culture, how can we find ways to curate this ubiquitous medium? With constantly evolving new technologies and the speed of global information, how can we work with moving images in an incisive and engaged way? Against this incessant and exhausting consumption of images, let's find ways to halt, to pause, to look, to listen, and most importantly hear each other.

NOTES

1. The following papers and dialogue were part of *Intimate Publics* Forum, chaired by Larissa Hjorth (RMIT University) and Daniel Palmer (Monash University), presented by Utopia@Asialink (University of Melbourne) in association with Melbourne Festival and RMIT University, October 18, 2011; and *Intimate Publics* exhibition curated by Utopia@Asialink, curatorium: Yusaku Imamura, Sunjung Kim, Natalie King, Deeksha Nath and Tan Boon Hui. Artists: Nikhil Chopra (India), Daniel Crooks (Australia), Larissa Hjorth (Australia), Masaru Iwai (Japan), Amar Kanwar (India), Takashi Kuribayashi (Japan), Charles Lim (Singapore), Minouk Lim (Korea), Tran Luong (Vietnam), and Jewyo Rhii (Korea), Fehily Contemporary, Melbourne, October13–November 5, 2011.
2. Frederic Jameson, "The Utopian Enclave" (2004), reprinted in *Utopia: Documents of Contemporary Culture*, ed. Richard Noble (London: Whitechapel Gallery, and Cambridge, MA: The MIT Press, 2009), 72.

3. Okwui Enwezor, "The Politics of Spectacle: The Gwangju Biennale and the Asian Century" (Gwangju, Korea: Gwangju Biennale, 2008).
4. Catherine Bernard, "Bodies and Digital Utopia" (2000), in *Utopia: Documents of Contemporary Culture*, 209.
5. Hou Hanru, "A Third Way", *Art Asia Pacific*, no. 80 (September/October 2012): 43.
6. Utopia and Larissa Hjorth, eds., "Utopia", special issue, *Contemporary Visual Art + Culture Broadsheet* 40, no. 4 (2011).
7. Robert Wilson and Arif Dirlik, *Asia/Pacific as Space for Cultural Production* (Durham, NC: Duke University Press, 1995).
8. Feroza Jussawalla and Reed Way Dasenbrock, eds., *Interviews with Writers of the Post-Colonial World* (Jackson: University of Mississippi Press, 1992), 233.
9. Philip Sclater published an article "The Mammals of Madagascar" in *The Quarterly Journal of Science* I (1864): 212–19, in which, puzzled by the presence of fossils of a group of primates he classified as Lemurs in both Madagascar and India but not in Africa or the Middle East, he proposed that Madagascar and India had once been part of a larger continent, which he named Lemuria.
10. Sumathi Ramaswamy, *The Lost Land of Lemuria: Fabulous Geographies, Catastrophic Histories* (Berkeley: University of California Press, 2004).
11. Michel Meurger and Claude Gagnon, *Lake Monster Traditions: A Cross-cultural Analysis* (London: Fortean Tomes, 1988).
12. Yongwoo Lee, "The Crisis and Opportunity of Biennials", in *Shifting Gravity: World Biennial Forum No 1*, ed. Ute Meta Bauer and Hou Hanru (Ostfildern, Germany: Hatje Cantz Verlag, 2013), 11.

17 Conclusion: Beyond the Intimate?
The Place of the Public in the Region

Larissa Hjorth, Natalie King, and Mami Kataoka

NEW MAPS FOR THE REGION

As noted in the introduction, the problematic history of Asia-Pacific as geopolitical notion has been fraught with debates as to how to redefine its shifting and contesting localities. For Wilson and Dirlik, the region is characterized by ambivalence: geographically, historically, and politically. In an age of mobile social media described as part of an "intimate turn", how we conceptualize, practice and contextualize the relationship between art and place changes. With mobile media as a ubiquitous part of everyday life, the role of media in art—as the content, medium, context, and dissemination—becomes central. It is no longer the prerogative of "new media" but rather an integral part of everyday life.

Ng elaborates on how various institutions and organizations in the region such as the Asia Art Archive (AAA) have sought to redefine their voice and dissemination through social media. Gardner and Green's chapter provided insight into the region on both a local and global level through mapping the rise of "Mega-Exhibitions, New Publics and Asian Art Biennials". Storer took us through an intimate analysis of the Asia Pacific Triennial of Contemporary Art (APT) through some of its key initiatives, while Sunjung Kim discussed her *Platform Seoul* projects as an alternative model to the all-pervasive biennale. This questioning about the limits and new possibilities for collaborative models and curating is discussed in King et al.'s 'Towards Utopia: A Pan-Asian Incubator" as well as in Lee and Hjorth's chapter. In particular, Lee and Hjorth argued for engaging "PlayStations" to shift power relations.

For Gaweewong, the uneven rise of digital media in Southeast Asia has seen a revision of the importance of oral culture in locations such as Indonesia and Thailand. Jurriens continues this investigation by focusing on the relationship between new media art and urban ecology in Indonesia. Butt highlights the role played by state regulation of the Internet in Vietnam and how artists can subvert and challenge such censorship. Cubitt's chapter investigated the politics of digital media regulations and its attendant normatives upon art, expression, and identity. The artwork of Cao Fei is

explored by Clemens as a way in which to reconceptualize and interrogate both intimacy and virtuality. For Tofts, the work of Australian new-media duo Soda_Jerk, is a prime example of the role of remixing in shifting aesthetic and historic paradigms for new media and art.

In Kataoka's "Intimate and Distance with the Public", we were reminded to contextualize current new media debates within a broader historical framework as she considers the social media interventions of Chinese artist Ai Weiwei. Drawing on 1960s artists, Kataoka showed us how art has long been haunted by the role of media and its relationship in constructing art publics and intimacy. For Hjorth, Sharp, and Williams, the role of climate change provides a powerful lens in which to understand the region's contesting and changing megacities. So, too, did Paspastergiadis et al. eloquently outline how public screens can play a powerful role in redefining participation in contemporary public spaces.

In this collection, we have sought to provide various and contesting voices in redefining the relationship among art, media, and place in the region. Through the rubric of "intimate publics", we uncover how art and media practice are entangled, leading to productive ways for rethinking public and the region's contested localities. In this conclusion, we signpost some possible directions for the region's intimate publics. These are by no means definitive but rather seek to ignite further reflection, critique and commentary. The first section is new networked and emplaced visualities. The second section is about future incubators for curating and collaboration in a post-relational aesthetics period. Then, we conclude with discussing the role of messiness as an integral part of everyday media practice and as a probe to understanding emplaced mobile publics.

NEW NETWORKED AND EMPLACED VISUALITIES

As Daniel Palmer noted in his study on iPhone photography, "cameras have colonized the mobile phone over the past decade".[1] Nokia has reportedly put more cameras into people's hands than in the whole previous history of photography.[2] From the mid-2000s, particularly since the launch of Flickr, photosharing has emerged as an important social practice in the new emergent visuality. The rise of user-created content (UCC) images with their "raw" and "amateur" aesthetics has become an important part of twenty-first century media cultures. Their *affect* and *effect* has shaped narratives around place and intimacy in ways that span the visual, social and emotional.

For Mikki Villi, "much of the traffic in photographs now circulates through digital networks and is facilitated by new platforms".[3] This photographic evolution—part of broader new networked visualities—has been accompanied with as much enthusiasm as anxiety. From user-created content images of disasters in Bangladesh and social revolutions in Egypt to sexting, camera phones have seemingly left no space unphotographed. But

more than a decade on from the ubiquitous rise of the camera phone as an essential part of mobile media, and its so-called crisis to traditional professions such as journalism and art photography, the types of images, and their relationship to place and co-presence still remains entangled and emplaced in often tacit ways. With location-based services such as geo-tagging added into the mix, we are witnessing an accelerated rate of camera phone taking, editing, and sharing. The overlays of locative and social media with the proliferation of photo apps and high quality camera phones has seen emergent forms of co-present visuality that interweave online and offline cartographies in different ways.

For some, the three key features of the mobile phone—social, locative, and mobile—are characterized by smartphones. For others, it is about mobile Internet. The mobile phone is no longer this century's Swiss Army knife, but instead is a metaphoric caravan that carries our personal and sociocultural baggage (aka apps) across changing notions of mobility, home, public and private, and work and leisure.

Smartphone apps—epitomizing the intimate turn whereby work and leisure is commodified into apps—such as Instagram are playing an important unofficial and official role in how place is experience, recorded and reconceptualized. Instagram provides a fascinating study given that only three years after its launch, the application already has more than 130 million registered users who have shared nearly 16 billion photos from all over the globe.[4] Nadav Hochman and Lev Manovich have conducted a thick visualization of the city through its Instagram images to create new ways for understanding the local and vernacular through social media.[5]

According to Hochman and Manovich, "the most prominent element that underlies Instagram's structure is its reliance on geo–temporal tagging: the geographical and temporal identification of a media artefact" that "suppresses temporal, vertical structures in favor of spatial connectivities". What their study does highlight is the complex ways in which camera phone photography, when embedded in location-based services and social media, takes on different spatial, temporal, and social dimensions.

Camera phone apps can be seen as part of broader shifts in the ways in which visuality, place, and intimacy are entangled. As noted by Hjorth and Sarah Pink elsewhere, increasingly camera phone practices are being overlaid with social and locative media in ways that change how place and time contextualize the image. Geo-tagging renders the image stuck to a "moment" within a series of everyday movements. This can be understood as a form of emplacement: temporal, spatial, emotional, and geographic. Emplaced visuality puts a theory of movement at the center of our understanding of contemporary media practice. Rather than movement being between nodes in the "network", movement needs to be understood as central to the way people and images become emplaced.[6]

While camera phone images are shaped by the affordance of mobile technologies, they also play into broader photographic tropes and genres. For

example, there is a need to link contemporary camera phone sharing with the UK-based Mass Observation movement that begun early in the twentieth century to define the emergence of vernacular photography. As Chris Chesher notes, the iPhone "universe of reference" disrupts the genealogy of mass amateur photography that was formed through the rise of the Kodak camera.[7] The rise of social mobile media also challenges models for curating, incubation, and collaboration.

BEYOND THE INCUBATOR: CURATING THE MOBILE

Following on from Charles Green and Anthony Gardner's nuanced account of the surge of Asian biennales with their distinctive modalities and Russell Storer's internal reappraisal of the history of the Asia Pacific Triennial of Contemporary Art, we might speculate on the changing role of the curator and museum in a networked society. When almost every museum has a digital policy and platform, what are the possibilities for curating and exhibiting this pervasive medium? With the acceleration of new media, how can we curate both slowly and quickly? Can exhibitions be iterative modalities with multiple and evolving incarnations? Are biennials alternative sites for experimentation and resistance within a recurrent exhibition format? ARKEN Museum of Modern Art has put forward a utopian strategy

> based on an eternally analysing, self-reflecting public which, with a point of departure in the observation of the artwork and consequent reflection and discussion, approaches an understanding of itself and the existence of which we are all a part.[8]

This participatory approach is amplified in the work of Cao Fei who explores utopia in virtual space while researching Siemens factory workers and the quasi-dystopian conditions of factory life. Her video documentation, text, and installation *Whose Utopia Is This?* 2006–2007 segued into her fantastical avatar as elucidated by Clemens. Moreover, Hans Ulrich Obrist in the World Biennial Forum No. 1, stresses the notion of utopia and the principle of hope in imagining biennials and conceptualizing new exhibition platforms.[9] Terry Smith articulates the desires of contemporary curating to locate itself deep inside the changes being undergone by thought itself within contemporary conditions, arguing for Kate Fowle's notion of "Reflexive Curating": platforms for curators, artists, and participatory publics' ideas and interests.[10]

In the essay "Earthworms Dancing: Notes for a Biennial in Slow Motion", Raqs Media Collective implore us to be cognizant of dormant, barely discernable, and hibernating practices, even still in formation, that cut across cultures and geography to generate an atmosphere or ambience. Biennales compete for peaks of attention, that high-intensity moment of the event's

iteration, yet we might look toward mobile telephony as an analogous situation:

> For decades, the telephony infrastructure in India was beset by chronic underperformance and shortages. For as long as a fixed landline infrastructure wholly owned and operated by a single agency defined what telephony was, it could take up to seven years to get a simple telephone connection, even in a metropolitan center. It took even longer in villages and small towns. Within a few years following the introduction of mobile telephony, India attained one of the highest densities of mobile telephone usage in the world, and has seen an exponential growth in rural telephone use. Today, India has one of the most dynamic cultures of mobile telephone usage in the world. . . . What kind of realities would suddenly surface if we were to extend this analogy of the transformation from a sluggish monopoly to a dynamic multiplicity to the sphere of the institutional life of contemporary art? If the museum and the large cultural institution were to contemporary art what the fixed landline telephony infrastructure was to telecommunication, what might be the equivalent of mobile telephony?[11]

The material and immaterial dimensions of mobility are amplified by mobile media. Socioeconomic, technological, and psychological platforms are all highlighted with mobile media use. Far from eroding the importance of place, the democratic qualities of access to mobile media still brings with it offline inequalities. As Jo Tacchi, Kathi R. Kitner, and Kate Crawford note in their article on development, gender, and technology, the everyday use of mobile phones plays an important role in Indian rural women lives.[12] Tacchi et al. introduce ways in which technologies might be thought about in terms of "meaningful motilities" by discussing attachments, structures of labor, agency, and specifically how mobiles are an active agent in complex and evolving gendered relationships. As Leopoldina Fortunati observes in her Marxist analysis of women's use of mobile media as part of their "double work" (home and paid labor), various forms of exploitation and empowerment can be found.[13] The gendered agenda around technologies is also generational.

In China, the dominance of mobile Internet sees very different media practices playing out in generational divides. Although Weibo dominates, it is China's oldest social media, QQ that is used by the old and young, in rural and urban locations.[14] In China, the total number of mobile phones in 2012 was 1.04 billion. Of the 590 million Internet users, about 380 million are on China's media-rich Twitter equivalent Sina Weibo.[15] The significant role played by mobile phones as the dominate portal for social and online media is highlighted by the CNNIC 2013 report that noted that mobile web users now total slightly more than 463 million. In China, mobile phones have afforded a version of the online that traverses across urban and rural divides. Although not everyone owns a computer, the ubiquity of mobile

phones has allowed many people access to various forms of online media. Increasingly across the globe, the mobile phone is becoming a dominant, if not the only mechanism for accessing the online.

It is not by accident that key artists such as Ai, curated and discussed by Kataoka, have utilized social mobile media such as Twitter, YouTube, and Weibo to broadcast to various fragmented and intimate publics (i.e., Twitter is banned in China). In locations such as post-tsunami and Fukushima nuclear disaster Japan, known as 3/11, mobile media such as Twitter and Instagram have blossomed in the wake of distrust for mainstream media such as NHK. The "intimate" turn has had an impact across various areas of life: from media to politics. If the new exterior is the interior, how does this shape the arts and their engagement with social media as conduits for intimate publics?

On the one hand, the rise of social mobile media has afforded institutions access and new ways to engage with fragmented publics. On the other hand, these highly individuated forms of media required institutions to rethink their ability to get intimate and into the hands and hearts of audiences while battling the growing overabundance of information Mark Andrejevic calls "infoglut". As Andrejevic notes, the overwhelming amount of information at our fingertips is changing the way we think and know.[16] One method is through apps. As Ng noted in her chapter, artists and organizations are embracing the role of apps as part of contemporary everyday life. But not everything can be compressed into an app or a series of tweets, and not everything should be condensed in such a manner.

Instead, as this collection has sought to illustrate, we need to understand art as part of broader contemporary gestures that both rehearse earlier practices while also signaling new directions for audience engagement, semi-engagement, and distraction. Like an analogy for the region, the multiple and competing screen cultures operate across various intimacies, co-presence, publics, and spaces. At the same time we see contemporary media participating in what Melissa Gregg dubs as "presence bleed": bleeding across media, platforms, and contexts.[17]

What we see is a need for new metaphors to describe contemporary media practice in everyday life. In Kim's chapter, she discussed her use of "platform" as a way to rethink the relationship among artist, art, and audiences. Her model revises the dynamic between art and audiences over nearly a decade. More recently, metaphors such as "network" and "platform" have come under question for their ability to address the complex entanglements between media, subjects, and places. As Tarleton Gillespie notes, "platform" has a number of definitions in English language, which together suggest "a progressive and egalitarian arrangement, lifting up those who stand upon it".[18] But within media spaces platforms are corporate applications that are far from impartial and equal. Instead, they highlight new divides in what Jack Qiu calls "have less" media practices. Although the platform metaphor seems to support the empowerment of the user, it also plays another role, echoing Wendy Chun's paradoxical alignment of freedom and control:[19] a tension that can be mapped throughout art history (see Figure 17.1).

Figure 17.1 Larissa Hjorth, *Locating the Mobile* (2004). Lightbox photograph, 45 × 60.
Source: Courtesy of the artist.

MESSY AND ENTANGLED: NEW METAPHORS FOR THE REGION AND MEDIA/ART PRACTICE

So how might we reframe the region and its contested art and media practices? How is this reflected in the changing face (and structure) of art institutions and organizations? As Geert Lovink notes, social media has simplified the complex historical definitions of the social into a prefix to media.[20] Moreover, we see the need to redefine the relationship between amateur and profession across a variety of discourses and disciplines. Although public institutions such as museums and galleries have long been the arbiters of taste—defining what is and what is not culturally significant—now these institutions have to respond to a more interactive public and be more demonstrably accountable to them, thanks in part to social media. Social media provides new ways for artists to connect, represent, and critique. From artists such as Cao Fei and Man Bartlett to artists on deviantART,[21] the role of private galleries in the art market is being challenged. Art historian Julian Stallabrass notes that social media poses a serious challenge to the authority of arts institutions. He writes that

> [t]o the extent that online art is associated with the culture of Web 2.0 and the "wealth of networks", it appears not merely dissociated from

the mainstream market for contemporary art but dangerous to it . . . Both museums and galleries are committed to the mystification of the objects that they display, holding to the fiction of a distinct realm of high art that stands above the bureaucratised world of work and the complementary vulgar blandishments of mass culture.[22]

As Raymond Williams noted, there are no "masses", only imagined ones. But with contemporary "participatory" media that "spreads" across a variety of platforms, contexts, and media, the role of audience agency has further transformed into what Anne Galloway defines as "mobile publics".[23] Social media messes up previously neat binaries between art and non-art and public and private space. Media, contexts, and platforms all bleed.[24] This messiness exposes methods and representational modes as well as speaking to increasingly fragmented audiences. As Lury and Wakeford have argued, methods cannot be separated from the research problem at hand.[25] They are intimately entwined in the process, shaping and being shaped by a key issue. Dourish and Bell have highlighted the need to understand ubiquitous media like mobile media as part of a messy ecology.[26] This messiness is not something negative but rather an embedded part of practice that needs to be considered when exploring such media. For Dourish and Bell, messiness is an important part of everyday life, and we need methods and theories that openly engage with this mess rather than just trying to tidy them up. This messiness returns us to the Introduction in which we discussed Galloway's notion of "mobile publics" as a way in which to encompass "messy" and "fluid" assemblages of everyday mobility which are more than just networked.

Arguably, the work of artists has been to expose these mechanisms and highlight the messiness of making meaning—something identified in avant-garde movements and artists like Duchamp[27] and stylized by relational aesthetics. For Dan Perkel, Web 2.0 is not creating new forms of art or artistic practices; rather, the fabric of the web is a "multi-faceted form of infrastructure" that forces old tensions in art to collide with Web 2.0 ideals.[28] This then, in turn, produces new tensions. Far from disrupting "[r]omantic conceptions of art and creativity", Perkel argues that the web uneasily accommodates these multiple, messy and often conflicting ideologies.[29]

Moreover, with the rise in a commodification and a professionalization of hobbyist discourses, new definitions around social and aesthetic language are required. If amateur art questions the boundaries of art, then vernacular creativity stretches them even further. Jean Burgess has called this kind of play "vernacular creativity", drawing upon the word vernacular, which implies language that is ordinary and everyday. This kind of creativity clearly predates modern technologies by hundreds if not thousands of years, but the rise of social media means that these forms of everyday, ordinary creativity can be circulated and shared. So how do we embrace

the messiness of practice and everyday life that acknowledges the historical hauntings as well as the new types of phenomenon in a productive manner?

Anthropologist Pink has argued that "emplacement" provides a productive metaphor for understanding movement within, and across, places. Emplacement, that is how place is situated through and within the movements and is integral in understanding everyday life. As we move unevenly into smartphone cultures and the attendant "applification" ecology, "network" no longer adequately seems to cover the entanglements between media practice, intimacy, and place. Rather, these practices are about a movement through and within place. Emplacement. *Emplaced visuality.* Emplaced visuality puts a theory of movement at the center of our understanding of contemporary media practice. Emplacement acknowledges the messiness of methods, meaning making, and transmission.

So how can we can begin to understand the region as a series of mobile publics that are dynamic as they are contesting? As we suggest in this conclusion, maybe utilizing concepts like emplacement and mobile publics can afford us a way to think through art practice and curation in, and outside, the movements of social media. In this conclusion, we have attempted to raise more questions about paradigms for imagining the intersection between art and media in the region. Some of these questions are rhetorical and have haunted debates around art, and imagining the region, for more than a century. Other questions are specific to the dynamics of media practice today and of what this messiness does to the entangled role of art in the region—in other words, the entanglements of mobile publics.

NOTES

1. Daniel Palmer, "Mobile Media Photography", in *The Routledge Companion to Mobile Media*, ed. Gerard Goggin and Larissa Hjorth (New York: Routledge, 2014), forthcoming.
2. This claim appears on Nokia's website in the "Camera Phones Backgrounder," accessed June 20, 2011, www.nokia.com/NOKIA_COM_1/Microsites/Entry_Event/Materials/Camera_phones_backgrounder.pdf.
3. Mikko Villi, "Visual Mobile Communication on the Internet: Publishing and Messaging Camera Phone Photographs Patterns", in *Seamlessly Mobile*, ed. Katie Cumiskey and Larissa Hjorth (New York: Routledge, 2013), forthcoming.
4. Cited in Nadav Hochman and Lev Manovich. Official usage statistics around the world are not yet available. The most recent report mentions 130 million monthly active users, 16 billion shared photos, 40 million photos per day, 8500 likes per second, and 1000 comments per second; see Seth Fiegerman, "Instagram Has 130 Million Monthly Active Users", *Masable.com*, June 20, 2013, accessed June 21, 2013, http://mashable.com/2013/06/20/instagram-130-million-users/; "Instagram Today: 100 Million People", *Instagram* blog, April 2013, accessed June 21, 2013, http://blog.instagram.com/post/44078783561/100-million; and *Instagram.com*, accessed June 21, 2013, http://instagram.com/press/.

5. Nadav Hochman and Lev Manovich, "Zooming into an Instagram City: Reading the Local through Social Media", *First Monday*, July 1, 2013, accessed June 20, 2013, http://firstmonday.org/ojs/index.php/fm/article/view/4711.
6. Larissa Hjorth and Sarah Pink, "New Visualities and the Digital Wayfarer: Reconceptualizing Camera Phone Photography and Locative Media", *Mobile Media & Communication* (2014): forthcoming.
7. Chris Chesher, "Between Image and Information: The iPhone Camera in the History of Photography", in *Studying Mobile Media*, ed. Larissa Hjorth, Jean Burgess, and Ingrid Richardson (New York: Routledge, 2012), 98–117.
8. *Utopia & Contemporary Art*, ed. Christian Gether, Stine Høholt, and Marie Laurberg (Ostfildern, Germany Hatje Cantz | ARKEN, 2012), 8.
9. Hans Ulrich Obrist quoted in interview with Moon Kyungwon and Jeon Joonho, *Shifting Gravity: World Biennial Forum No. 1*, ed. Ute Meta Bauer and Hou Hanru (Gwangju: Hatje Cantz, 2012), 111.
10. Terry Smith, "The Insfrastructural", in *Thinking Contemporary Curating* (New York: ICI, 2012), 249.
11. Raqs Media Collective, "Earthworms Dancing: Notes for a Biennial in Slow Motion", *e-flux journal*, no. 7 (June 2009), accessed September 1, 2013, www.e-flux.com/journal/earthworms-dancing-notes-for-a-biennial-in-slow-motion/.
12. Jo Tacchi, Kathi R. Kitner, and Kate Crawford, "Meaningful Mobilities", *Feminist Media Studies* 12, no. 4 (2012): 528–37.
13. Leopoldina Fortunati, "Gender and the Mobile Phone", in *Mobile Technologies: From Telecommunications to Media*, ed. Gerard Goggin and Larissa Hjorth (London: Routledge, 2009), 23–34.
14. Larissa Hjorth, Jack Linchuan Qiu, Zhou Baohua, and Ding Wei, "The Social in the Mobile: QQ as Cross-Generational Media in China", in *The Routledge Companion to Mobile Media* (London: Routledge, 2014), forthcoming.
15. China Internet Network Information Center (CNNIC) Statistical Report on *Internet in China*, January 2013, accessed September 11, 2013, www1.cnnic.cn/IDR/ReportDownloads/201302/P020130221391269963814.pdf; also see Takamitsu Nakao, "Social and Mobile Media in China," *Social Media and Mobile in China*, July 17, 2013, accessed August 20, 2013, http://socialmediainasia.blogspot.com.au/2013/07/the-latest-cnnic-report-said-that.html.
16. Mark Andrejevic, *Infoglut* (New York: Routledge, 2013).
17. Melissa Gregg, *Work's Intimacy* (Cambridge, UK: Polity, 2011).
18. Tarleston Gillespie, "The Politics of 'Platforms'", *New Media & Society* 12, no.3 (2010): 347–64 (350).
19. Wendy Chun, *Control and Freedom* (Cambridge, MA: MIT Press, 2006).
20. Geert Lovink, *Networks Without a Cause: A Critique of Social Media* (Cambridge, UK: Polity Press, 2012).
21. Sam Hinton and Larissa Hjorth, *Understanding Social Media* (London: Sage, 2013); Dan Perkel, "Making Art, Creating Infrastructure: DeviantART and the Production of the Web" (PhD diss., University of California, 2012), accessed June 13, 2013, http://people.ischool.berkeley.edu/~dperkel/diss/Dan Perkel-dissertation-2011_update.pdf.
22. Julian Stallabrass, "Can Art History Digest Net Art?", in *Net Pioneers 1.0: Contextualizing Early Net-based Art*, ed. Dieter Daniels and Gunther Reisinger (New York: Sternberg, 2010), 7.
23. Anne Galloway, "Mobile Publics and Issues-Based Art and Design", in *The Wireless Spectrum*, ed. Barbara Crow, Michael Longford, and Kim Sawchuk (Toronto: University of Toronto Press, 2010), 63–76.
24. Gregg, *Work's Intimacy*.
25. Celia Lury and Nina Wakeford, eds., *Inventive Methods: The Happening of the Social* (London: Routledge, 2012).

26. Paul Dourish and Genevieve Bell, *Divining a Digital Future: Mess and Mythology in Ubiquitous Computing* (Cambridge, MA: MIT Press, 2011).

27. Erkki Huhtamo, "Virtual Museums and Public Understanding of Science and Culture" (paper presented at Nobel Symposium [NS 120], Stockholm, Sweden, October 2002).

28. Perkel, *Making Art, Creating Infrastructure*, 1.

29. Ibid.

Contributors

Amelia Barikin is a postdoctoral research fellow at the School of English, Media Studies and Art History at the University of Queensland. Her recent publications include *Making Worlds: Art and Science Fiction* (2013, coedited with Helen Hughes) and *Parallel Presents: The Art of Pierre Huyghe* (2012).

Zoe Butt is Executive Director and Curator of Sàn Art, Vietnam's most active independent contemporary art space and reading room in Ho Chi Minh City. From 2007 to 2009, she was Director, International Programs, Long March Project—a multiplatform, international artist organization and ongoing art project based in Beijing, China. From 2001 to 2007, she was Assistant Curator, Contemporary Asian Art, Queensland Art Gallery, Brisbane, Australia, where she assisted in the development of the Asia-Pacific Triennial of Contemporary Art (APT), in key acquisitions for the Contemporary Asian art collection, and in other associated gallery programs.

Justin Clemens has published extensively on contemporary European philosophy and contemporary art. His books include coedited scholarly collections on the work of Giorgio Agamben, Alain Badiou, Jacques Lacan, and others, all published by major university presses. His most recent book, *Minimal Domination*, is a collection of art criticism.

Sean Cubitt is Professor of Global Media and Communication, Goldsmiths. He was previously Professor of Media and Communication at Winchester Research Centre for Global Futures in Art Design and Media and, before that, the director of the program in Media and Communications at the University of Melbourne and Honorary Professor of the University of Dundee. His publications include *Timeshift: On Video Culture, Videography: Video Media as Art and Culture, Digital Aesthetics, Simulation and Social Theory, The Cinema Effect*, and *EcoMedia*. He is the series editor for Leonardo Books at MIT Press. His current research is on public screens and the transformation of public space and on genealogies of digital light technologies.

Gridthiya Gaweewong cofounded "Project 304", an independent/nonsite art organization based in Bangkok since 1996. Gridthiya Gaweewong is very much interested in working with regional and international networking and on collaborative art projects. Her projects deal mostly with contemporary local, regional, and international artists from the 1960s generation, addressing issues of subculture, globalization, migration, and alienation. She has curated art exhibitions and films festival including *Under Construction*, Tokyo, Japan (2003); *politics of fun, Haus der Kulturen Der Welt*, Berlin (2005); *Bangkok Experimental Film Festival*, Thailand (1997–2007), *Nothing, A Retrospective of Rirkrit Tiravanija and Kamin Lertchaiprasert*, Chiangmai (2004); *Saigon Open City*, Vietnam (2006–7); *Unreal Asia*, a thematic program for the fifty-fifth Oberhausen International Short Film Festival, Germany (2009). Currently she serves as an artistic director of the Jim Thompson Art Center, Bangkok.

Anthony Gardner is University Lecturer in Contemporary Art History and Theory at the Ruskin School of Art, University of Oxford. He writes extensively on postcolonialism, postsocialism, and curatorial histories and is an editor of the MIT Press journal *ARTMargins*. Among his publications are *Mapping South: Journeys in South-South Cultural Relations* (2013) and *Politically Unbecoming: Postsocialist Art Against Democracy* (2014).

Charles Green is Professor of Contemporary Art at the University of Melbourne. He has written *Peripheral Vision: Contemporary Australian Art 1970–94* (1995) and *The Third Hand: Artist Collaborations from Conceptualism to Postmodernism* (2001) and has been an Australian correspondent for *Artforum* for many years. As Adjunct Senior Curator, Contemporary Art, National Gallery of Victoria, he worked as a curator on *Fieldwork: Australian Art 1968–2002* (2002), *world rush_4 artists* (2003), "2004: Australian Visual Culture" (ACMI/NGVA, 2004), and "2006 Contemporary Commonwealth" (ACMI/NGVA, 2006).

Larissa Hjorth is an artist, a digital ethnographer, and Professor in the Games Programs, and co-director of RMIT's Digital Ethnography Research Centre (DERC) with Heather Horst. Since 2000, Hjorth has been researching the socio-cultural dimensions of mobile, social, locative, and gaming cultures in the Asia-Pacific region—these studies are outlined in her books, *Mobile Media in the Asia-Pacific* (2009), *Games & Gaming* (2010), *Online@AsiaPacific: Mobile, Social and Locative in the Asia–Pacific region* (with Michael Arnold, 2013), *Understanding Social Media* (with Sam Hinton, 2013), and *Games of Being Mobile* (with Ingrid Richardson, 2014). She has published more than forty book chapters and twenty journal articles. Hjorth has had more than a dozen solo exhibitions at institutions such as Experimental Art Foundation and Gyeonggi Museum of Modern Art and has participated in more than

fifty art exhibitions (such as Yokohama Triennale 2001 with the Japanese Internet group Candy Factory). Her art practice explores entanglements between ethnography, art, and mobile media.

Yusaku Imamura is the founding director of Tokyo Wonder Site since 2001 and Counselor on Special Issue to the Governor, Tokyo Metropolitan Government. Trained as an architect, Imamura has fostered numerous collaborative international platforms through Tokyo Wonder Site, a contemporary art space and residency program in Tokyo that supports emerging creators and new systems for arts and culture in Tokyo. He was part of the think tank that conceptualized the Utopia project during the 2008 Sydney Biennale.

Edwin Jurriëns is Lecturer in Indonesian Studies at the Asia Institute, University of Melbourne. His publications include *From Monologue to Dialogue: Radio and Reform in Indonesia* (2009) and *Cosmopatriots: On Distant Belongings and Close Encounters* (2007).

Mami Kataoka is Chief Curator at the Mori Art Museum (MAM) in Tokyo since 2003, where she most recently curated *Aida Makoto: Monument for Nothing* while extending her curatorial practice in many international projects including ninth Gwangju Biennale (2012) in South Korea as Joint Artistic Director, *Phantoms of Asia: Contemporary Awakens the Past* (2012) at Asian Art Museum in San Francisco as guest curator, and *Ai Weiwei: According to What?* (2012) at Hirshhorn Museum and Sculpture Garden in Washington, D.C., which has been touring other North American venues. She was International Curator at the Hayward Gallery in London between 2007 and 2009, where she curated *Laughing in the Foreign Language* (2008) and co-curated *Walking in My Mind* (2009). Prior to her work at the Mori Art Museum, she was Chief Curator at Tokyo Opera City Art Gallery from 1997 to 2002. Kataoka also frequently writes and gives lectures on contemporary art in Asia.

Sunjung Kim is a director of Samuso, a curatorial organization in Seoul. She is Artistic Director of the REAL DMZ PROJECT, an ongoing platform for the development of diverse research practices engaging with the complex issues surrounding the DMZ. Kim is part of Utopia.

Natalie King is a curator, writer, and the inaugural director of *Utopia*—a pan-Asian incubator, under the auspice of Asialink at the University of Melbourne. She has curated exhibitions for numerous museums including the Singapore Art Museum; the National Museum of Art, Osaka; the Tokyo Metropolitan Museum of Photography; the Tjibaou Cultural Centre, New Caledonia; the Bangkok Art and Culture Centre; and the Museum of Contemporary Art, Sydney. She is a correspondent for *Flash*

Art International and has contributed to *ARTit* (Japan), *Art Asia Pacific*, *Art and Australia*, *British Art Monthly*, *Art World*, *The Age*, *Artlink*, LEAP (China) and *Australian Art Collector*. She has published interviews with Ai Weiwei, Cai Guo-Qiang, Joseph Kosuth, Tacita Dean, Hiroshi Sugimoto, Carolyn Christov-Bakargiev, Massimiliano Gioni, Hou Hanru, and Jitish Kallat, amongst others.

Lee Weng Choy is an art critic based in Singapore; he is director of projects, research and publications at the Osage Art Foundation, Hong Kong, and is a consultant lecturer with the Sotheby's Institute of Art, Singapore. Lee has lectured on art and cultural studies, convened international conferences, and written widely on contemporary art and Singapore. His essays have been published in *ArtAsiaPacific*, *Art Journal*, *Broadsheet*, *Column*, *eyeline*, *Forum on Contemporary Art & Society*, *Journal of Visual Culture*, *Positions: East Asia Cultures Critique*, *Over Here: International Perspectives on Art and Culture*, *Theory in Contemporary Art since 1985*, and *Yishu*. Lee also serves on the academic advisory board of the Asia Art Archive in Hong Kong and is president of the Singapore Section of the International Association of Art Critics. From 2000 to 2009, he was the artistic co-director of The Substation arts center.

Scott McQuire is Associate Professor and Reader in the School of Culture and Communication at the University of Melbourne. His books include *The Media City: Media, Architecture and Urban Space* (2008) and the *Urban Screens Reader* (coedited with Meredith Martin and Sabine Niederer, 2009).

Deeksha Nath is an independent critic and curator based in New Delhi. She is desk editor of *ArtAsiaPacific* and *ArtEtc*, and her writing has been published widely in books, exhibition catalogues, national and international magazines. Previous assignments have been with the Tate Modern, London, and the National Gallery of Modern Art, New Delhi. Her curatorial projects include *Zones of Contact: Propositions on the Museum*, Kiran Nadar Museum of Art, New Delhi (2013); *Step Across this Line*, Asia House, London (2011); *Astonishment of Being*, Birla Academy of Art and Culture, Kolkata (2009) and *Still Moving Image*, inaugural exhibition of Devi Art Foundation, Gurgaon, India (2008) among others. She co-curated the Best of Discovery section at ShContemporary, the Asia Pacific Contemporary Art Fair, Shanghai (2008). She is part of Utopia.

Elaine W. Ng is publisher and editor of *ArtAsiaPacific*, the 17-year old journal dedicated to contemporary art from Asia, the Pacific, and the Middle East. Ng has sat on the jury of the UNESCO Digital Arts Award 2003 at IAMAS, Gifu, Japan; Ars Electronica's Prix Ars (2004, 2005, 2007) in Linz, Austria; and the Abraaj Capital Art Prize in Dubai, UAE (2008,

2009, 2010). Ng is also a contributing editor to the *Leonardo Electronic Almanac* (MIT Press) and sits on the academic advisory board of the Asia Art Archive in Hong Kong, the international committee for the Abraaj Capital Art Prize, and the advisory panel for Art HK.

Nikos Papastergiadis is Professor at the School of Culture and Communication at the University of Melbourne and Director of the Research Unit in Public Culture. His current research focuses on the investigation of the historical transformation of contemporary art and cultural institutions by digital technology. His publications include *Modernity as Exile* (1993), *Dialogues in the Diaspora* (1998), *The Turbulence of Migration* (2000), *Metaphor and Tension* (2004) *Spatial Aesthetics: Art Place and the Everyday* (2006), and *Cosmopolitanism and Culture* (2012) as well as being the author of numerous essays that have been translated into more than a dozen languages and have appeared in major catalogues such as the Biennales of Sydney, Liverpool, Istanbul, Gwangju, Taipei, Lyon, Thessaloniki, and Documenta 13.

Dr. Kristen Sharp is Senior Lecturer and Coordinator of Art History & Theory in the School of Art, RMIT University. Her research interests include contemporary art and urban space, collaborative practices in transnational art projects, and contemporary Asian art. Sharp's contribution to the field of interdisciplinary research and transnational studies is exemplified through research grants, publications, and doctoral thesis (*Superflat Worlds: A Topography of Takashi Murakami and the Cultures of Superflat Art*, RMIT University, 2007).

Russell Storer is Curatorial Manager, Asian and Pacific Art, at the Queensland Art Gallery/Gallery of Modern Art, Brisbane, Australia. He was on the curatorial team for the sixth Asia Pacific Triennial of Contemporary Art (APT6) in 2009–10 and for the APT7 (2012–13). He was previously a curator at the Museum of Contemporary Art, Sydney, where he organized numerous exhibitions. He was a co-curator of the third Singapore Biennale, '*Open House*', in 2011, and a visiting curator at Documenta 12 in 2007.

Tan Boon Hui has been Director of the Singapore Art Museum (SAM) from 2009 until July 2013. Prior to this, he was Deputy Director for Programmes at the National Museum of Singapore. SAM has organized key surveys of contemporary Southeast Asian art, and since 2010, Tan Boon Hui heads the secretariat for the Singapore Biennale. He is also a Utopia partner and is currently Group Director of Programmes at the National Heritage Board.

Darren Tofts is Professor of Media and Communications, Swinburne University of Technology. Tofts is one of Australia's leading writers on media

arts and contemporary aesthetics. His publications include *Parallax: essays on Art, Culture and Technology* and *Illogic of Sense: the Gregory L. Ulmer Remix* (with Lisa Gye). He is a regular essayist on contemporary media arts for publications such as *RealTime, Photofile, Mesh, Rhizomes,* and *Scan.* With Christian McCrea he edited a special issue of *Fibreculture Journal* (2009) devoted to remix practices and contemporary media art.

Linda Williams is Associate Professor of Art, Environment & Cultural Studies in the School of Art at RMIT University in Melbourne, where she leads a university research cluster: Art & Environmental Sustainability. Along with her work as a widely published art critic, she has published in the field of the history of culture and science, philosophy and critical theory, and is an active member of the Globalization and Culture project in the Global Cities Research Institute at RMIT.

Audrey Yue is Associate Professor in Cultural Studies at the University of Melbourne. Her recent publications include *Transnational Australian Cinemas* (2013), *Queer Singapore* (2012), and *Ann Hui's Song of the Exile* (2010).

Index